JOHNNY GRUELLE
Creator of
RAGGEDY ANN
and ANDY

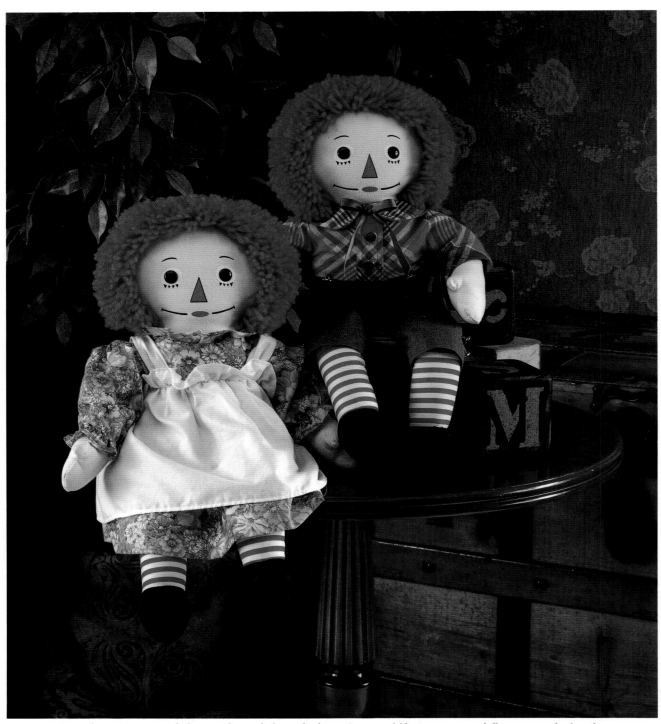

In 1992 Applause, Inc. issued these authorized, limited edition Seventy-fifth Anniversary dolls, patterned after the Georgene Raggedy Ann and Andy of the early 1940s. (Courtesy Applause, Inc.)

JOHNNY GRUELLE

Creator of
RAGGEDY ANN
and ANDY

By Patricia Hall

PELICAN PUBLISHING COMPANY
Gretna 1993

The word "Pelican" and the depiction of a pelican are trademarks of Pelican Publishing Company, Inc.,
and are registered in the U.S. Patent and Trademark Office.

Library of Congress Cataloging-in-Publication Data

Hall, Patricia.
 Johnny Gruelle, creator of Raggedy Ann and Andy / Patricia Hall.
 Includes bibliographical references and index.
 ISBN 0-88289-908-2
 1. Gruelle, Johnny, 1880?-1938. 2. Illustrators—United States—Biography. I. Title.
NC975.5.G776H35 1993
741.6'092—dc20
[B] 92-30264
 CIP

Art photography by the author, Chromatics (Nashville, TN), W. Jackson Goff Photography (Nashville, TN), Prophoto (Nashville, TN), Bob Schatz (Nashville, TN), and Thompson-McClellan (Champaign, IL)

Research for this book was supported, in part, by a National Endowment for the Humanities Grant-in-Aid, awarded to the author in 1988 by the Indiana Historical Society and the American Association for State and Local History.

The names and depictions of Raggedy Ann and Raggedy Andy are registered trademarks of Macmillan, Inc. All rights reserved.

The Raggedy Ann and Andy stuffed rag dolls are copyright Johnny Gruelle.

Manufactured in Hong Kong
Published by Pelican Publishing Company, Inc.
1101 Monroe Street, Gretna, Louisiana 70053

For Worth, who carries on the legacy,
and
for my David, who believes in the magic

For more than seventy-five years, Johnny Gruelle's Raggedys have delighted little boys and girls alike. (Photograph by Patricia Hall)

Contents

	Foreword	9
	Preface and Acknowledgments	11
Chapter 1	Through the Eyes of a Child: An Introduction	17
Chapter 2	Art for the Heart's Sake: Richard Buckner Gruelle	23
Chapter 3	Ring Out Wild Bells: Johnny Gruelle's Early Years	27
Chapter 4	The Whimsical Observer: Johnny Gruelle, Newspaper Cartoonist	35
Chapter 5	And Their Journey Begins: Johnny and Myrtle Gruelle	47
Chapter 6	A Sprite for All Seasons: "Mr. Twee Deedle"	57
Chapter 7	On the Banks of the Silvermine River: The Gruelles Settle In	67
Chapter 8	By the Glow of a Lamp: Johnny Gruelle, Magazine Free-lancer	71
Chapter 9	*Grimm's Fairy Tales* and *Nobody's Boy:* Johnny Gruelle and Cupples & Leon	79
Chapter 10	Through the Door: Marcella Gruelle	87
Chapter 11	Good Books for Kindly Children: Johnny Gruelle and the P. F. Volland Company	93
Chapter 12	In the Crook of a Dimpled Arm: The Raggedys Debut	103
Chapter 13	Everybody Loves Uncle Johnny: Gruelle in the Early 1920s	123
Chapter 14	At the Door of the Hoosier House: Johnny Gruelle and the Bobbs-Merrill Company	129
Chapter 15	Where Nature Lavished Her Bounties: Johnny Gruelle Goes West	139
Chapter 16	Back in the Old Home Port: Johnny Gruelle in the Late 1920s	147
Chapter 17	The Passing of Summer: Johnny Gruelle and the Great Depression	155
Chapter 18	Sailing into a Land of Light: Johnny Gruelle's Florida Years	161
Chapter 19	Raggedy Ann's Day in Court: Gruelle vs. Molly-'Es Doll Outfitters	169
Chapter 20	Goodbye, Uncle Johnny	179
Chapter 21	The Raggedys Carry On	183

Chapter 22 From Whence the Magic Came: Johnny Gruelle and His Muses 193
Appendix A Johnny Gruelle's Books: A Checklist 199
Appendix B Johnny Gruelle's Periodical Appearances: A Chronological
 Checklist 207
 Principal Sources 211
 Credits 214
 Index 215

Foreword

Five years ago Patricia Hall came to me with a proposal to do a book about my grandfather, Johnny Gruelle. There had been so little written or documented about the man who was one of this century's finest illustrators and children's storybook writers, that the Gruelle family thought it a grand idea that Patty write the book.

During my grandfather's too-short, but fabled, career, he created thousands of pieces of artwork for national periodicals, worked as a nationally known syndicated political cartoonist, and provided illustrations for dozens and dozens of books. More than twenty-five of these were books that eventually appeared as part of his Raggedy Ann series.

Now, at the hand of a writer and folklorist, the story of Uncle Johnny and his beloved Raggedy Ann and Andy magically comes to life. Congratulations, Patty, for a job well done. I am sure that Grandfather and Grandmother Gruelle are looking down with happiness and love in their hearts.

"For as you look, so shall you see; and as you think, so shall you be." May the magic of Raggedy Ann and Andy live forever in the hearts of young and old alike.

KIM GRUELLE
Norton, North Carolina

I never knew the man who lit up the world with his sunshine and laughter. But it has been a special blessing to be the granddaughter of Johnny Gruelle—a person who, through his magical storytelling, created a loving and wholesome message for his readers.

Characters that lived with me so closely as a child seemed to come alive when I had the opportunity in the 1960s to assist my dad, Worth, in illustrating several of my grandfather's unpublished manuscripts. What a joy it was to contribute, in a small way, to the lasting memory of a man who wanted to make life a little brighter, and each heart a little warmer.

JONI GRUELLE KEATING
Atlanta, Georgia

Preface and Acknowledgments

It was early in the summer of 1988 when I first ventured into the Deep Deep Woods of western North Carolina. Earlier that year I had corresponded with Kim Gruelle, expressing my interest in writing a book about his grandfather, American author and illustrator Johnny Gruelle. Responding to my letter, Kim (himself an artist and proprietor of his own shop) offered me the decisive encouragement I needed to proceed. "I will gladly lend my mind and good spirit to the historical documentation of Raggedy Ann and Andy and the near mystical quality that pervades so much of what my grandfather, Johnny Gruelle, creatively did," Kim wrote. He added, "The timing of this project is excellent."

And so, that summer, I traveled to North Carolina to meet with Kim and his parents, Worth and Suzanne. Sitting together on the Gruelles' shady porch overlooking the mist-filled ridges, we got to know one another, while fragile butterflies and shy bluebirds fluttered amongst the wildflowers in the yard below. It was, I couldn't help but note, a scene right out of one of Johnny Gruelle's books—those beautifully illustrated works with which I had become smitten several decades before.

In my twenty years of collecting and studying Gruelle's works, I'd been surprised to find no comprehensive bibliographies and very little published about his life; puzzling indeed, in light of his wide-ranging talents and prodigious output, which included thousands of cartoons, hundreds of illustrated stories, dozens of books, and a whole host of original playthings. The sad fact was, while Johnny Gruelle had made countless contributions to the entertainment world of early twentieth-century America,

there was no single book nor more than a half dozen definitive articles written about him and his career.

Later that evening, while leafing through family albums and scrapbooks, and listening to Worth (a published artist and illustrator in his own right) talk about his father, I began to comprehend the depth and contours of the legacy Johnny Gruelle had spawned. Our conversations punctuated by the sounds of fast-moving mountain thunderstorms, the Gruelles and I began that weekend exploring together the equally important facts and legends about Johnny and his Raggedys.

There would be other visits, Worth and his family welcoming me into their homes in North Carolina and Florida, patiently answering many more questions. In between visits, there were countless more interviews—with other Gruelle family members and with special friends who still remembered Johnny. There were also dozens of phone calls and letters to follow up on leads, many days spent leafing through old magazines and scanning reels of microfilm, and numerous photo sessions.

Worth Gruelle and his family were vital resources as I proceeded with my research, sharing not only anecdotes and memories, but also precious family photographs, keepsakes, and papers, including the eloquent, heartfelt memoirs of Johnny's wife, Myrtle—all indispensable materials as I sought to convey the nuances and the spirit of Johnny Gruelle's life. To Worth and Sue, the generous and gentle perpetuators of Johnny Gruelle's tradition, I offer a loving thank you for your help, your many kindnesses, and for believing in my work.

My heartfelt gratitude goes, as well, to Kim

Gruelle—friend, guide, and voice of reason, whose unfaltering faith in this book and in the positive forces of the universe provided the spiritual underpinnings of the project. And, special thanks to Joni Gruelle Keating (Kim's sister and her grandfather's namesake) for unfailing enthusiasm and encouragement.

I am also indebted to Ruth Gruelle (whose late husband, Richard, was Johnny Gruelle's younger son) and to Ruth's daughter Kit Gruelle, for sharing multiple family materials and memories. And an emphatic thank you to Johnny Gruelle's nieces, Jane Gruelle Comerford (who lent her father Justin Gruelle's magnificent family scrapbooks and memoirs) and Peggy Y. Slone (who allowed me to copy many precious family photographs).

In addition to the Gruelle family, I am extremely grateful to the following people and institutions for their generous assistance and good wishes as this book grew:

The friends and acquaintances of Johnny Gruelle, who shared firsthand memories, and lent photographs and keepsakes reflecting their fond associations with Johnny and his family: Jane Marcella Ferguson Braunstein, Lynda Oeder Britt, Jessie Soltau Corbin, Monica Borglum Davies, Jane Meek Diller, Betty MacKeever Dow, Shirley Miller Holmes, Anne laDue Hartman Kerr, Janet Smith Leach, Virginia Crandell MacDougall, Alice McGee, Ruby Mason, Norman Meek, Graham Miller, Nancy Parkin, Jane and Norman Peterson, Larry Powell, Caroline Cox Scheffey, Phyllis Smith, Jeanette Sterling, Louise Sturges, and Charlotte Miller Weller;

The collectors and bibliophiles; writers and editors; librarians and curators; scholars and artists; specialists, friends, and family who willingly shared information, advice, leads, and materials: Pauline Baker, the late Ruth Baldwin, Barbara Barth, David Begin, Kathy Bennett, Bill Blackbeard, Ralph Bloom, Candy Brainard, Sharon Brevort, Natalie Brown, Judie Bunch, Kent Calder, John Cech, Arnold Citroen, Sue Cloak, Harry and Jeanne Cohen, Donald Crafton, Ron and Sandy Crain, Carol Crockett, Nancy Powell Dobson, Barbara and Roy Dubay, David Durham, Julie Duijker, Marjorie Edens, Kathy and John Ellis, Betsy Fisher, Flora Faraci, Alice Fleming, Elizabeth Fowler, Audrey Frank, Martin Gardner, Barbara and Don Gaskin, Audrey Geisel, the late Theodor Geisel (Dr. Seuss), Lynda Graves, Janice Hall, Michael and Gladys Hall, Peter Hanff, Peter Harstad, Bob Hitt, Nancy Holmes, Elizabeth Hoover, Sally Hopkins, Chris Horsnell, Patricia Hudson, Arnie Klein, Joel and Kate Kopp, Clay Lancaster, Mark Langer, Shirley Lawson, Peggy Lenney, Brad Linder, Laura Linnard, Janet McCullough, Craig McNab, Richard Marschall, Thomas Mason, Melanie Maxwell, Marge Meisinger, Jeryl Metz, Margarette Miller, Marjorie O'Harra, Robin Olderman, Ed Penney, Robert Plowman, Nolan Porterfield, Lawrence Powell, the late Ray Powell, Alice Rogan, Thomas Salmon, Dan Scheffey, Justin Schiller, Charlie Seemann, John Seltz, Patricia Smith, Sol Solomon, Lynnita Sommer, Joseph Stouney, Carol Sullivan, Andrew Tabbat, Robert Tabian, Saundra Taylor, Gloria Timmell, Maryann Waddell, John Walk, William Wepler, Helen White, the late Martin Williams, Debbie and Jim Wiltjer, Susan Wissman, Jackson and Amber Wolffe, Steve Wyatt, Barbara Young, Noraleen Young, Helen Younger, Michael Zibart, Robert and Ruth Zimmerman, and Jack Zipes;

The museums, libraries, archives, businesses, and other repositories that held the Gruelle gemstones for which I searched: Brown University Library, California State University Library, Chicago Public Library, Cleveland State University Library, Committee of One Hundred of Miami Beach, Connecticut State Library, Country Music Foundation, Friends of the Library—University of California at Santa Cruz, Hallmark Cards, Historical Society of Douglas County (IL), Historical Society of Southern Florida, Illinois State Library, Indiana Historical Society, Indiana State Library, Indiana State Museum, Indiana University Library, Indianapolis Museum of Art, Indianapolis Public Library, the Kentucky Library, Library of Congress, McCall's Pattern Company, Miami-Dade County Library System, Nashville Public Library, the National Archives, New Canaan (CT) Historical Society, New York Public Library, Norwalk (CT) Historical Commission, Franklin D. Roosevelt Library, Southern Oregon Historical Society, The Strong Museum, University of Connecticut Library, University of

Florida Library, Vanderbilt University Library. Special thank-yous go to Susan Manakul, my research assistant, whose careful eye and diligent searching resulted in valuable and, in some cases, unanticipated discoveries; Rita Rosenkranz, my wise and intuitive literary agent, whose expertise and unwavering commitment to this book resulted in placement with the ideal publisher; and Nina Kooij, my editor at Pelican, and Dana Bilbray, production manager, who skillfully helped me turn a complicated manuscript into a book.

A nostalgic thanks goes to my parents: Frances Hall, who in 1949 made me my first Raggedy Ann doll; and Verl Hall, who not only offered insights and advice on the manuscript, but also was the one who, years ago, first acquainted me with the lush and tempting aroma of old bookstores.

Finally, I'm ever grateful to my family: husband Barry Cohen, for his keen editorial eye, excellent suggestions, and loyal support; son Russell, for the many Raggedy surprises; and little son David, who kept me focused on the magic and stayed ever so patient while Mommy worked.

During the mid-1920s, Volland introduced a Beloved Belindy character doll to accompany Gruelle's new book, Beloved Belindy. (Courtesy Candy Brainard)

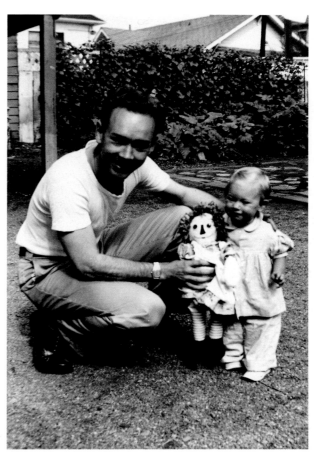

The author, with her father and favorite Raggedy, 1949. (Photograph by Frances Hall)

In May of 1929, Volland published Marcella: A Raggedy Ann Story, *a set of tales about a little girl who takes her dolls to the seashore. Full of the bright colors of sun and surf and the hearthglow of the holidays (and apparently not based on his newspaper serials) this book was, for many readers, Gruelle's long-awaited tribute to his late daughter.* (Courtesy Jane Addams Book Shop Collection; used by permission of Macmillan Publishing Company)

JOHNNY GRUELLE
Creator of
RAGGEDY ANN
and ANDY

Johnny Gruelle by Johnny Gruelle, ca. 1936.
(Courtesy the Wardell Family)

CHAPTER ONE

Through the Eyes of a Child:
An Introduction

I was with you all the time but I let your own kind hearts suggest what to do.

<div align="right">

Mr. Twee Deedle
1912

</div>

He never met a knight in shining armor, but knew the hearts of medieval princesses and understood their courtly gestures. He never set foot on an airplane, yet somehow could convey the wonders of flight and awe of space travel. From his subconcious sprang ancient motifs and future themes; about things and events he never witnessed firsthand, but about which he wrote lovingly and knowingly. And though he was born long after the time of the Brothers Grimm and did not live long enough to see a motion picture in Technicolor, his palette gleamed with all the colors of the forest primeval and the wide theater screen. Though his life was brief, his knowledge of other times and other places was deep and omniscient; his imagination, a many-windowed time machine.

Johnny Gruelle is best known for creating Raggedy Ann and Raggedy Andy, the whimsical dolls and storybook characters that escorted him to national prominence in only several years' time. But

Gruelle was a man of many talents and persuasions—writer, cartoonist, musician, songwriter, toy designer, businessman, spiritualist, and nature-lover. Above all, he was an artisan with an astonishing and uncanny grasp of past and future motifs.

Gruelle began his career as a newspaper cartoonist, working successfully in that medium for ten years. His decision to branch out into other entertainment media may have been the most prudent one of his career. Had he chosen to continue only as a front-page political cartoonist, he would never have reached his most adoring audience: children.

Gruelle chose never to see himself solely as a cartoonist, illustrator, writer, or toy designer. He never forsook one endeavor for the other, and he often applied what he had learned in one arena to his work in another. To his credit (his broad store of literary and artistic talents notwithstanding) Johnny Gruelle never lost sight of what his calling *really* was: entertaining the public.

John Barton Gruelle was born in 1880 in Arcola, Illinois. His father, Richard Buckner Gruelle—known as R.B.—was a self-taught portrait and landscape painter, later to become known as a member of the Hoosier Group of Indiana-based impressionist artists. R.B. was also a musician and writer, who extolled regional values and aesthetics—ones that would profoundly influence Johnny and his younger siblings, Justin and Prudence.

When Johnny was still a toddler, the Gruelle family moved to Indianapolis, where they lived among other Midwestern artists and writers. One frequent visitor to the Gruelle home was the poet James Whitcomb Riley, whose nostalgic tales, stories of newspaper work, and vagabond lifestyle captivated young Johnny.

At age nineteen, Gruelle chose newspaper work himself, working as a chalk-plate artist for several Indianapolis papers before signing on in 1903 as assistant illustrator for the newly founded *Indianapolis Star.* Johnny's talent as a cartoonist eventually led him to other newspapers, in other cities. In 1910, Gruelle's big break occurred when he entered a *New York Herald*-sponsored comic-drawing contest. His two submissions won first and second place in a blind competition of 1,500 entries. Gruelle garnered a $2,000 cash prize and what turned out to be an extended contract with the *Herald* to provide weekly installments of his prizewinning, full-color, full-page cartoon, "Mr. Twee Deedle."

Johnny Gruelle immersed himself in his work, and soon became known for his prodigious output. A speedy worker, he would often finish his newspaper cartoons early in the day, spending his afternoons completing commissioned assignments for a variety of periodicals. Illustrated fairy stories and satirical "bird's-eye-view" cartoons became his specialties.

Johnny Gruelle's first book commission came in 1914—a set of illustrations for an ambitious volume of Grimms' fairy tales. He rendered a dozen lavish full-color plates and more than fifty pen-and-ink drawings for traditional tales whose content, form, and structure would serve as the foundation for his own yet-to-come storybooks.

During this time Gruelle had caught wind of the growing popularity of commercial playthings and diversions, many of which reflected traditional values.

With his fanciful stories and ideas, he must have known he was in an excellent position to capitalize on this quest after homespun, leisure-time entertainment.

In this light, Gruelle may have specifically anticipated the potential for a commercial "folk" doll. Or he may simply have been advised to seek protection for a family rag doll on which he had rendered a new and original face. In any event, in 1915, Johnny Gruelle applied for a design patent for a slue-footed doll he called Raggedy Ann. In the weeks that followed, Gruelle set to work producing enough handmade Raggedy Ann dolls to sell to secure a registered trademark for the logo "Raggedy Ann." Though they predated by three years Gruelle's first published books about Raggedy Ann, these first trademarked dolls launched Gruelle's little yarn-haired moppet as a commercial entity.

By 1918, Gruelle had sold a volume of Raggedy Ann tales to the Chicago-based P. F. Volland Company. By fall of that year the first editions of *Raggedy Ann Stories* were rolling off the presses. The book's covers featured front-and-back views of a Raggedy Ann doll, which the Volland Company had also begun producing to sell along with the books. Two years later—in 1920—Johnny Gruelle created Raggedy Andy, who made his literary debut in his own volume, *Raggedy Andy Stories,* and also joined Raggedy Ann as a commercially available Volland doll. These events set Johnny Gruelle squarely on the path to becoming a well-known children's author and illustrator.

Anyone with a sewing machine and a little imagination might well have created similar storybooks or rag dolls. And many in Johnny Gruelle's time had tried. But it was Gruelle's eye for design and form, his innate sense of what the public wanted, and his ability to synthesize original and borrowed elements that made his Raggedys special. Gruelle's floppy moppets were distinctive, but somehow familiar looking; funny and huggable, yet original and saucy. In looks and gestures, they suggested softness, wisdom, and nostalgia, but also high-spiritedness, whimsy, and brightness—all qualities guaranteed to appeal to children and their parents, whose senses and sensibilities were being piqued by the sights and sounds of a bustling, very modern era, later to be dubbed the Jazz Age.

Though Johnny Gruelle would find fame as a children's author and playthings designer, he would always be, at heart, an artist who felt most at home with pen and brush. His illustrations are colorful glimpses into lands of magic: forest glades, complete with dancing wood sprites and carpets of colorful flowers; bulging little bungalows with crooked chimneys, homes to good and bad witches; and scenes in which the kindly rag dolls, Raggedy Ann and Andy, lope their way through adventure after adventure.

Gruelle's early artistic style is romantic, almost dreamlike, and his use of color borrows heavily from the gold-and-violet palettes of his father and other early-twentieth-century American fine artists. His later illustrations are bright and fluid. Facial expressions and body movements, be they of dwarfs, fairies, dolls, or mortals, are crisply captured with pen and brush.

As an artist and a writer, Johnny Gruelle was an astute observer and a skilled adaptor; a bearer of tradition as well as an innovator. As a result, he created and presented the kinds of characters and themes that felt simultaneously familiar and brand new to his audience.

No doubt, a childhood spent among the writers of late nineteenth-century Indianapolis exposed Johnny to the language and power of expert storytelling. Johnny Gruelle's original stories contain scores of traditional motifs gleaned from European folk- and fairy tales. However, Gruelle would style his prose to

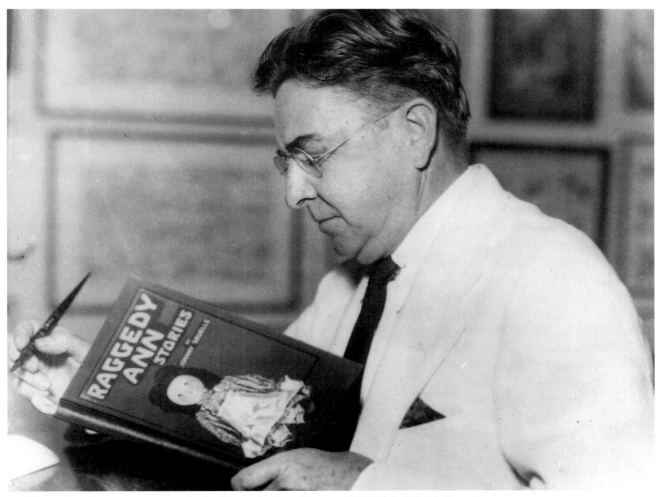

Johnny Gruelle prepares to inscribe his Raggedy Ann Stories. (AP/Wide World Photo)

suit a more contemporary audience, sidestepping the severe moral tone and cruelties often found in many of the Grimms' and Andersen's fairy tales.

Gruelle's own tales are laced with subtle humor, and many contain updated fable-like explanations for life's many mysteries. He filled his stories with made-up characters with whimsical names like "Snoopwiggy" or "Snarleydoodle"; animals with alliterative names like "Maurice Mouse," and "Henrietta Hedgehog"; and amazing contraptions he called "Watchamacalits," "Doodgnippers," and "Dingbats." Gruelle set many of his tales in a nursery full of dolls, inspired by his children's own playthings. Others, he set in make-believe realms on which he bestowed names like the Magical Land of Noom or the Deep Deep Woods.

Gruelle's ability to speak to youngsters stemmed from his profound affection for children and an identification with their world. He seemed to possess the witty, original imagination of a child. In the words of longtime friend Clifton Meek, Gruelle "wrote the story as a child would tell it."

Gruelle's humor and turn-of-phrase were aimed at delighting not only the children who would be listening to his tales, but also the adults who would be reading them aloud. Gruelle's stories are also filled with lessons about sharing, compassion, and honesty—virtues parents would approve of. But while emphasizing right and wrong, Gruelle's messages are not punitive or forbidding. Rather, they are conveyed as humorous parables spoken by the gentle forest critters, contrite witches and magicians, or the two wise Raggedys.

Johnny Gruelle was a deeply spiritual man, holder of a variety of private, sacred beliefs. He was a mystic, at times clairvoyant, who put great stock in psychic phenomena. He endeavored throughout his life to tap the shared body of beneficent magic—the *prisca theologia* (secret wisdom)—spoken of by the Ancient Rosecrucian Order. He was a knowledgeable student of the laws of science and nature, yet believed in a higher source for all creations. Most at home in natural settings, amidst the creatures whose secret language he seemed to understand, Gruelle upheld the sanctity of all living things. In his day-to-day dealings, he was an embodiment of the Golden Rule. Personally devoted to the ethics that appear in his works, he was a credible scribe for the doings of innocent woodland creatures, magical fairies, and kindly elves.

But, Gruelle was also a modern, forward-thinking man. Avidly interested in science and technology, he stayed scrupulously abreast of cultural, business, and consumer trends, assimilating and applying whatever might give his nostalgia-based works a certain crisp, up-to-date appeal.

Gruelle was a dapper fellow with a compact physique. He cut a handsome figure, with his shock of thick brunette hair, and dark brooding brows. He always dressed impeccably, and for the season, often with a hat rakishly pulled down over one eye, and a gold, ruby-eyed monkey stickpin gleaming in his lapel. He spoke in a soft voice and appeared shy and retiring in public. He rarely smiled for a photograph.

Gruelle was a faithful husband and dedicated family man. Always making time for his children, despite his heavy workload, he spent many a late night churning out his multiple free-lance commissions, prodded along by his loving but business-minded wife, Myrtle. To relax, he'd pound on the family piano or blare out a few tunes on his beloved saxophone, which he'd taught himself to play in the early twenties when jazz was all the rage.

Johnny Gruelle projected a childlike innocence, with merriment bubbling under the surface. Whether delivering a witty luncheon address, or writing about the perils of aging and his own expanding midsection, Gruelle was a kindly jokesmith and a wellspring of good humor. He was liked instantly by most who met him. Though a self-made gentleman, he felt genuine empathy for those less polished or fortunate. Gruelle was deeply loved and trusted by his closest friends, prominent and humble alike. Many of his usually stoic colleagues cried openly when he died.

But, like all men, Gruelle's personality was not without contradiction and conflict. Though reclusive by nature, he loved being the center of attention at gatherings, called upon to tell stories or to give impromptu piano recitals, banging out by-ear, "black-key" renditions of popular songs.

Though he loved hearth and home, Johnny Gruelle remained haunted throughout his life by a chronic restlessness and insatiable wanderlust. He longed for the periodic escapes—out the back door or across the country—during which he could drop all responsibilities to fish quietly with his hand-tied

flies, hunt squirrel and woodcock, or embark on an open-ended road trip. During these times, Johnny Gruelle would break free to misbehave and cavort like a runaway boy.

Gruelle's boyish leanings might give the mistaken impression that he enjoyed a charmed and protected life. Quite the contrary. Though humor was his handmaiden, and his store of childlike mirth seemed ever-plentiful, many of Gruelle's adult years were spent coping with career setbacks and personal tragedy. When he was but thirty-four years old, he had faced by far the greatest tragedy of all—the death of his young daughter, Marcella.

Throughout his life, Gruelle was plagued by various physical ailments, including a heart condition that was exacerbated by overwork and anxiety. His fame had come in fits and starts, his career progress impeded by the residual effects of a world war, a major economic depression, and the demise of his primary publisher, whose coffers Raggedy Ann had filled for nearly two decades.

Gruelle had worked extremely hard, at times against near-insurmountable odds, to keep his Raggedy Ann and Andy before the public. Then, when his rag dolls finally had become popular and lucrative commodities, he found himself embroiled in legal battles to retain his rights to them. The worst was a protracted lawsuit that cost him years of income and whose accompanying stress likely contributed to his death.

Yet, despite all the heartache and hardships, despite a puzzling lack of recognition during his lifetime, Gruelle remained devoted to his chosen work, and kept his keen sense of humor. As an artist, writer, and designer, Johnny Gruelle was only one of many who had found careers in the burgeoning American popular entertainment industry during the early twentieth century. His wide-ranging artistic abilities, his willingness to conform to a model, and his ability to produce a large volume of work on demand made Gruelle well suited to the rigors and unpredictable demands of free-lancing.

But it was Gruelle's originality—his innate whimsy, and his knack for capturing traditional values and presenting them in new, marketable ways—that made his best work memorable. Despite an attimes difficult and disappointing career, Johnny Gruelle never lost his ability to feel the wonder and see the magic—as though for the first time—through the wide-but-knowing eyes of a child.

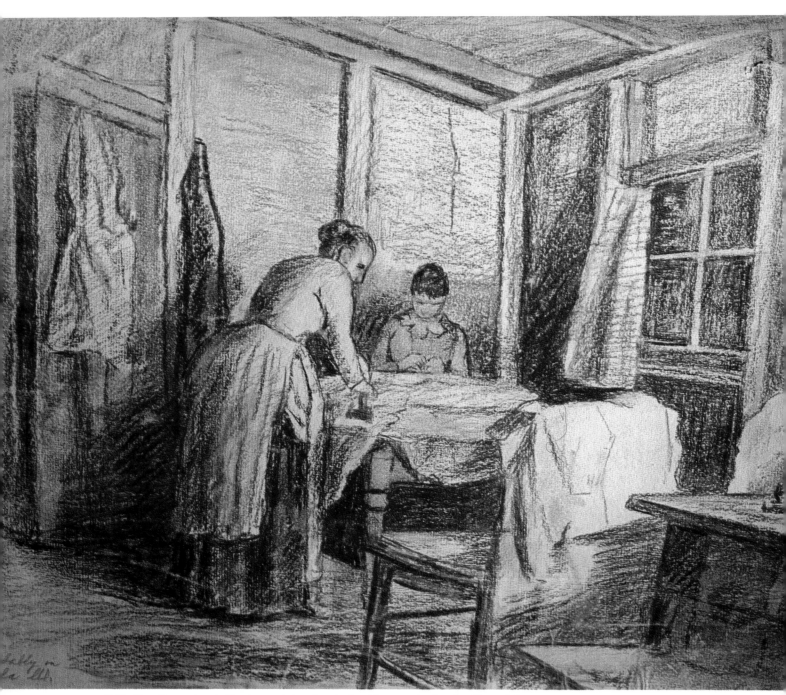

R.B. Gruelle rendered this charcoal drawing during his years in Arcola. One of the women was probably his own young wife, Alice, whom Gruelle often used as a model. This early work reveals R.B.'s native ability, honed without benefit of a formal art education. (Courtesy Jane Gruelle Comerford)

Art for the Heart's Sake: Richard Buckner Gruelle

The fragrance of sweet jessamine in the woods was not so sweet as the smell of new canvas and new tubes of colors.

RICHARD B. GRUELLE

By the time warm breezes had heralded the coming of yet another summer to Arcola, Illinois, Alice Benton Gruelle knew she was expecting a baby. It would mean another mouth to feed, which she and her husband could ill afford. An artist's salary was, by nature, modest, and the couple's hard-earned income was already going toward supporting themselves and her husband's mother and aunt. But the prospect of her baby's arrival thrilled Alice, and it seemed to thaw the chilled, beleaguered spirit of her husband, R.B., who had been preoccupied for months.

The year was 1880, and as Alice Gruelle looked ahead to the future, she thanked God for the day that she had met her fine husband; so strong, and such a good, responsible provider, yet never letting loose of his lifelong ambition to be an artist.

Richard Buckner Gruelle had been born nearly thirty years before, on February 22, 1851, in Cynthiana, Kentucky. His own father, John Beauchamp Gruelle (born in November 1809) had descended from a French family of silk and gold merchants.

In France, the Gruelle family had spelled their name Grouvelle. Once in America, the surname was changed to facilitate pronunciation: first, to Grouvel; later, to Gruwell; and finally, to its present spelling, Gruelle.

Richard's father, John, was a tanner by trade. He had met and married Prudence Elizabeth Moore in 1832—he was twenty-three; she was three months shy of seventeen. Richard Buckner Gruelle was the ninth child born to Prudence and John, and was next to the youngest. Sometime between 1856 and 1857, when Richard was five or six years old, the Gruelle family moved to Illinois, living first near the small town of Bourbon, and finally settling in Arcola, located in Douglas County.

By the time the family was settled in Arcola, young Richard's passion for art had been kindled. When he was a very young boy, his mother and teachers would notice him doodling on anything he could find, and often he was punished for spending

school time on artwork. But, Richard's mother carefully nurtured his passion, praising his artistic accomplishments, proudly hanging his slate renderings (among them, one of George Washington) on her wall.

The panorama and magic lantern slide shows that came to Arcola as public entertainment during those post-Civil War years captured young Richard's imagination, and he took up producing his own magic lantern shows. Painstakingly, he would paint Civil War scenes—among them, the battle between the ironclad ships *Merrimack* and *Monitor*—on pieces of glass, and then present his show to the neighborhood children, using a joint of stovepipe, a tallow candle, and bits of powder. Not only a showman and an artist, but also a budding businessman, Richard charged each child five pins to view his shows.

By age twelve or thirteen, Richard Gruelle was forced to quit school and find work to help his parents support their large family. The husky boy tried working as a farmhand, but soon apprenticed himself to the village house-and-sign painter. From this first mentor, Richard learned the rudimentary, though essential, skills of pigment mixing and letter placement. He soon excelled at grinding and mixing his own colors and became known for his ability to match colors exactly.

During time off, Richard Gruelle continued honing his artistic talents, using the rough supplies of a house painter. He painted on bits of board, insurance cards, and anything else he could find.

"Rainy days and Sundays found our young apprentice endeavouring to paint pictures using common house paints."

—Richard B. Gruelle

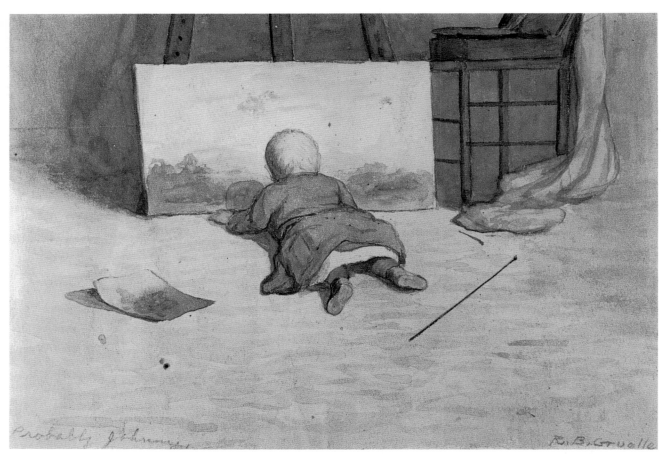

In this early watercolor by R.B. Gruelle, an infant Johnny Gruelle surveys his father's latest work. (Courtesy Jane Gruelle Comerford)

Richard's artwork was eventually noticed by a young graduate of an Eastern college, who had given up her own art career. Recognizing his talent, she gave him all of her art supplies and materials, feeling that it would be a shame for them to go to waste. After years of struggling with house paints and rough wood, Richard was delighted with the fragrant oil paints, gleaming brushes, and crisp canvasses—his first real tools of the professional artist.

R.B. (as he eventually became known) was now a young man. Around 1872, following a bout with paint-related lead poisoning, and a stint working as a railroad surveyor in western Illinois, R.B. opened up his own studio in the nearby town of Decatur, Illinois. As in Arcola, live portraiture was not in great demand, and R.B. soon found himself working as a postmortem portrait artist, giving art lessons on the side. He traveled for a time to Cincinnati, where he painted commissioned landscape scenes on the doors of safes and began attending classes in life drawing—

his first, and as it turned out, his only, formal art training.

In 1876, R.B.'s father passed away. R.B. returned to Arcola to help support the family, again putting his artistic aspirations on hold. His move back to Illinois did allow him to propose marriage to the woman he loved, and on August 29, 1877, Richard Gruelle and Alice Benton were wed in Decatur, a W. D. Best officiating.

Settling into married life in Arcola, R.B. continued to paint uncommissioned pieces, mostly for himself. He was so devastated by his father's death that he and Alice kept to themselves for several years, helping to care for R.B.'s elderly Aunt Lucinda and going out very little. For income, R.B. had been forced to return to painting postmortem portraits. So, news of his impending fatherhood was like a ray of bright light, cutting through the fog of his somber day-to-day existence.

Sometime during the night, on Christmas Eve,

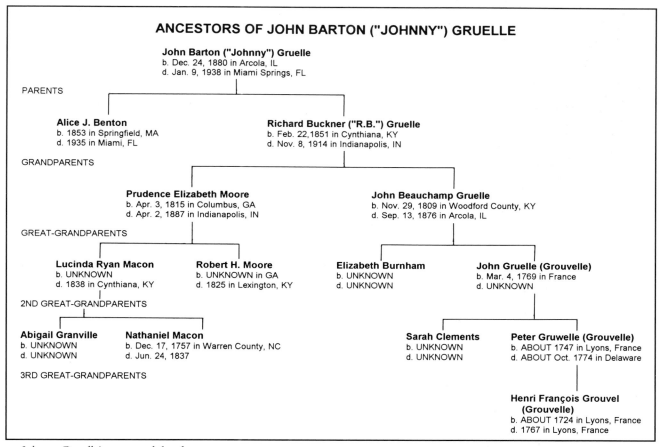

Johnny Gruelle's ancestral family tree.

1880, Alice Benton Gruelle gave birth to a healthy son. The young couple rejoiced, naming their new baby John, after R.B.'s recently deceased father. The boy would be known as Johnny, and his birth was celebrated in the Gruelle family as a Christmas blessing. With their brown-eyed baby came a renewed feeling of hope, and R.B. and Alice Gruelle began making plans for the future.

Young Johnny Gruelle favored both his mother and father in appearance, with his straight hair, brown eyes set off by lush lashes, and dark handsome brows. (Courtesy Worth and Sue Gruelle)

CHAPTER THREE

Ring Out Wild Bells:
Johnny Gruelle's Early Years

I am one who believes in the idea—"that blood tells"—that children resemble physically, mentally, and morally, the stock from which they spring. The laws hold in Man as in all other things.

JOHN P. GRUWELL
West Liberty, Ohio
October 23, 1893

Sometime in 1881, not long after little Johnny was born, the Gruelle family packed up their few belongings and left their modest home on Arcola's South Locust Street, migrating to Gainesville, Florida. There, they stayed for a time with R.B.'s brother, Nathaniel (Uncle "Rice"), and continued planning their future. After years of barely scraping by with his artwork, R.B. longed to be in a bigger city where he might make a decent living with his artwork, and broaden his artistic education.

Many out-of-town visitors who passed through Arcola over the years (including the poet James Whitcomb Riley) had told of the the bustling Midwest metropolis called Indianapolis, where trolley cars were running and gas lamps lit the streets at night. The city's population was growing daily with the influx of newcomers, many of whom would settle in planned suburban communities. Between 1881 and

1882, the city's population had grown by more than 3,000, a sizable gain for the time. Indianapolis was also attracting its share of young writers and artists, and would soon be entering a period of regionally inspired literary and artistic expression, retrospectively named "The Golden Era."

Sometime between 1882 and 1883, R.B. Gruelle, along with his wife, mother, and toddler son Johnny, moved to Indianapolis, settling with his brother, Thomas Gruelle, at his home at 309 North Pine, located three or four blocks from Indianapolis's now-famous Lockerbie Street. Thomas was in the newspaper and printing business, having moved to Indianapolis after running the Arcola *Democrat* for several years, to launch the *Labor Signal*.

The neighborhood, first settled by Germans, was populated with shopkeepers, factory workers, and skilled craftsmen, along with a sprinkling of other

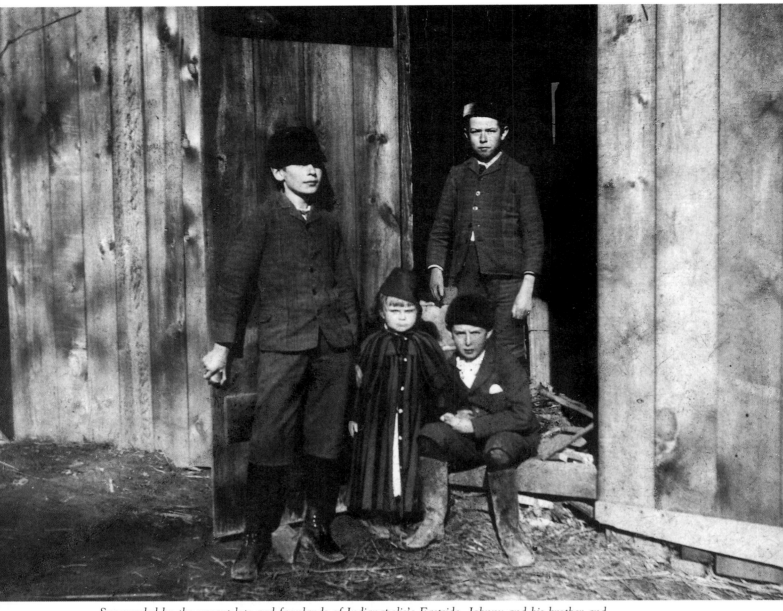

Surrounded by the vacant lots and farmlands of Indianapolis's Eastside, Johnny and his brother and cousins had room to roam and play. Left to right: Carl Gruelle, Justin Gruelle, Johnny (in boots) and Will Gruelle. (Courtesy Jane Gruelle Comerford)

artists and writers, representing a broad range of incomes. Drinking deeply of the bustle and promise of this new, "city" life, R.B. soon took up landscape painting as a profession.

Growing from toddler to child, little Johnny played on the treelined streets with his cousins, and watched his father at work. Around 1886 or 1887 (when he was six or seven), Johnny would have probably entered School Number 9, a three-story structure of only eight rooms, then located on the corner of Vermont and Davidson streets. Even in those early years, little Johnny's interests leaned more to the arts than to classroom work. He loved the times when friends of his parents and uncle—artists and men from the printing trade—would gather in the parlor for visits that usually produced

lively discussions about newspaper work, art, music, and the cosmos. These enthused young adults, who saw such great promise for their futures, had an indelible effect on Johnny's own developing belief that anything was possible, if one developed his own special God-given gifts.

Occasionally these gatherings would include James Whitcomb Riley. Like R.B. Gruelle, Riley had been a sign painter in his youth. He had moved to Indianapolis in 1877 to begin what would be an eight-year assignment at the Indianapolis *Journal*, producing as newspaper fillers the kind of poems that would later make him famous. Riley was especially smitten with the ambiance of the neighborhood where R.B. and Alice lived. In 1880, he had even honored nearby Lockerbie Street (where he often

boarded, and, much later, would live permanently) with his "urban pastoral" poem, "Lockerbie Street."

About the time Riley was beginning to extoll folksy, nostalgic values in his poetry, R.B. Gruelle was rendering landscapes, in which he tried to capture the pastoral essence of central Indiana. The two became admirers of one another, and began a friendship that would endure for their lifetimes.

By 1888, R.B. Gruelle had saved enough money to rent his own house, located at 287 Davidson Street, just one block away from his brother's home on North Pine. The Gruelles' move may have been precipitated by a growing family. On August 14, 1884, Alice had given birth to a daughter, whom they had named Prudence, after R.B.'s mother.

Life on Davidson Street was bustling and friendly,

As a youth, Johnny Gruelle earned a reputation as an ace marble player. Watching him shoot here, ca. 1890, are his baby brother Justin, sister Prudence, and several neighborhood children.
(Courtesy Worth and Sue Gruelle)

people working hard by day, and in the evenings, sitting out on their stoops drinking nickle buckets of beer, watching their children playing their sidewalk games. Davidson was located near a small river, called Pogues Run, a meandering stream that usually flowed gently enough for Johnny and the other children to play in, but, during heavy rains, would swell to terrifying proportions, occasionally flooding the homes along Davidson.

Two blocks from the Gruelles' home on Davidson was a grocery store owned by a German family. The jolly proprietor, John Soltau, had several sons; one, named Edward, was closest to Johnny's age. Johnny would spend his pennies at Ed's father's grocery, and the two boys forged the beginnings of a lifelong friendship.

On July 1, 1889, another boy would join the Gruelle family. He would be named Justin Carlyle, after Alice's brother, Justin, and the essayist, Thomas Carlyle, to whom Alice's family claimed an ancestral relationship. To accommodate their growing family, sometime in 1890, using money they had carefully saved, R.B. and Alice purchased from friends Frank and Mary Flann a tract of land located in Indianapolis's Eastside.

Here, on a small street near Michigan Avenue, R.B. and Alice oversaw construction of a new home. When it was finally finished, 31 Eureka Avenue was a modest, snug abode consisting of only three rooms plus a pantry off the kitchen and a back porch. The house had no electricity or indoor plumbing. Several years later, R.B. and Alice would add a second story, an entrance hall, and a front porch to their home (whose address would later become 29 Eureka, then change to 517 North Tacoma), making it more gracious and accommodating for what would be a growing extended family.

In a neighborhood still sparsely settled, Eureka Avenue lay beside open farmlands, where Johnny, his siblings, and friends roamed to their hearts' content. On one corner of an adjacent vacant lot (dubbed "the Cow Lot," since the Gruelles kept one tethered there) R.B. Gruelle set up a studio. In this small, red structure, situated near a silver beech tree, R.B. positioned his easel by a north window. It was here that Johnny was allowed to experiment with his father's mysterious fragrant paints and soft brushes.

The Gruelles loved celebrating holidays and did so with great flourish. At Christmastime, Johnny would help put up a huge tree with real candles, and his mother would bake dozens of fragrant Christmas and Winter Solstice cookies. On the Fourth of July, neighborhood adults and children alike would gather to marvel at R.B. Gruelle's impressive displays of pinwheels, Roman candles, and skyrockets.

The Gruelles were a musical family, R.B. being a somewhat shy, by-ear musician. Though he never had formal music lessons, Johnny began doing his share of plunking at the front-parlor piano, displaying an uncanny sense of melody, but preferring to work out renditions of popular favorites only on the piano's black keys.

R.B. and Alice welcomed many artists, musicians, and writers to their Eastside home, including James Whitcomb Riley, who had become a good friend of the family. Riley would occasionally participate in the Gruelles' "sittings" or séances and eventually became the center of a salon of sorts, which met regularly in R.B. Gruelle's home and studio. His belief in the supernatural, his facility as a storyteller, and his robust-but-genteel personality made the poet a colorful, if somewhat flowery, spokesperson for the nostalgic regional lore that began captivating young Johnny Gruelle.

When Riley visited, Johnny would sit enraptured with the poet's style and demeanor, soaking up his zesty monologues—idealizations of rural life and times gone by—and marveling at his adroit use of dialect and nonsense words. Riley's profound effect on Johnny Gruelle would become apparent years later, when Gruelle began writing his own stories.

By the early 1890s, Indianapolis was a combination of burgeoning metropolis and unspoiled countryside. Mules pulled flatboats up the canal that lazily meandered through a city that continued to grow. The safety bicycle was a new phenomenon and in 1893, Johnny Gruelle became the proud owner of one. The memory of it stayed with him always. "I

"He who has the power to take the simpler things of utility and lift them up into the realms of the beautiful, so that they may vie with the wild flowers of the field in their humble beauty, is indeed an artist and is one whose influence is world-building in its nature."

—R.B. Gruelle
1898

had my choice of going to the Chicago World's Fair, or getting a 'safety,' " Gruelle would write. "I chose the 'safety'; one of the first in Indianapolis with pneumatic tires. That was one of the thrills which comes [only once] in a lifetime."

While surely making Johnny the envy of his neighborhood, the shining bike also marked the beginning of a passion that Gruelle would carry into adulthood—owning and tinkering with smooth-running, well-engineered, and perfectly appointed vehicles.

When the Gruelles moved to Eureka Avenue, there was no public school to serve the outlying community in which they lived. In 1892, on a tract of land purchased by the Indianapolis School Board, School Number 15 was opened. There, in the small white cottage of several rooms, Johnny Gruelle attended school for only a short time, before his formal education purportedly came to an abrupt end.

According to a widely circulated story, Johnny ceased attending school in about the fifth or sixth

AN OFFICER NAMED McGINTY: JOHNNY GRUELLE'S FIRST MENTOR

This is a story that Johnny himself loved to tell. It was a particularly hot day during the summer of 1894, when neither pad and pencil nor the family piano could offer the usual consolation. So, Johnny and a buddy cooked up a scheme to hop a freight from Indianapolis's Brightwood Trainyards, located several miles from Johnny's Eastside home, and "bum" their way East.

When the train carrying the boys finally lumbered into Cleveland, Ohio, the two wanderers hopped off. Hungry and broke, they headed for a nearby saloon, where they supposedly signed on for a night's work, Johnny playing some piano and his friend sweeping up. In the midst of the boys' labors, a portly and friendly cop, known by all the regulars as McGinty, wandered into the pub. Johnny was so struck by the officer's appearance and demeanor that he left his post at the piano, picked up the closest drawing implement he could find (which happened to be a bar of soap), and drew the officer's likeness on a backbar mirror.

McGinty was not only amused, but also apparently quite impressed with Gruelle's artistry and offered to stake Johnny while he looked for a newspaper cartooning job in Cleveland. However, Johnny declined, opting instead to return to Indianapolis, hungry and ready to face the consequences of having run away from home. Though the thirteen-year-old Johnny chose not to stay in Cleveland to work, he never forgot McGinty's encouragement.

Years later, when Gruelle moved to Cleveland as an adult, he would become reacquainted with Officer McGinty, even residing on the same street for a time. Later still, Gruelle would honor the spirit of the friendly, portly policeman in his newspaper cartoons and in newspaper serials (later published in 1942 as a

book entitled *Raggedy Ann and Andy and the Nice Fat Policeman*).

Johnny Gruelle loved to tell and retell his McGinty story, especially in later years. Rendered to appreciative listeners, including his own impressionable children, the tale no doubt picked up embellishments, though the core account was most likely true. For Johnny, the story of how he had hopped freights and gotten his artwork taken seriously by an outsider was a way of sustaining a boyish belief that the most magical and providential of events happen on the open road.

JUDGE A. C. AYRES
AYRES, JONES & HOLLETT
LAWYERS

Gruelle would depict policemen in his cartoons as friendly, portly sorts—his way of honoring his first mentor, the jolly Officer McGinty.

grade, after refusing to recite an assigned poem—Alfred Lord Tennyson's "Ring Out Wild Bells." Johnny's strong-willed rejection of a formal education did not impede a growing desire to learn more about art, however. Though he continued to refuse his father's offers of formal art lessons (perhaps unconsciously mimicking R.B.'s own experience of having been self-taught), Johnny watched his father

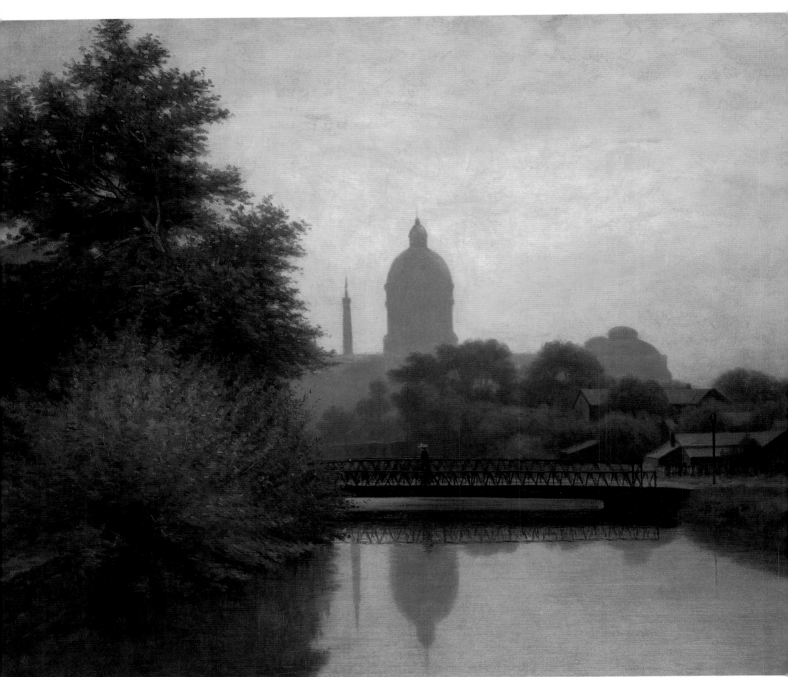

In 1894, R.B. Gruelle painted The Canal—Morning Effect, *an ethereal oil portrait of downtown Indianapolis. R.B., whose works glowed with the hues and natural lighting found in nature, would become known as one of the "Hoosier Group," along with artists T. C. Steele, J. Ottis Adams, William Forsyth, and Otto Stark. He would also coin the phrase that became his watchword: "Art for the Heart's Sake."* (Courtesy Indianapolis Museum of Art)

"Ring out, wild bells, to the wild sky,
 The flying cloud, the frosty light!
 The year is dying in the night;
Ring out, wild bells, and let him die!

"Ring out the old, ring in the new;
 Ring, happy bells, across the snow!
 The year is going—let him go;
Ring out the false, ring in the true."

—Alfred Lord Tennyson
In Memoriam
1850

intently and learned the rudiments of form and composition. By age sixteen or so, Johnny was carrying a pad and pencil with him wherever he went. While his younger brother, Justin, would begin to work in watercolors and oils, emulating R.B.'s fine-art style, Johnny's preference was to sit, sometimes for hours, sketching people's likenesses in a cartoon style all his own.

By 1898, Johnny Gruelle had grown to manhood. Slight in stature, his diminutive dark-haired, dark-eyed good looks gave him an exotic, somewhat mysterious air. He still lived at the Gruelle homestead. When he wasn't working odd jobs, he spent time with his younger brother, Justin, and sister, Prudie, playing with them and entertaining them on piano. He especially loved accompanying them to the circus when it came to town, where he also could indulge his growing fascination with clowns and their variety of costumes and painted facial expressions. Though shy, Johnny had also begun attending parties, where he and his friends would dress up in foppish coats and hats, hoping that some pretty girls might notice them.

By this time Johnny was asking his father much more specific questions about composition and technique, applying his father's advice to his own pencil cartoons and satirical sketches of people. Hardly considered art by most, Johnny's caricatures were occupying more and more of his time. Strangely drawn to creating these humorous, cartoon views of the world, Johnny Gruelle began wondering if, someday, he might make a real living with his funny little drawings.

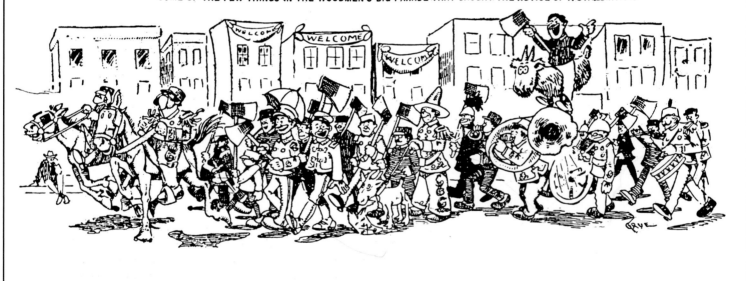

THE INDIANAPOLIS MORNING STAR, FRIDAY, JUNE 19, 1903.

SOME OF THE FEW THINGS IN THE WOODMEN'S BIG PARADE THAT CAUGHT THE NOTICE OF A STAR ARTIST.

On June 19, 1903, *just two weeks after* The Indianapolis Star *was inaugurated, this cartoon by* Johnny Gruelle *appeared.*

CHAPTER FOUR

The Whimsical Observer: Johnny Gruelle, Newspaper Cartoonist

*'Thout the funny picture makers
There'd be lots more undertakers.*

JAMES WHITCOMB RILEY
to Johnny Gruelle
New Year's, 1904

On a warm morning in early June 1903, a half-million red paper stars mysteriously descended from the sky over Indianapolis. A hot-air balloonist had been paid $650 to go aloft to create this display; some of the paper stars were later retrieved from as far away as Illinois. Several days later, on June 6, the purpose behind the stellar shower was revealed when presses began rolling at the city's newest newspaper, *The Indianapolis Star*.

The seven-day-a-week paper was the brainchild of its founder, wealthy Muncie industrialist George F. McCulloch. McCulloch, who had made a fortune investing in interurban electric railway systems, was prepared to invest thousands of dollars in his new venture, positioning it to compete, head-to-head, against Indianapolis's two largest newspapers, the *Journal* and the *Sentinel*. On June 6 and 7, every

household in Indianapolis received a free copy of the *Star*. The paper then went on sale for the unheard-of low price of one cent, and by the end of six months, the *Star* boasted more than 70,000 subscribers.

On Friday, June 19—just thirteen days after the *Star*'s first issue rolled off the presses—several small cartoons appeared on the paper's inside pages, signed simply "GRUE." They would be the first of hundreds that Johnny Gruelle would provide for McCulloch's bold new newspaper. From among many other cartoonists, Gruelle had been handpicked to be the paper's first assistant illustrator.

By this time, Gruelle had a track record at several other Indianapolis newspapers, where he had earned a reputation as a clever, diligent worker. His new job at the *Star* was but the next step in realizing an ambition sparked in him years before.

As a young boy, Johnny had learned to artistically capture a split-second gesture, a fleeting nuance, a passing mood, with nothing more than a pencil. As he matured, he also had developed a wry, humorous world view. His sketches were hand-drawn snapshots, in which he portrayed the funny side of people: their foibles, triumphs, and the ironic predicaments in which they found themselves. In short, he had the heart, the sensibility, and the hand of a cartoonist.

Gruelle also had two uncles in the newspaper business—his Uncle Tom, and his late Uncle John, who for seventeen years had owned and operated the Arcola *Record*. Leafing through the daily newspapers, studying the cartoons of others, Gruelle had begun thinking that he, too, might have something to offer, via the newspaper page. Printing techniques being what they were, and photography still a nascent documentary form, these late-nineteenth-century newspapers relied to a great extent on a daily supply of illustrations and cartoons to capture reader attention, illustrating news stories, sporting events, fashion and leisure features, even the stock market.

But what caught Gruelle's eye were the single-frame, front-page editorial cartoons. These drawings (with a legacy going back hundreds of years to the Englishman William Hogarth) satirized current events, society's ills, and the less-than-savory doings

During his brief stint at The Indianapolis Sun, *Gruelle's still-tentative style improved daily.*

of certain city fathers. In form, they were quite similar to the caricatures and drawings Gruelle had been producing for himself.

So, in 1901, with the encouraging words of his parents, his Uncle Tom, James Whitcomb Riley, and even Officer McGinty playing in his head, Johnny Gruelle went after, and got, his first newspaper job at a small Indianapolis tabloid called the *People*. Located at 27 Virginia Avenue in downtown Indianapolis, the *People* was an independent publication, popular with the working classes. Gruelle later aptly described the *People* as "devoted to sensational and extremely personal news." Crowded together on the paper's front page were a bulging personal column, amateur poetry, and "true" stories the editors deemed "stranger than fiction."

Gruelle later recalled his work at the *People*, describing the unwieldy chalk plates upon which he "scratched political cartoons and portraits(?) of police court type." Negatives made from these plates would reproduce as black-on-white cartoons. By virtue of the process, the resulting image was scratchy and rough. But, to his delight, Gruelle was paid five dollars a week for his labors. He stayed with this first job for an unspecified number of months (he himself recalled six, but it may have been longer), before moving to another, larger Indianapolis newspaper, the *Sun*.

Like the *People*, the *Sun* was an independent paper, but much less sensational. Being a daily, it enjoyed a much wider circulation. Gruelle had been hired as a replacement for departing *Sun* cartoonist Kin Hubbard, who had accepted a job at the Indianapolis *News*. Gruelle's new position provided not only more money, but also a greater opportunity for serious cartooning.

In January 1903, Johnny Gruelle left the *Sun* to go to work for the Detroit-based Peninsular Engraving Company. While there Gruelle received word that a new newspaper would soon be starting up in Indianapolis. This prompted his decision to return to the Hoosier capital, in hopes of getting a better job for more pay, at a newspaper where he could draw his cartoons with materials less crude than chalk on a slate.

When Johnny first showed up for work at the *Star*, its headquarters were still in a two-story, shuttered house, located at 115 East Ohio Street. During his first few months at the paper, the young artist's work seemed tentative and somewhat awkward, as he tried out different styles to see which one best suited him. But, his work showed rapid refinements and Gruelle honed an already uncanny knack for capturing, in pen and ink, political nuances and the irony of everyday life. Gruelle was soon rewarded with a thirty-five-dollar-a-week salary, a far cry from the five

Johnny Gruelle's business card. (Courtesy the Baldwin Library, University of Florida)

DEAD GIRL ENGAGEMENT

[text obscured]

WIVES MARSHALS

Their Tearing s on Comoperty.

OR WIFE SERMON

Suicide Says Led Him Act.

AMES BALDWIN

of His Name loodling Is Enemies.

DATE-BREAKING STAGE REACHED IN FRAT CLASH

Indiana's "Big Five" Boycott of Co-eds, In Sympathy with Rivals, Sole Topic of Discussion.

DEAN MARY BREED CALLS THE SORORITIES TOGETHER

She Will Meet Boycotting Frats Today and Try to Have Them Respect Their Dates.

PRESIDENT BRYAN MAY TAKE HAND IN AFFAIR

Member of Outside Faction Says Girls Will Resent the So-Called Infringement.

BLOOMINGTON, Ind., December 7.—

[column text illegible]

DAMAGES FOR PLAINTIFF ARE CUT ONE-THIRD

NEGROES MAKE PLEA FOR AID

In Breaking All Party Ties They Declare in Platform Against Whisky and Cocaine.

FREEDOM HAS NOT TAUGHT DUTY TO SUPPORT FAMILY

Demand Enactment of Law Making It an Offense to Desert Wife and Family.

CHATTANOOGA, Tenn., December 7.—

[column text illegible]

WILL THE DRIVER VACATE?

Oh, now forever
Farewell the tranquil mind! Farewell content!
Farewell the plumed troop and the big wars
That make ambition virtue! Oh, farewell!
Farewell! Othello's occupation's gone!
—Shakespeare.

HALE OR FRYE PROPOSED IN PLACE OF ROOSEVELT

CINCINNATI, O., December 7.—The Commercial Tribune Saturday, in a leading editorial questioned the advisability of the Republican party nominating Roosevelt unless it could be shown that he could certainly carry New York, a fact which at present the Commercial Tribune says it doubts. Tomorrow the same paper will say in part:

[column text illegible]

LANGTRY PLAY CUT BY DETROIT CENSOR

DEPUTY CONSTABLE IN A STREET FIGHT

WARRANTS FOR SEVEN MORE IN WATER SCANDAL

Another Bomb Exploded in the Grand Rapids Boodle Investigation as Result of Salsbury's Confession.

PROMINENT NEWSPAPER MEN AND LAWYERS TO BE HELD

Conspiracy, Perjury and Subornation of Perjury Among the Charges.

MORE ARRESTS TO BE MADE, SAYS PROSECUTOR

Men Against Whom Warrants Have Been Issued to Be Arrested Today.

GRAND RAPIDS, Mich., December 7.—

[column text illegible]

dollars he had made at the *People* only several years before.

On a single day, it was not uncommon for the *Star* to feature three or four different kinds of cartoons by Gruelle: a sports cartoon, a masthead-headline illustration, or even a comic strip, which Gruelle often ended with some kind of "lesson"—a sort of moral resolution that would later become a hallmark of his storytelling style.

Occasionally, Johnny would be sent out of town with a news correspondent to render his cartoon impressions of a breaking news event. As a proud mark of his entry into the great brotherhood of cartoonists, Gruelle began using acronyms to sign his work: the four-letter "GRUE," and sometimes, the phonetic "GRUE·L·".

It wasn't long before the *Star*'s managing editor, Earle Martin, was positioning more and more of Gruelle's cartoons on the front page. So pleased was Martin with Gruelle's work that he also requested that Gruelle design a special front-page weather bird, based on a critter that Gruelle had originally created as an acerbic-tongued little commentator in his stock market cartoons. On February 19, 1904, Johnny's skulking little crow winged his way onto the front page, alighting next to the weather forecast. The vocal little bird would go by the name of "Jim Crow." Though the name "Jim Crow" implies otherwise, there was no connection between Gruelle's little cartoon bird and the restrictive, racist laws of the postbellum South. And Gruelle never intended, nor did he use, his weather bird to portray African-American stereotypes.

Nevertheless, by the 1950s, "Jim Crow" (who, to this day, continues on at the hand of contemporary *Star* cartoonists) had been renamed "Joe Crow," no doubt a reflection of rising social consciousness.

"I'm going fishing if it's warm this afternoon."

—Jim Crow
The Indianapolis Star weather bird

A BRIEF INTERLUDE: THE DAILY SENTINEL

THE GUIDING HAND.

During the spring of 1904, Johnny Gruelle left the *Star* to work for a short time at Indianapolis's other more sensational morning newspaper, *The Daily Sentinel*, which had likely lured him with a slightly better salary, plus more chances to appear on their front page. Beginning on March 15, Gruelle's cartoons became a daily feature; one-framers in which he satirized the doings of Teddy Roosevelt, Indiana Republican politics, and the political situation in Latin America. Gruelle also provided the *Sentinel* with pencil drawings, in which he captured the realistic likenesses of gubernatorial candidates and prominent Indianapolis business figures; and large, sweeping chiaroscuro illustrations, sometimes filling up half a page.

It was at the *Sentinel* that Johnny Gruelle developed a habit of finishing his work early, in order to have his afternoons free. One of his colleagues, William Heitman, later recalled: "Johnny loved to fish and was kind of funny in some ways. During fishing season he often came to the office wearing boots and carrying his fishing rod and minnow bucket. As soon as his cartoon for the day was finished (it usually took an hour and a half) he would leave in a hurry. He wasn't particular about the kind of fish he caught; just so he caught fish."

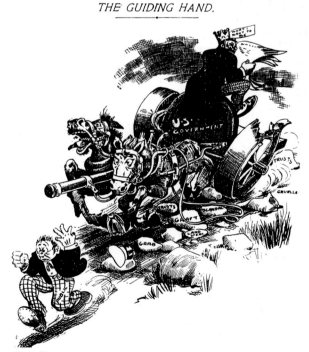

Gruelle's stint at the Sentinel *was an opportunity to explore new artistic realms within a newspaper context.*

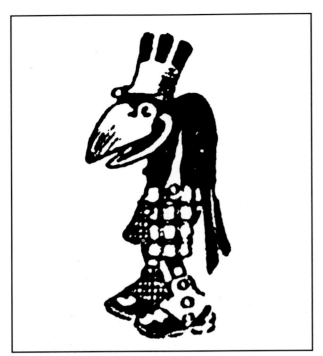

Gruelle's rascally weather bird, "Jim Crow," appeared daily on the Star's front page, offering his little words for the day, sometimes about the weather; other times, about current events. Though, on most days, Gruelle dressed his bird in natty coat, tails, and top hat, on warm days, he gave him a straw hat and fishing pole, ready (like the artist who created him) to play hooky.

Gruelle was correct when he later characterized "Jim Crow" as his most indelible contribution at *The Indianapolis Star*. "The only prints of my teeth in the bed post there are in the shape of Jim Crow, the weather bird," he would write. "I laid the egg."

Even as a beginning cartoonist, Gruelle thought enough of his own work to shop his talents around. Following a brief time spent working for the *Star*'s rival newspaper, the *Sentinel*, Johnny returned to the *Star*, most likely with promises of a higher salary and a better position. Though Gruelle's weather bird had been taken over by fellow cartoonist Homer McKee, Gruelle once again began supplying the paper with sports cartoons, headline comics, and single-frame commentary cartoons.

On April 30, 1905, in the *Star*'s four-page comic section, a half-page comic appeared entitled "Cousin Bud—He Shows the Bear a New Trick." This was Johnny Gruelle's first full-color newspaper cartoon,

and would be only the first in a series of "Cousin Bud" strips that would appear later that spring and summer. The strip was stilted and amateurish, but for Gruelle, it was a milestone. Though it was not indicated anywhere in the *Star*, Gruelle was, in fact, free-lancing "Cousin Bud" for a St. Louis-based company, World Color Printing, whose specialty was producing ready-made comic sections for distribution in numerous newspapers across the U.S. What this meant was, "Cousin Bud," Gruelle's first color comic strip, was receiving national exposure.

By summer 1905, Johnny Gruelle was illustrating the *Star*'s Sunday Magazine section: full-page layouts with hand-lettering, decorated borders to set off photographs, and swirling drawings to accompany romantic and tragic feature stories. This change in assignments (from cartoons to illustrating) was likely a promotion for the young artist, and Johnny stayed with the assignment for a year. But, by the summer of 1906, Johnny Gruelle had decided to seek his fortune elsewhere.

Exactly why Gruelle left *The Indianapolis Star* (and the city of Indianapolis) for good is a subject of conjecture. Young, aspiring artists, acting on the promise of a "better" position or increased pay, often flitted from town to town, actively courted by editors of rival papers. And, in Johnny's case, there was just such a tempter. The *Star*'s former managing editor, Earle E. Martin (who had helped George McCulloch found the paper), had left his managing editorship there in 1905 to become editor of *The Cleveland Press*. During the next several years, Martin's leadership would establish the *Press* as a cutting-edge newspaper, with its fearless editorializing about world events and local politics. It is very likely that Martin (for whom Gruelle had created "Jim Crow") had ultimately lured Gruelle away from the *Star*.

By fall of 1906, Johnny Gruelle had relocated to Cleveland and his cartoons were appearing regularly in *The Cleveland Press*. Rising before the sun, at his drawing board by seven o'clock, Gruelle turned out sometimes three or more daily cartoons. Though he had been hired initially to be a sports cartoonist, Johnny began producing a variety of comics, which he usually signed with his favorite acronym, GRUE. In making the move to Cleveland, Gruelle had boosted his weekly salary to seventy-five dollars.

Distinctive elements and favorite formats began emerging from Gruelle's pen that distinguished his

Sunday Star.
MAGAZINE SECTION
INDIANAPOLIS · JULY 30·1905

*In 1905, Gruelle supplied the Star with several covers for their Sunday Magazine. These beautiful
renderings of modern pompadoured maidens were Gruelle's own versions of the classic Gibson Girl.*

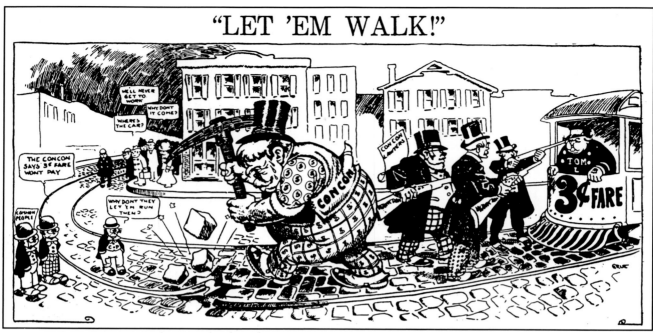

"LET 'EM WALK!"

Gruelle eventually became The Cleveland Press*'s artistic commentator for ongoing fare wars waged by citizens against the looming, bureaucratic behemoth, the Cleveland Electric Railway Company, known as "Concon."*

work, and his material began appearing on the *Press*'s front page—cartoons that poked fun at President Teddy Roosevelt or paid satirical homage to Cleveland mayor Tom L. Johnson. Johnny also continued polishing a cartoon format he had only experimented with at the *Star*, one that would later become a Gruelle specialty: the satirical "bird's-eye-view."

Gruelle's facility with language and his humorous turns of phrase in his newspaper cartoons belied the fact that he had received so little formal education. And Johnny never succumbed to the temptation to use his drawings to showcase lofty concepts. Instead, he would often use his cartoons to poke fun at those who put on airs with their overblown vocabularies.

Gruelle's grandson Kim would later observe, "My grandfather was an open-minded commentator; he could laugh about the foibles of the conservatives as well as the liberals, and be apolitical enough to not get either side mad at him."

While in Cleveland, Gruelle met a young cartoonist named Sidney Smith, whose job Johnny eventually took over, but who would rise to fame, himself, as creator of "The Gumps." Early in 1910, another young artist named Clifton Meek fell under

his tutelage—a man who deeply admired Gruelle and would later become one of his most trusted friends. It was also in Cleveland that Gruelle got to know Ray Long (later president and editor of the Hearst-owned *Cosmopolitan* magazine), Roy W. Howard (an *Indianapolis Star* alumnus, who would chair the board, and foment the name change from Scripps-McRae to Scripps-Howard), and Kent Cooper (who would become general manager of Associated Press). Gruelle's careful cultivation of friendships with these powerful men on their way up would pay him back tenfold in years to come.

By 1908, Gruelle had ascended to the level of head political cartoonist at *The Cleveland Press*. For producing one cartoon a day, Gruelle was paid $150 per week. Finishing up early in the day, he used the three or four remaining hours to do his free-lance work for World Color Printing (which included strips entitled "Handy Andy" and "Bud Smith"). And he also spent these hours working on a new interest: writing illustrated short stories and verses for children.

By late 1910, Gruelle had begun laying plans to move again—this time to the East Coast, where he meant to try his hand at free-lancing in New York

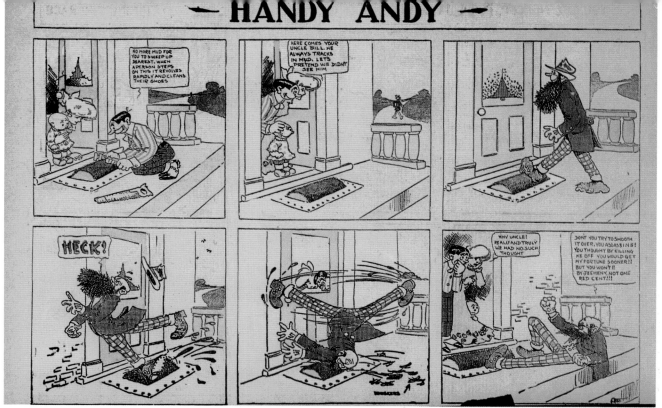

During his tenure at The Cleveland Press *Johnny Gruelle continued working for World Color Printing, for whom he produced installments of "Handy Andy"—a fellow who delighted in creating futuristic Rube Goldberg-type contraptions to solve everyday problems.*

GRUELLE AND THE NEWSPAPER ENTERPRISE ASSOCIATION

By 1909, Johnny Gruelle was producing cartoons and little illustrated fairy stories for the Cleveland-based Newspaper Enterprise Association. The N.E.A., as it was known, produced entire feature pages (comprising articles, photographs, comics, and cartoons) for the Scripps-McRae newspapers throughout the country.

Having his work distributed by the N.E.A. not only afforded Gruelle broader exposure for his cartoons, but also helped him focus on his little illustrated tales. Gruelle's brother, Justin, later corroborated that it was during those years in Cleveland that the idea of writing for children had really taken hold in Johnny's mind. The illustrated tales were forerunners to his dozens of yet-to-come illustrated children's books.

Gruelle's "Playtime Stories," written for the N.E.A., usually appeared on the woman's page, accompanied by simple, one-frame illustrations, on which Gruelle had applied a tiny little "G" or "Grue."

Comic Supplement

For Boys and ~~Girls~~

LOS ANGELES SUNDAY HERALD

SUNDAY MORNING

FEBRUARY 7, 1909

YES—THIS IS ANOTHER BUD SMITH STUNT!

City. When his bosses learned of Gruelle's plans to resign from his Cleveland newspaper work, they offered him a raise if he stayed. But his mind was made up. And so as the talented cartoonist made ready to embark upon yet another, bigger adventure, he could not help but marvel at just how much had transpired in the past ten years—so much water under the bridge since that afternoon, a decade before, when, as a shy but determined suitor, he had shown up uninvited at the home of the beautiful Myrtle Swann.

AT LEFT:
Gruelle inherited "Bud Smith" from comic artist George Herriman, who had originated it in 1905 for World Color Printing. A dandy in short pants, foulard tie, and high button shoes, Bud was a typical comic bad boy.

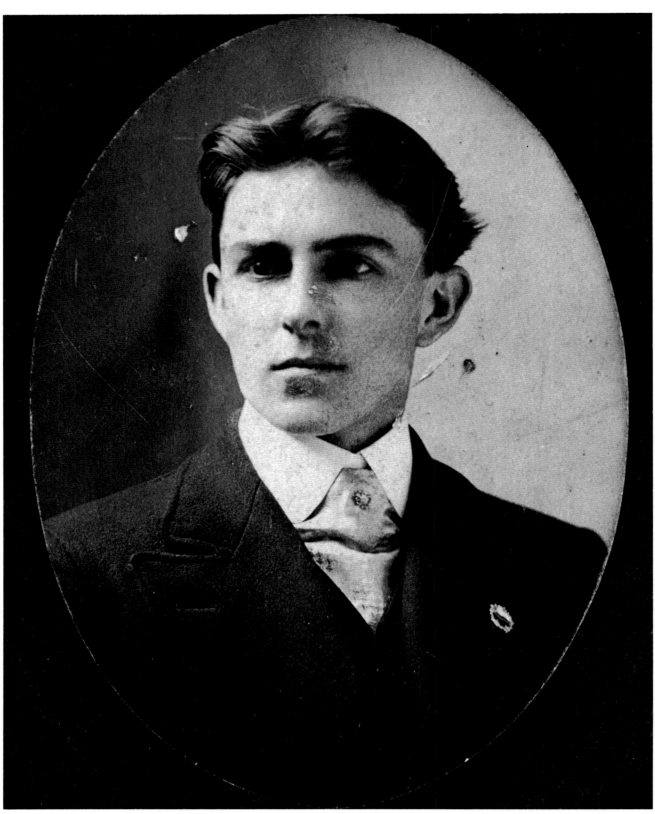

Johnny Gruelle, ca. 1900. (Courtesy Worth and Sue Gruelle)

CHAPTER FIVE

And Their Journey Begins: Johnny and Myrtle Gruelle

There was but one: Johnny.

MYRTLE SWANN GRUELLE

Johnny Gruelle and his friends had not been invited to Myrtle Swann's house that Sunday afternoon in 1900. But, armed with a guitar, a banjo, and a mandolin, the three nattily dressed boys virtually took over the party, filling the house with the strains of stringband music. With his derby hat cocked rakishly to one side, the ordinarily shy Johnny felt bolder than usual, for he knew he had caught Myrtle's eye the night before.

And what a night that had been. Instead of inviting their regular beaux to the Saturday-night social, Myrtle and her girlfriend, "Chum," had come alone. Hearing that there would be three "new" boys attending the party—older fellows from the Eastside— the girls wanted to be free to mingle. "And how we used the curling iron that night, heating it over the glass chimney of the lamp," Myrtle later wrote. "We tied our ribbons over and over again."

When the older fellows arrived, Myrtle had immediately noticed Johnny's dark eyes and quiet manner. Though it took her several hours to get up her nerve,

Myrtle, around the time she met her husband-to-be. (Courtesy Worth and Sue Gruelle)

she finally walked over to where Johnny sat in a corner, sketching on his pad of paper. When she asked him for his rose boutonniere, he looked up, put down his cigarette, and gave her the flower without speaking. Though the two said little to each other that evening, Myrtle knew this brown-eyed boy was nearby, watching her, and it set her heart to pounding.

The nineteen-year-old Johnny had calmed down considerably since his earlier freight-hopping days. By the time the exuberant sojourner had reached his mid-teens, he had become a quiet, contemplative young man, known in his neighborhood not only for his dandy clothes and musicianship, but also for his cartooning. Often he could be spotted, seated on the sidelines of family or church gatherings, with his slight 5′ 7″ frame relaxed in a chair and his dark head bent over a pad of newsprint. Looking up frequently, then down again, Johnny would work his pencil methodically and rapidly, capturing the likenesses and expressions of the people in the room.

The night he and his friends had gone to the party where he met Myrtle, he was not looking for anyone in particular. But when he finally noticed Myrtle, Johnny was smitten. From across the room, her porcelain complexion, delicate heart-shaped face, and fine features seemed illuminated. As he handed her his boutonniere, he knew, somehow, that this enchanting young woman with the melodious laugh would always have his heart.

Myrtle J. Swann, daughter of William Fenton Swann and Harriet Foster Swann, had been born in Morning Star, Ohio, on August 12, 1884. Moving to Indianapolis in 1895, the family had settled on Davidson Street, only several blocks from where the Gruelles had resided several years before. Myrtle had grown up happy and protected; in summer, playing on the steps of her parents' stone house; in winter, sliding about on a sled her father had made for her at the basket factory where he worked as an engineer.

Later, as a young teenager, Myrtle began wearing her hair up and rubbing her shoes with glycerine until they glistened. With her group of pals (which always included her dearest friend, "Chum") Myrtle Swann roller-skated, flirted mercilessly with handsome boys, and hosted numerous taffy-and-popcorn parties like the one at her house, where Johnny had shown up. By the time she was sixteen, Myrtle had had many suitors, but none more ardent or persuasive than Johnny Gruelle.

The two had been courting for only several months, when Johnny had a chance to go to Illinois to work with one of his uncles. He knew if he wanted a future with this beautiful girl, he needed to find steady work, even if it meant leaving town. So, his mind made up, in early spring of 1901, Johnny Gruelle proposed marriage to Myrtle Swann, promising to send for her as soon as he was settled in Illinois.

"The next night when I heard the click of the gate I ran out to meet Johnny, and his kiss was long and sweet," Myrtle later recounted. The two young lovers then ran to catch the next trolley out to the Eastside, to tell R.B. and Alice their news. During the evening, Johnny alternately beamed, paced, smoked his hand-rolled cigarettes, and nervously played the

THE INDIANAPOLIS NEWS, MONDAY, MARCH 25, 1901.

BRIDE	REPORT ON INDIANA BANKS	CZAR SEES HIS DANGER	DAILY CITY STATISTICS.
			Marriage Licenses.
ROBAT R.	A COMPARATIVE STATEMENT PREPARED BY COMPTROLLER.	MINISTERIAL COUNCIL DISCUSSES THE RIOTS.	Alvin I. Meyers and Blanche H. Pruitt. Fred W. Blommer and Lucie B. Chaffee. Will M. Van Treese and Ella Mack. John B. Gruelle and Myrtle J. Swann. Frank Kroo and Mary Drobial. Louis Schultz and Ricky Disher.
hy, but by	Marked Increase in Liabilities and Resources—Number of New Banks Established.	Cossacks Ask That They be Not Compelled to Fight Defenseless People—Students Active.	**Birth Returns** W. Harry and Pearl Roberts, 3110 Lexington ave., boy. Lloyd and Addie Van Sandt, 3311 Sheridon st., boy. Frank W. and Emma Flay, 814 River ave., girl
		ST PETERSBURG, March 25.—A min-	

On Monday, March 25, 1901, The Indianapolis News *carried this small announcement noting Johnny's marriage to Myrtle Swann.*

piano. And, though R.B. tried to gently pursuade Myrtle and Johnny to wait to marry, he could not hide his delight at his oldest son's choice of a bride.

Johnny Gruelle and Myrtle Swann were married at 1:00 P.M., on March 23, 1901. It was a small wedding, held on a gray and gusty Saturday afternoon, officiated by a German minister and attended only by the immediate families. The two youngsters began married life by bidding each other a tearful goodbye at the train station as Johnny departed for his new job in Illinois.

Myrtle spent her first weeks as a married woman waiting for Johnny's letters and dreaming of the day she could join her new husband. Many evenings were spent with her in-laws, and Myrtle loved passing the time in their Eastside parlor. With its gleaming wood floor, old piano, and antique desk, it was a floor-to-ceiling gallery of R.B. Gruelle's watercolors and oil paintings. Sitting and listening to her talk, R.B and Alice grew to love Myrtle, knowing that she was the ideal wife for their freespirited son—gentle enough to share his dreams, but determined enough to help direct his talent.

Johnny's work in Illinois was taxing, and his letters were full of longing for his young bride. One evening, when Myrtle arrived at the Gruelles' house, Alice sent her to the parlor. There on the sofa sat Johnny. The two fell into each other's arms, Johnny explaining how he had quit his job to come home to be with her.

R.B. and Alice welcomed the newlyweds to their now enlarged home on North Tacoma Avenue. The young couple moved in upstairs, settling into married life, and Johnny was soon at work, scratching out chalk-plate cartoons for the *People*. These were times of great hope and planning. Myrtle later recalled the night that Johnny came home, handing her a bag of candy, proudly announcing that he had put thirteen dollars in the bank that day.

One night, early in the spring of 1902, as Johnny and Myrtle lay in the darkness of their upstairs bedroom, Myrtle whispered to her husband, "I'll bet you

Marcella Gruelle as a toddler. (Courtesy Worth and Sue Gruelle)

A QUIET OBSERVER

In her sunny nursery, Marcella Gruelle would often play by herself. Bestowing personalities on her many dolls she would converse with them as though they were real little people. Johnny Gruelle would sometimes watch his daughter, marveling at the make-believe universe she created, in which inanimate playthings seemed to come to life.

Already an astute and probing observer of adults (whose antics and foibles he adroitly satirized in his newspaper cartoons), through his daugher, Gruelle became more and more attuned to the magical world of children and learned the essential prerequisite for make-believe: the suspension of disbelief.

Little Marcella's playtime routines would become a rich source of inspiration for Gruelle—a world in which he found many of the settings, the details, and the language he would use in his own stories for children.

a nickel we're going to have a baby." On August 18, 1902, only several days past her own eighteenth birthday, Myrtle delivered a healthy baby girl. She had gone to her mother's to have the baby, Johnny remaining at her side throughout the lengthy labor. The next morning, he presented his wife with a tiny bottle of cologne, and both marvelled at their tiny, perfect daughter, whom they would name Marcella Delight.

By this time, Gruelle had left his first newspaper job at the *People* for a better position with the *Sun*, and would soon be working at the newly founded *Indianapolis Star.* The Gruelles were soon able to set up housekeeping in their own place and had been living in a rented bungalow on Jefferson Street for approximately a year when they were finally able to purchase a lot at 5606 Lowell Avenue in an area called Irvington, a middle-class university surburb adjacent to Butler University. There, they would eventually move into a three-story house of their own.

Despite the hard work, and the couple's continuing frugality, life was full of domestic pleasures. Following hours spent downtown at his drawing board, Johnny would rush home from work every evening to have a few hours to play with his little baby, "Muggins." Myrtle willingly embraced housewifery and motherhood, but never far from her thoughts were her aspirations for the future.

Already, she had dedicated herself to her husband's success—a sure way, she reasoned, to secure the right kind of life for her family. Myrtle's own tastes ran to fine things, for which she had to scrimp and save, but to which she felt entitled. Myrtle's grandmother and rich maiden aunts, embittered by their own unfulfilled dreams, chided her jealously for what they felt were her overblown notions. But Myrtle just laughed and continued dreaming about her husband's success and someday owning fine china, a car, and a diamond ring. "I hitched my wagon to a star," she would later profess.

Myrtle and Johnny visited frequently with family, and Johnny kept in touch with his old childhood friend, Ed Soltau, with whom he would often fish at nearby Lake Wawasee. A grocer like his father, Ed would sometimes invite the Gruelles to join him and his wife, Grace, for after-hours picnics around the

In 1904, Johnny Gruelle captured his young daughter Marcella's likeness. (Courtesy Richard Gruelle Family)

grocery store meat block, eating huge German sausage sandwiches, drinking beer, and laughing, while their two daughters, very close in age, cavorted happily through the store aisles. But most evenings, the Gruelles preferred to stay at home in their little upstairs studio, Johnny drawing and writing poetry and Myrtle reading. It was a tranquil life.

Then, the night arrived when Johnny had rushed home from the *Star* to tell his wife about the job offer from *The Cleveland Press.* Though R.B. and Alice felt Cleveland was much too far away, and the Swanns wept for the departure of their only remaining child (Myrtle's brother having died earlier that year from typhoid fever), both sets of parents eventually gave Myrtle and Johnny their blessings. It took all the willpower the young couple could muster to make a career move that would distance them more than ever from family.

AT RIGHT:
Johnny Gruelle would often send his closest friends hand-drawn cards with personalized messages.
(Courtesy Jessie Soltau Corbin)

In 1910 or 1911, the Gruelles would travel to Indianapolis and celebrate, in high style, the opening of Ed Soltau's new grocery store on Michigan Avenue. (Courtesy Jessie Soltau Corbin)

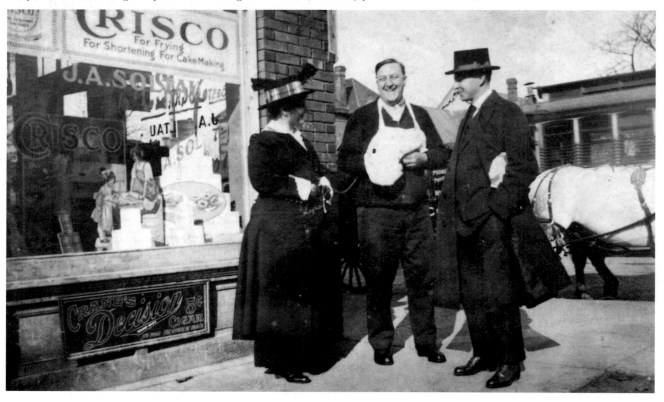

JOHNNY GRUELLE, CREATOR OF RAGGEDY ANN AND ANDY

Gruelle's original artwork for a cartoon, rendered ca. 1910. (Courtesy Norman Meek)

Johnny ventured ahead to Cleveland to find a house, and Myrtle stayed behind in Indianapolis to pack. Gruelle could not wait to show his wife the apartment he had chosen, on Linwood Avenue, located in a Cleveland suburb. When Myrtle and his little Muggins finally arrived on the train, Johnny served them sweetened grapefruit with cherries, the first they had ever tasted.

There would be many firsts in the heady, exciting days that followed in this new, noisy city. The young family spent many a late afternoon around windy Lake Erie, where they had their first glimpse of a real airplane, buzzing over the water. Automobiles were now chugging along in the same streets where horses and buggies had ruled, and Myrtle and Johnny were determined to own one someday.

As sports cartoonist, Johnny went to all the Cleveland ball games, almost always accompanied by

his wife. The Gruelles spent time with many friends, including Gruelle's old acquaintance, Officer McGinty, who happened to live on the same street they did. The Gruelles continued saving and soon, Myrtle owned her own mink muff and scarf and the set of Haviland china she had always dreamed about.

Little Marcella was no longer a baby, and Myrtle dressed her in tiny, feminine frocks and enormous matching hair ribbons. But Johnny's little Muggins happily traded her dresses and bows for trousers and little rubber boots, to go fishing at Rocky River, where she would splash about, catching minnows in her own bucket.

The next few years passed quickly, and by 1910, Johnny Gruelle was doing well enough with his regular job and free-lancing to move his family to a flourishing Cleveland suburb called Lakewood, where they would reside at 1503 Mars Avenue. Meanwhile, R.B. and Alice Gruelle had been making plans to move east from Indianapolis to a sixteen-acre farm in a place called Silvermine, in the New Canaan-Wilton area of Connecticut.

As it turned out, R.B. Gruelle would be among the first of many artists to migrate to Silvermine. Soon would arrive the artist Addison T. Millar; the sculptor Solon Borglum; portrait artists Howard L. Hildebrandt, Henry Salem Hubbell, and many others, making the community a veritable artists' colony.

When Johnny and Myrtle Gruelle had first heard of the elder Gruelles' decision to relocate to rural Connecticut, they were distressed, confessing to a friend, "We were so discouraged when our folks told us that they had purchased an old mill and a 'farm' 'way' out in the 'country.' We were sure that they were making a grave mistake."

Then, in early fall 1910, Johnny and his family took a train to Connecticut to spend their vacation with R.B. and Alice. After being in Silvermine only several days, they were smitten, and admitted that the isolation they had envisioned for their folks was an illusion. The regular fishing expeditions to Long Island Sound, church socials, lawn fetes, and neighborhood suppers—sometimes two or three times a week—left little chance for loneliness. It was this idyllic environment, so full of nature and creative and spiritual fellowship, that also beckoned to Johnny and Myrtle Gruelle.

During that visit, Johnny's mother had called his attention to several space ads in *The New York Herald,* announcing a comic-drawing contest. His interest was piqued. Returning home to Cleveland, with the contest announcement stuffed in his back pocket, Gruelle studied the work of the veteran *Herald* cartoonists (among them Winsor McCay's "Little Nemo in Slumberland" and Robert Outcault's "Buster Brown") and spent some late nights idly playing with ideas, before completing several entries.

By October of 1910, the winds over Lake Erie had grown cold again, and Johnny was suffering from bouts of exhaustion, and illness. He arrived home from work one evening, and gathering his family around him, announced that N.E.A. was dividing its art department between its West Coast and Chicago offices. Knowing that he could go to either place, he asked his wife what she thought about moving to Connecticut, where they could be closer to family, and Johnny could try his hand at free-lancing. The family vote was unanimous for Connecticut.

It was a brilliant, autumn Sunday when the train carrying Johnny and his family finally rolled into the station. They walked from the end of the trolley line, in order to surprise R.B. and Alice with their arrival. After a hearty, homecooked dinner, the elder Gruelles took Johnny and Myrtle across the road, to the mill that was to be their new home. The three-story structure that stood on the Gruelle property was already in use by R.B., son Justin, and son-in-law Albert Matzke—all artists, who used the mill as a studio. But there was plenty of room upstairs to make a comfortable, three-room apartment overlooking the Silvermine River.

Johnny and his young family soon settled in, and Marcella began attending the Silvermine country school. Myrtle cooked, cleaned house, and kept her mother- and sister-in-law company. When he was not at work at his drawing board, playing with new ideas, Johnny and his brother, Justin, regularly fished the nearby streams. Other times, they would hunt together in the quiet wooded areas surrounding their folks' place. That lush forest was exactly where Justin and Johnny were on the damp fall afternoon when the elder Gruelles frantically beckoned them home with news that would prove to be yet another milestone in young Johnny Gruelle's career.

Johnny Gruelle conveyed the quiet beauty of Indiana's Lake Wawasee in this ethereal watercolor.

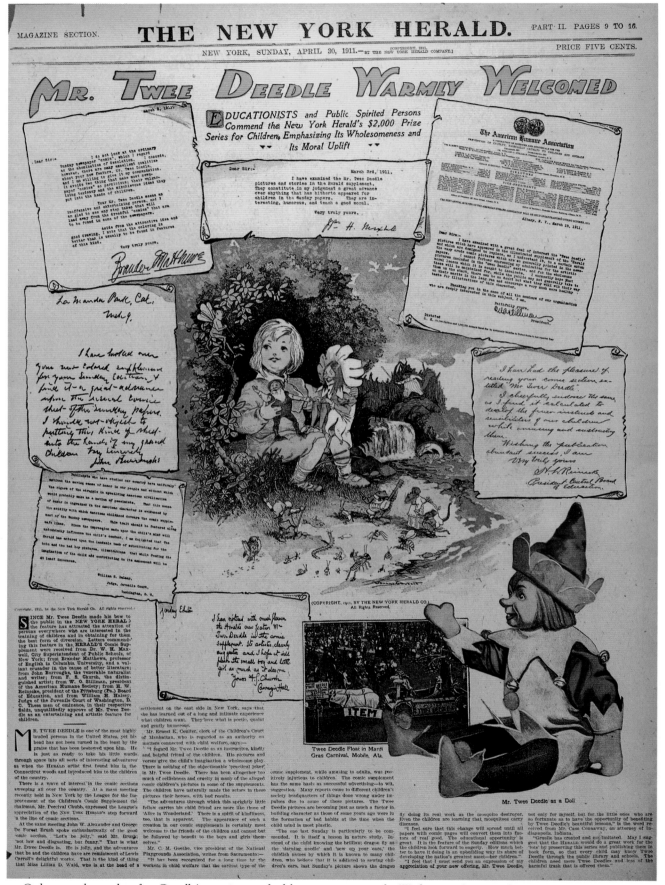

Only several months after Gruelle's comic page had begun appearing, the Washington Society of Fine Arts adopted a resolution commending "Mr. Twee Deedle" and its publisher, the Herald, for improving the general character of comics. (Courtesy David Begin)

CHAPTER SIX

A Sprite for All Seasons: "Mr. Twee Deedle"

If I have won in this contest, I am more glad of the honor than of the money I shall get. . . . With that to give me courage and the beautiful Connecticut countryside to inspire me, I ought to be able to do some first-class drawing. I don't care if I do get snowed up this winter. I am going to stay right here and work.

JOHNNY GRUELLE
1910

Years later, Justin Gruelle would write about that fall day in 1910, when he and his brother, Johnny, were trudging through the chilly Connecticut woods: "We had a horn that mother blew if important mail or visitors arrived," he recounted. "That morning Johnny and I were out squirrel hunting on the land around the place. When we heard three toots on the fish horn, we returned home."

When the brothers finally arrived at the Gruelle farmhouse, it was after dark. Alice showed them the letter Myrtle had retrieved from the mailbox earlier that day that summoned Johnny to *The New York Herald* headquarters. The next morning, Johnny and Justin took the train into Manhattan and were back by 4 P.M., giddy with the news that Johnny had won the cartoon contest he had entered several months before.

More remarkable than winning was the fact that not one, but two of Gruelle's entries had tied for first place in the contest. And, Gruelle had won out over numerous, formidable competitors. By the October 1 deadline, the contest judges had counted more than 1,500 entries from amateurs and professionals alike—an onslaught for which the newspaper had been completely unprepared. During the contest's final days, piles of flat and rolled-up entries filled an entire room in the *Herald*'s offices.

"His are whimsical characters, but they are neither coarse nor grotesque. The human element makes them lovable as well as laughable."

—*The New York Herald*
1910

Eventually the entries had been narrowed first to 100, then to 50, finally to 6—each of which, in the judge's words, "would have made an admirable comic feature." With no little deliberation the judges chose 2 finalists, describing both as "cleanly drawn fanciful creations with a distinctive charm." Unable to make up their minds, the judges looked on the back of each, only to find that both were signed by John Gruelle of Norwalk, Connecticut. None among them claimed to have ever heard of Gruelle.

Finding themselves unable to choose a clear, first-place winner from the two entries (but knowing that Gruelle would be the winner either way) the judges decided to summon him to *Herald* headquarters, to present him with his cash prize. They also put their reporters to work on what would be a full-page article about this intriguing young newcomer, John Gruelle.

Winning the contest instantly lifted Gruelle's spirits, and was an undeniable tonic in his campaign to regain his health and stamina. "I can tell you," he would say, "that it has put so much heart into me to win this prize that I feel as if I can do anything now . . . I'm tired, but I don't mind it a bit. I'm getting well and I've got the prize."

Describing the eleventh-hour nature of his hastily penned submissions, Gruelle noted: ". . . they were about the last work I did before leaving on vacation . . . I did them under a great handicap. I could have done better if I had not been ill and if I could have worked on them in the daytime when I was fresher."

Gruelle's clinching of the prize naturally inspired

"I did not really expect to get the prize when I sent my drawing to the *Herald*, but I thought I would see what I could do along the line that I had in mind and felt that it might lead to something better for me."

—Johnny Gruelle
1910

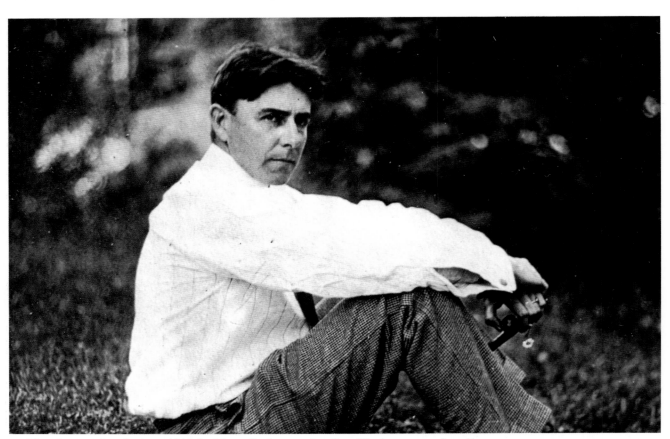

This photograph, taken ca. 1910 by Norwalk photographer Sam Weed, captures the selfsame Johnny Gruelle described in a news article as a "dark, delicate looking youth." (Courtesy Worth and Sue Gruelle)

curiosity among the established East-Coast artists and cartoonists who had also competed in the contest. Although Gruelle's work had been appearing in papers throughout the U.S. for several years, the *Herald*'s newspaper accounts staunchly maintained that Gruelle was, for the most part, unknown to those on the East Coast.

To break the tie between Gruelle's two entries, the *Herald*'s art editor took a steamer to Paris, France, to deliver both personally to *Herald* owner and pub-lisher, James Gordon Bennett. The curmudgeonly Bennett was impressed with the clever themes and flowing artwork of each cartoon, but quickly resolved the tie, choosing as first-place winner the page featuring a comely little fairy, whom Gruelle had named "Mr. Twee Deedle."

Though *The New York Herald* did not, until some months later, formally announce any permanent arrangement with Gruelle, they would hint in a feature story that one of his winning entries would form the

MR. TWEE DEEDLE: A NEIGHBORLY INSPIRATION

Beyond more generalized influences, there lay one very attributable inspiration for Gruelle's Mr. Twee Deedle. Johnny would, himself, confirm that the little fairy protagonist had not originally sprung from his own imagination, but from the storytelling of his dear friend and Silvermine neighbor, Solon Borglum. The story behind Mr. Twee Deedle's genesis reveals the spirit of generosity that existed between the artists and writers of Silvermine. It also confirms just how well liked Johnny Gruelle was.

Solon Borglum (the brother of the more well known Gutzon Borglum, who would achieve world renown as the sculptor/designer of Mount Rushmore) was a fun-loving sculptor, living not too far from the Gruelles on a farm called "Rocky Ranch." Borglum was not a writer, but like Gruelle, he possessed a whimsical world view, a fascination with magic, and a penchant for tale-telling, especially fairy stories. According to Borglum's biographer (and son-in-law) A. Mervyn Davies, during one storytelling session for his daughter, Monica, Borglum had come up with a special make-believe fairy he called Twee Deedle.

Wrote Davies: "Twee Deedle was an elf who lived in a gnarled apple tree not far from the brook that passed through the farm. He was a remarkable little creature with a wonderful ability to make himself invisible whenever he wished."

One day, Monica brought along her playmate, Marcella Gruelle (who was visiting her grandmother in Silvermine), to show her the fairy's domicile. The first time, Marcella saw nothing and heard only "a rustle and a squeak." The next time, Marcella thought she really did see Twee Deedle, and she raced home to tell her parents all about the little fairy.

Johnny Gruelle was intrigued and asked the sculptor if he might develop Twee Deedle into his own comic-strip character, to submit to the *Herald*'s comic-drawing competition. Borglum readily consented. When Gruelle eventually won the contest, Borglum could not have been happier for his affable, gentle-hearted friend.

Though Mr. Twee Deedle was born in the mind of another, his development into a fanciful little teacher took place at the adept hand of Johnny Gruelle. It was Gruelle who breathed life and soul into the little comic-page sprite, who each week taught thousands of readers the virtues of kindly and compassionate living.

And Johnny Gruelle would never forget the man in whose imagination Twee Deedle had originated. To thank Solon Borglum for his gift, Gruelle created a large card, rendered in ink and red and green watercolor, which read: "To Solon Borglum, who discovered me. I send my Xmas Greetings. Mr. Twee Deedle."

To thank Solon Borglum for the inspiration for Mr. Twee Deedle, Gruelle created this fanciful Christmas card. (Courtesy Monica Borglum Davies)

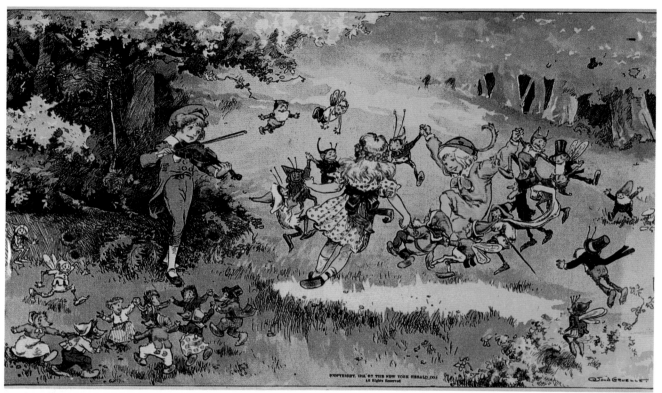

Gruelle produced "Mr. Twee Deedle" using the techniques of commercial illustration, resulting in installments more resembling bookplates or posters than they did Sunday comic pages.

basis for a regular comic series. In fact, the *Herald*'s request for Gruelle to come in person to New York had been not only to present him with his prize money; it was also to make him a job offer.

The *Herald* wanted Gruelle's "Mr. Twee Deedle" for the front page of its Sunday comic section, which also appeared in editions of the *London Herald* and *Paris Herald*. And, although the paper had not said so in its announcements, the comic-drawing contest (made very attractive by its substantial cash prize) may well have been a cleverly designed recruitment scheme to replace a prominent *Herald* cartoonist, Winsor McCay, who would soon depart to a rival newspaper. Even before McCay's departure, Johnny Gruelle would begin his ascent as the *Herald*'s new star, his "Mr. Twee Deedle" occupying the coveted front-page slot, while McCay's once front-page "Little Nemo in Slumberland" lived out its final days on a much less visible inside page.

Once Johnny's large cash prize and position were announced, he was deluged with congratulations, and a flurry of letters lionizing him. But, he laughed off the adulation. Determined not to let his winning nor the new job go to his head, Gruelle diligently set to work, composing more "Mr. Twee Deedle" pages, forging a long and lasting association with one of the country's largest and most well known newspapers.

On Sunday, February 5, 1911, the *Herald*'s front-page headlines blared out: "Mexican Rebels to Attack Ciudad Juarez at Dawn Today." Meanwhile, on the front page of the newspaper's comic section, there appeared the first installment of "Mr. Twee Deedle"—a gentle, colorful counterpoint to the harsher black-and-white world of current events and world politics.

In this premiere page (and in each of the weekly episodes that followed) Gruelle would spin out an illustrated morality tale, in which the elfin Mr. Twee

"What manner of personality has this John Gruelle, the children's 'funny man?'"

—*The New York Herald*
1910

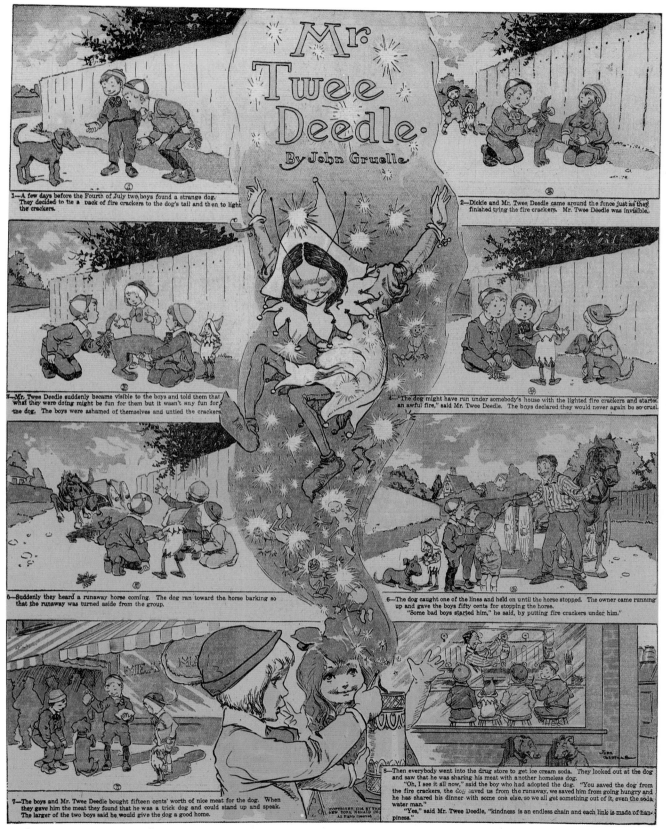

Certain "Mr. Twee Deedle" pages are extraordinary for their design, penwork, and coloration.
Gruelle experimented with frame size and perspective until his woodsprite seemed to literally reach
up out of the page to beckon the reader.

Deedle appeared to a cherubic sibling team, Dickie and Dolly, to teach them (and the *Herald*'s little readers) about kindness, honesty, and respect.

In many episodes, Mr. Twee Deedle would magically "shrink" Dickie and Dolly so that they could frolic with bugs or woodland critters, showing his little readers, by example, what it might feel like to be much smaller, and subject to the whims of those larger than themselves. Gruelle would incorporate lessons in almost every "Mr. Twee Deedle" episode—parables and axioms that were variations on the Golden Rule, along with more pedagogic tidbits about the effects of gravity, the physics of flight, and types of flora and fauna.

But, unlike some of his colleagues' comic strips featuring children, Gruelle's "Mr. Twee Deedle" was rarely punitive. In many ways, Gruelle's comic strip mirrored his own philosophy to educate, not intimidate.

Occasionally, Gruelle would use "Mr. Twee Deedle" as a humorous soapbox, from which he exposed his least favorite characters: reckless drivers; trappers; farmers who whipped their horses; and tramps and hoboes, whom Gruelle depicted as lazy and shiftless indigents, in need of only a good shave (and stern upbraiding from Mr. Twee Deedle) in order to change their ways.

The *Herald*'s little comic readers came to adore Gruelle's sprite, and their parents looked forward each week to the strip's gentle moralizing and subtle humor. "Mr. Twee Deedle"'s popularity helped convince Gruelle that he had, indeed, done well by joining the ranks of one of America's preeminent newspapers.

Founded in 1835 by James Gordon Bennett, Sr., by the time Gruelle joined the staff, the *Herald* was running under the heavy-handed direction of James Gordon Bennett, Jr., who spent much of his time living in Paris, overseeing several European editions of the paper. The younger Bennett's presence was perpetually felt at all of his newspapers, which he ruled with an iron hand. Though Gruelle would soon become one of Bennett's favorite cartoonists, the young artist would get occasional tastes of producing work, on demand, for a high-strung, egotistical boss.

By 1911, newspapers throughout the country were enjoying expanded circulation and improved printing technology. Placement was also key, and "Mr. Twee Deedle" (syndicated to other newspapers out-side the *Herald* chain) was well positioned as a front-page comic to be appreciated by thousands of readers.

"Mr. Twee Deedle" would also benefit from a superior color printing technique, known as the "Benday Process." *The New York Herald* was among the first newspapers to employ this process (patented in 1879 by New Yorker Benjamin Day), which allowed for subtle shading and gradations of tone and color.

By November 1911, Gruelle had begun experimenting with other themes and formats for "Mr. Twee Deedle." One of these would be a serialized adventure that would run, off and on, for several years, entitled "The Tearful Tale of the Moonman." Most significant about Gruelle's "Moonman" saga is how he would use it, nearly ten years later, reprising its basic theme of space travel and many of its characters and their exploits. The result would be a beautifully illustrated book chronicling the make-believe adventures of children who fly to the moon in a homemade flying machine.

As Gruelle produced more and more "Mr. Twee Deedle" pages, he became increasingly creative with the strip's format. By 1913, instead of the usual ballooned dialogue, Gruelle was accompanying his frames with clever cutlines; many written as rhyming couplets. He continued borrowing from traditional folktales, creating modern-day stories of giants, princes, and princesses—tales in which the old magically turn young again and in which food (or money) magically appears. Occasionally characters from folktales and nursery rhymes would make cameo appearances; among them Rip Van Winkle, Santa Claus, and Old Mother Hubbard.

Gruelle used "Mr. Twee Deedle" to play to his urban readers' nostalgia for simpler times. His artistic style and gentle, post-Victorian moralizing harkened back to a turn-of-the-century romanticism—in which popular tales were full of magic, nymphs, fairies, and elves. About "Mr. Twee Deedle," Gruelle, himself, had commented: "I wanted to get away from

"... children will recognize at once that they have found a new friend, one who knows what children like and can put it into delightful pictorial form."

—*The New York Herald*
1910

the slap-dash style of comics. I have always loved fairy tales and have wanted to illustrate them."

In 1915, a new Sunday editor, feeling no particular attachment to Gruelle, or his little elf, unceremoniously removed "Mr. Twee Deedle" from the newspaper's comic section. It was not long, however, before "Mr. Twee Deedle" 's absence was noted by one of its most ardent fans: the *Herald*'s publisher,

A DOLL CALLED TWEE DEEDLE

As the publisher had done with several other characters (including Robert Outcault's Buster Brown), *The New York Herald* had anticipated a market for a three-dimensional plaything based on Gruelle's "Mr. Twee Deedle." Wasting no time, by spring 1911, the *Herald* had authorized A. Steinhardt and Bro. of New York to manufacture a Twee Deedle character doll. The felt doll dressed in red, yellow, orange, and white was available only two months after the inauguration of Gruelle's comic strip.

During the next few years, several versions of the Twee Deedle doll (each a different design, ranging in size from fourteen to eighteen inches, priced to retail for between $1.00 and $1.70) were produced by different doll manufacturers. In 1913, a Twee Deedle doll made by Steiff was advertised by Borgfeldt, Steiff's sole U.S. distributor, and a version of the doll may also have been produced by Horsman.

Though articles and advertisements for the Twee Deedle doll would tout the *Herald*'s $2,000-winning comic strip, stressing its popularity, none even once credited Johnny Gruelle by name. But, recognition aside, the Twee Deedle dolls constituted a significant milestone for Gruelle, for they were the first commercial playthings to be based on his artwork. Though the Twee Deedle dolls were never best sellers, they undoubtedly alerted Gruelle to the commercial potential of other characters that were regularly springing to life in his imagination. Mr. Twee Deedle, the doll, was a harbinger of what exciting things lay ahead in Gruelle's career.

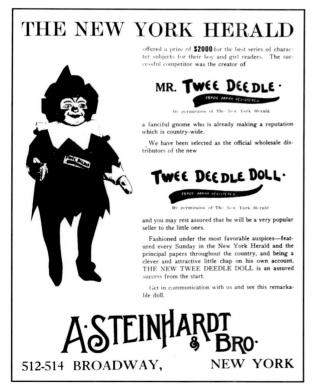

In April 1911, Steinhardt launched a promotional campaign for its Twee Deedle doll, directed at toy buyers and retailers.

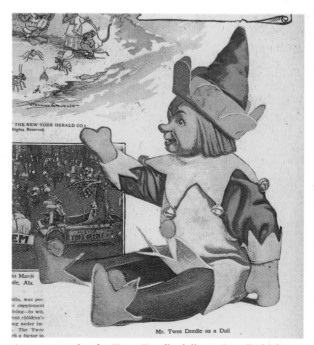

A prototype for the Twee Deedle doll, as Gruelle had conceived it.

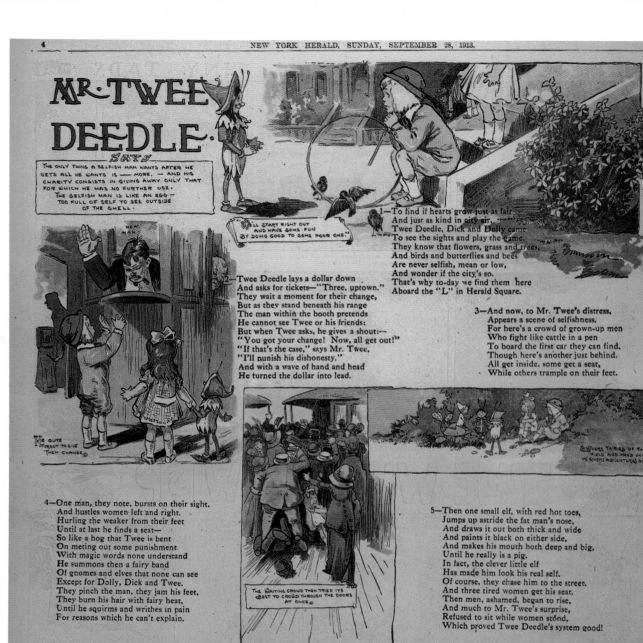

Gruelle often rendered his "Mr. Twee Deedle" pages as modern fairy stories, his artwork setting off his tales-in-verse. Gruelle used "Mr. Twee Deedle" to sharpen his narrative technique, the strip reflecting a cartoonist's move from comic artist to storyteller.

James Gordon Bennett. In Paris at the time, Bennett fired off one of his famous cables to the *Herald*'s managing editor, demanding to know what had become of the strip.

"Discontinued by Sunday editor," the managing editor's return cable read.

"Discontinue Sunday editor!" were Bennett's terse and final words.

Johnny Gruelle's "Mr. Twee Deedle" was summarily reinstated in the *Herald,* where it would run for several more years on page two of the comic section. Unfortunately, by this time, reduced to a half-page, Gruelle's strip no longer was the inspired, full-color, sparkling production it had once been.

In the spring of 1918, "Mr. Twee Deedle" would be permanently replaced by strips with titles like "Fritz Von Blitz: The Kaiser's Hoodoo," whose characters were aimed at a wartime audience. Other fac-tors in "Mr. Twee Deedle"'s discontinuation may have been Bennett's death that same year, and the eventual decline and demise of the newspapers he had once ruled. Once it ceased appearing in the *Herald,* Gruelle's "Mr. Twee Deedle" would never again appear in newspaper form.

During his seven-year stint with the *Herald,* Johnny Gruelle had taken another important step — from black-and-white political cartoonist to color illustrator. But more significantly, it was in "Mr. Twee Deedle" that Johnny Gruelle had found the strength and power of his own narrative voice. His transition into graphic storytelling would open many new doors for him. As his brother, Justin, would succinctly put it, "Mr. Twee Deedle was a breakthrough for Johnny. [As a result] a lot of work moved across the drawing board, in the new house up the river."

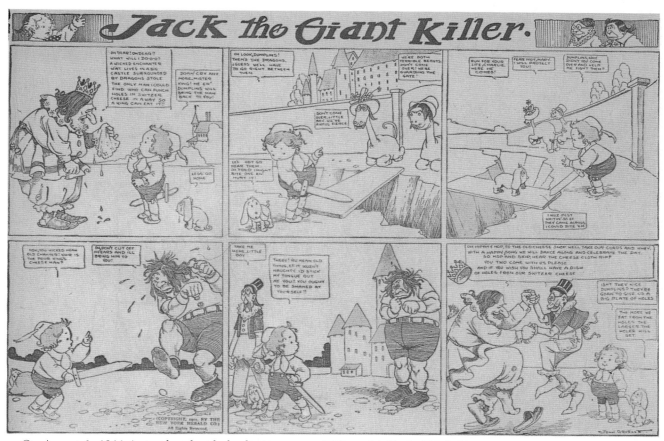

On August 6, 1911 (coincidental with the disappearance of Winsor McCay's "Little Nemo in Slumberland") the first of several installments of Gruelle's "Jack the Giant Killer" (Gruelle's other winning entry in the Herald's comic-drawing competition) appeared in the comic section of The New York Herald.

In this evocative watercolor, Johnny Gruelle captured the concentration of his father, R.B., fishing the Silvermine River.

CHAPTER SEVEN

On the Banks of the Silvermine River: The Gruelles Settle In

When we came here on our vacation and saw the country in all its wildness and beauty and saw just how lonely the folks were, we could hardly wait until we could come East and make our home in this lonely spot.

JOHNNY AND MYRTLE GRUELLE
1913

Silvermine was lush with natural beauty and rich with history. Not far from the Gruelles' farmhouse lay a historic road, over which Washington's troops had marched when they dislodged the British from nearby Norwalk. "The very air is full of the poetry and prose that marked the advent of the pioneer fathers," proclaimed a newspaper reporter, describing the wonders of Silvermine.

As Johnny Gruelle settled in and began working, he found himself in excellent company. By this time the cadre of artists living in the area had organized themselves as "The Silvermine Neighbors" (later to become the Silvermine Guild of Artists) and already were gathering weekly for "Knockers Club" meetings. These informal Sunday afternoon salons (which Johnny, R.B., and Justin often attended) were hosted by Solon Borglum in his large studio.

Any Silvermine artist caring to bring work forward for comment and good-natured criticism was welcome.

Sometime in 1911, a family came to Silvermine with whom the Gruelles would forge a long and lasting association. Andrew Henry Oeder (a New York City dentist and professor of medicine at New York University) and his wife, Emma, had decided to summer that year in the country, to help their four-year-old daughter, Lynda, recover from whooping cough. Though Lynda was nearly five years younger than Marcella, the two girls would often play together, usually venturing to their secret hiding place underneath the mill, where they would giggle and share confidences.

By summer of 1911, Johnny and Myrtle had decided to build a home of their own in Silvermine;

Myrtle, no doubt, had initiated the idea. In addition to cherishing her own privacy, Myrtle had always been protective of her husband's, wanting him never to be without a quiet refuge, in which he could work uninterrupted. A home of their own seemed the perfect way to keep Johnny focused on the projects that ultimately fed the family.

Myrtle and Johnny found three meadows, located on the Mill Road, around the bend and across a bridge from R.B.'s and Alice's house. The farmer from whom they would buy the property agreed to carry a mortgage in exchange for continuing to graze his horses on the land. As the two rode into town with the farmer to register the deed, they were giddy at the prospect of building their dream house in the country.

Slowly but steadily, the new house began taking shape. The holidays arrived, and on Christmas morning, Myrtle, Johnny, and Marcella crossed the road from their mill apartment to spend Christmas day with R.B. and Alice. Marcella squealed with delight when she spotted her new shiny bicycle. Myrtle

Marcella Gruelle (front row, second from right with hair ribbon) stood proudly for this class portrait taken at Silvermine's country school, ca. 1912. (Courtesy Monica Borglum Davies)

"... A person would have to be out of the ordinary to get lonesome out here...."

—Johnny Gruelle

R.B. and Alice Gruelle, ca. 1913. (Courtesy Peggy Y. Slone)

*Johnny Gruelle eventually persuaded his friend Clifton Meek (with whom he had worked at the
N.E.A.) to move to Silvermine. Later, Gruelle would present him with this portrait, taken ca.
1910.* (Courtesy Norman Meek)

blushed when she opened her gift from Johnny: a larger and more resplendent diamond ring. And, everybody cheered at the couple's holiday announcement that they were expecting another baby.

By spring 1912, the Gruelles had moved and were finally settled in their nearly completed home. And a grand one it was. The house (which would eventually be dubbed "Twee Deedle Lodge") sat atop a wide grassy slope overlooking the Silvermine River. Myrtle had insisted on electricity, running water, and indoor plumbing, and the two-story structure boasted airy, spacious rooms. There were also other amenities that most homes of the era lacked: broad, carefully placed staircases; and roomy cupboards and closets in all the upstairs bedrooms, to hold clothes, toys, and other stowable items. The Gruelles had even planned their home to have a separate apartment with its own kitchen, so that Myrtle's parents, now in their seventies, could come live with them.

With what Johnny was now earning, the couple soon paid off the mortgage, and welcomed Myrtle's parents from Indianapolis. At Father Swann's insistence, Johnny bought ten white hens and several pigs that roamed the property and provided dozens of eggs, scores of sausages, and plenty of hams to eat and sell.

On June 28, 1912, after a spring spent cutting grass, gardening, and helping fix up her new home, Myrtle gave birth to a son. She and Johnny named their new little boy, Worth, after their good friend, illustrator Worth Brehm, who had moved to Silvermine from Indianapolis. The Gruelles doted on their brown-eyed baby boy, and nine-year-old Marcella was gleeful to finally have a baby brother to dress up and take care of.

The Silvermine surroundings were a ready-made fairyland for Marcella, who would play with her dolls in the wide grassy yard, or on a huge moss and fern encrusted rock, down by the river. Occasionally, she would venture to the woods with the Borglums' daughter, Monica, who was a year older. There, under the sweeping, moss-covered trees, the two would craft elaborate floor plans with pieces of moss, playing for hours in the many "rooms" they had created.

Johnny found Silvermine to be a tailor-made haven, appealing to both his solitary and sociable sides. The quiet Connecticut forest, with its lush greenery and wild creatures, was perfect for meditative afternoon walks. Those dense woods surrounding his home also held for Gruelle a more mystical significance, and from this forest came some of the inspiration for the imaginary fairyland settings Gruelle would incorporate in many of his later tales.

Johnny also enjoyed the spontaneous, year-round get-togethers with his neighbors, who grew to know both sides of him: quiet and meditative when he was at work, but charming and jovial when it was time to play. Many parties were held at the Gruelles' new abode. When everyone had gone home, Johnny would often retire to his studio to work all night on commissions, stopping only when the first rays of sun lightened the landscape outside his studio window. On mornings like these, peering out into the swirling dawn mists, Johnny Gruelle knew, in his heart, that he had made the right decision in coming here to this very enchanted place in the Connecticut hills.

"September in Ohio, I thought beautiful, but September in the hills of Connecticut, where green hemlock holds hand with swamp maple and the yellow dips down to show their reflection in the pond . . . oh, it's lovely."
—Myrtle Gruelle

By the Glow of a Lamp: Johnny Gruelle, Magazine Free-lancer

"I wish you had wings," said Tommy Grasshopper, *"so that we might both fly away together and have lots of fun!"*

JOHN GRUELLE
"Tommy Grasshopper's Wings"

Mr. Twee Deedle was Johnny Gruelle's own fairy of good fortune. Not only had the fey sprite won Gruelle a place in the hearts of thousands of readers; he also had secured his creator a good job and more-than-comfortable salary at *The New York Herald*. And, he was providing an entre for Gruelle in another kind of venue in whose pages the young artist could foresee a fine future for himself: magazines.

By 1910, magazines had become a popular and accessible form of entertainment, and magazine publishers had already begun to target specific interest groups—consumers of particular kinds of products and merchandise. For several of these groups (such as homemakers and young mothers) special magazines had been created, with a revenue base built on advertising for mail-order merchandise. It was to these magazines—which invariably featured a special activity page or read-aloud story for youngsters—that

Gruelle began directing samples of his work, hoping to sell an individual illustration or story, or better yet, be offered a regular commission.

In September 1911, *McCall's* magazine (a purveyor of home sewing patterns) began publishing a series of Gruelle's drawings. Gruelle's reputation as "Mr. Twee Deedle" 's creator had obviously preceded him, as evidenced in *McCall's* announcement the previous month: "We have arranged with Mr. John Gruelle, the well-known artist, for a series of cut-out fairy plays for this department of McCall's—a feature that is sure to become popular with our many little friends. . . ."

These one-page plays, each based on a fairy tale, were written by Carolyn Sherwin Bailey, with Gruelle providing accompanying sets of technically drawn pen-and-ink cutouts. Between September 1911 and March 1912, Gruelle illustrated a total of

Cinderella, The Glass Slipper and The Fairy Coach

B

A

PASTE FLAP "A"
SO LINES COME EVEN
WITH OTHER MICE.

CUT SLIT ↑ AND INSERT
FLAP "B"

five. *McCall's* ran Gruelle's photograph several times on its contents page, touting him as "the creator of the most fascinating fairy people ever brought to notice since the days of Andersen and Grimm." Though brief, Gruelle's association with *McCall's* afforded him national visibility and was an important step in his still-nascent free-lance illustrating career.

Gruelle was also intent on publishing some of his own writings. He adored the traditional European tales, which his wife, Myrtle, often read aloud to him for inspiration while he worked on his cartoons. In his own tales, which Gruelle shaped as nostalgic, pastoral fables, he sought to give life to fairies, elves, and insect critters, who "explained" the wonders of the universe and espoused the gentler virtues. Similar to his earlier N.E.A. newspaper stories (and in many ways, paralleling the themes he was using in "Mr. Twee Deedle") these prose tales were, in style and format, forerunners to the hundreds of stories and dozens of books Gruelle would write later during his career.

In December 1911, *The Ladies' World* (a leading mail-order magazine that would boast such well-known writers and illustrators as L. Frank Baum and Franklin Booth) published one of Gruelle's illustrated stories entitled "Tommy Grasshopper's Pennies; or How Willie Ladybug Happens to Have the Little Pennies on His Back."

In 1913, *The Ladies' World* published two other illustrated tales by Gruelle, but not before *The Designer* (another ladies' magazine promoting mail-order dress patterns) would, in June 1912, publish a Gruelle story entitled "Tommy Grasshopper's Adventure."

In October 1913 Gruelle would begin a long-term association with another magazine. His work for this periodical would not only bolster his career as a fairy-story author and artist; it would also mark the first time his work would appear regularly in a publication serving children exclusively.

The magazine, *John Martin's Book*, was a subscription monthly, serving much the same readership as the more well known *St. Nicholas Magazine*. *John Martin's Book* was the brainchild of a man named Morgan von Roorbach Shephard, who founded it in

Gruelle's tales for The Ladies' World *were accompanied by his own inventive illustrations of bugs and other critters, who, though anthropomorphized, retained some distinctive attributes unique to their particular species.*

AT LEFT:

Beginning in its September 1911 issue, McCall's *published a series of fairy plays written by Carolyn Sherwin Bailey, each accompanied by a page of pen-and-ink, cut-out drawings rendered by Gruelle.*

1912. Born in Brooklyn in 1865, and raised in Maryland by a mother who was devoted to nurturing her son's literary and creative development, Shephard had grown up with a deep respect for the arts and learning.

As an adult (no doubt fueled by nostalgic memories of his own childhood), the eccentric Shephard possessed a strong penchant for corresponding with boys and girls of all ages, to whom he would write long, illustrated letters filled with tales and original poetry. Eventually, these meandering missives evolved into a newsletter, which Shephard would sign with the pseudonym "John Martin," a name he eventually adopted. By late 1912, Martin had renamed his newsletter (which had grown in length to resemble more a magazine) *John Martin's Book.*

Intended for a readership beween the ages of three and ten, each issue of *John Martin's Book* featured nonfiction articles, stories, poetry, activity pages, and ingenious puzzles—all reflecting high morals and Martin's own deep respect for the basic intelligence of children.

It is quite likely that John Martin was familiar with Johnny Gruelle's work in the *Herald,* as well as in magazines, and had sought him out to add to his growing stable of artists and writers; a cadre that would eventually include his associates, George Carlson and Helen Waldo, as well as W. W. Denslow, Jack Yates, Wanda Gag, and Gruelle's brother, Justin.

Philosophically and graphically, *John Martin's Book* was a medium tailor-made for Gruelle. Martin's emphasis on wholesome subject matter meshed well with the uplifting themes that propelled Gruelle's stories and comics. And Gruelle was very much at home producing the style of artwork that suited perfectly the Arts-and-Crafts-inspired design and layout of *John Martin's Book.* Though Justin Gruelle would become a much more frequent contributor to *John Martin's Book,* Johnny Gruelle's graphics and fanciful writings would appear frequently in the magazine throughout the next eight years.

But, amidst the flurry of his magazine and newspaper work for children, Johnny had not abandoned his adult audience. On June 8, 1912, the first of many Gruelle cartoons appeared in a very different sort of magazine; one called *Judge.* Entitled "Bird's-Eye-View of Chicago During the Convention," it was a busy, full-page drawing, chockablock with hand-drawn storefronts festooned with humorous names, and as many little figures as perspective would allow squeezed into the space. This cartoon would inaugurate a long and lasting relationship between Johnny Gruelle and *Judge.*

Founded in 1881 by a dissatisfied *Puck* cartoonist, James Wales, *Judge* had become known as a highbrow humor weekly, featuring its own brand of social satire, amusing verse, and droll cartoons. Among its regular contributors were (or would be) writers Bertha M. Coombs, J. N. Stewart, and N. C. Bleecker; and artists James Montgomery Flagg, John Randolph Bray, and Grant Hamilton. It was a perfect outlet for Gruelle's satirical cartoon commentary.

By 1913, Gruelle's name would be listed prominently among *Judge's* regular contributors. Following a fifteen-month hiatus (in which, oddly enough, none of his work appeared in the magazine) in spring of 1915, his cartoons began appearing once again, and quite regularly. During the elapsed time, Gruelle's full-page cartoons seemed to have become more stylized, and his themes, even more satirical than before.

In these cartoons, Johnny featured gaggles of whimsical men, women, and critters, whose cacophonous activities were usually tied to a single theme—most often a humorous look at an actual (or mythical) event or locale. As more and more of these cartoons appeared, *Judge's* readers began associating the name John Gruelle with this very distinctive type of cartoon: the satirical "bird's-eye-view." (See illustrated sidebar.)

By spring of 1915, Gruelle would inaugurate a series of bird's-eye-views whose action was centered at a crossroads he dubbed "Yapp's Crossing." On the countrified storefronts and backfiring jalopies of this mythical junction, Gruelle began incorporating names of friends, acquaintances, as well as local and national dignitaries.

In his "Yapp's Crossing" pages Gruelle took on both the rich and the modestly endowed, the young

"Young Timmy Toodles never thought that he could learn to fly, until he met a queer old man who told him he should *try.* 'Just put this pebble in your mouth and give your foot a pound,' said Queer Old Man. So Timmy did, and rose up from the ground."

—John B. Gruelle
"The Travels of Timmy Toodles"
1914

and the old, the famous and the anonymous. Neither bohemian artists nor pompous socialites were safe from his ribbing and gentle wit. Gruelle's friends loved seeing their names in print, and a growing number of *Judge* readers would, each week, turn straightaway to the "Yapp's Crossing" page, to search for their own names, or the name of someone they knew.

By 1918, Gruelle would earn the status of "contributing editor" at *Judge*, his cartoons enjoying numerous reprintings in *Judge* annuals, and in such compilations as Sis Hopkin's *The Magazine of Fun*. By spring of 1919, Gruelle would have earned local and national notoriety with "Yapp's Crossing." His attendance in spring of that year at a local costume party, dressed as a ragamuffin character out of his "Yapp's Crossing," would be written up in his hometown paper—Gruelle's small linen cap tied under the chin, outsize coat, and short pants and green stockings making him the hit of the party.

A dozen or more of Gruelle's "Yapp's Crossing's" would run annually in *Judge* until the fall of 1923. Gruelle's ongoing connection with *Judge* enabled him to sustain a link with the world of satire at the same time that he worked at establishing himself as a children's illustrator and author. For Gruelle, it was important not to lose the audience he had developed during his years as a political cartoonist. "Yapp's Crossing" became a vital outlet for his adult humor and commentary, and *Judge* served well as his conduit to a more sophisticated readership.

Not suprisingly, Gruelle's adult cartoons and his work for children were not a complete separation of outlooks. "Yapp's Crossing," though satirical, was also gentle and whimsical; by the same token, Gruelle's illustrated fairy stories often contained subliminal threads of satire aimed at the parents who would usually do the reading aloud.

With sometimes as many as three or four different kinds of commissions to fulfill at once, Gruelle

A BIRD'S-EYE-VIEW OF THE WORLD

The bird's-eye-view cartoons for which Johnny Gruelle would become known were not his own invention. Other cartoonists before Gruelle's time had employed the selfsame format—one which imparted the perspective of being suspended high in the air, looking down over a landscape (a crossroads, a neighborhood, sometimes a building cutaway) to observe the humorous doings of dozens of characters. This wide-angle vantage point allowed for the presentation of several simultaneous storylines or gags.

Gruelle had first experimented with bird's-eye-views as early as 1904, while at *The Indianapolis Star*; later at *The Cleveland Press*, he had adapted it for several of his comics. While working for *Judge*, Gruelle would refine the format, adding to it so many original touches that, in a few years' time, many *Judge* readers came to associate the format with Gruelle.

In his bird's-eye-view cartoons for *Judge*, and later for other humor magazines, Gruelle took on subjects of current or topical interest that would appeal to highbrow readers, but safely couched his sometimes biting

commentary in whimsical drawings depicting downhome, provincial, unthreatening slices of life.

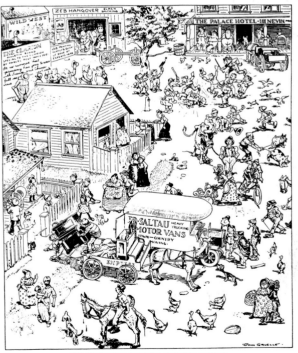

THE NEW FAMILY MOVES IN AT YAPP'S CROSSING

On May 29, 1915 this full-page bird's-eye-view by Gruelle appeared in Judge, *featuring a moving van emblazoned with his friend Ed Soltau's name, inadvertently or purposely misspelled "Saltau."*

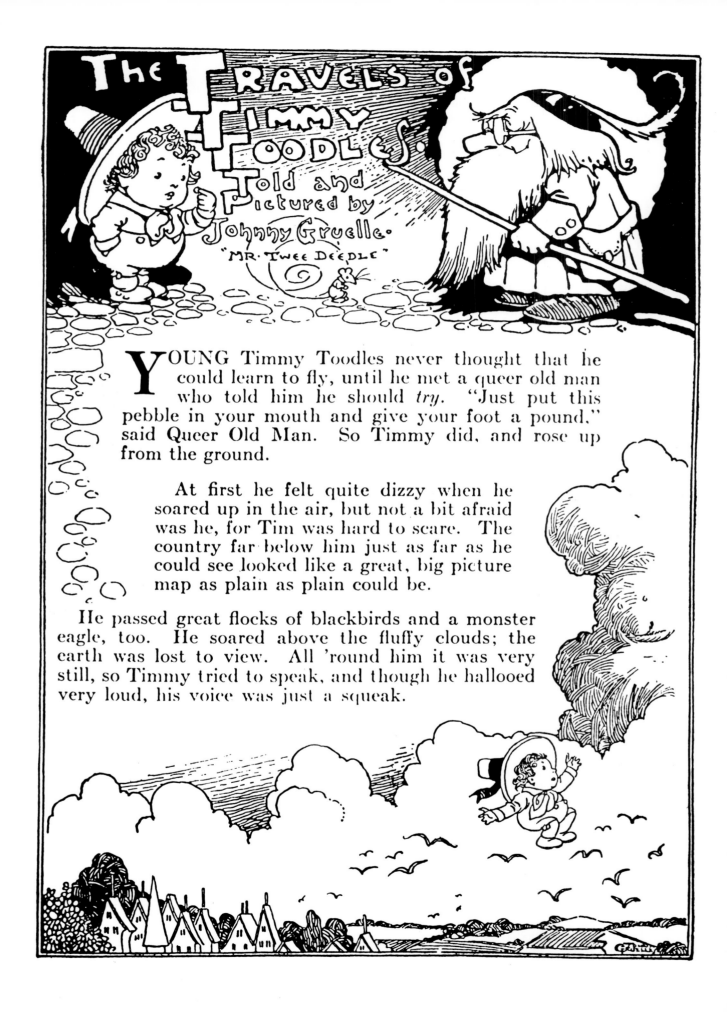

The Travels of Timmy Toodles.

Told and Pictured by Johnny Gruelle.
"Mr. Twee Deedle"

YOUNG Timmy Toodles never thought that he could learn to fly, until he met a queer old man who told him he should *try*. "Just put this pebble in your mouth and give your foot a pound," said Queer Old Man. So Timmy did, and rose up from the ground.

At first he felt quite dizzy when he soared up in the air, but not a bit afraid was he, for Tim was hard to scare. The country far below him just as far as he could see looked like a great, big picture map as plain as plain could be.

He passed great flocks of blackbirds and a monster eagle, too. He soared above the fluffy clouds; the earth was lost to view. All 'round him it was very still, so Timmy tried to speak, and though he hallooed very loud, his voice was just a squeak.

In 1916, John Martin's House published this thirty-page book that reprinted all six episodes of Gruelle's "Timmy Toodles" stories, and which Gruelle dedicated to his two children, Marcella and Worth. (Courtesy Brown University Library)

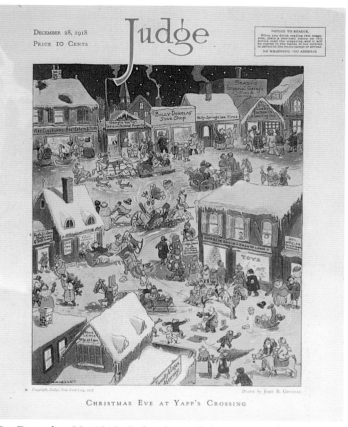

On December 28, 1918, Judge featured this "Yapp's Crossing" cartoon on its cover.

needed to move quickly from "Mr. Twee Deedle" to "Yapp's Crossing," then on to his illustrated fairy stories. He grew proficient at making these transitions with little loss of momentum.

Gruelle's productivity (and his ability to move smoothly from one kind of work to another) was, no doubt, aided by self-taught powers of concentration. A believer in a higher source for his inspirations, Gruelle would often take time, before beginning work or in between commissions, to meditate quietly, tapping his own inner creative reserves, and clearing the spiritual channel through which he believed his inspirations flowed. Other times Gruelle's

meditation took a different form: pounding out a few tunes on the family piano, or taking a quiet walk in the woods just outside his door. During these times, his mind would open and ideas would come.

Gruelle had grown to love the Silvermine countryside, not only as a source of repose and inspiration, but also as a getaway. Often to reward himself after a day's work, or as a momentary escape from a full-to-groaning drawing board, he would venture into the woods, arriving unannounced at the back door of his friend, Cliff Meek, and barking out an invitation to go fishing.

Ever watchful over her husband's career, Myrtle was determined that Johnny's forays into the Silvermine woods not interfere with his growing number of

AT LEFT:
Gruelle's "The Travels of Timmy Toodles" (appearing in John Martin's Book beginning in January 1914) was a serial in rhymed couplets, in which the quixotic little Timmy and his sidekick, Pony, pursued their adventures.

deadlines. But she also understood that the forest was where Johnny felt most closely in touch with his muses, and knew that once he sat down at his drawing board, he would often work long into the night. So, instead of standing in his way when the urge to escape overtook her husband, Myrtle would usually let him go—waiting, then luring him back to his studio, where, refreshed and restored, he would magically transform his ideas and inspirations into the writings and illustrations that, she knew, would someday make him famous.

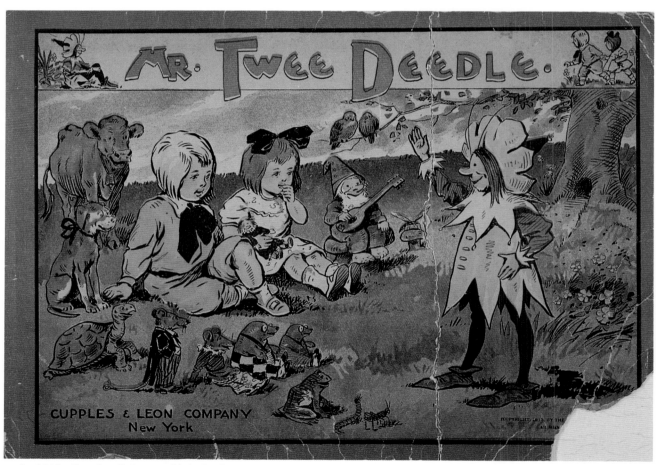

In 1913, Cupples & Leon published a board-cover compilation of eight of Johnny Gruelle's "Mr. Twee Deedle" pages. (Courtesy Homer Babbidge Library, University of Connecticut)

CHAPTER NINE

Grimm's Fairy Tales and Nobody's Boy: Johnny Gruelle and Cupples & Leon

Dedicated to the Nicest Child in the Whole World

JOHN B. GRUELLE

The year was 1913. In New York, the city to which Johnny Gruelle now commuted regularly, automobiles filled the streets and subways rumbled beneath them. Magazine ads touted new, electrical labor-saving devices. Thousands of farm families from outlying areas were migrating into the City in hopes of finding work. Thousands more—immigrants from the Old World—were coming into New York each week, to forge a future in this new land of opportunity. Signs of industrial, technological, and social change were everywhere, and everything seemed energized in this metropolis that teemed with businessmen and artists; industrialists and workers; fathers, mothers, and children, all after their piece of the American Dream.

During his train rides into New York City, Johnny Gruelle spent his time reading the newspaper, pondering current events, and plotting how he might cash in on this electrified state of affairs. With mul-

tiple commissions to his name and a reputation to trade on, Gruelle felt ready to seek his fortune in a bigger, more lucrative arena: the world of books.

Compared to the ephemeral and disposable newspapers and magazines, books were, by far, a more permanent and satisfying illustrating medium. And books were enjoying a popularity they had never known before.

Advances in printing technology, increases in literacy (resulting from compulsory public education), and improvements in home lighting had made the reading of books an affordable and accessible home-based family pastime, even during the dark evening hours. Since the late nineteenth century, juvenile books had evolved from merely textbooks to being a form of popular entertainment. Parents still expected books to offer their children some kind of uplifting message, but unlike before, these messages seemed to be presented more cheerfully. Popular children's

THE HUT IN THE FOREST.

BROTHER AND SISTER.

Gruelle's dozen colorplate illustrations for Grimm's Fairy Tales *glowed with the same gold-and-violet tones found in many of R.B. Gruelle's paintings.*

books featured normal, healthy child protagonists who might sometimes behave in a less-than-model fashion.

The advent of improved halftone engraving and color printing had, by this time, revolutionized the technology of book illustrating, resulting in volumes filled with sharply reproduced line drawings and well-registered colorplates. Gruelle studied these books, especially their illustrations, internalizing elements of style and form. Many were books of folk- and fairy tales; among his favorites (he later professed) were ones illustrated by Arthur Rackham. Gruelle had already begun plotting what he might do to secure such a book illustrating commission, when his own friendly sprite, Mr. Twee Deedle, once again provided just the entrée Gruelle had been seeking.

In June 1913, the New York-based Cupples & Leon Company had issued, through arrangement with *The New York Herald,* a selection of Gruelle's "Mr. Twee Deedle" pages, bound in boards and entitled *Mr. Twee Deedle.* Though only a reprint of existing material, the book was significant because it had brought Gruelle's work to the attention of a publishing house.

Founded in 1902, by Victor Cupples (a veteran of the Houghton Mifflin Co.) and Arthur T. Leon (formerly with Laird & Lee Publishers), Cupples & Leon Company specialized in juvenile series books, dictionaries, and flexible board-cover comic strip reprints like *Mr. Twee Deedle.* Like many publishers of the time, Cupples & Leon sought to set itself apart from the purveyors of the more pulpy children's adventure books.

With *Mr. Twee Deedle* standing as a testament to Gruelle's artistic aptitude, it was not long before Victor Cupples and Arthur Leon offered Johnny his first book-illustrating commission. As it turned out, it was an assignment after Gruelle's heart: a cloth-bound edition of the fairy tales of the Brothers Grimm. Gruelle's facility with both pen-and-ink and

"When you see our name, Cupples & Leon Company, printed on a book, you can rest assured that it is a fit book for them in every way, that the reading matter is clean, interesting, inspiring, and educational."

—Cupples & Leon Company
Message to Parents

watercolor, and his familiarity with European folk-tales, made him the perfect choice as the book's illustrator.

When *Grimm's Fairy Tales* was finally published in 1914, it was an impressive volume. Accompanying the 200 tales and 10 "Children's Legends" (translated from the German by Margaret Hunt) were Gruelle's dozen colorplates—rich, incandescent watercolors depicting velvet-clad princesses, exotic Nubians, scowling commonfolk, and skulking ogres, each evoking the European flavor of the Grimms' tales. More than fifty of Gruelle's crisp pen-and-inks were interspersed throughout the text. These were meticulous renditions, and Gruelle used them to appeal to his modern readers, bestowing on the forests, roads, and other locales unmistakable American place-names.

This first big book-illustrating commission with a New York publisher, his other commissions, and the hope of more work soon convinced Gruelle that he needed a regular workspace in New York City. So, in fall of 1914, he rented an apartment at 210 West 108th Street, in the heart of New York's Upper West Side. There he would sometimes work all night to meet several simultaneous deadlines, and following a quick bath at dawn, deliver his commissions. When many deadlines pressed, he would stay there for a week or more at a time before returning to Silvermine. Eventually, Johnny was in New York so much that he sent for his young family to come live with him.

The Gruelles had no sooner gotten settled in the New York apartment than Johnny's father, R.B., became seriously ill. Several summers before, in 1912, the sixty-one-year-old artist had suffered a stroke that paralyzed his entire right side. Homesick for his native Midwest, R.B. had departed Silvermine, returning with his wife to Indianapolis.

Though determined not to let his paralysis keep him from his easel, by fall of 1914, R.B.'s physical condition had deteriorated. In early November, Johnny took leave from his rigorous schedule to join the rest of the Gruelle family at his father's bedside, where they were gathered when the elder Gruelle passed away in the early morning hours of November 8, at the home of his mother-in-law, Rachel Benton. R.B. Gruelle was buried at Crown Hill Cemetery in Indianapolis. Though R.B.'s life and work would be

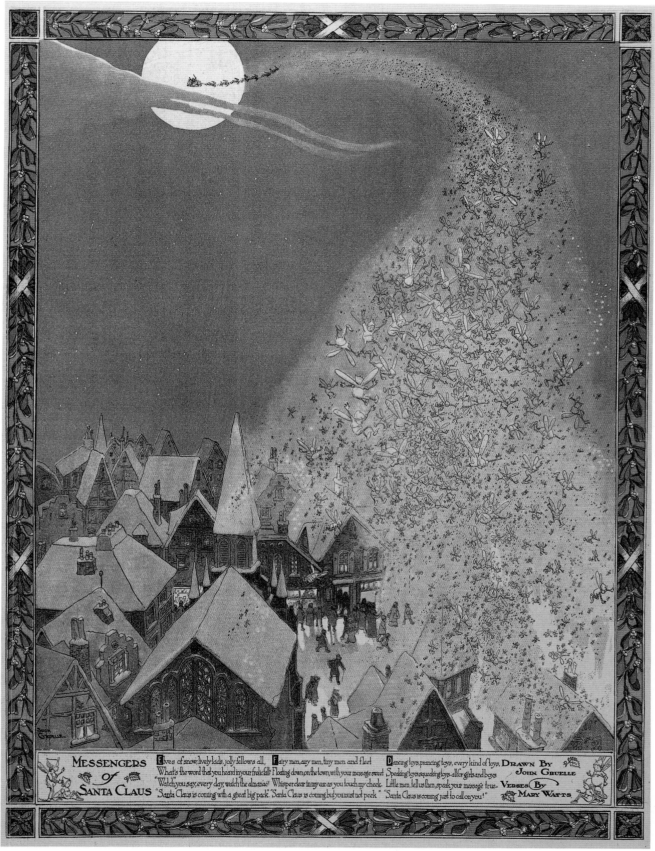

In December 1914, Gruelle rendered this resplendent, full-page holiday greeting for The New York Herald.

For Nobody's Boy, *Gruelle supplied three colorplates, plus an oval-shaped cover label.*

lauded in many eloquent obituaries, Myrtle Gruelle perhaps expressed best the personal loss so many felt at his passing. "He was," she would write, "my finest friend."

Disconsolate at his father's death, Johnny returned to New York City, where, attempting to lay aside his grief, he picked up again with his work, which included several new commissions for Cupples & Leon. One of these was to provide several color illustrations for an English translation of the French children's classic, *Sans Famille.* Written by Hector Malot, and translated from the French by Florence Crewe-Jones, the book was entitled *Nobody's Boy* and told the story of Remi, a plucky, homeless orphan. Cupples & Leon published the 372-page *Nobody's Boy* in 1916.

Gruelle's watercolors for *Nobody's Boy* were formal and appropriately European-flavored, echoing the style and colorations so favored by his late father, R.B. Each was an impressionistic, haunting glimpse of the orphan, Remi, and his counterparts.

Gruelle's next commission for Cupples & Leon would be a very different kind of assignment: to illustrate six books in the company's "All About" series of fairy story and nursery rhyme books. During the next few years, Gruelle would also supply Cupples & Leon with other artwork, including a watercolor used as a cover for an abridged edition of fairy tales.

Though Gruelle occasionally expressed concern that Cupples & Leon's printing technolgy did not do justice to his original artwork, his illustrations were rich, fanciful accompaniments, full of the craggy good fellows, comely princesses, and frightful witches that would reappear in his later books. Representative of a broad stylistic range, Gruelle's Cupples & Leon work showcased to what extent the young artist could stretch his abilities to embrace several very different illustrating assignments.

By 1915, Johnny Gruelle was pleased at his acceptance as a comic artist, satirical cartoonist, fairy-story author, and illustrator—for newspapers, magazines, and books. Within each of these media, Gruelle had successfully found a niche. Though innately talented, he had worked hard to achieve the versatility that he knew was his key to successful free-lancing. And ever mindful of the dangers of being pigeonholed according to medium, Gruelle was already presenting himself in a broader way: as one

Beginning in 1916, Cupples & Leon commissioned Johnny Gruelle to provide cover and interior illustrations (and in some cases, "retellings") for their "All About" series of small, illustrated fairy tale and nursery rhyme books for young children.

"The wicked step sisters were so sorry over the way they treated Cinderella that they decided to give their wealth to the poor and live in a cottage."

—*All About Cinderella*
Illustrated and retold by Johnny Gruelle
1916

whose business was, quite simply, to entertain the public.

However, what might have continued as a pleasant, steady period of growth and acclaim for the ambitious free-lancer became, all at once, bitterly blighted. In the midst of well-deserved success, Johnny Gruelle would be struck by a devastating loss.

In December 1918, Cupples & Leon published this fairy-tale volume, with a cover by Johnny Gruelle. (Courtesy Crain Collection)

CHAPTER TEN

Through the Door:
Marcella Gruelle

She came into our lives, loaned to us, gave us her love . . .

MYRTLE GRUELLE

One afternoon, in 1915, Marcella Gruelle came home from the New York City school she was attending and announced to her mother that she had to be vaccinated.

Though controversy raged over the still-evolving innovation of vaccination (whether its risks outweighed risks of the disease it was intended to prevent), the threat of epidemic illness prompted school health officials to embrace mass inoculations. When schools decided to vaccinate, parents were often pressured into giving permission. Reluctantly, Myrtle Gruelle gave hers.

The next day, Marcella lined up with several other children and was given the required vaccination. Days passed, and it became apparent that hers had not "taken." Myrtle and Johnny took it as a sign that their healthy daughter was immune to the vaccine. So, they were horrified when Marcella came home several days later, claiming that the school nurse had given her a second vaccination—this time, with neither of the Gruelles' permission. Ten days later, Marcella complained of pains in her legs. "She had to

stop school," Myrtle would later recount. "Doctors were called. She had been poisoned."

Weeks passed, and Marcella's condition seemed only to worsen. Eventually Johnny and Myrtle admitted her to a New York hospital, and enlisted a team of doctors. But none could give her back her health. Chagrined at their daughter's condition, but hopeful that fresh country air might be recuperative, the Gruelles decided to leave New York City. With his daughter in his arms, and his somber wife at his side, Johnny Gruelle returned to his home in Silvermine.

The family hired a nurse, who, together with Johnny and Myrtle, attended to Marcella around the clock. So that they could be closer to their daughter during the day, the Gruelles furnished a small room

"It all seemed so unnecessary and beyond understanding."

—Johnny Gruelle

Marcella Gruelle, 1905. (Courtesy Worth and Sue Gruelle)

on the first floor of their spacious home. Here, Marcella spent her days, and many of her nights, lying in a small bed, sleeping fitfully, delerious with fever.

As she went about her day-to-day housekeeping chores, Myrtle did her best to foster a positive, healing atmosphere. Johnny reached deep within himself for the spiritual strength to cope with his daughter's decline. He all but lost his usual enthusiasm for work. Only with his wife's encouragement could he force himself to complete the commissions that provided the family livelihood.

Johnny spent as much time as he could at Marcella's bedside, reading aloud stories he had written. Other times, he would simply make up tales, hoping to lift his little girl's spirits by incorporating her own dolls and toys as characters.

Word of Marcella's grave condition traveled fast within the close-knit Silvermine community. Encouraged by her mother, fourteen-year-old Monica

Borglum occasionally visited Marcella. "She was as pale as the sheets she lay on," Monica later recalled. "It hurt me to see her like that – but I went anyway."

Despite medical attention, and the abundant love and prayers of family and friends, on November 8, 1915, Marcella Gruelle, after months of battling her illness, finally succumbed. Upstairs in Johnny's studio, cradled in her father's arms, she lay quietly and closed her eyes for the final time. "In sweet small smiles and whispers, she talked to someone, and we felt loved ones were near," her mother would later write. The young girl who had brought such gaiety and laughter into the lives of her family—Johnny's little Muggins—had lived barely three months past her thirteenth birthday.

Still in shock, the Gruelles turned to the grim but necessary rituals of death. Funeral services for Marcella were held at the Gruelles' home in Silvermine at 3:30 P.M. on November 10, the Reverend Louis B.

THE VACCINATION

In May of 1921, more than four years after Marcella's death, Gruelle's long association with a magazine called *Physical Culture* would come to an abrupt end, when a well-intentioned request to illustrate a piece entitled "Vaccination Killed My Two Sisters" drew a terse response from Gruelle. He provided the requested cartoon, shown here, along with the accompanying letter. The assignment would be Gruelle's last for the magazine.

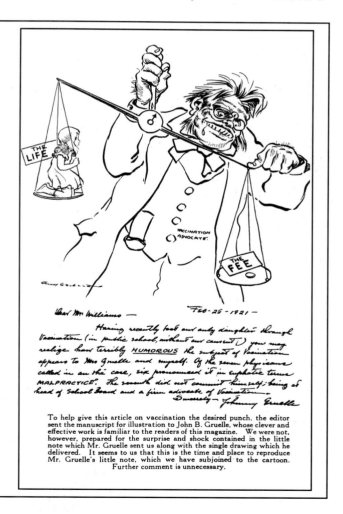

To help give this article on vaccination the desired punch, the editor sent the manuscript for illustration to John B. Gruelle, whose clever and effective work is familiar to the readers of this magazine. We were not, however, prepared for the surprise and shock contained in the little note which Mr. Gruelle sent us along with the single drawing which he delivered. It seems to us that this is the time and place to reproduce Mr. Gruelle's little note, which we have subjoined to the cartoon. Further comment is unnecessary.

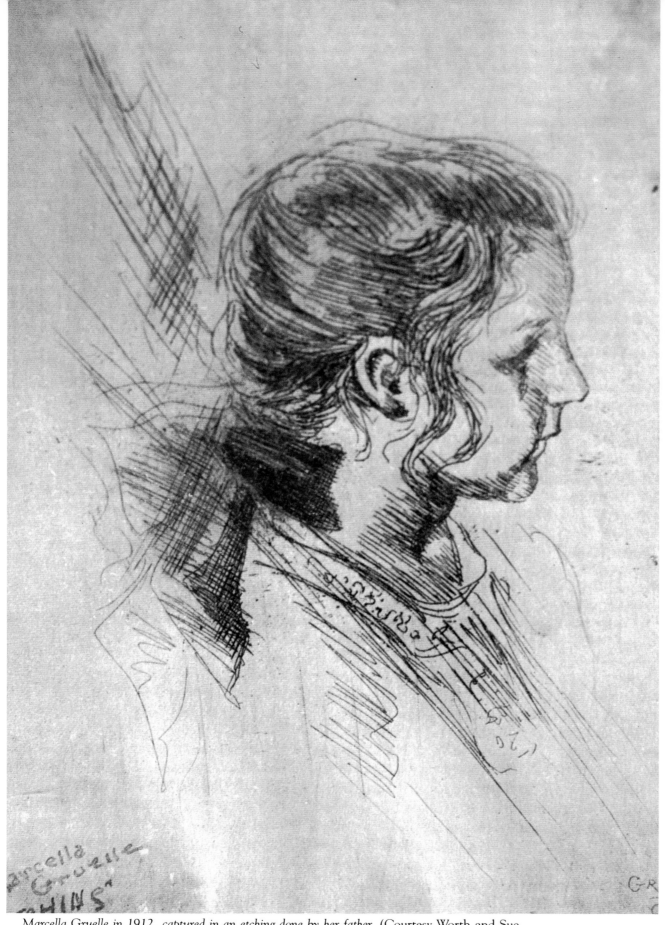

Marcella Gruelle in 1912, captured in an etching done by her father. (Courtesy Worth and Sue Gruelle)

Marcella's tragic death was acknowledged in several announcements in the Norwalk Hour.

Howell officiating. Following the brief ceremony, attended by family and scores of friends, Marcella Delight Gruelle was laid to rest in the small Silvermine Cemetery.

Though Myrtle and Johnny Gruelle staunchly maintained that a bad vaccination had killed their daughter, Marcella's death certificate, prepared the day after she died, cited valvular heart disease of sev-

eral years' duration as the cause of death. The secondary/contributory cause listed was oedema, with a duration of about ninety days. Nowhere on the certificate was a vaccination or an infected vaccination implicated as a cause of death.

However, valvular heart disease is a condition that, especially without antibiotics, can turn fatal if a bacterial infection ever takes hold. The heart itself becomes infected and inflamed, eventually going into cardiac arrest. Though difficult to prove, a dirty vaccination needle or contaminated serum was the most likely cause of the infectious illness that had proven fatal for the Gruelles' little daughter.

Johnny tried desperately to comprehend his daughter's death. But it was as though a frigid wind had blown across his heart, and his usually straight posture bent under the cold load of his grief. In public, Myrtle Gruelle bore the loss of Marcella stoically, but went often to the edge of the Silvermine River where she could be alone, to mourn in private. Around their three-year-old son the Gruelles tried to disguise their sadness. But little Worth was very

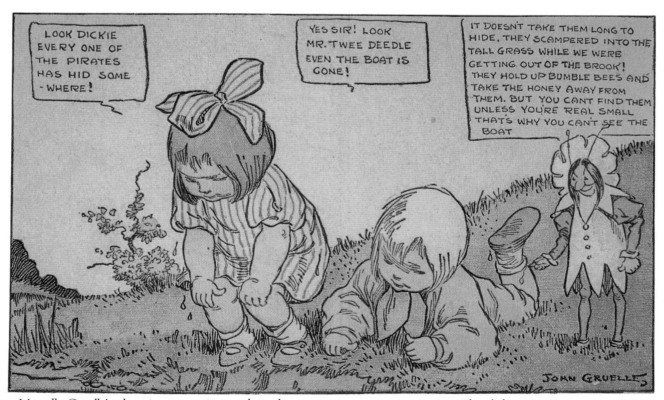

Marcella Gruelle's charming mannerisms and angelic appearance were an inspiration to her father, who occasionally patterned the features of both Dickie and Dolly in "Mr. Twee Deedle" after his young daughter's.

aware of his parents' devastating loss, and had night-mares for months after his sister died. It would be years before the family's memories of Marcella's twinkling eyes and ruddy cheeks would bring plea-sure, rather than pain.

In their sorrow, Myrtle and Johnny let go of many tangible things they associated with their daughter. Monica Borglum Davies still vividly recalls the day, not long after Marcella died, when Myrtle offered to give her a drawerful of Marcella's hair ribbons. "I don't remember just how I got out of accepting them, but I politely told Mrs. Gruelle, no,' " Davies remembered. "There was just too much of Marcella in them."

With a heavy heart, Johnny eventually returned to his drawing board, picking up his commissions where he had left off. It was during those days fol-lowing Marcella's death that a story, about Johnny, began taking shape, told by and circulated among those who knew him; a story that, in its multiple re-tellings, progressively took on all the qualities of a legend.

According to friends who visited Gruelle during this time, Johnny was keeping in his studio a single, tangible reminder of his daughter, one of the few that he could bear to have near. This memento, made so many years before by Alice Gruelle, had been adopted and held and loved by Marcella as her very own.

According to the accounts, when all else would fail, it was this plaything—a floppy, tattered little rag doll, with a crooked smile and scraggly hair—that seemed to give Johnny Gruelle consolation and inspiration, as he worked to lift himself out of a pool of incredible sorrow.

"I always felt that, had she matured, Marcella would have been another creator in the fields of art and music."

—Justin Gruelle

CHAPTER ELEVEN

Good Books for Kindly Children: Johnny Gruelle and the P. F. Volland Company

Books for children should contain nothing to cause fright, suggest fear, glorify mischief, extenuate malice or condone cruelty. That is why they are called "books good for children."

P. F. VOLLAND COMPANY IDEAL

Following Marcella's funeral, Myrtle and Johnny Gruelle went back to New York City, where they remained for several months, returning to Silvermine only for weekends and to spend a quiet Christmas with family. Eventually, they sold their house by the Silvermine River—a home so lovingly conceived only several years before, but now so unbearably full of memories of their daughter.

By 1916, the Gruelles had moved into nearby Norwalk, a small industrial town known for its hat manufacturing. Their new home, a spacious Victorian house at 2 Union Park, was big enough for Myrtle's parents to continue living with the family and close enough to the school that little Worth would soon begin attending.

To help dull his heartache, Gruelle immersed himself in his work. His story-writing and illustrating serving as rituals of recovery, Gruelle continued

turning out his weekly installments of "Mr. Twee Deedle" (reinstated after the cancellation that was likely due to his inability to work during Marcella's illness and subsequent death), "Yapp's Crossing" cartoons for *Judge,* some commissions for *John Martin's Book,* and several more books for the Cupples & Leon Company. In the midst of this already heavy workload, Gruelle also turned his attention back to some business, initiated during the months before Marcella had become ill.

Nearly a year before, Gruelle had crafted a set of full-color illustrations for a book of children's stories. Written by Rose Strong Hubbell (children's author and playwright, and the wife of Silvermine portrait artist Henry Salem Hubbell), the stories-in-verse told of whimsical toy ducks called Quacky Doodles and Danny Daddles. The Hubbell-Gruelle "Quacky Doodles" manuscript had been accepted by the P. F.

DESIGN.

J. B. GRUELLE.

TOY DUCK.

APPLICATION FILED MAY 28, 1915

47,787.

Patented Sept. 7, 1915.

Fig. 2. *Fig. 1.*

INVENTOR

John B. Gruelle

BY

~~Emery Booth~~ Janney & Varney

~~by his~~ ATTORNEYS

On September 7, 1915, Gruelle was granted design patents for toy ducks to be named *Quacky Doodles* and *Danny Daddles.* (U.S. Patent Office)

UNITED STATES PATENT OFFICE.

JOHN B. GRUELLE, OF NEW YORK, N. Y.

DESIGN FOR A TOY DUCK.

47,787. Specification for Design. Patented Sept. 7, 1915.

Application filed May 28, 1915. Serial No. 31,071. Term of patent 14 years.

To all whom it may concern:

Be it known that I, JOHN B. GRUELLE, a citizen of the United States, residing at New York, in the county of New York and State of New York, have invented a new, original, and ornamental Design for a Toy Duck, of which the following is a specification, reference being had to the accompanying drawings, forming part thereof.

Figures 1 and 2 are front and side elevations respectively of a toy duck, showing my new design.

I claim:

The ornamental design for a toy duck, as shown.

JOHN B. GRUELLE.

Copies of this patent may be obtained for five cents each, by addressing the "Commissioner of Patents, Washington, D. C."

DESIGN.

J. B. GRUELLE.
TOY DUCK.
APPLICATION FILED MAY 28, 1915.

47,788.

Patented Sept. 7, 1915.

Fig.1 *Fig. 2*

INVENTOR

John B. Gruelle

BY

Emery Booth Janney & Varney

ATTORNEY

UNITED STATES PATENT OFFICE.

JOHN B. GRUELLE, OF NEW YORK, N. Y.

DESIGN FOR A TOY DUCK.

47,788. Specification for Design. Patented Sept. 7, 1915.

Application filed May 28, 1915. Serial No. 31,072. Term of patent 14 years.

To all whom it may concern:

Be it known that I, JOHN B. GRUELLE, a citizen of the United States, residing at New York city, in the county of New York and State of New York, have invented a new, original, and ornamental Design for a Toy Duck, of which the following is a specification, reference being had to the accompanying drawings, forming part thereof.

Figures 1 and 2 are front and side elevations respectively of a toy duck, showing my new design.

I claim:

The ornamental design for a toy duck, as shown.

JOHN B. GRUELLE.

MAKE YOUR CHILDREN HAPPY
WITH
VOLLAND
BOOKS

It is the Volland ideal that books for children should contain nothing to cause fright, suggest fear, glorify mischief, extenuate malice or condone cruelty. That is why they are called "*books good for children*"

Look for this mark ⊕ in each book

The P. F. Volland Company Ideal promised to give children only the best.

Permit us, friends, with cheer to greet you;
We are very glad to meet you.
We're the nimble, jolly toys
Happy with good girls and boys.
　　　—Booklet accompanying Quacky Doodles Toys
　　　　　　　　　　　P. F. Volland Company
　　　　　　　　　　　　　　　　　1916

excellence in content, materials, and manufacturing. The Volland Company's focus on inspirational cards soon led them into the manufacture and sale of giftbooks and calendars, then eventually into the arena of children's books. For these books, Volland would enlist writers such as Elizabeth Gordon, Elizabeth Brown Kirkland, Caroline Hoffman, Olive Beaupré Miller, and Miriam Clark Potter; and illustrators such as M. T. Ross, John Rae, John Gee, and Maginel Wright Enright (Frank Lloyd Wright's sister). Like the company's cards, the Volland children's books contained uplifting and inspirational messages. To appeal to the gift buyer, Volland books came packaged in colorful presentation boxes.

The P. F. Volland Company was a regular advertiser in *John Martin's Book*, where Gruelle's illustrations and verses had been appearing for several years. This is, quite possibly, how Gruelle and officials at P. F. Volland had first become acquainted. When Volland published the whimsical *Quacky Doodles' and Danny Daddles' Book* in May of 1916, it initiated a long and profitable relationship with Johnny Gruelle; one that would span three decades.

Whether the Quacky Doodles characters (a mother duck, Quacky Doodles; a father duck, Danny Daddles; and two baby ducks) were originally Gruelle's or Hubbell's creations (and to what extent Gruelle, the consummate verse-writer, might have even helped craft the book's poems) no one can say with certainty. One thing is certain, however. The designs for Quacky Doodles and Danny Daddles were Gruelle's own.

And on May 28, 1915, Gruelle had claimed ownership of his designs, applying to the U.S. Patent Office for patents for two toy ducks. His application contained black-and-white designs, each bearing their respective names, that matched Gruelle's distinctive illustrations in the Quacky Doodles book. By September 1915, his patents approved, Gruelle

Volland Company, a Chicago-based publisher of gift- and inspirational books.

Founded in 1908, and headquartered at 58 East Washington Street in downtown Chicago, the Volland Company had grown rapidly under the leadership of its visionary president, Paul Frederick Volland. The company (which by 1917 would be incorporated and occupy a nine-acre plant) had initially specialized in inspirational greeting cards, intended to compete in the European-dominated greeting card market.

With limited capital, the German-born Volland hired the best artists he could find and insisted on

had positioned himself to do business with the Volland Company—not simply as an illustrator, but also as a toy designer.

In February of 1916 (several months before *Quacky Doodles' and Danny Daddles' Book* was published) Volland revealed its plan to market toys based on Gruelle's patented designs: ones that could be sold along with the book. That month the company placed a $692 order with the Philadelphia-based A. Schoenhut Company for wooden Quacky Doodles and Danny Daddles character toys. With this order, Schoenhut began manufacturing toy ducks to be sold under the Volland label. The wooden, fully jointed, hand-painted ducks would be made in three sizes, ranging from 5 1/2 to 12 1/2 inches: a duo called Baby Quacky Doodles and Baby Danny Daddles; a midsize duo called Miss Quacky Doodles and Danny Daddles Junior; and a large duo called Mama Quacky

Doodles and Daddy Danny Daddles. Each was an uncanny approximation of Gruelle's design patent and book illustrations.

The Schoenhut Company was an excellent choice as a jobber of the Quacky Doodles toys, upholding high standards for its own lines of wooden toy pianos, lifelike dolls, animals, and complete circus

I, Miss Quacky, am entrancing,
I am fond of mirth and dancing.

Danny Daddles Junior! Say,
I'm the boy for romp and play.

Baby Danny Daddles Glows
with happiness as his face shows,

Baby Quacky Doodles. I
never pout and never cry.

—Ad copy, **Quacky Doodles Toys**

QUACKY DOODLES AND THE SILVER SCREEN

In 1917, Johnny Gruelle's Quacky Doodles family would come before the public via another medium—the still nascent, still very silent silver screen. The Quacky Doodles would star in a set of animated cartoon shorts produced by the J. R. Bray Animation Studios of New York. Studio head John Randolph Bray (whom Gruelle would have known through their associations as cartoonists for *Judge*) was also an animation pioneer.

In all, seven Quacky Doodles cartoons were produced, each only several minutes in length. Released along with another series of Bray Pictographs, "Colonel Heeza Liar," the Quacky Doodles cartoons were patriotic little pieces, aimed at audiences energized by impending war. Though it is questionable whether Gruelle did any of the actual animation work (according to J. R. Bray, an animator named F. M. Follett animated the Quacky Doodles cartoons), the characterizations were true to Gruelle's designs and illustrations.

Bray-Paramount publicized the Quacky Doodles Pictographs, both to the industry and the public, with posters and magazine articles. Judging from the promotion and licensing efforts, all parties had been, at least initially, quite invested in the success of the Quacky Doodles family as screen stars.

LITTLE DOODLES AND QUACKY DOODLES

First story about the Quacky Doodles Family whose further adventures you can see on the screen and read about in this magazine.

IT is not every little boy or girl whose daddy could do what little Johnny Gruelle's father did for him. You see, Johnny Gruelle's father was an artist. One of those chaps whose hair is long, wears windsor tie and spats. But in spite of these deficiencies, Daddy Gruelle was a regular fellow and thought all the world—and then some—of his boy. And because his daddy thought so much of him, he devised a name that should be all his own and he called him "Little Doodles."

Little Doodles was very fond of animals and birds. He simply couldn't have enough of them about him. He acquired first, a puppy, then a kitten, a rabbit, a canary and about every other kind of pet that could be crowded into a Harlem flat—and anybody who ever lived in one of them knows that flats in Harlem were never built to hold much of a menagerie.

NOW, Little Doodles was truly fond of all his pets, but really because he was very young, he quite often forgot to feed them or to give them a drink of water, and so one and all, on such occasions, would set up that sort of outcry which old Dame Nature had equipped them with to

express their feelings when their proper provender was not promptly furnished them. And so Daddy Gruelle decided that he simply must make Little Doodles give up his pets. That, he knew, would be no easy matter. Finally, however, he hit upon a happy thought. He would take Doodles out to the country for a few weeks, get rid of the animals and birds, and when his son and heir returned he would have forgotten all about them and so, of course, not miss them.

ALL went just as Daddy Gruelle had planned, excepting that when the country home and his mother returned to the city, lo and behold, they brought with them a new-found friend in the form of the quaintest and cutest little duck that you can possibly imagine. That wasn't so bad, because one duck couldn't possibly set up such a fuss as could the combined

efforts of all of the former little pets, but sad to relate, the duck —who, by the way, Little Doodles had named "Quacky," because it "quack-quacked" all the day—was unaccustomed to the ways of flat life, and dissatisfied with the bathtub as a swimming pool in place of its luxurious pond on the farm, so it languished and died.

DEAR Little Doodles mourned for his Quacky and simply would not be comforted. And now you see how very lucky he was to have an artist for a father, for what did his daddy do but sit himself down at his drawing board and make for him, not one, but a whole family of Quackies and since they certainly were Little Doodle's very own Quackies, he called them "Quacky Doodles."

And so now they are going to appear on the screen as part of the Paramount-Bray Pictographs, and they are going to cut their funny capers where all little boys and girls may see and learn to love them, and have a hearty laugh at the expense of Quacky Doodles in the Moving Picture Theatre.

In the April 1917 issue of Picture Progress *there appeared this full-page fairy tale, "documenting" the birth of Quacky Doodles.*

Made up of separate tales of rhymed couplets, Quacky Doodles' and Danny Daddles' Book featured a mama duck named Quacky Doodles, a papa duck named Danny Daddles, and a duo of baby ducks. Another of the book's characters, Cleety the Clown (patterned by Gruelle after a slotted-foot Schoenhut circus clown), would also make appearances in some of Gruelle's later books.

sets. The movable joints of Schoenhut dolls and toys (including the Quacky Doodles family) were strung together internally, in accordance with methods patented in 1902 and 1903. By the time it began producing the Quacky Doodles for Volland, the Schoenhut Company had already built a reputation for quality toys, many based on licensed book and comic-strip characters.

Volland introduced the Quacky Doodles toys and book to the public at the same time, the book retailing for $1.00 and the various-sized toy ducks for 50 cents, $1.00, and $1.50 each. In releases sent to newspapers all over the country (including Gruelle's former employer, *The Indianapolis Star*) and in advertising circulars, the book and toys were promoted together.

From the joint advertising and matching designs, it was apparent that Volland had, from the begin-

ning, intended to market the Quacky Doodles book and toys in coordinated fashion. In fact, Quacky Doodles may have been a marketing experiment. As of 1915, the company had not yet engaged, to any great extent, in direct sales or licensing of toys depicting characters featured in its books. Gruelle's funny little ducks were among the first of many such reciprocal promotions, in which Volland intended different kinds of products, based on the same characters, to serve not only as individual sources of revenue, but also as promotional tools for each other.

Volland was by no means the first or only company to promote books and toys in tandem, or to use reciprocal marketing. But like other purveyors of gift items, Volland logically hoped that projects like the Quacky Doodles would help expand their presence in the competitive marketplace.

Eventually, the Quacky Doodles and Danny Dad-

A LONG-DISTANCE COLLABORATION: *RHYMES FOR KINDLY CHILDREN*

During the spring of 1916 (after Gruelle and the Volland Company had embarked on the Quacky Doodles venture, but most likely, before they realized their ducks would not be best sellers) Gruelle had submitted another project to the company—a set of original children's nursery rhymes. Gruelle had agreed to give an as-yet-unknown author, Ethel Fairmont, an entrée to Volland, sending her manuscript to the company along with a set of his own illustrations.

Using the pen name Fairmont Snyder, and known to her friends and family only as "Monty," Fairmont had sent Gruelle her manuscript on the advice of a friend. He, in turn, created a dummy book of illustrations and submitted the package to Volland. Gruelle would later admit to Fairmont that he and Paul Volland had eventually sat up all night together, while Gruelle produced a second set of new, simpler illustrations, quite unlike his usual artwork. Volland published the Gruelle-Snyder book in the fall of 1916, calling it *Rhymes for Kindly Children: Modern Mother Goose Jingles.*

Gruelle's cleanly drawn, unsigned illustrations for Rhymes for Kindly Children, *though departing from his usual style, contained some of his favorite colorations and character types.*

dles characters would even be licensed for use in other media; among them, as characters printed on fabric and as animated cartoons (see illustrated sidebar). However, despite Volland's efforts to promote the Quacky Doodles, history confirms that the odd little ducks did not exactly take the world by storm. During the second year of production (1917), only 30,000 ducks were produced, as compared to 100,000 the year before. A wartime economy had, no doubt, contributed to sagging production and sales.

By 1918, Volland was placing no more orders with Schoenhut for the Quacky Doodles toys, though the company would continue to advertise the wooden ducks (most likely selling off remaining inventory) until the early 1920s. Though there are no reliable figures available to document sales of *Quacky Doodles' and Danny Daddles' Book* during its few years in print, it, too, only stayed on Volland's book lists through the early 1920s. By the mid-1920s, Gruelle's frolicsome little ducks had all but disappeared from bookstores and toyshops.

However marginal their success, the Quacky Doodles book and toys held their own significance, for both Johnny Gruelle and the Volland Company. Gruelle had become increasingly interested in exploring multiple outlets for his creations, welcoming the opportunity to enter the playthings arena, whose mass-production technology made toys available to a far greater number of children than ever before. Though not documented, judging from his previous experience with the Twee Deedle dolls, it is possible that Gruelle may even have been instrumental in urging Volland to consider the Quacky Doodles toy-book combination. And, the Quacky Doodles venture would pave the way for another, similar coordinated toy-and-book promotion that Gruelle and Volland would embark upon several years later; one that would eventually stand as a landmark in the company's history.

It was not long before Johnny Gruelle submitted another project to the Volland Company—a set of verses, penned by (Ethel) Fairmont Snyder, accompanied by his own illustrations. Published as *Rhymes*

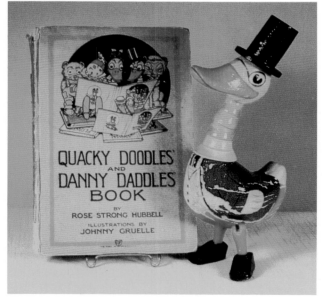

The Schoenhut Company constructed the wooden Quacky Doodles family with jointed necks made in five sections. The ducks came in three sizes, each packaged to be sold separately in its own yellow box, decorated in the same design as Gruelle's cover for the Volland book. (Courtesy Robert and Ruth Zimmerman)

for *Kindly Children* (see illustrated sidebar), the book whetted Gruelle's appetite for seeing one of his own illustrated manuscripts in print.

Eventually Paul Volland agreed to publish a volume of Gruelle's own illustrated fairy stories. Though it probably was submitted much earlier, Gruelle's book (fittingly entitled *My Very Own Fairy Stories*) began rolling off Volland's presses in October 1917. Comprising a dozen original tales, bearing titles such as "The Cheery Cricket," "The Good Finger Fairies," and "The Rubbery Dubbery Smiles," *My Very Own Fairy Stories* incorporated numerous traditional folktale themes and motifs. But, it was also apparent that the cavortings and mild mischief-making of his own children had provided Gruelle with a rich stock of more modern ideas for his prose.

Unlike the simple, precise illustrations he had created for *Rhymes for Kindly Children*, Gruelle's illustrations for *My Very Own Fairy Stories* were fluid and spontaneous, glowing with lush, freehanded detailing.

My Very Own Fairy Stories sold well, eventually going into numerous reprintings and further solidifying Gruelle's relationship with the P. F. Volland Company. Thusly established, Gruelle turned his attention back to yet another project that had occupied his thoughts, off and on, for several years. Unlike the Quacky Doodles family, this was a softer, more huggable character, whom Gruelle had tried to infuse with just the right persona before introducing her to the American public.

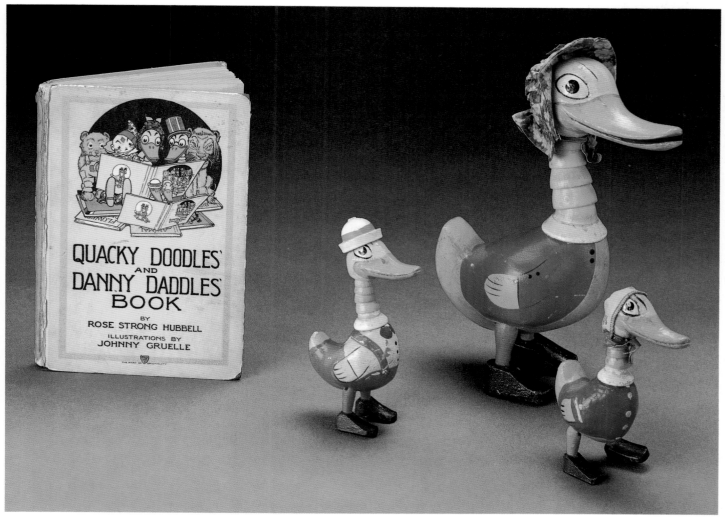

Quacky Doodles and her brood strut alongside the book that chronicled their adventures.
(Photograph by W. Jackson Goff)

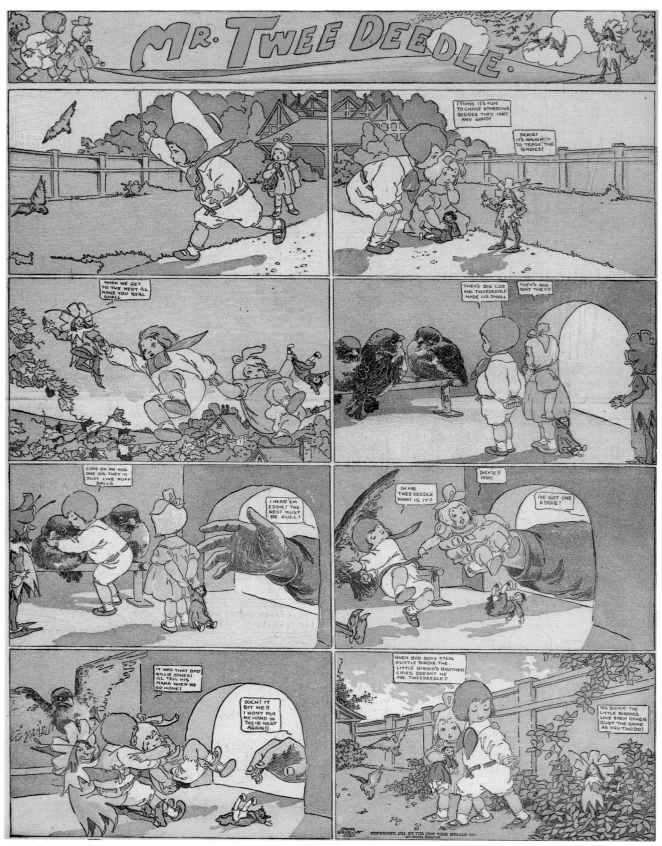

In this, Gruelle's very first "Mr. Twee Deedle" page, published in February 1911, Dolly is shown with a floppy yarn-haired rag doll, trailing from her hand.

CHAPTER TWELVE

In the Crook of a Dimpled Arm: The Raggedys Debut

. . . Who knows but that Fairyland is filled with old, lovable Rag Dolls—soft, loppy Rag Dolls who ride through all the wonders of Fairyland in the crook of dimpled arms, snuggling close to childish breasts within which beat hearts filled with eternal sunshine.

JOHNNY GRUELLE
Raggedy Ann Stories
1918

On May 28, 1915—the same day he submitted his Quacky Doodles and Danny Daddles designs—Johnny Gruelle had also submitted to the U.S. Patent Office a third design. Quite different from his two toy ducks, this one depicted front and side views of a shy-looking rag doll with out-turned hands and feet. Dressed in a plain frock, a voluminous apron, scallop-edged pantaloons, and a straw hat with flowers, the doll was charming in every way. On a small ribbon hanging from her hat Gruelle had neatly printed the name "Raggedy Ann."

Rag dolls were certainly nothing new. Throughout history, going back to the days of ancient Egypt, dolls of cloth remained among the most cherished and affordable of homemade playthings. There had been such a rag doll in Gruelle's own family, made either for or by his mother and eventually adopted by

his daughter, Marcella.

By the time Gruelle submitted his design patent for Raggedy Ann, there was already an established market for commercial cloth dolls. Izannah Walker had patented and sold some as early as 1873, and since 1891, Martha Chase had been designing and selling her own popular line; stockinet character dolls with formed faces, manufactured in a "factory" behind her home in Pawtucket, Rhode Island. Though a generic, homemade cloth doll retrieved from his mother's attic had supposedly first given Gruelle the idea for the character rag doll for which he now sought patent protection (see illustrated sidebar), his design for Raggedy Ann was quite specific, and different from the more realistic Chase dolls. Her vulnerable expression, mismatched attire, and turned-up toes were carefully calculated to bespeak humor and

DESIGN.

J. B. GRUELLE.

DOLL.

APPLICATION FILED MAY 28, 1915.

47,789.

Patented Sept. 7, 1915.

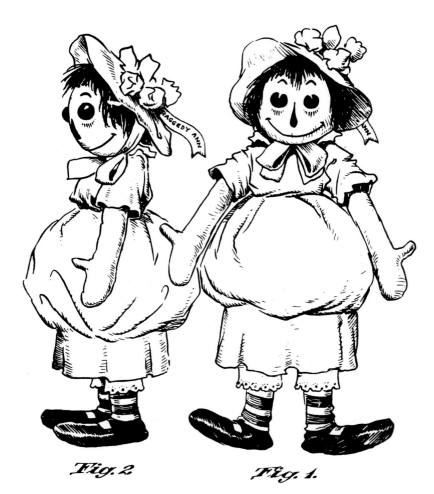

Fig. 2

Fig. 1

INVENTOR

John B. Gruelle

BY
Emery Booth January & Varney
his ATTORNEYS

UNITED STATES PATENT OFFICE.

JOHN B. GRUELLE, OF NEW YORK, N. Y.

DESIGN FOR A DOLL.

47,789. Specification for Design. **Patented Sept. 7, 1915.**

Application filed May 28, 1915. Serial No. 31,073. Term of patent 14 years.

To all whom it may concern:

Be it known that I, JOHN B. GRUELLE, a citizen of the United States, residing at New York city, in the county of New York and State of New York, have invented a new, original, and ornamental Design for a Doll, of which the following is a specification, reference being had to the accompanying drawings, forming part thereof.

Figures 1 and 2 are front and side elevations respectively of a doll, showing my new design.

I claim:

The ornamental design for a doll, as shown.

JOHN B. GRUELLE.

Johnny Gruelle's design patent for Raggedy Ann showed a doll with dark, scraggly hair; horizontally striped leggings; and funny, upturned feet, shod in black shoes with straps. With her floppy hat, ruffled pantaloons, and puffy apron, she was a comic ragbag princess. (U.S. Patent Office)

UNITED STATES PATENT OFFICE.

JOHN B. GRUELLE, OF NEW YORK, N. Y.

TRADE-MARK FOR DOLLS.

107,328.

Registered Nov. 23, 1915.

Application filed June 17, 1915. Serial No. 87,361.

STATEMENT.

To all whom it may concern:

Be it known that I, JOHN B. GRUELLE, a citizen of the United States of America, residing in New York city, New York, and doing business at No. 210 West One Hundred and Eighth street, in the borough of Manhattan of said city, have adopted for my use the trade-mark shown in the accompanying drawing, for dolls, in Class 22. Games, toys, and sporting goods.

The trade mark has been continuously used in my business since June 5th, 1915.

The trade mark is applied to the dolls by affixing a label bearing the trade mark.

JOHN B. GRUELLE.

RAGGEDY ANN

DECLARATION.

State of Connecticut county of Fairfield ss:

JOHN B. GRUELLE, being duly sworn, deposes and says; that he is the applicant named in the foregoing statement; that he believes the foregoing statement is true; that he believes himself to be the owner of the trade mark sought to be registered; that no other person, firm, corporation or association, to the best of his knowledge and belief, has the right to use said trade mark, either in the identical form or in any such near resemblance thereto as might be calculated to deceive; and that the said trade mark is used by him in commerce among the several States of the United States; that the drawing presented truly represents the trade mark sought to be registered; and that the specimens shown the trade mark as actually used upon the goods.

JOHN B. GRUELLE.

Subscribed an dsworn to before me this 9th day of June, 1915.

[L. s.] CHESTER S. SELLECK,
Notary Public.

Copies of this trade-mark may be obtained for five cents each, by addressing the "Commissioner of Patents, Washington, D. C."

Not long after applying for his Raggedy Ann design patent in 1915, Gruelle registered "Raggedy Ann" as a trademark, confirming his commercial intentions for his creation. (U.S. Patent Office)

whimsy; her distinctive open-armed stance meant to convey a beguiling warmth. Like the countrified folk who cavorted across his "Yapp's Crossing" pages, Gruelle's Raggedy Ann was a comic character with a down-home flavor; the doll was, in many ways, a three-dimensional cartoon. Having come up through the ranks as a comic artist, Gruelle knew how to create just the right mood or effect with de-

sign details. With Raggedy Ann, he had deliberately crafted a doll that was funny, appealing—and, most of all, original.

Not that Gruelle's design had not been influenced in part by his own experience and what he saw around him. Gruelle loved costume parties and attended many, sometimes dressed up as a striped-socked, country ragamuffin character much like the

doll he eventually designed. Then, there was Gruelle's lifelong fascination with clowns. About this, his brother, Justin, later wrote: "My brother . . . especially liked to get himself up as a clown. As a small boy (I was around six when Johnny was 16), I remember visits to the circus with him and his delight at some of the clown acts. When I look at the face of Raggedy Ann, I am reminded of some of the clown faces he used to transform his own face into: white skin with a wide grinning mouth."

With her teardrop nose, broad linear smile, and round stuffed face, Gruelle's Raggedy Ann design

also echoed certain characteristics of another popular, whimsical character; namely, the affable, floppy Scarecrow that illustrator W. W. Denslow had drawn for L. Frank Baum's *The Wonderful Wizard of Oz.*

Judging from his design for her, it was quite clear that with Raggedy Ann, Gruelle was after a marketable commodity. Not surprisingly, on June 17, 1915—soon after he had submitted his design patent—Gruelle also filed a trademark application for the stylized logo, "Raggedy Ann." Even more than the design patent, this trademark registration spelled out Gruelle's commercial intentions. Know-

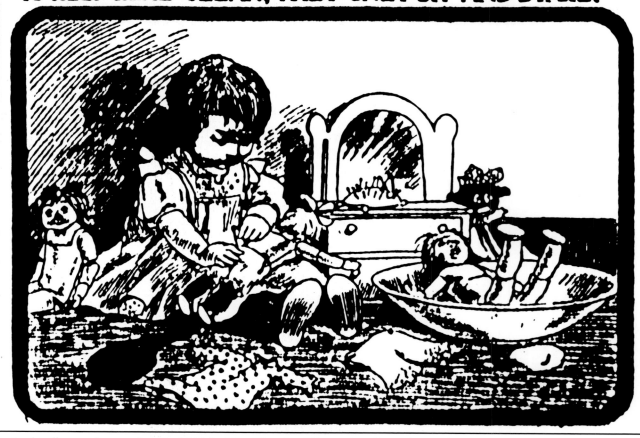

OUR LITTLE MOTHERS

I THINK SMALL CHILDREN ALL ARE SUCH A CARE.
I DRESS THEM NEAT AND BRUSH AND COMB THEIR HAIR.
I CHIDE THEM AND I SCOLD THEM
BUT EVERY TIME IVE TOLD THEM
TO KEEP REAL CLEAN, THEY ONLY SIT AND STARE.

In this illustrated verse, done in 1909 for The Cleveland Press, *Gruelle unobtrusively incorporated a doll with buttonlike eyes and a discernable triangular nose—a comic forebear to Raggedy Ann.*

ing that other artists' character dolls (Palmer Cox's Brownies, Robert Outcault's Buster Brown, and Rose O'Neill's Kewpies, to name only a few) had carved out a sizable niche in the playthings marketplace, Gruelle was now ready to cash in on his own

character—the floppy, cloth moppet he called Raggedy Ann.

Years later, Gruelle would recount the story of designing, then initiating production of his first Raggedy Ann dolls, recalling that "starting on or about

THE RAGGEDYS' ORIGINS: FACT AND FANCY

Many tales have been offered regarding the origins of Johnny Gruelle's distinctively designed "Raggedy Ann" and "Raggedy Andy." Like most legends, each Raggedy "birth" tale is a wealth of romantic details that have affixed themselves to the relatively few documentable facts.

One popular account, well liked by journalists and feature writers, places Johnny's daughter, Marcella, at the center of Raggedy Ann's beginning. The story begins (some have claimed, on an afternoon in 1914) with Marcella rushing into her father's studio, a floppy rag doll in tow. Breathlessly she tells him of finding her tattered charge in Grandmother's attic. Gruelle takes a break from his cartooning, draws a smile on the doll's faded face, and attaches two round, black buttons for eyes. Recalling two James Whitcomb Riley poems, "The Raggedy Man" and "Little Orphant Annie," Gruelle bestows the name Raggedy Ann on the doll.

Another account identifies the doll found in the attic as one made years before by Johnny's mother, Alice, for Johnny's sister, Prudence, when the family lived in Indianapolis. There, the story goes, the little doll slept, until being discovered years later, quite by accident.

In the early 1950s, Myrtle Gruelle related her own account. Speaking of a homemade rag doll made many years before in the state of Illinois (presumably for her mother-in-law, Alice Benton), Myrtle told of the doll being put away and then discovered years later by her husband while visiting R.B. and Alice in Indianapolis. According to Myrtle, when she and her husband and Marcella returned to Cleveland, they took this family rag doll home with them, dressed in new clothes.

Years later Myrtle would offer another, slightly different account: "We were young marrieds on a visit to Johnny's folks in Indianapolis. There was something he [Johnny] wanted from the attic. While he was rummaging around for it, he found an old rag doll his mother had made for his sister. He said then the doll would make a good story. "I guess he kept it in mind until we had Marcella. He remembered it when he saw her play dolls. You know how little girls are. He wrote the sto-

ries around some of the things she did. He used to get ideas from watching her."

Of all the accounts of there being a family doll, this forthright explanation by Myrtle Gruelle is probably closest to being factual.

As to Marcella's actual role in the doll's retrieval from an attic, several Gruelle family members have expressed doubt. Myrtle would claim that this oft-repeated account (also put forth in Gruelle's own introduction to *Raggedy Ann Stories*) was just part of the story as her husband had written it. And Justin Gruelle would write: "This was an excellent story to introduce Raggedy Ann to the readers, but shouldn't be taken too literally."

With his Raggedy Andy, Gruelle himself helped spawn yet another legend cycle that persists to this day. In *Raggedy Andy Stories*, Gruelle includes a fanciful chapter entitled "How Raggedy Andy Came." And, as a preface, he presented what appear to be two real letters, in which he "documented" the original Raggedy Andy being sent by a former neighbor to his own mother. As he was accustomed to doing, Gruelle probably drew on actual events and circumstances, but through embellishment made it seem as if wonderful, miraculous events, like the two original Raggedy dolls uniting, could really happen. Factual or fictional, the two letters in *Raggedy Andy Stories* ingeniously set the stage for Raggedy Andy's debut.

With fanciful accountings and well-meaning speculations far outnumbering a dwindling number of primary sources, the historian may always remain frustrated. However, the legend cycles that have grown up around the Raggedys' origins are, in many ways, as Gruelle would have liked. In creating a body of Raggedy apocrypha, Gruelle was exercising rightful literary license, perhaps not realizing how it might later complicate historical documentation of his dolls' geneses. Gruelle's own preference, it seems, was to keep the factual origins and inspirations for his rag dolls shrouded in the romantic mists of his own fanciful prose, thusly assuring for his little dolls the more make-believe, magical dossiers that he felt befitted them.

June 5, 1915, I sold these dolls in interstate commerce and from time to time therafter." Gruelle claimed to have affixed his trademark to each of the dolls, which he described as being of "a very distinctive type." Unlike the design illustration, however, these dolls had no hats. Thus by the summer of 1915—in addition to continuing his work as illustrator and author—Johnny Gruelle had, to a degree, entered the arena of plaything production.

How many of these first Raggedy Ann dolls were made, for what purpose, where, and by whom are subjects of great speculation. Furthermore, the number sold, and in what specific venues, cannot be absolutely documented either. Complicating documentation is that no one seems to be able to produce a verified example of these first dolls.

Supposedly, Gruelle's family helped fashion these inaugural Raggedy Ann dolls, either at home or in a rented loftspace (see illustrated sidebar). However,

no ads or announcements of Gruelle's Raggedy Ann doll appeared either in *Playthings* magazine, or even in Gruelle's hometown newspaper, the *Norwalk Hour*, during 1915 or 1916, indicating that production of the first Raggedy Anns was probably quite limited, with sales transacted privately (most likely in Connecticut and New York City) or on a very small scale.

Judging from the events that followed, Gruelle's purpose in producing and selling the initial batch of Raggedy Ann dolls was, first and foremost, to qualify for his trademark, securable only if he could show evidence of active use of the mark on items manufactured for sale. But, these first home-crafted Raggedy Anns would have also been useful for another reason: as prototypes or samples to interest an outside manufacturer in taking on larger-scale production of the doll.

Raggedy Ann had also begun her literary life.

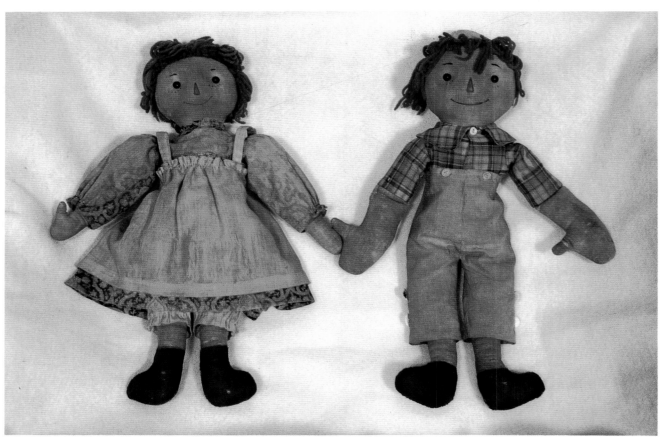

The Coral Gables Public Library currently exhibits these early Raggedys, made by the Gruelle family and presented to the library in 1968 by Myrtle Gruelle as "The Original Raggedy Ann and Andy." In 1989, the dolls underwent badly needed professional conservation. (Courtesy the Coral Gables Branch of the Miami-Dade County Library)

Myrtle Gruelle confirmed that while still living in Cleveland her husband had penned some short Raggedy Ann tales. Gruelle himself had this to say, in a newspaper interview of the 1920s: "I was in a room with fourteen other artists, and I only had to draw this one picture, and was generally through by noon. When I'd start to go out, the other artists would look at me, and I'd feel kind of ashamed and decide to stay around a while longer. So I got to doing things to take up the time—writing sketches and bum

THE FAMILY-MADE RAGGEDYS

Sometime during the teens decade, members of Johnny Gruelle's own family helped make Raggedy Ann dolls. According to Worth Gruelle some of these family-made dolls were intended originally as display props to accompany *Raggedy Ann Stories.* Worth recalls that the bulk of the family dollmaking took place in Norwalk in a downtown loftspace, complete with multiple sewing machines. There, Worth's grandmothers, aunts, and mother (under his father's watchful eye) supposedly cut and assembled dolls on which his father would hand-paint the faces.

In her papers, Myrtle Gruelle confirmed that there were, in fact, dolls made by the Gruelle family, but she did not mention a loft; rather, she indicates that it may have occurred in Silvermine, writing: "My mother and Johnny's mother had a lot to do with making up the dolls—sewing them up in her home by the river." In this instance, Myrtle may well have been recalling a different batch of dolls; namely the first Raggedy Anns, made in 1915 to secure her husband's trademark.

At least a portion of the dollmaking that has been attributed to the Gruelle family may have also occurred in 1920, when Gruelle first struck his deal with William Beers, and needed sample Raggedy Andy dolls to show the company. Gruelle family friend Lynda Oeder, then a young teenager, recalls visiting Prudence Gruelle in Norwalk in 1920 and seeing rows of unstuffed doll heads stacked up on the living room sofa, ready for stenciling. And Myrtle Gruelle would later write, "There was a lot of excitement in the Gruelle home. Grandmother Gruelle, Grandmother Swann and Momma Myrtle worked for days, trying to copy the design of the old rag doll, and then the samples were ready and in no time, in production by a doll firm in Norwalk, Connecticut."

Amid the speculation resulting from the lack of hard evidence (and the fact that in the teens and twenties, many so-called manufactured cloth dolls actually were handmade with hand-painted faces), many early Volland dolls have been mistakenly identified by collectors as being early Gruelle-made dolls, and vice versa.

Regrettably, there are precious few early Raggedy dolls remaining to study. Further complicating any attempts to date certain dolls is that even after P. F. Volland had begun selling commercially produced Raggedys, Johnny Gruelle's sister, Prudence, continued producing handmade dolls.

Two early Raggedy Ann dolls with hand-painted faces— either from among the few that were made by Johnny Gruelle and his family, or some of the very first commercial Volland dolls. (Courtesy Lynda Woodrow Graves)

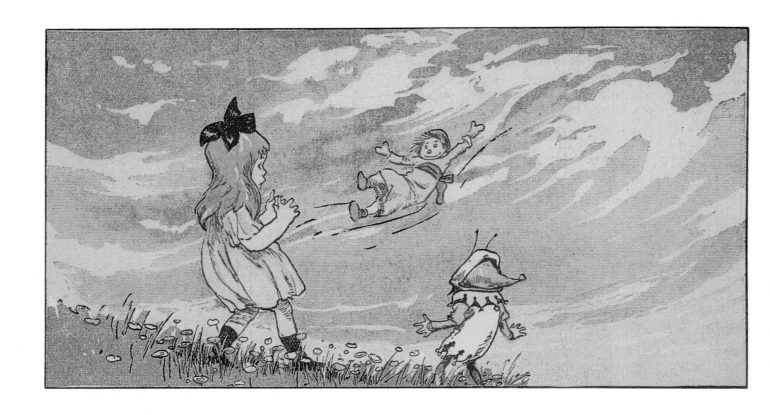

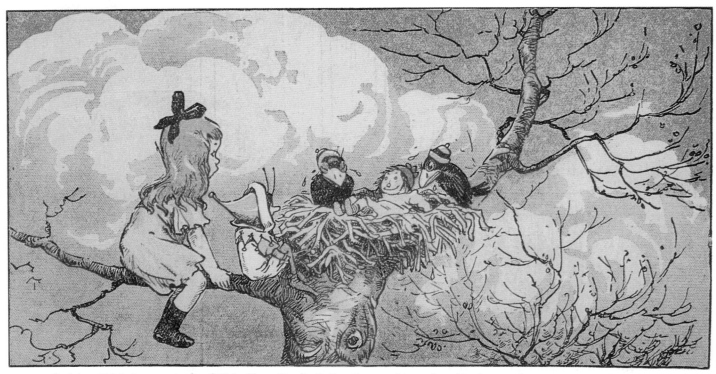

In May 1914, in an episode of "Mr. Twee Deedle," Gruelle gave his readers this closeup glimpse of the doll that Dolly called "Rags."

verses—you know the kind—and finally got to writing Raggedy Ann in verse, and making pictures for it. . . ."

Gruelle had also been experimenting for more than several years with rag doll characters in his illustrations and comic drawings. At least one had appeared in *The Cleveland Press*. And by 1911, in his "Mr. Twee Deedle" pages, Gruelle had introduced, trailing from Dolly's hand, an unmistakably Raggedy Ann-like doll on whom he would eventually bestow the name "Rags."

By 1917 (nearly two years after patenting his Raggedy Ann doll design), Johnny Gruelle would provide a clue that hinted he was already at work on at least the concept for some tales featuring dolls in a nursery—the archetypal setting that Raggedy Ann would eventually call home. Nestled among the other folktale-like stories in *My Very Own Fairy Stories* was a very different, more contemporary tale, set in the playroom of a little girl named Marcella. Entitled "Uncle Clem," the story centers on one of Gruelle's children's playthings (a costumed Steiff "Highlander" doll named after Marcella's uncle to whom the doll bore a resemblance). Though Raggedy Ann is not mentioned in this tale about dolls in a nursery, "Uncle Clem" was a pilot of sorts for the kind of stories in which Gruelle would soon introduce his new rag doll. "Uncle Clem" may well have been included by Gruelle in this, his first full book authored for the Volland Company, to convince company officials that stories about dolls in a nursery would, in fact, be embraced by a buying public.

Eventually, Gruelle approached the Volland Company about publishing an entire book of Raggedy Ann tales-in-verse. But, as he later admitted, negotiations to publish them were protracted. Supposedly, Paul Volland was not initially enthusiastic about the verse format, and perhaps with good reason—sales of *Quacky Doodles' and Danny Daddles' Book* (also a book of verses) had been less than overwhelming.

On the other hand, early sales figures for Gruelle's *My Very Own Fairy Stories* were encouraging. Furthermore, Gruelle's literary focus on the virtues of kindness, benevolence, and honesty was closely aligned with Volland's Ideal. Gruelle had also more than proven himself as a versatile artist, producing illustrations filled with charming children, fanciful toys, and helpful fairies—the stuff of which Volland books were made. Reluctant to do anything to tarnish his relationship with such a promising author and illustrator, Paul Volland purportedly accepted

RAGGEDY ANN'S CANDY HEART: REAL OR LEGENDARY?

In keeping with the winsome looks and gentle persona of Johnny Gruelle's Raggedy Ann, a special characteristic has been attributed time and again to the earliest dolls. This sweet, sugary body part, sewn deep into her stuffing, eventually came to define and embody the entire spirit of Raggedy Ann—a candy heart.

Raggedy Ann's candy heart is yet another subject of speculation. Did the first dolls really have candy hearts, or is the candy heart simply another metaphorical attribute bestowed on Raggedy Ann by Johnny Gruelle?

Worth Gruelle, a very small child at the time, claims that the first Raggedy Ann dolls made by his family had candy hearts sewn inside, adding that he was often sent to a nearby confectionery to buy them. With Johnny Gruelle's penchant for whimsy, coupled with what must have been the small production volume for any family-made dolls, placing a sugar heart into each Raggedy Ann's chest may well have been a

final, loving touch; an easy-to-accomplish, inexpensive addition, giving each Raggedy Ann a literal source for her sweet, kindly persona.

While it would have been easy, indeed, to sew a sugary goodie inside these hand-assembled dolls, no Raggedy Ann doll has survived that still possesses any signs of a sewn-in candy heart. As a result, many doll collectors remain skeptical.

The candy heart attribution may well have had its genesis in Gruelle's *Raggedy Ann Stories*, in which Gruelle tells how Raggedy Ann's sweet candy heart affects her persona and outlook, and how it fares during various kinds of mishaps, drenchings, and washings. In one of the book's tales ("Raggedy Ann's New Sisters") Gruelle closes with the original Raggedy Ann returning safely to the nursery, after being sent to a doll factory, asserting to the other dolls that her hundreds of "new sisters" each possess a candy heart, just like her own.

Gruelle's proposal to do a book of Raggedy Ann tales, provided he transform his rhyming verses into prose stories.

On September 10, 1918, just in time for the pre-Christmas selling season, the first published signatures of Gruelle's *Raggedy Ann Stories* rolled off the presses. During the remainder of September and October, the Volland Company received shipment of another 3,810 bound copies of the book.

The cornerstone premise of *Raggedy Ann Stories* was dolls and toys coming alive and enjoying a secret, magical life when humans were away or asleep. Other authors had successfully employed this kind of theme for their own storybooks; most notably, Josephine Scribner Gates (in *The Story of Live Dolls*, 1901) and Frances Hodgson Burnett (in *Racketty-Packetty House*, 1906).

Gruelle maintained that *Raggedy Ann Stories* consisted of tales he had made up to tell his daughter. "The episodes in these stories were the adventures and experiences of the doll 'Raggedy Ann' and other dolls, all of which belonged to a little girl named Marcella," Gruelle would later recount, adding, "Marcella was the name of my small daughter. . . ."

Gruelle had filled *Raggedy Ann Stories* not only with whimsical prose, but also with colorful, literal images of his little rag doll, sprawled about in various humorous poses. Though Marcella Gruelle did not live to see herself and her playthings immortalized in her father's drawings and stories, her fictional, impressionistic counterpart was kept alive, as the human "mama" to a nursery full of dolls, led by the wise and kindly Raggedy Ann.

Soon after the first boxes of the book were shipped to booksellers and department stores in the fall of 1918, it became clear to Volland officials that Johnny Gruelle's *Raggedy Ann Stories* was a success. One of Volland's top salesmen, Howard Cox, would claim years later that as soon as the book arrived at the retailers, the reorders began coming in, and, for

In his art accompanying the "Uncle Clem" chapter in My Very Own Fairy Stories, *Gruelle incorporated several Steiff dolls (probably patterned after ones his children owned), and a behatted rag doll resembling the Raggedy Ann depicted in his patent artwork.*

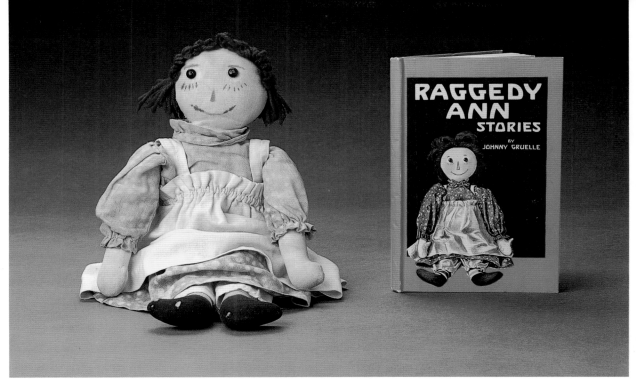

With her hand-painted face, shoe-button eyes, Mary-Jane shoes, and other handwrought detailing, this very early Raggedy Ann may have been among the first commercial dolls made as special accompaniments to Gruelle's Raggedy Ann Stories. The doll's most distinctive feature is her dress fabric, identical to the fabric design Gruelle depicted in his artwork for the cover of Raggedy Ann Stories. *(Photographs by W. Jackson Goff; used by permission of Macmillan Publishing Company)*

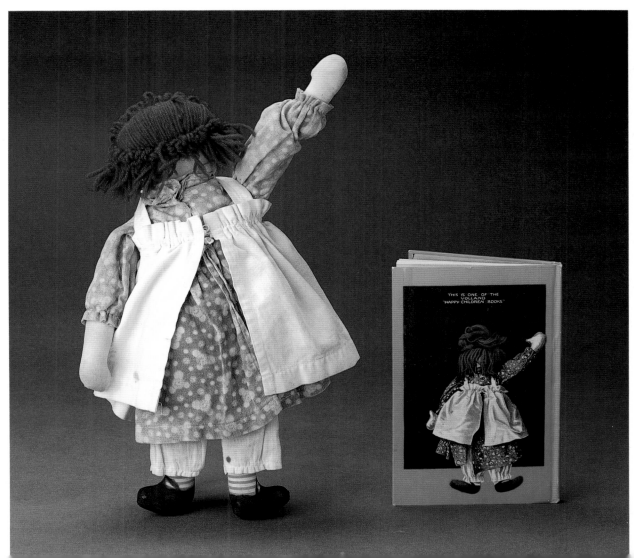

the remainder of 1918, any Chicago printer with an idle press was enlisted by Volland to print more copies of *Raggedy Ann Stories*.

The encouraging sales figures for *Raggedy Ann Stories* were also indicators of something else: that the public might, indeed, be ready for a doll depicting Gruelle's saucy yet gentle book heroine. Along these lines, Gruelle and Volland already had made preparations.

On September 6, 1918—several days before *Raggedy Ann Stories* ever rolled off the press—the P. F. Volland Company had ordered twenty-four dozen Raggedy Ann dolls from the Non-Breakable Toy Company, a Midwestern playthings manufacturer. It is possible that this small number of dolls could have been intended by Volland as display dolls, meant only to promote *Raggedy Ann Stories*. Volland regularly assisted retailers with such displays for a variety of its products. Far more likely, however, is that these dolls were the first of many commercially manufactured Raggedy Anns that Volland intended, right from the start, to sell under its own label, along with the book, just as it had done with the Quacky Doodles family.

By the time *Raggedy Ann Stories* was published, Gruelle had, in fact, granted to Volland the exclusive right to manufacture and sell, under its own label, a Raggedy Ann doll, as long as it remained the exclusive publisher of Gruelle's Raggedy Ann books. The Volland Raggedy Ann doll would be based on a *new* design of Gruelle's making—one that differed from his 1915 design patent. Gruelle later claimed to have purposefully created this new design, which ". . . was in all essential respects a representation of the *character* 'Raggedy Ann,'. . ." as he had depicted her in *Raggedy Ann Stories*. Raggedy Ann thusly entered the commercial marketplace as an item inextricably linked to Gruelle's literary and artistic depictions of her.

In the first eight months of production, the P. F. Volland Company ordered approximately 3,200 more Raggedy Ann dolls from Non-Breakable. Though it would be several more years before Raggedy Ann would be a household word, by spring of 1919, Johnny Gruelle had realized that his rag doll might become very popular. But fate threatened to topple what Gruelle and Volland had built together.

On May 5, 1919, Vera Trepagnier, a sixty-year-old Volland author and widow of a wealthy New Orleans sugar planter, burst into the Chicago offices of the P. F. Volland Company. Enraged and shouting deliriously that the company had bilked her out of $5,000 in royalties, she forced her way into Paul Volland's office. With a small pistol, she shot the company president dead at his desk.

With this sudden, bloody turn of events, leadership of the Volland Company shifted abruptly to company secretary-treasurer F. J. Clampitt. While Paul Volland's successor was competent to lead, he had to do so without the vision and outlook of a figurehead whose eye for beautiful, unusual published materials and shrewd marketing acumen had literally made the company. No one could predict the extent to which Paul Volland's death would change the Volland Company's editorial philosophy, its commitment to excellence, and its ambitious marketing campaigns.

When Johnny received news of Volland's murder, he grieved the loss of his visionary publisher. But he also was overcome with concern, fearing that the sudden shift in command might initiate irreversible changes in his relationship with the company, just at the time when things were promising to go so well for him.

Not that Gruelle was not already well established in the Volland Company's growing stable of authors and illustrators. In addition to his earlier books for the company, he had just completed work on several volumes in Volland's "Sunny Book" series. Among these were his own *The Funny Little Book* (1918) and illustrations for *Sunny Bunny* (1918) by Nina Wilcox Putnam, with several more titles in the works.

And by that time, something else was abundantly clear: Johnny Gruelle's books were providing increasingly larger shares of Volland Company profits. *Raggedy Ann Stories* was promising to be far and away Volland's most popular book, and would soon outsell all of the company's other titles, including its well-

AT LEFT:
The faces of the Raggedy Ann dolls sold by the Volland Company during the late teens and early 1920s (like this one, who lacks her original apron) differed from Gruelle's 1915 design patent, and from the earlier dolls with hand-painted faces. (Courtesy Southern Oregon Historical Society #81.40.10)

Even though they differed from Gruelle's original patent design, most of the Volland Raggedy Ann dolls produced during the late teens and early 1920s were stamped on the torso with the patent date—September 7, 1915. (Courtesy Lynda Woodrow Graves)

The Volland Raggedy Ann dolls manufactured during the early 1920s had uniform stenciled faces (with shoe-button eyes and blushed cheeks), brown yarn hair, and feet that turned out. Each had sewn into its chest a hard cardboard heart. (Courtesy Mr. Kim Gruelle; photograph by William Wepler)

loved *Mother Goose* volumes. The Volland Raggedy Ann dolls were also selling well. As the Volland Company sought to recover from the loss of its talented president, it was unspoken but known: if anything could save the company, it was Johnny Gruelle's funny, floppy little rag doll.

On May 27, 1919—only several weeks following Paul Volland's death—Johnny Gruelle wrote a businesslike letter to F. J. Clampitt, stating: "Mr. Volland wished to get out a Raggedy Andy book and we talked it over the last time he was in the city. . . ." In view of the sales figures for *Raggedy Ann Stories*, it should have surprised no one—least of all, Clampitt—that Johnny Gruelle and Paul Volland had discussed the idea for a second book of rag doll stories, or that Gruelle already had up his sleeve the idea for a floppy brother for Raggedy Ann.

There were no previous appearances of a male rag doll, either in *Raggedy Ann Stories* or in Gruelle's magazine or newspaper drawings. However, as early as his first "Mr. Twee Deedle" pages, Gruelle had successfully employed male-female character teams in his stories. These "duet protagonists" allowed Gruelle to convey an entire range of gender-specific motives and traits, assuring broader appeal among both boys and girls. By adding a male rag doll character to Raggedy Ann's domain—one possessing rough-and-tumble qualities—Gruelle was likely betting that a Raggedy Ann and Andy combination would work even better than stories about a single doll.

Clampitt was apparently convinced that a sequel to *Raggedy Ann Stories* was in order. Gruelle set to work, and in May of 1920 sent his finished manuscript, entitled *Raggedy Andy Stories*, to the Volland

"They [the stories] would come to him so fast; he would then type them, on a little typewriter he had bought for thirty-five dollars, just as they came to him, and my mother would read them back to him. My grandmother and I would sit in on these readings. Sometimes he'd change them, but they seemed as romantic to him as they did to us. They seemed to just 'flow through' him."

—Worth Gruelle
1989

With Raggedy Andy Stories, *his second book of rag doll tales, Gruelle was betting that a rag-doll brother-sister team would be popular.* (Used by permission of Macmillan Publishing Company)

DESIGN.

J. B. GRUELLE.

DOLL.

APPLICATION FILED MAR. 16, 1920.

56,149.

Patented Aug. 24, 1920.

Fig. 1. Fig. 2. Fig. 3.

Inventor

John B. Gruelle

By Emery, Varney, Olmsted & Hogue

his Attorneys

UNITED STATES PATENT OFFICE.

JOHN B. GRUELLE, OF NORWALK, CONNECTICUT.

DESIGN FOR A DOLL.

56,149. Specification for Design. Patented Aug. 24, 1920.

Application filed March 16, 1920. Serial No. 366,428. Term of patent 14 years.

To all whom it may concern:

Be it known that I, JOHN B. GRUELLE, a citizen of the United States, and a resident of Norwalk, county of Fairfield, State of Connecticut, have invented a new, original, and ornamental Design for a Doll, of which the following is a specification, reference being had to the accompanying drawing, forming a part thereof.

Figure 1 is a front view of a doll showing my new design,

Fig. 2 is a side view of the same, and Fig. 3 is a rear view of the same.

I claim:

The ornamental design for a doll as shown.

In testimony whereof I have signed my name to this specification this 12th day of March, 1920.

JOHN B. GRUELLE.

Gruelle's 1920 design patent for a male rag doll was quite generic, bearing neither a name nor a costume.

Company. His illustrations soon followed, with a bill for $600. (In addition to royalties based on sales of his books, Volland usually paid Gruelle a separate, flat fee for his illustrations.) In the book's eleven illustrated stories, Raggedy Andy proved to be every bit as good-hearted as (though perhaps a bit less practical and more rambunctious than) his sister. When Clampitt approved Gruelle's bill, he wrote enthusiastically on the invoice that *Raggedy Andy Stories* was a "good manuscript!"

As it had with Raggedy Ann, the Volland Company had every intention of also exploiting the character-doll market for Raggedy Andy. But this time, Gruelle had decided to exert more control. He had

taken the first step in March of 1920, applying for a design patent for another rag doll. Unlike his patent for Raggedy Ann, this one was much more simply drawn and generic, Gruelle perhaps reasoning that he could use it to protect not only Raggedy Andy, but also any other kinds of future rag doll characters he might develop.

The next step was to enlist a doll manufacturer. This time Gruelle did not (as he had for Raggedy Ann) assign exclusive manufacturing rights for a Raggedy Andy doll to Volland (which was currently jobbing the Raggedy Ann dolls to the Muskegon Toy and Garment Works). Gruelle chose instead the much more powerful position of personally selecting

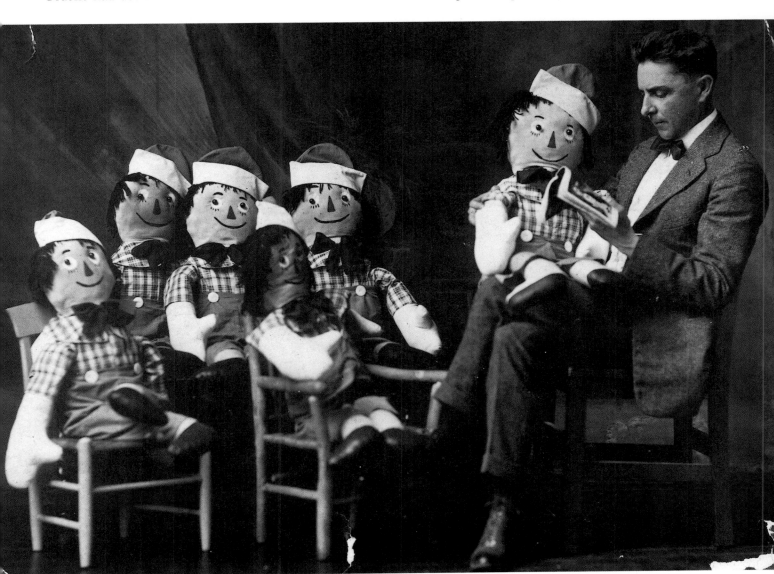

Sometime in late 1920, the E. M. Jackson Studio of Norwalk photographed Johnny Gruelle "reading" to six oversized Raggedy Andys—a charming portrait of the dapper Gruelle playing solemn father to his new boy rag doll. (Courtesy Norman Meek)

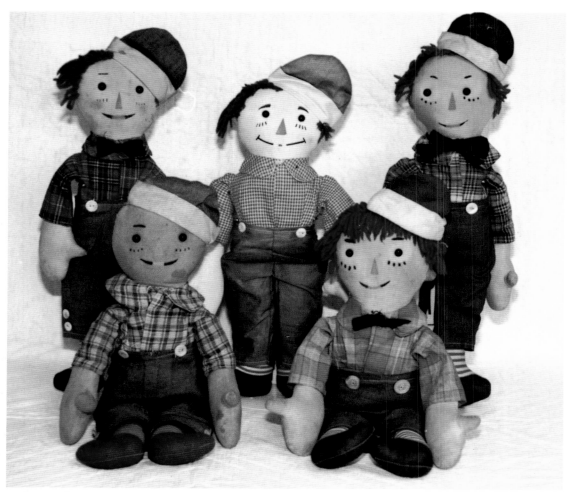

During the sixteen years that Volland would offer Raggedy Anns and Raggedy Andys under their own label, the dolls changed dramatically in appearance and design. And until at least 1927, the very different-looking Volland Raggedy Anns and Andys were each jobbed to separate manufacturers, accounting in part for the early dolls not being matched sets. (Courtesy John and Kathy Ellis)

and overseeing the manufacturer for the Raggedy Andy dolls that Volland would sell under its own label. As it turned out, it would be a manufacturer located much closer to home.

Myrtle Gruelle clearly recalled the day that a Mr. William Beers came to discuss manufacturing her husband's Raggedy Andy doll. Beers was a prominent local businessman in Norwalk, and Gruelle had known him for years, having included Beers' name in several "Yapp's Crossing" cartoons as early as 1915. During the summer of 1919, Beers had sold his stationery and sporting goods store, only several months later becoming president and part-owner of Beers, Keeler, and Bowman, a company set up exclusively to manufacture patented character dolls. Headquartered first in inauspicious offices, by November the company had purchased a three-story brick building in downtown Norwalk to remodel into a modern doll factory.

Though he likely had been talking with Beers for some time, in May of 1920, Johnny Gruelle provided Beers, Keeler, and Bowman with some prototype Raggedy Andys (ones that members of his family probably helped fabricate) and ordered a dozen fifteen-inch Raggedy Andy dolls, along with one oversized Andy, which was to stand nearly three-and-a-half feet tall. Beers, Keeler, and Bowman shipped the dolls to Volland for approval. By July, Johnny Gruelle; Beers, Keeler and Bowman; and the P. F. Volland Company were doing business together.

What this meant was that, at least for the time being, the Volland Raggedy Ann and Raggedy Andy dolls would be manufactured separately. The result was that the Volland Raggedy Anns and Raggedy Andys of the late teens and early twenties, while similar in basic design, were not produced as matched sets.

Volland introduced Raggedy Andy to his public with an ambitious campaign. In August 1920, Volland ordered from Beers, Keeler, and Bowman 1,000 more small Raggedy Andy dolls, and 50 more oversized dolls, most likely intended for display purposes. Then, on September 14, 1920, the first editions of *Raggedy Andy Stories* rolled off the presses. Volland had printed 2,500 Raggedy Andy posters, and the Volland sales team encouraged retailers to mount "Raggedy" window displays, featuring Gruelle's two dolls and books together. By late 1920, Volland's monthly order for Raggedy Andy dolls stood at nearly 4,000.

Stores in Gruelle's hometown of Norwalk (which, several years before, had not greeted his Raggedy Ann doll or *Raggedy Ann Stories* with much fanfare) were now competing with each other in Christmas advertising that headlined both Raggedy Ann and Andy by name, and trumpeted their newness. And, soon, it would be that way throughout the country.

Though it would be several years before he would begin receiving national acclaim for his floppy little Raggedys, by the time Johnny Gruelle sat down with his family to celebrate Christmas—and his own fortieth birthday—he knew that he had created the beginnings of something very special, indeed.

"Raggedy Ann is popular and she has brought with her this year, her brother, 'Raggedy Andy,' who is homelier than Ann, but a good boy."

—D. M. Read (department store) ad December 1920

Though there is no evidence that candy hearts were sewn inside any of the commercial Raggedy dolls, each early Volland Raggedy Ann did come with this thick pressed cardboard heart sewn into her chest, which could be easily felt when hugged. (Courtesy Lynda Woodrow Graves)

Like these original renderings done for his Friendly Fairies, Gruelle would often "gang" his watercolor-and-ink artwork two or three to a board. (Used by permission of Macmillan Publishing Company)

CHAPTER THIRTEEN

Everybody Loves Uncle Johnny: Gruelle in the Early 1920s

"What is the law of Gravitation, Hannah?" asked the Pirate.

"Is it a riddle, or some kind of bird seed?" Hannah asked in reply.

"Hannah," the little Pirate said solemnly, "the Law of Gravitation is the sticky stuff inside the world which makes our feet stick to the ground."

JOHNNY GRUELLE
The Cruise of the Rickity-Robin

In early 1921, as he studied the sales figures for Raggedy Ann and Andy, Johnny Gruelle had every reason to wonder what his future held, considering the events of the preceding few years.

During the late teens, while Gruelle had been caught up in getting Raggedy Ann before the public, Americans had become immersed in wartime, purchasing bonds, conserving on foodstuffs, and otherwise rallying behind the war effort at home and abroad. By the time *Raggedy Ann Stories* and the Volland Raggedy Ann dolls had first appeared in stores, what would later become known as World War I was over.

The end of the war marked the continuing evolution of certain distinctly American cultural trends, in which the old seemed to temper the new. The Arts-and-Crafts movement (in which Gruelle's father, R.B., had immersed himself both as an artist and as an art critic) had merged with the German Bauhaus tradition, spawning architecture, furniture, and everyday objects that, though modern and mass-produced, boasted functional, organic form. It had created a whole new American aesthetic. A lively

"If you think you are going to like your new uncle, send me a little letter, or something. Best wishes from, Uncle Johnny"

—**"Uncle Johnny Gruelle's Page for Good Boys and Girls"**
Woman's World
December 1918

new form of American music, born of ragtime and Southern blues, had caught on with urban audiences, causing this era-just-beginning to eventually be dubbed the Jazz Age.

Gruelle was captivated by this convergence of traditional and modern, and, ever attuned to what was going on around him, had become a rapid assimilator. He had also noted that a number of his fellow citizens, while enlivened by the excitement of a new postwar era, had become weary of urbanized living and impersonal approaches. Many had begun seeking diversions that bespoke solid, old-time values. In a word, the same Americans who were embracing the challenge and excitement of the future were also hungry for nostalgia.

Gruelle's stories and characters had always conveyed the old-fashioned virtues the public now seemed to want. This could explain why his floppy, slue-footed Raggedys (and books chronicling their adventures) would, slowly and steadily, catch on with consumers who had all but ignored his Quacky Doodles Family. Though funny and fanciful, the Quacky Doodles had lacked the charismatic, embraceable qualities of Raggedy Ann and Andy. As dolls, and as literary characters, the Raggedys seemed tailor-made to public sentiment and to the times—a perfect combination of the comfortably familiar and the seductively brand-new.

Perhaps unwittingly, but more likely with an uncanny prescience of consumer taste, Johnny Gruelle and the Volland Company had created the beginnings of a phenomenon that would carry them into a postwar decade that promised a strong market for playthings.

For now, more than ever, Americans seemed willing to spend money on ready-made, commercial toys for their children. Many of these were, like Gruelle's Raggedys, mass-produced versions of what had previously been homemade kinds of items. The United States would soon move ahead of Germany as the worldwide leader in the manufacture of dolls. New York's own toy district was thriving, boasting numerous showrooms and commission houses. Sales agents and distributors represented thousands of new products introduced at the American Toy Fair, held every spring in New York City.

THE MAGAZINES: *PHYSICAL CULTURE*

In January 1916, Johnny Gruelle had forged what would be a five-year relationship with a magazine called *Physical Culture*. Founded in 1899 by visionary health enthusiast Benarr MacFadden, *Physical Culture* would eventually be considered the outstanding monthly in the growing health-and-exercise movement. In addition to ads for tonics and health-giving products, the magazine featured expertly illustrated articles of interest to both sexes on topics (such as divorce, and smoking and cancer) that were considered bold for the times.

Between 1916 and 1921, Gruelle provided Physical Culture *with a wide variety of black-and-white illustrations, covering a broad stylistic spectrum. His work for the magazine, accompanying pieces by authors such as George Bernard Shaw and Upton Sinclair, is a remarkable showcase of Gruelle's artistic versatility.*

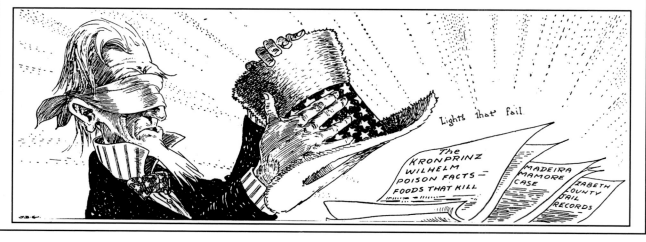

But Gruelle had only just begun to taste the popularity that would eventually envelop his Raggedys. Accordingly, he had by no means abandoned his free-lancing career. He had kept up with his *Judge* cartooning, regularly supplying the magazine with his bird's-eye-view "Yapp's Crossing" pages. By this time, Gruelle had also launched several series of illustrated children's stories for the ladies' magazines *Woman's World* and the Hearst-owned *Good Housekeeping*. And, for several years he had been supplying illustrations to the health and exercise monthly, *Physical Culture* (see illustrated sidebars). Fortunately for Gruelle, these kinds of gender- and interest-specific publications were now leading the

magazine market in circulation. As a result, more and more Americans were becoming familiar with his work.

Having mastered the tricks of the trade for generating a high volume of work in a short period of time, by the early twenties, Gruelle had become a dependable, punctual provider of publishable material. Like other successful free-lancers, he had gradually embraced a formula-based way of working, structuring his stories with plots, motifs, and characters that he could re-use, knowing that the more he could borrow from a tried-and-true stockpile, the more time and energy he would have left to apply to new creations. Though Gruelle's heart would always

THE MAGAZINES: *WOMAN'S WORLD*

In 1918, just about the time *Raggedy Ann Stories* was published, Johnny Gruelle signed on with a Chicago-based magazine called *Woman's World*, with which he would enjoy a thirteen-year (off and on) association. Under the watchful eye of its editor/owner Walter W. Manning, *Woman's World* would eventually vie for a top spot among mail-order magazines.

Gruelle debuted in *Woman's World* in December 1918, with his "Uncle Johnny Gruelle's Page for Good Boys and Girls." Appearing each month, "Uncle Johnny's Page" alternately featured illustrated legends, some set in real-life places such as the Silvermine River; morality tales patterned after the traditional German märchen of the Brothers Grimm; and fables similar to Rudyard Kipling's "Just So" stories.

Gruelle's association with *Woman's World* would continue well into the 1920s, and he eventually supplanted his "Uncle Johnny's Page" with illustrated serials. Though Gruelle's last new story for the magazine would appear in 1929, as late as December 1931, *Woman's World* was still reprinting Gruelle's work.

Woman's World was extremely important to Gruelle's writing career, and he used its pages to pilot a variety of styles, formats, plot elements, and motifs that he would use again later. Some of these—like magically replenishing pancakes, and bottomless soda-water fountains—would become cornerstone themes in his later books about Raggedy Ann and Andy.

Between September 1921 and April 1923, Johnny Gruelle provided Woman's World *with an adventure serial he called*

"The Thrilling Adventures of Andy and Ann on the Cruise of the Rickity-Robin," starring a sister and brother named, not coincidentally, Ann and Andy who travel to foreign and imaginary ports, where they find high adventure and learn new customs. In one episode Gruelle introduces an adventuresome crusader called Kid Corry, from Peru, Indiana—a swashbuckling predecessor to today's popular heroes like Indiana Jones.

said in funny little voices, "Mama, what kind of a funny little game are you and Papa playing?" "We have been playing a funny little game that we were funny little strangers," said the funny little lady as she picked up the funny little girl with the funny little doll and the funny little boy with the funny little puppy dog and sat down in the funny little man's lap. "Tell us a funny little

In May of 1918, Volland published Gruelle's The Funny Little Book. *This dummy page with original art prepared by Gruelle reveals the inspiration for the book's theme: the small wooden trees, figures, and other shapes found in a child's block set.* (Courtesy Jane Addams Book Shop Collection; used by permission of Macmillan Publishing Company)

Gruelle always presented copies of his newest books to close friends. This one was inscribed especially for little Carl Hartman of Norwalk, Connecticut. (Courtesy Anne laDue Hartman Kerr; used by permission of Macmillan Publishing Company)

DEAR CARL —

I WANT TO GIVE YOU THIS
FUNNY LITTLE BOOK BECAUSE
YOU ARE SUCH A FUNNY LITTLE BOY
AND HAVE SUCH A FUNNY LITTLE
SISTER AND A FUNNY LITTLE "MAMMA"
AND A FUNNY LITTLE "DADDDY"
AND A FUNNY LITTLE "AUNNTY"
AND A FUNNY "LITTLE GRAN'DADDY"
AND FOR A LOT OF OTHER REASONS TOO —
BUT, THE CHIEF ONE IS JUST —
 — BECAUSE !!!

AND — MERRY CHRISTMAS —

 "UNCLE"
 JOHNNY

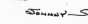

NORWALK CONN.
DECEMBER - 1919 -

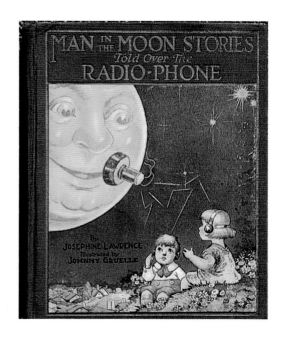

Gruelle provided black-and-white and full-color illustrations, as well as an enchanting cover illustration, for this 1922 book by Josephine Lawrence.

be devoted to his art, his pocketbook and lifestyle required that he attend to the business side of keeping multiple commissions in the pipeline.

By the early 1920s, Gruelle's creations and commissions were beginning to provide the kind of gracious life and social standing in the community to which he and his wife aspired. Gruelle had since moved his family (which now included another son, Richard, born on September 23, 1917) to a new, larger house in Norwalk. With his increasing income, Gruelle could afford to invest in more real estate, and indulge his various whims and hobbies.

THE MAGAZINES: GOOD HOUSEKEEPING

In late 1920, Johnny Gruelle began a brief association with *Good Housekeeping* magazine, providing the periodical with a series of charming, illustrated stories called "The Dwarfies." Featuring the bearded little people Gruelle had created much earlier for *Judge* and *Grimm's Fairy Tales*, the "Dwarfies" installments for *Good Housekeeping* were fanciful lessons about kindness, consideration, and mutual respect.

Following the final episode of "The Dwarfies" in November 1921, *Good Housekeeping* asked Gruelle to continue his contract; this time, providing a series that they wanted to entitle "The Adventures of Raggedy Ann and Raggedy Andy." Gruelle went so far as to submit a sample illustrated episode, but then balked. With his wife, Myrtle, advising against serialization of his rag doll stories (based on her fear that such exposure might detract from future sales of Raggedy Ann and Andy books), a *Good Housekeeping* Raggedy Ann and Andy adventure series never materialized. Several years later, however, Gruelle would change his mind about a Raggedy serial, but it would be for a venue other than *Good Housekeeping*.

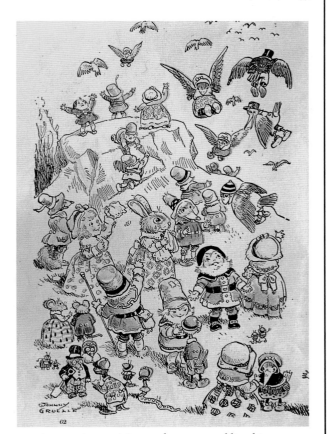

Gruelle filled his illustrated "Dwarfies" stories with alliteratively named critters such as "Harry Hare," "Annie Angleworm," "Reeny Rabbit," and "Grumpy Grundy," his own interest in mysticism and nature enabling him to convey, with great reverence and humor, the secret lives of the creatures he drew and wrote of.

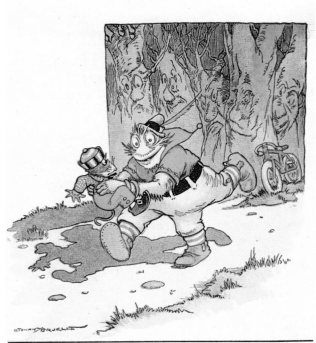

Johnny Mouse kicked and twisted and wriggled around and called to the Woozgoozle as loud as he could

The Whaziss

A Johnny Mouse and the Woozgoozle Story

By JOHNNY GRUELLE
Author of "My Very Own Fairy Stories," "Raggedy Ann Stories," etc.

never doing what he is expected to do, Now the Woozgoozle did not quite
did just the opposite thing and did not understand what this was all about, but

In the June 1920 issue of Woman's World, *Gruelle's "Uncle Johnny's Page . . ." would be replaced by a series of illustrated stories entitled "Johnny Mouse and the Woozgoozle." In these tales that appeared nearly every month for the next year, Gruelle chronicled the adventures of a pert, bewhiskered little mouse.*

By early 1921, Gruelle's *Raggedy Ann Stories* and Raggedy Ann doll had become top sellers for the Volland Company. In the wake of the founding president's death, the Volland Company had continued its tradition of sparing no expense in producing and aggressively marketing its high-end giftbooks and toys. As a result, Gruelle's creations were now for sale in thousands of stores across the country, rang-

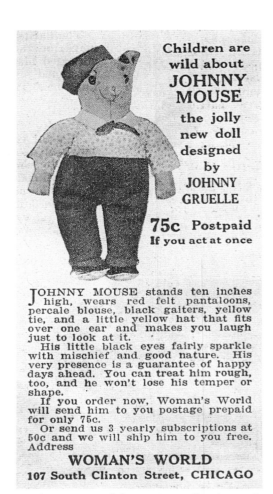
A Johnny Mouse doll was eventually advertised in the pages of Woman's World, *marketed as an accompaniment to Gruelle's "Johnny Mouse" stories.*

ing from local drugstores to Macy's and Marshall Field Company.

But, despite his and his Raggedys' apparent success, Gruelle was harboring misgivings about the Volland Company. He remained concerned about retaining control over his creations. And he longed for some extra insurance, should his relationship with his primary publisher begin to unravel.

Ever alert to signs of how well his literary and artistic creations were playing to a public who, at a moment's notice, might turn its loyalties to someone else's novel creation, Gruelle was restless to reach out in other independent ventures; ones in which he could create new characters that might become even more popular than Raggedy Ann and Andy.

In the spring of 1921, fate would once again intervene. This time, it was an opportunity—not a tragedy—that came calling, in the form of a letter.

CHAPTER FOURTEEN

At the Door of the Hoosier House: Johnny Gruelle and the Bobbs-Merrill Company

You have made yourself distinctively the Hoosier illustrator and children's story-teller. James Whitcomb Riley is distinctively the Hoosier poet. And we are pretty generally recognized as the Hoosier publisher.

Isn't it time for these three Hoosier products to get together? It would seem so to us, certainly.

BOBBS-MERRILL COMPANY
to Johnny Gruelle
May 19, 1921

The letter, addressed to John Gruelle, Esquire, arrived at the P. F. Volland Company's Chicago offices on a blustery February day in 1921. The company waited several days before forwarding it to Gruelle in Norwalk. When Johnny finally received it he surmised, with some aggravation, why Volland had postponed sending it to him. Postmarked Indianapolis, this letter had come from the well-known publisher, Bobbs-Merrill.

"My Dear Mr. Gruelle:" the letter began, "We have a publishing idea that we'd very much like to confer with you about and I write to ask if it wouldn't

be possible for you to run down and spend a day with us."

The letter, signed by Bobbs-Merrill president H. H. Howland, prompted an immediate reponse from Gruelle, who sometime during the weeks that followed ventured to New York City to discuss specifics of the company's proposal with Bobbs-Merrill officials.

Bobbs-Merrill wanted Gruelle to write and illustrate several volumes of stories for children, deriving from the work of someone Gruelle had always held in the highest regard: his late friend, the Indiana poet,

James Whitcomb Riley. The poems Bobbs-Merrill had in mind were two of Riley's most popular (and the ones that, purportedly, had inspired Raggedy Ann's name): "The Raggedy Man" and "Little Orphant Annie."

By the time Bobbs-Merrill contacted Gruelle, the company had published more than sixty volumes of Riley's verses, including *Neighborly Poems*, featuring illustrations by Johnny's father, R.B. Bobbs-Merrill continued to seek ways to capitalize on Riley's reputation, and foresaw great possibilities in engaging someone like Gruelle to help. In doing so, the company could continue to profit from the reputation of one of its most popular authors, while engaging the talents of a new one.

From Gruelle's perspective, a commission from Bobbs-Merrill (which just happened to be headquartered in his beloved Indianapolis) was the break he had been looking for. Whereas P. F. Volland manufactured and sold its books primarily through the gift market, Bobbs-Merrill was a much larger, bona fide trade publisher, possessing a long history and illustrious reputation.

In the trade, Bobbs-Merrill was affectionately known as the Hoosier House. The company had begun in 1885 as the Bowen-Merrill Company (not acquiring its present name until 1903), when two established Indianapolis booksellers, Col. Samuel Merrill and Silas T. Bowen, decided to close their respective bookstores and go into business together. This was but a few years before the poems of James Whitcomb Riley would help to establish them as a publisher.

From its beginnings, the Bobbs-Merrill Company had been devoted to publishing works extolling Midwestern ideals—many by native Hoosiers. During the teens, Bobbs-Merrill had become a master of visionary promotional strategies such as single-title advertising and full-color book jackets.

But, despite these innovations, Bobbs-Merrill had experienced some financial setbacks. By the time the company wrote to Gruelle in 1921, it was hoping to make up somehow for sagging sales in its trade book division with new items in other divisions, which included a thriving juvenile department. The company's biggest children's book to date was a reprint of L. Frank Baum's *The Wonderful Wizard of Oz*, originally published in 1900 by the George M. Hill Company.

With Gruelle's growing reputation as the creator of Raggedy Ann and Andy, Bobbs-Merrill had hopes that Gruelle's work might sell as well as *The Wonderful Wizard of Oz*, and was prepared to spare little expense in making this happen.

At his first meeting with Bobbs-Merrill officials, Gruelle met a man with whom he would have weekly communication during the next several years; a gifted editor who, years later, would ascend to the company presidency: David Laurance Chambers. A stooped but stately figure, D. L. Chambers was known among his authors for both his kindness and crustiness. Chambers' and Gruelle's initial meeting marked the beginning of a very close—albeit, formal—friendship that would endure until Gruelle's death.

Following his meeting, Gruelle quickly set to work on several chapters of a manuscript based on Riley's "Raggedy Man." In a flurry of frequent—sometimes daily—letters and wires, Chambers and Gruelle sent drafts back and forth. Gruelle also began working simultaneously on a second Riley-inspired manuscript; this one based on the poem "Little Orphant Annie." By March 1921, the Raggedy Man manuscript was scrapped in favor of the one about Orphant Annie.

On July 7, 1921, Bobbs-Merrill issued Johnny Gruelle the first half of a $500 advance for his new book, now bearing its official title, *Orphant Annie Story Book*. With several more months' work, Gruelle delivered the completed manuscript and final artwork, and Bobbs-Merrill proceeded immediately with production. Gruelle's *Orphant Annie Story Book* was ready for shipment to bookstores by early November 1921, just in time for the Christmas shopping season. Chambers was intent that *Orphant Annie*, which retailed for $1.25, be his company's ". . . big new juvenile title at the head of our juvenile list. . . ."

Orphant Annie Story Book resonated with Gruelle's own love of the well-spun tale. Its text told of an orphan girl, Annie, who had come to live and earn her

"In memory of James Whitcomb Riley, who knew the child-mind and delighted in its every fanciful imagining; who was himself a child at heart, a player of make believe, a dweller in fairyland."

—Dedication
Orphant Annie Story Book

keep at the home of brother and sister, Carl and Bessie. She soon captivates the two children with fanciful tales of fairies, elves, and woodland creatures. Using Orphant Annie's yarn-spinning as a framing device, Gruelle was able to stitch together ten original fairy stories, featuring many characters he had used before, and would use again. In *Orphant Annie Story Book*, Gruelle intermixed local lore and details from his own Indiana childhood with the sorts of idyllic literary meanderings he so associated with his childhood idol, James Whitcomb Riley. For Gruelle, the book was (as an early letter from Chambers had predicted it would be) a "peculiarly fitting labor of love."

By mid-December 1921, *Orphant Annie Story Book* already had sold 16,000 copies in the U.S. and was receiving attention overseas. Sales were enough to yield Johnny Gruelle a tidy $500 royalty payment, is-

THE NEWSPAPER SERIALS: THE ADVENTURES OF RAGGEDY ANN AND RAGGEDY ANDY

During the spring of 1922, Johnny Gruelle began generating serialized stories about Raggedy Ann and Andy. Having wisely retained serial rights to his Raggedy stories, Gruelle was free to create newspaper or magazine stories about his characters, but had not wanted to do so unless (and until) he felt that his book and doll sales would not be compromised by overexposure of his figures.

Gruelle eventually sold his serial idea to United Features Syndicate, which, in April 1922, began distributing his illustrated stories entitled "Bed-Time Stories of Raggedy Ann." The daily serial (whose name was eventually changed to "The Adventures of Raggedy Ann and Raggedy Andy") was soon a regular feature in more than forty newspapers throughout the country.

Most significant about these newspaper stories is that they would later serve not simply as prototypes, but as the textual bases for almost every one of Gruelle's subsequent Raggedy Ann books. Though they seemed to disappear from most subscribing newspapers in 1924 (Gruelle claimed they ran in some publications until 1926) "The Adventures of Raggedy Ann and Raggedy Andy" serials were a grand opportunity for Gruelle to showcase his rag dolls in yet another medium, while maximizing earnings for his work.

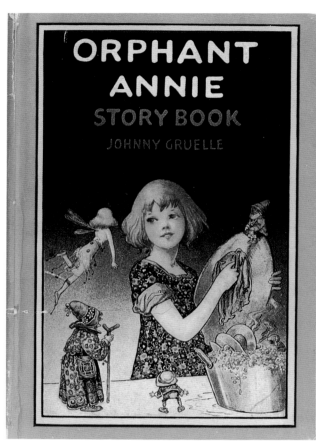

The cover for Orphant Annie Story Book *was Gruelle's fantasy of what he had always thought Riley's Orphant Annie had looked like—a wistful maiden surrounded by fairies and elves, her eyes filled with dreams. (Used by permission of Macmillan Publishing Company)*

Gruelle's illustrations for Orphant Annie Story Book *were a mixture of detailed, dreamlike portraits and cartoon depictions of bugs, elves, and make-believe critters. Some, like this original watercolor, were elegant portraits of the book's characters. (Courtesy Crain Collection; used by permission of Macmillan Publishing Company)*

sued to him on December 21, just in time to go into his Christmas stocking.

Not surprisingly, it was not long before Gruelle pressed upon Bobbs-Merrill an idea for a larger life for Orphant Annie: as a character doll. Volland had begun marketing character dolls based on Gruelle's Sunny Bunny, Eddie Elephant, and Little Brown Bear, and Gruelle did not see why Bobbs-Merrill could not do the same with Orphant Annie.

Gruelle fashioned a prototype doll of scraps of material and silk he found around his house. However,

though Bobbs-Merrill had initially been receptive to the idea, plans to proceed with an Orphant Annie doll mired in the prototype's apparent lack of charm and prohibitive manufacturing costs.

During the fall of 1921, with his work nearly complete on *Orphant Annie Story Book*, Johnny Gruelle had also proposed to D. L. Chambers another book idea; one based on Gruelle's "Johnny Mouse and the Woozgoozle" stories, currently running in *Woman's World* magazine. Gruelle had assured Chambers of Johnny Mouse's potential: "I believe," he wrote,

At the same time that he was preparing his Orphant Annie manuscript for Bobbs-Merrill, Gruelle was at work on a Volland "Little Sunny Book" entitled Eddie Elephant, *filled with vivid watercolors like this one.* (Courtesy Jane Addams Book Shop Collection; used by permission of Macmillan Publishing Company)

A LUNAR ADVENTURE:
THE MAGICAL LAND OF NOOM

In 1921, Johnny Gruelle began crafting an illustrated work quite unlike any of his Raggedy Ann books. The result of his labors was a 40,000-word, 157-page adventure story, dictated in only several days. First published in August 1922 by the Volland Company, this illustrated odyssey for older children was entitled *The Magical Land of Noom.*

In it, Gruelle told the story of Janey and Johnny, and their trip to the other side of the moon; a land appropriately dubbed "Noom." In *Noom* (subtitled *With Sundry and Mondry Illustrations by the Author*) Gruelle's keen wit and love of wordplay is at its best, and once again, he employed duet protagonists, to give readers of both sexes a character with whom to identify. For Gruelle fans, some elements of *Noom* would seem familiar, since it incorporated characters and motifs first introduced in his 1911 "Mr. Twee Deedle" Moonman serial, and shared much with his ongoing "Cruise of the Rickity-Robin" for *Woman's World.*

The Magical Land of Noom also possessed certain Oz-like qualities, its protagonists meeting up with fellow travelers, and ending up in a magical royal city. Gruelle and Volland may well have been seeking to produce an adventure story structured along the lines of the very successful Oz books.

The Magical Land of Noom is one of Gruelle's best

works—a fresh, original fantasy, sprung from the imagination of a man whose own boyish awe and fascination with the wonders of science and outer space would stay with him until he died. In its text and many illustrations, *Noom* extolled the lure of the unknown, stressed the victory of good over bad, and celebrated the wonder of flight, at a time when air travel was but a few years old, and space flight, a mere fantasy.

(Used by permission of Macmillan Publishing Company)

"that a Woozgoozle book would make a good book. . . . I met so many children out in Indianapolis who spoke of Johnny Mouse and the Woozgoozle the first thing and who liked the stories better than the Ann stories. . . ." With Johnny Mouse, Gruelle had wisely retained the book, dramatic, and moving picture rights, as well as holding a fourteen-year design patent for the Johnny Mouse doll marketed through *Woman's World.*

Chambers gave Gruelle approval to move ahead and by late summer 1922, *Johnny Mouse and the Wishing Stick* (a near-verbatim reprint of Gruelle's magazine stories) was submitted to Bobbs-Merrill. In October, the book went to press, promoted in sixty of the nation's largest bookstores with giant handmade cutouts of the book's whimsical little rodent.

As early as 1921, Gruelle had begun giving Bobbs-Merrill first option on book manuscripts before he submitted them to Volland. Gruelle also continued to relate to D. L. Chambers his growing doubts about the Volland Company. Dissatisfied with the quality of the Volland Raggedy Ann dolls, Gruelle had enlisted Beers, Keeler, and Bowman (manufacturers of the Volland Raggedy Andy) to produce some smaller, less expensive prototypes for a new Raggedy Ann doll, which he felt were better quality than the ones currently being produced for Volland by Muskegon Toy and Garment Works. But Volland stubbornly refused to change manufacturers, no doubt aggravated over Gruelle's increasingly cozy relationship with the Hoosier House.

"Now that we have the magic stick, there is nothing to be afraid of."

—*Johnny Mouse and the Wishing Stick*

Johnny Mouse and the Wishing Stick *contained all but one of the tales that had appeared in Gruelle's Woman's World series—an omission made to conserve on word count. The handsome volume, full of new illustrations by Gruelle, was sold in its own presentation box.* (Courtesy Crain Collection; used by permission of Macmillan Publishing Company)

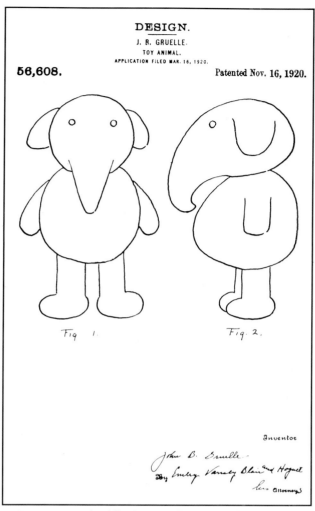

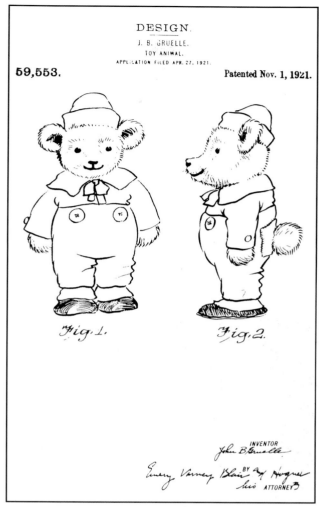

Beginning in the fall of 1921, the P. F. Volland Company introduced a trio of character dolls based on Gruelle's storybook characters, including a Little Brown Bear, a Sunny Bunny, and an Eddie Elephant doll. Several were based on Gruelle's patented designs, and all would also comprise part of a much-enlarged line of character dolls, marketed by Volland a decade later. (U.S. Patent Office)

Though Raggedy Ann and Andy were enjoying unprecedented public recognition, Gruelle's disillusionment and irritation were apparent when he confided to Chambers, "I do not intend letting the Volland Company grab off all the dollars while I get the nickles." In the same four-page letter, Gruelle made Chambers a very specific pitch, stating, "I would like to talk 'Turkey' with you on Raggedy books and dolls." As part of his offer to switch his loyalties completely to Bobbs-Merrill, Gruelle requested an annual retainer, backing it up with the prediction that ". . . the next Raggedy book will go 45,000 the first year."

However, though Bobbs-Merrill editors and exec-

utives respected and liked Gruelle, they were reluctant to enter into a long-term contract under the conditions he had proposed. And a retainer was out of the question. Bobbs-Merrill ultimately turned down Gruelle's pitch for an exclusive contract, preferring to continue their book-by-book relationship. This decision disappointed Gruelle, but did not dissuade him (or the company) from continuing to discuss new project ideas.

In January of 1922, Bobbs-Merrill approached Johnny Gruelle about providing a set of updated illustrations for a new version of L. Frank Baum's *The Wonderful Wizard of Oz,* whose reprint rights it had acquired nearly two decades before. At first, Gruelle

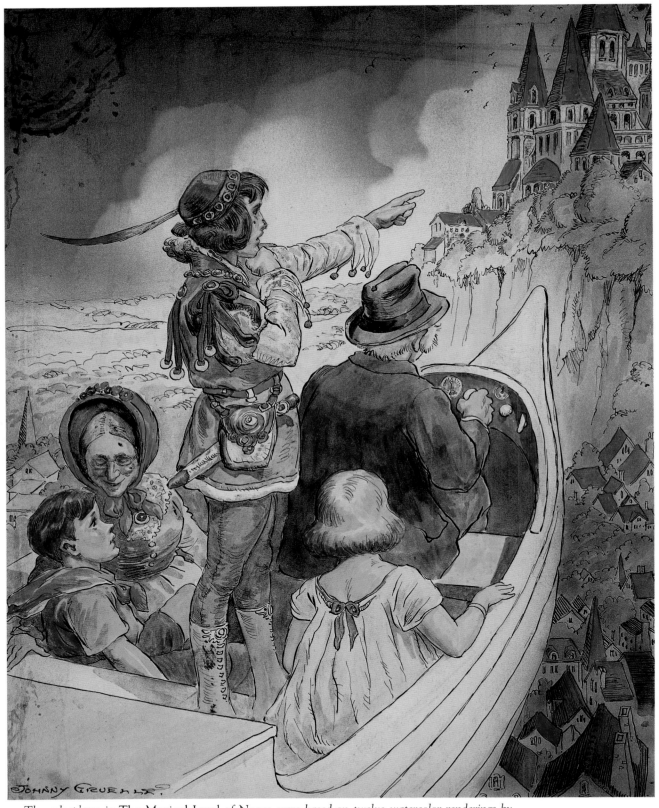

The colorplates in The Magical Land of Noom *were based on twelve watercolor renderings by Gruelle. Like this original, each featured rich colors and intensified perspective, harkening back to some of Gruelle's earlier work.* (Used by permission of Macmillan Publishing Company)

expressed reservations about providing new artwork for a book whose illustrations, by veteran illustrator W. W. Denslow, were considered classics. However, he eventually relented, even becoming enthusiastic about the possibility, writing to Bobbs-Merrill: "I know that I can give you some good drawings. . . ." However, Bobbs-Merrill attorneys could never reach an agreement with the Baum or Denslow heirs about replacing the Denslow illustrations, so a Gruelle-illustrated edition of *The Wonderful Wizard of Oz* was, regrettably, never to be. However, by 1922, Gruelle had written and illustrated his own Oz-like adventure story for the Volland Company, entitled *The Magical Land of Noom* (see illustrated sidebar).

With his Bobbs-Merrill and Volland work, as well as his other commissions (which included work for *Judge* and *Woman's World* and daily newspaper serials featuring Raggedy Ann and Andy—see illustrated sidebar), Gruelle sometimes stayed at his drawing board all night long. Now in his forties, Gruelle was beginning to feel the effects of impending middle age. In letters to Chambers, he joked about the increasing size of his midsection: "Boys! A stomach is something to be avoided," Gruelle mused, ". . . if it once fastens itself on you, it's as hard to get rid of as an insurance agent." He also complained of colds, the grippe, and "rumatrix" (his humorous label for rheumatism), and that he had not felt well all summer. In short, by early 1923, Gruelle was feeling exhausted and old.

It was during those winter months, as the days lengthened, that the tired free-lancer began to dream of getting away somewhere with his family—someplace warm, someplace new, where he could still work, but could also fish and hunt. Johnny began imagining an open-ended journey across the country; one that would rejuvenate, refresh, and revitalize. With a tired body and a thirsty spirit, Johnny Gruelle stood ready once again, a willing and eager sojourner.

"My stomach interferes with my jazz piano playing even now and a pipe organ with two or three manuals is a thing of the past; I can still reach around a saxophone but I have to hold it more like a flute.

"A front porch is all right only on a house!"

—Johnny Gruelle
to D. L. Chambers
1922

Their "Raggedy Ann" bus, parked here at 114 Granite Street, made the Gruelle boys the envy of their Ashland neighbors. Shown here: Johnny, Worth, Myrtle, and Dickie Gruelle, and Lynda Oeder. (Courtesy Lynda O. Britt; print provided by Judie Bunch)

Breakfasts and suppers on the road were usually eggs, toast, fried apples, and coffee, cooked on a pressure kerosene stove. Lunches were usually picnics of crusty bread, cheese, milk, and olives, laid out in the shade of the bus. (Courtesy the Baldwin Library, University of Florida)

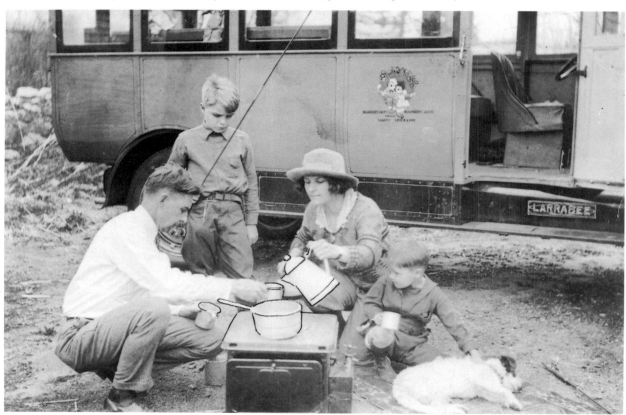

Where Nature Lavished Her Bounties: Johnny Gruelle Goes West

To have good health, you must live where the climate is ideal, where the air is sweet and where the water is pure. And to have a happy home, you must locate where the scenery is lovely, where Nature shows her finest handiwork, and where it is a never-ending joy just to look at the mountains, the stately forests, the running rivers and the fertile valleys.

BERT MOSES
Where Nature Lavished Her Bounties
1925

When they first glimpsed the gleaming bus, ten-year-old Worth and five-year-old Dickie Gruelle could scarcely believe their eyes. The tan and brown Larrabee "Coach De Lux" had been completely outfitted on the inside by a cabinetmaker, with long leather-covered seats that converted into bunks, mahogany cupboards, and lockers with burnished copper hardware. The six-cylinder bus boasted curtains and screens in every window, and along its back wall, above the windows, was a nine-tube, regenerative shortwave radio, capable of picking up signals from across the continent. The bus's sides were festooned with a Gruelle-rendered Raggedy Ann and Andy and the words "Yapp's Crossing" and "Coast-to-Coast." After weeks of planning, packing, and watching their shining mobile home take shape, the Gruelles' vacation was about to begin.

"I dunno who tipped you off to that trip of mine but it's true. The bus is ready and she's a beaut. Me and the missus and the kids are all set and we'll get away pretty quick now and we're goin clear across to the Pacific."

—"The Mayor of Yapp's Crossing" by Johnny Gruelle
Judge
May 1923

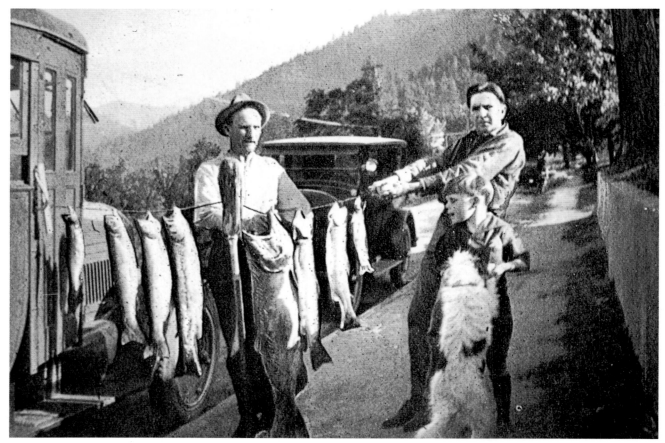

Jackson County's Rogue River would often lure Gruelle away from his work. Here, Johnny shows off his catch, with friend Jack Hughes, son Worth, and dog Rags. (Courtesy Southern Oregon Historical Society)

Worries about work and family (Worth having just recovered from a nearly fatal case of appendicitis) had made a long vacation essential. So, by the time Emma Oeder's letters had begun arriving from southern Oregon, Johnny and Myrtle were already talking about a getaway.

Johnny and Myrtle had first met Emma and her husband during their early years in Silvermine. By 1922, the free-spirited Emma had departed Connecticut to obtain a Reno divorce, and she and her teenaged daughter, Lynda, had set out for the small town of Ashland, Oregon, determined to make a new life for themselves.

Emma's descriptions made Ashland sound like a destination just short of heaven. Nestled in the foothills of Oregon's southern mountains, the town was known for its year-round moderate climate, restorative mineral waters, and diverse cultural offerings that included regular Chautauqua performances by nationally known celebrities. By the early 1920s,

Johnny Gruelle and his editors at Judge *had foreseen a promotional opportunity, using Gruelle's cross-country trek as a way of giving his "Yapp's Crossing" cartoons (which, since fall of 1921, had appeared only sporadically) a new, humorous twist.*

JOHNNY GRUELLE'S SPIRITUAL LIFE

Johnny Gruelle had grown up during a revival of Spiritualism in America; a time marked by renewed fascination with mysticism and acknowledgment of psychic phenomena. The Gruelles attended a Spiritualist church in Indianapolis, and from time to time, R.B. Gruelle had experimented with automatic handwriting. R.B. and Alice often hosted parlor séances, in which Alice would serve as medium, contacting spirits of the departed. On occasion, James Whitcomb Riley was among the participants.

Johnny's own fascination with the supernatural would continue into adulthood, and during the late teens, his love affair with spiritualism and psychic phenomena peaked. He and Myrtle began hosting afternoon and evening séances of their own, which they referred to as "sittings." "We had some beautiful messages come through the trumpet, and in the dim, red light, we saw the trumpet rise and float," Myrtle would write.

On a trip back to his native Indianapolis in 1921, Gruelle looked up several psychic mediums he had remembered from his youth. Gruelle also had had some clairvoyant experiences. For instance, in 1922, he received a chilling premonition of his mother-in-law's death. Later, in 1923, after arriving in Ashland, the Gruelles would continue their séance tradition with friend and fellow psychic enthusiast, Emma Oeder.

Gruelle was not a mere dabbler in metaphysics; he believed in the power of séances, relying on psychic signs to provide evidence that his deceased loved ones were fine and "living" well, somewhere on "the other side." The sittings and slate-messages reassured Gruelle that there was, in fact, a very real life after death, where he would one day be reunited with family.

Both Johnny and his father, R.B., also subscribed to the precepts of the Ancient Mystical Order of the Rosae Crucis. Otherwise known as the Rosecrucian Order, this educational and cultural fraternity stressed metaphysics, mysticism, and meditation to achieve inner illumination. It promoted the cultivation of one's inner powers, and the tapping of a body of magical knowledge for the betterment of oneself and others. The precepts of Rosecrucianism guided both R.B. and Johnny Gruelle as they sought to understand the mysteries of the universe and attempted to channel their creative talents.

Motifs reflecting Gruelle's interest in metaphysics and magic occasionally found their way into his writings and illustrations.

Ashland's 4,000 residents included a fair number of prominent artists, writers, and philanthropists. Jackson County, in which Ashland was located, was also popular with annual tourists, who had dubbed the area, with its stately forests, scenic rivers, and fertile valleys, "The Switzerland of America." Timbering, fruit growing, mining, and dairying were all thriving industries, and in the crystal-clear Rogue River ran fish of all varieties.

In her letters to the Gruelles, Emma Oeder had extolled not only the weather, the healthful lithium-rich water piped right into downtown, and the fishing, but also the proximity of other kindred, creative folk. The decisive incentive was Emma's offer of the guesthouse that stood on her property. Here, the Gruelles could settle in and stay for as long as they liked.

On May 1, 1923, with their East Avenue home closed up, and their new Larrabee bus packed with living essentials and Johnny's art supplies, the Gruelles and their dog, Rags, clamored aboard to begin their cross-country trek.

Gruelle had revealed his planned route to a newspaper reporter, explaining: "We'll drive out to the West Coast, and then as far north as we can. Then, when it begins to get chilly in the autumn, we'll turn south and spend the winter either in southern California or in Arizona. When we get there, we'll rent a cottage, because [our] oldest boy has to go to school."

The Gruelles' trip began with an unseasonable snowstorm that stranded the travelers for two days at Salamanca, New York. Johnny made the best of the delay, sitting on the steps of the bus and honking out the strains of "In the Good Old Summertime" on his beloved saxophone. The next few days on the road were cold, the whole family (plus Rags) piling into the same bunk in the frigid mornings to stay warm. Making numerous stops in many cities to sightsee and take pictures, the Gruelles' bus finally lumbered into Indianapolis on May 15.

There, Johnny and Myrtle visited with their old friends, Horace and "Chum" Mathews, and the Soltaus, with whom the Gruelles revived their old tradition of after-hours picnics, eaten off the meat block in Ed's grocery store. Johnny and Myrtle also joined several friends at the Indy 500, Gruelle basking in the glow of being back in his hometown, now

as the creator of the well-known Raggedys. By June 1, the family was packed up again, and Johnny guided the bus out to the "Ocean-to-Ocean" Highway that would take them farther west.

The Gruelles' trip was never intended as a complete hiatus in Johnny's work. Driving in the coolness of the mornings, he had usually parked the bus by midafternoon, setting to work on his commissions while Myrtle kept the boys entertained with stories and hikes. As he crossed the country, relishing the open road, Gruelle turned out cartoons for *Judge* and his "Adventures of Raggedy Ann and Raggedy Andy" newspaper serials, which he would send off, several batches at a time, from the same General Delivery outposts to which he had also arranged to have his checks sent. At night, with chores all done and the boys put to bed, Myrtle and Johnny would sometimes sit together talking in the darkness, nothing visible but distant storms flashing across the dark horizon and the small flares of their own cigarettes.

One night, in the oil fields near Casper, Wyoming, the Gruelles had a real adventure when, while eating their bus-side dinner, they were harassed by a band of Gypsies. Energized by her own outrage and adrenaline, Myrtle wielded the family pistol high above her head, shooting into the air until the intruders were long out of sight. Johnny and the boys gaped open-mouthed at their usually demure wife and mother, suddenly transformed into a modern-day Annie Oakley.

Some nights the Gruelles stayed at tourist camps, where, sooner or later, other travelers would discover Johnny's identity as the Raggedys' creator. Gruelle could usually be pursuaded to tell stories—yarns about his dolls, and fact-based, but embellished, sagas of his youth. As shy and unassuming as everyone insists Johnny Gruelle was, he loved this kind of invitation to entertain. It was his way of quietly, spontaneously commanding an audience without abandoning his humble persona.

Forging on across the country, the Gruelles stopped off where and when it suited them. Worth's birthday was celebrated at the working ranch of a millionaire, and in Montana, Johnny visited his very own five-acre apple orchard—a by-mail investment scam that he and several newspaper cronies had fallen for. Upon spotting the wizened trees, with typical good humor, he comically sunk his teeth into

one of the few hard green apples that lay about.

On August 28, 1923, after nearly four months of travel, the Gruelles guided their bus into Ashland, Oregon. Weary and in need of showers, they piled out in front of Emma Oeder's snug little house at 108 Granite Street and looked around them. Breathing the fresh air, and taking in the spectacular scenery, Gruelle was immediately smitten. He later wrote that ". . . Oregon seemed to contain a part of the best of every state through which we passed."

The Gruelles were soon settled in Emma's guesthouse at 114 Granite Street, located on a corner lot atop a hill that looked down into Ashland's eigh-

teen-acre Lithia Park. Based on a natural design by Golden Gate Park developer John McLaren, Lithia Park boasted a performing stage, mineral water fountains, and a children's playground. Wending its way through the park's quiet center was Ashland Creek, spanned by quaint footbridges—an uncanny double for the babbling brooks Gruelle had regularly included in his Raggedy Ann and Andy tales.

Gruelle soon settled into a working routine. With Worth and Dickie enrolled in school, Myrtle spent her fall and winter canning peaches and tomatoes, attending Civic Club luncheons, and receiving local ladies at the modest guesthouse on Granite Street,

When they arrived in Ashland, Oregon on August 28, the Gruelle family had been on the road 120 days. They had spent an average of $150 a month on their living necessities, including $141 for bus fuel and maintenance. (Courtesy Indiana State Museum)

Where Nature Lavished Her Bounties 143

neatly logging their names in her diary. The Gruelles and Oeders spent many evenings together, often with other artistic and literary friends, discussing art or holding front-room séances.

Weekends were spent picnicking with neighbors, fishing on the Rogue River, or taking expeditions to Emma Oeder's cabin at nearby Lake of the Woods. Here, at this rustic getaway, the Oeders and the Gruelles shared many a memorable adventure, cooking out, fighting infestations of pack rats and yellow jackets, and otherwise "roughing it" together.

It did not take Ashland residents long to realize that they had yet another celebrity in their midst, and Gruelle would be stopped often on the street to sign his books and dolls, which the local stationery store, Elhart's, displayed in its window. As was his custom, Gruelle usually drew a little picture with each autograph.

But by far the most memorable renderings Gruelle did while in Ashland were a set of mural-size paintings of the Raggedys and their storybook friends, which Gruelle painted for the walls of the downtown Ashland ice-cream parlor owned by Emma Oeder. Called the Raggedy Ann Sweet Shoppe, it was a haven of delectable delights, reminiscent of the bottomless soda-water fountains and ice-cream mud puddles Gruelle wrote about.

Johnny and Myrtle made a point of becoming active and involved in the business and social doings of

As a special touch for the New Year's Eve party he and his wife hosted in 1923, Johnny illustrated an original place card for every guest. Shown here is Emma Oeder's place card documenting a yellow-jacket attack at Lake of the Woods. (Courtesy Lynda O. Britt)

Ashland. Gruelle got to know poet-professor Irving Vining, novelist Zane Grey, and well-known Chicago newspaper columnist Bert Moses, who had given Gruelle an open invitation to use his downtown studio.

The prankish Gruelle also became known around town for his practical jokes. Once, when he had grown tired of a neighbor's chickens coming in his yard, he tied pieces of string to kernels of corn, long enough to reach down a chicken's gullet. After eating the "bait," each chicken ventured home with a string hanging out of its mouth, from which hung notes from Johnny that read: "Please Keep Me Home."

On New Year's Eve 1923, to honor their new friends, Myrtle and Johnny hosted a sit-down dinner and dance. The Gruelles rented the newly erected Ashland Civic Club House. As he had for many other gatherings that he and his wife had hosted, Gruelle had prepared a special handwrought place card for each of the dozens of guests. And, as he loved to do, Gruelle, the shy-but-eager entertainer, allowed himself to be pursuaded that night to render several tunes on the black keys of the Civic Club House's piano.

During the early months of 1924, Gruelle completed work on a Raggedy book, his first in four years. Entitled *Raggedy Ann and Andy and the Camel with the Wrinkled Knees,* the book was published by Volland in May (see illustrated sidebar). Gruelle was not nearly as obsessed as he once had been with keeping multiple commissions in the pipeline, and as he had intended, he had slowed his work pace considerably. Though the Gruelles never made it to California as originally planned, they did take several side trips. One, a boat trip up the coast to Alaska, Gruelle spent horribly seasick. Another, more to his taste, was a three-week pack trip to prospect for gold—in his own words, "just for the fun of it."

In fall of 1924, the Gruelle boys went back to school, and as the trees in Lithia Park turned from green to gold, it seemed as if Johnny and Myrtle might stay permanently in this Northwest paradise, enjoying a slower way of life. Then, in early November, Worth came down with scarlet fever. His condition worsening, he was admitted to the local hospital by parents overcome with dread, having already lost one child to illness.

RAGGEDY ANN AND ANDY AND THE
CAMEL WITH THE WRINKLED KNEES

While in Ashland, Oregon, Johnny Gruelle completed work on *Raggedy Ann and Andy and the Camel with the Wrinkled Knees,* his first Raggedy book since *Raggedy Andy Stories,* published four years before. Gruelle's literal inspiration for his Camel with the Wrinkled Knees character (as with many of his other characters) had supposedly come from one of his own children's toys. Gruelle told of having spotted a canton flannel camel in a Norwalk store window, purchasing it for a quarter, and bringing it home for his boys. When Gruelle plopped him down on the table, a metal skewer in the camel's leg emerged, poking his hand. Yanking all four of them out, he pushed the toy animal back down on the table, upon its newly wrinkled knees.

In his book, Gruelle bestowed on his camel a persona quite suitable for one whose stuffing has sagged: absentminded, but kindly and lovable. And in *Raggedy Ann and Andy and the Camel with the Wrinkled Knees* Johnny Gruelle first presented, in book form, an outdoor wonderland full of critters and make-believe characters, no doubt inspired by the many woodland paradises Gruelle had known—in Indiana, Silvermine, and southern Oregon. Though he had actually introduced it two years before in his newspaper serials as the "Deep Woods," in this book he dubbed his outdoor wonderland the more alliterative "Deep Deep Woods."

Gruelle completed his illustrations for *Raggedy Ann and Andy and the Camel with the Wrinkled Knees* in early 1924, during an expedition to Emma Oeder's cabin at Lake of the Woods, hanging his oversized artwork on the cabin walls as he finished it. He had dearly wanted

to give the Bobbs-Merrill Company first option on publishing this, his newest Raggedy book, and it seemed for a time that Bobbs-Merrill might even try to negotiate directly with Volland to acquire the manuscript. But in the end, Volland published it, in May 1924.

Following the book's publication, Bobbs-Merrill editor D. L. Chambers wrote to Gruelle in Ashland, saying, "As I understand it *The Wrinkled Knees* clears off all scores with them [Volland] and leaves you perfectly free to turn to another publisher. And I hope you will feel like coming to us, exclusively. I'll bet you have in the back of that clever head a perfectly grand idea for a book . . . that will sweep 'em off their feet. I hope it is an Ann an' Andy book. Whisper it to me."

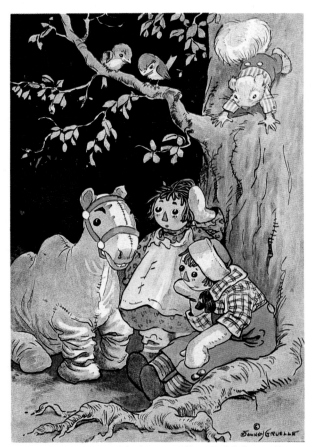

(Used by permission of Macmillan Publishing Company)

Gruelle had first introduced his Camel with the Wrinkled Knees in a one-page illustrated tale for Woman's World *magazine.*

In mid-November, a handwritten card with an Ashland postmark arrived in Bobbs-Merrill's Indianapolis office—not (as D. L. Chambers expected) from Johnny Gruelle, but from Myrtle. In it, she conveyed the shocking news that several nights before, Johnny also had been rushed to the same hospital in Ashland where their son was still recovering. Doctors there had performed emergency surgery on Johnny, operating for kidney stones and acute appendicitis. For three days, Gruelle had lain near death, with blockages in his kidneys and bladder. Only the work of several doctors and a homeopathic specialist, urged along by Myrtle, had kept him alive.

By Thanksgiving, both father and son were out of the hospital. Buoyed by the prayers of Ashland townsfolk, but shaken and subdued, Johnny Gruelle believed that he had received an omen that his stay in the West was finally over.

By the time Johnny felt well enough to travel, the beloved "Coast-to-Coast" bus was sold, many family possessions were given away, and plans were set for a return trip east. With only essentials packed, the Gruelles bade Lynda and Emma Oeder and their other Ashland friends goodbye and boarded an eastbound train.

The Gruelles arrived back in Norwalk just in time to celebrate the holidays and Johnny's forty-fourth birthday. Gone nearly two years, which seemed in many ways like a decade, Myrtle Gruelle peered in her mirror that Christmas Eve, and was startled to see the woman staring back at her. "I noticed," she wrote, "that my hair was no longer brown."

CHAPTER SIXTEEN

Back in the Old Home Port: Johnny Gruelle in the Late 1920s

Now that we are back home again, doesn't it all seem far away and strange, like a fairy tale one has read a long time ago?

JOHNNY GRUELLE
The Magical Land of Noom

Coming back to Connecticut after nearly two years in the West was, for Gruelle, like awakening from a long dream possessing elements of his own fairy stories. An open-ended journey to another "land" (in a Raggedy Ann traveling bungalow, no less), forays to the woods and rivers and mountains, storytelling and music and séances with new friends—all these echoed themes that constantly percolated in Gruelle's imagination.

The Gruelles were soon settled into one of the several houses they now owned in Norwalk; this one, at 1 Eversley Avenue. Sobered by his brush with death, Johnny welcomed every opportunity to play with his sons, now seven and twelve, thrilling them with baseballs that he could hit ambidextrously, and with his ability to hit a target with a spinning string top or slingshot.

Still recuperating, Gruelle wrote, "I am feeling fine, though I tire out easily. My 'chest' however is beginning to increase and slide down around my waistline, but we can't have everything just as we would always like it."

In many ways, Gruelle's trip west had been the mental and spiritual respite he had needed. Yet, he had stayed worried about the P. F. Volland Company—and with good reason. Several days after his return to Norwalk, Volland officials announced

"For, be it man or beast or bird
Where two friends meet, God forms a third . . ."
—Johnny Gruelle
"Friendship"
1926

the company's merger with the Gerlach-Barklow Company, an art-calendar and greeting-card business. Several months later, Volland would move its longtime Chicago headquarters to Joliet, Illinois, where Gerlach-Barklow was headquartered.

Much to Gruelle's relief, Volland would continue issuing, under its own imprint, the colorful, well-designed giftbooks on which it had built its reputation. But Gruelle wanted some solid assurances that the reorganized company would be properly committed to keeping his now well known Raggedy Ann and Andy before the public. Now, more than ever, he longed for an ongoing affiliation with a trade publisher like Bobbs-Merrill. Short of that, he knew that it would be in his best interest, at least for the time being, to keep his contracts current with Volland and to continue supplying them with new books.

Earlier that year, Volland had published Gruelle's *Raggedy Andy's Number Book*, as a linen book for toddlers. Later that year, Gruelle had sold to Volland a manuscript of illustrated verses entitled *Raggedy Ann's Alphabet Book*, which the company would eventually publish in its "Sunny Book" series, in the fall of 1925. In the meantime, during the spring of 1925, Gruelle worked on finalizing three new Raggedy Ann manuscripts for Volland. These three works would mark a significant change in the way Gruelle would put together his books.

Whereas Gruelle's first few Raggedy Ann books for Volland had borrowed certain motifs and characterizations from his previously published comics and stories, each was essentially a newly crafted work. By contrast, these manuscripts that Gruelle now readied (though accompanied by new color illustrations) were near-word-for-word compilations of his previously published newspaper serials, "The Adventures of Raggedy Ann and Raggedy Andy."

Because he had retained serial rights for his Raggedy Ann tales, it was Gruelle's prerogative to recycle his stories any way he chose, enjoying remuneration from whoever published or reprinted them. Reusing the serials enabled Gruelle to supply Volland with the one Raggedy Ann book per year called for in his contract, with only a modicum of extra effort. And, with more than several years of daily stories on which to draw, he possessed an enormous, ready store of potential book material. From this point on, it was a rare Raggedy Ann book that would not be a compilation (in many cases, verbatim) of his previously published serials.

The first of Gruelle's three "new" manuscripts, *Raggedy Ann's Wishing Pebble,* was published by Volland in September 1925. A compilation of serial episodes from 1922 (which, in turn, included many plot elements from Gruelle's *Good Housekeeping* "Dwarfie" stories) the tales were built around a traditional folktale motif: namely, a stone that possesses magical powers, but only for the good and kindly.

The second and third manuscripts were published in the spring and summer of 1926. *Beloved Belindy* featured a maternal African-American mammy doll

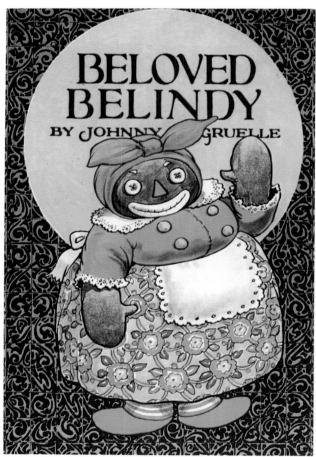

In May 1926, Volland published a volume of eleven stories by Johnny Gruelle entitled Beloved Belindy. *Though his usual protagonist, Raggedy Ann, is present in the book, taking her place as leader of the nursery is a wise and maternal African-American mammy doll named Beloved Belindy.* (Used by permission of Macmillan Publishing Company)

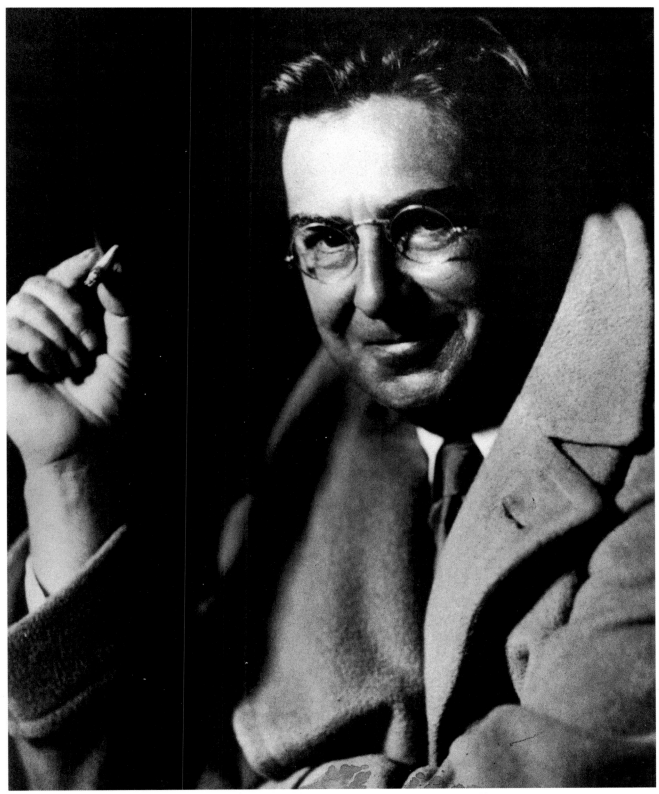

Johnny Gruelle, showing a smile rarely revealed before the camera. (Courtesy Jane Gruelle Comerford)

and *The Paper Dragon: A Raggedy Ann Adventure* was an odyssey similar to *Raggedy Ann and Andy and the Camel with the Wrinkled Knees*.

In Gruelle's next book, *Wooden Willie* (published in July 1927), he replaced his usual protagonists, Raggedy Ann and Andy, with Beloved Belindy, and the kilted Scotsman doll, Uncle Clem. By doing so, he no doubt hoped to make what originally had been serial stories about his Raggedys seem like new tales. He probably also saw this as an opportunity to test-market two new characters.

In July 1928, Volland also published Gruelle's *Raggedy Ann's Magical Wishes*, a compilation of newspaper serials from 1923. While it streamlined his workload and allowed him to extract maximum earnings from his stories, Gruelle's recycling had its unfortunate side as well. While each of the serial-based Raggedy Ann books contains the kinds of charming characterizations and high values that had

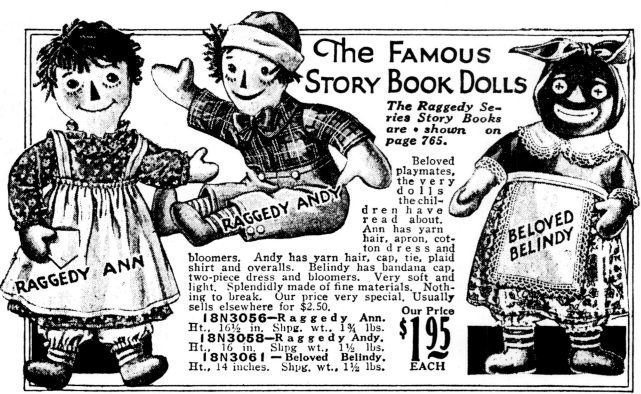

In 1928, a Beloved Belindy, Raggedy Ann, or Raggedy Andy doll could be had for $1.95 from the Sears Roebuck catalogue.

In 1927, Gruelle created a bird's-eye-view cartoon called "Yayhoo Center" (later renamed "Yahoo Center") for the humor weekly Life.

made Gruelle famous, the texts (which were not substantially edited) seemed at points loose and rambling, lacking the precision of Gruelle's first few Raggedy books. A good book editor might have helped. But, not being a trade publisher, Volland did not seem to have such an expert on hand to help Johnny Gruelle shape his serial installments into tight book manuscripts. And, from a marketing perspective, there seemed to be no need. As of 1928, *Raggedy Ann Stories* had sold more than 500,000 copies, and *Raggedy Ann's Magical Wishes*—Gruelle's tenth and latest Raggedy Ann book—had sold 54,000 copies during its first two months on the market.

By the end of the 1920s, recycling had become a way of life for Gruelle, as he had mastered what was necessary to turn out books that would sell. Gruelle continued to oblige the Volland Company by traveling on booktours, all the while aware of the role that he and his dolls were playing in keeping Volland's company coffers filled.

In 1929, Volland published Gruelle's *The Cheery*

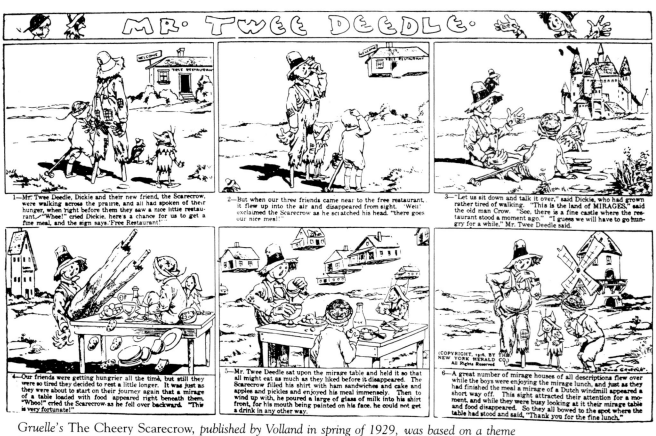

Gruelle's The Cheery Scarecrow, *published by Volland in spring of 1929, was based on a theme he had created nearly fifteen years earlier in his "Mr. Twee Deedle" comic strip. (Book cover used by permission of Macmillan Publishing Company)*

Scarecrow, and another book in the Raggedy Ann series; this one honoring his late daughter, entitled *Marcella.* Still not giving up hope that he might someday interest Bobbs-Merrill in his material, Gruelle had continued to submit book manuscripts to them as well. One, entitled *Little Gates to Nowhere,* was an adventure story with duet protagonists; but Chambers had returned it, with a gentle letter of rejection. Bobbs-Merrill's reluctance to publish any more of Gruelle's work (which could well have been related to internal changes and a shift in publishing priorities) seemed not to tarnish the strong professional and personal bond between Johnny Gruelle and D. L. Chambers.

To take his mind off work, Johnny indulged in a variety of hobbies that included fishing, attending prizefights in New York City, and tinkering with cars and his shortwave radio—sources of relaxation that also served as vital links to the world that lay beyond the confines of Gruelle's drawing board.

Eventually the Gruelles purchased a home in the gracious waterfront community of Shorefront Park in East Norwalk. Here, they entertained out-of-town guests, and spent many a balmy day on Long Island Sound. "We are living right on the water with oodles of ocean right in our front yard," Gruelle would write.

Gruelle was proud of the fact that his comfortable life had resulted from his own hard work. One afternoon, Johnny pulled up to his house behind the wheel of a shining new Cadillac. Feeling the pride of being a successful author and illustrator (who could afford, on impulse, to trade his Model-T Ford for a new car), but beaming like a boy of ten, Johnny shouted up to where his astonished wife gaped from an upstairs window. In the spring of 1927, he had purchased the boat of his dreams—an Elco Cruisette, which he affectionately dubbed *The Raggedy Ann.* About the boat (on which he would play host to dozens of friends) Gruelle had confessed: "I am as thrilled over getting the delivery as any kid could be over Christmas; maybe more so, for, I had the fun of working for this pleasure."

But, towards the end of the twenties, the good life had become more difficult to maintain for a working man whose livelihood depended not on inherited wealth, nor on industrial riches, but on a free-lancer's advances and royalties. Cutbacks in publishing in general, as well as re-emerging problems at the Volland Company, threatened to erode Gruelle's income. And, despite his fame and several regular contracts, the fact was that by the end of the 1920s, work was not coming to Gruelle in nearly the quantities, nor as steadily, as it once had.

By autumn of 1929, as the leaves began falling into great piles along Norwalk's East Avenue, Johnny Gruelle was doing a fair amount of brooding. Once again disquieted by the forces that threatened his career and lifestyle, Johnny had no way to know that what troubled him were small, but accurate, harbingers of what would begin crashing down several weeks later to devastate the entire American economy.

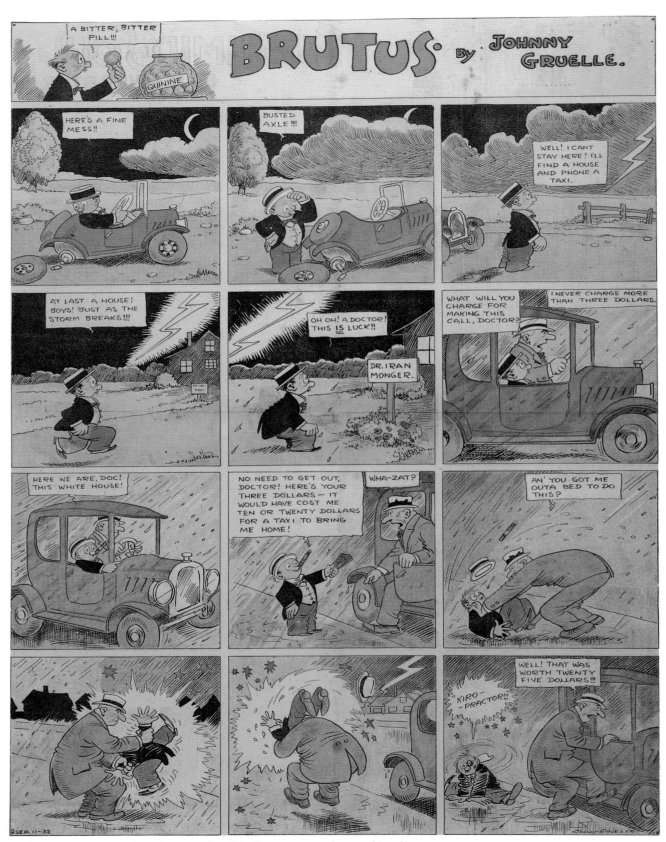

A short, cigar-chomping wise guy, Gruelle's Brutus managed to get himself into numerous scrapes (usually disagreements over lending or borrowing money), and always seemed to have words of advice for every situation.

CHAPTER SEVENTEEN

The Passing of Summer: Johnny Gruelle and the Great Depression

"Cheer up!" the kindly ragman laughed. "One is never lost while there is the least bit of hope."

<div align="right">

JOHNNY GRUELLE
"Jan and Janette"
December 1928

</div>

By the last week in October 1929, Johnny Gruelle had submitted the final installment of his "Jan and Janette" series to *Woman's World,* and was finishing up some work for Volland when the news reached him. Sixteen million shares of stock had been dumped on Wall Street, and panic had ensued as investors rushed to sell. As events unfolded and crowds of frightened people raced to the banks to withdraw their money, Johnny and Myrtle Gruelle began hearing from friends who had lost entire fortunes. Though alarmed, the Gruelles congratulated themselves for not having invested beyond Johnny's few real estate ventures. Gruelle (like many Americans) would not immediately feel the devastating effects of what would become known as one of the country's bleakest eras—the Great Depression.

Eventually the financial decline would affect the printing, publishing, and playthings industries, but officials at Volland steadfastly held to their high standards during the next several years. Though the company would economize on manufacturing (using somewhat less expensive paper and covers) it would not cheapen the overall look of its product lines. Volland was gambling on the notion that while customers might be poorer, they would continue to spend their now-precious dollars on familiar, high-quality goods.

But, from looking at their sales records, company officials must also have known they had a safety net; namely Johnny Gruelle and his very popular Raggedys. For the last half of the 1920s decade, Gruelle's books and dolls had outsold all items in the Volland

catalogue, putting hundreds of thousands of dollars into company coffers. Volland's business-as-usual attitude as the Depression worsened was likely based on a hunch that Gruelle's dolls and books, which had already charmed one generation, would continue to sell, regardless of the economy.

Between 1929 and 1932, Gruelle provided the Volland Company with three more book manuscripts, each based on his newspaper serials from 1923 and 1924. *Raggedy Ann in the Deep Deep Woods* was published in May 1930; *Raggedy Ann in Cookie Land,* in May 1931; and *Raggedy Ann's Lucky Pennies,* in August 1932. All were continuing tales of the rag dolls and other characters with whom newspaper readers were already familiar: Gran'ma and Gran'pa Hootieowl, Hookie-the-Goblin, and the Bolivar, to name only a few.

As Volland had hoped, sales of Gruelle's books had remained steady, and his books and dolls—at least for the time being—were helping Volland stay afloat. By June 1930, *Raggedy Ann in the Deep Deep Woods,* only in its first month of distribution, had enjoyed sales exceeding 50,000 copies. And, in 1932, company president Ted Gerlach would profess to Gruelle (who would continue to receive $10,000 annual advances from the company) that Volland's annual profit on the Raggedy Ann books had amounted to more than $400,000.

Volland continued sending Gruelle on promotional booktours during the early 1930s. In a manner similar to a vaudevillian "lightning sketcher" (which his younger sister, Prue, had been for a time) he would stand before his crowd, drawing page after page of illustrations on a giant pad of newsprint, while telling condensed versions of the tales included in his most recent book. Though nervous at first, once up in front of an eager audience Gruelle would relax, projecting an animated persona that attracted adults and children alike. Years later, one chalk-talk observer keenly recollected Gruelle's soft

"The illustrated tales are enough to entice any young child, and if the parent or older youngster will read these stories to the tot not yet in school, the joyous reaction will be immediate."

—Newspaper review of *Raggedy Ann in the Deep Deep Woods*
1930

voice, kindly face, and what he called his "sad little smile."

Volland officials kept its corps of energetic salesmen busy during those early years of the Depression. The company also expended considerable funds on space ads, display goods, by-mail pieces, advertising bulletins, and form letters to retailers, including the likes of Macy's, Gimbel Brothers, and Bullock's.

And Volland had not forgotten the power of multiple venues and reciprocal marketing. By 1929, the two Raggedys and Beloved Belindy dolls were available in twelve-inch and thirty-inch sizes. And, in

After Franklin D. Roosevelt appointed Will Woodin as secretary of the Treasury, Woodin, Roosevelt, and Gruelle would collaborate on a set of illustrated poems. (Courtesy Franklin D. Roosevelt Library)

1931, the company introduced to the toy trade a much enlarged line of stuffed character dolls. Ten of the fourteen dolls in the new line were based on characters that had sprung from Johnny Gruelle's imagination, having made their first appearance in his Volland books. A complete assortment of the dolls (three of each) could be had for a wholesale price of $47.55, accompanied by a special 19" x 36" park bench that could be used as a display prop for window or counter. Touting its new line, Volland reminded retailers: "Remember, every child who has ever read a Volland Raggedy Ann book is a prospect

JOHNNY GRUELLE AND MUSIC

With no formal training, but possessing an innate sense of melody, Gruelle had grown up playing and loving music. Throughout his life he would use music as a meditation while working, plunking idly at the black keys of the piano. Or, for fun, he would gather with friends for impromptu jam sessions, honking out tunes on his beloved saxophone.

Through the years Gruelle had gotten to know New York-and Connecticut-based writers and composers, and eventually tried his own hand at songwriting, collaborating with John E. ("Jack") McMahon, a musical comedy composer who lived in South Norwalk. In March 1930, Harms, Inc. (which had issued the sheet music for *Stepping Stones*, a musical starring Raggedy Ann and Andy) published "Lonely for You (My Sweet One)," a romantic ballad cowritten by Gruelle and composer Harry Archer.

Then, in 1931, shortly after publishing *Raggedy Ann's Sunny Songs* (Gruelle's colorful collaboration with composer-industrialist Will Woodin), Miller Music published two more nostalgic ballads by Gruelle: "Beneath Southern Skies" (cowritten with lyricist Joan Jasmyn and tunesmith M. K. Jerome) and "Beyond the Moon" (cowritten with Johnny Mercer and composer Gay Stevens).

Gruelle's other musical collaborations included an unpublished ballad, "Lu-cille" (cowritten with Carl Loveland), and a special chord chart for piano or organ to help untrained musicians — like himself — master the rudiments of keyboard playing; designed with pianist and friend John Proetz.

With several projects to his credit, Gruelle enjoyed his crossover into the music business. Besides being income-producing, these commissions enabled Gruelle to blend writing and artistry with his musical talents, and to work side by side with kindred creative types who, like him, expressed themselves best in melody and rhyme.

Raggedy Ann's Joyful Songs, *published in 1937, would feature Gruelle's artistic and lyrical talents. (Used by permission of CPP/Belwin, Inc)*

During World War I, Johnny Gruelle had illustrated this piece of patriotic sheet music, a commission that might well have been his entrée into the world of music publishing. (Courtesy Mr. Kim Gruelle)

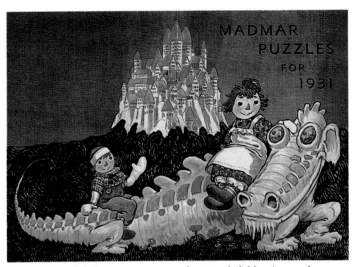

The Madmar Company, producers of children's puzzles, featured this wraparound cover illustration by Gruelle on its 1931 catalogue. Inside were listed several die-cut jigsaw puzzles featuring reproductions of full-color endpapers Gruelle had produced for various Volland books.
(Courtesy Alice Fleming)

for a sale—and there are thousands of them everywhere. If you want to see sales action this year, just keep your eyes on the Raggedy Dolls."

Not ever wanting to be solely dependent on Volland for income, Gruelle kept his feelers out for new projects, and eventually enlisted a literary agent to help him find markets for his works-in-progress. Back in November of 1929, Gruelle had reentered the arena of Sunday comics, creating for the *New York Herald Tribune* (which, a decade before, had absorbed his former employer, *The New York Herald*) a new full-page color strip entitled "Brutus." A rough-and-tumble dandy, Brutus evolved at Gruelle's hand into a Hard-Times Everyman. Eventually traveling out west to seek his fortune at the mythical Hot Dog Ranch, Brutus was a wise guy offering comic relief to a Depression audience. Though later reduced to half-page, "Brutus" would continue in national syndication for nearly a decade.

By 1930, Johnny Gruelle had also tried his hand at songwriting (see illustrated sidebar), and in the process became acquainted with music publisher Charles Miller. Miller (formerly with Harms, Inc.) would call on Gruelle that year to collaborate with his partner, Will Woodin, on Miller Music's inaugural songbook.

Woodin, a colorful, high-powered industrialist, was also an avid musician and composer. From the time of their initial meeting, Woodin and Gruelle got along famously, and with Miller's help, soon set to work on a folio of songs. Gruelle later described the classic Tin-Pan-Alley-style songwriting sessions: "Will Woodin, Charles Miller, and I would go to the New York apartment of Mr. Woodin and lock ourselves in. Mr. Woodin would improvise the music on his favorite instrument, the guitar, and Mr. Miller would jot down the notes as he played, much as a stenographer writes shorthand. As soon as Will was sure the music was the way he wanted it to be, Charley would transpose it for the piano and I would write the lyrics for it."

By late 1930, the songwriters had finished and Gruelle had also crafted a set of whimsical, colorful illustrations that would fill the new book. *Raggedy Ann's Sunny Songs* was in stores in time for Christmas 1930, promoted with special advertising folders and space ads in all the daily newspapers. Encouraged by the sales, in late 1931 Charles Miller struck a deal with Victor Records of Camden, New Jersey, to record the Gruelle-Woodin songs. Gruelle was present at the recording sessions, watching in delight as popular singer Frank Luther crooned out the tunes.

"I believe the musicians had as much fun recording the music as we did writing it," Gruelle recalled. "As the men played more than one instrument during the length of the record, it was necessary for them to hop about the room at times to the various instruments and more than once a record was ruined and had to be retaken due to some last-minute tomfoolery on our part."

Gruelle would remain affiliated with Miller Music, collaborating on several other projects. Though Woodin would sustain his warm friendship with

"I had long recognized the distinctive character and high quality of the literary work of Mr. Gruelle, and upon making his personal acquaintance, discovered that he was not only a distinguished author but also had the gift of writing beautiful music."

—Charles Miller
President, Miller Music, Inc.

RAGGEDY ANN
The best-known, best-loved doll in the world.

BELOVED BELINDY
The mammy of the Raggedy Dolls. Muslin and gingham body.

RAGGEDY ANDY
Raggedy Ann's famous companion. A fine doll for boys.

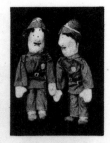

PERCY THE POLICEMAN
Appears in many of the Raggedy Ann Books.

EDDIE ELF
Made of felt; he appears in many of the Raggedy Ann stories.

UNCLE CLEM
Felt, chambray and gingham; shoe-button eyes. In many Gruelle books.

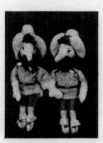

PIRATE CHIEFTAIN
A jolly character from "Raggedy Ann."

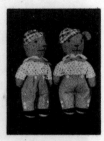

LITTLE BROWN BEAR
A plush animal dressed in boy clothes, from book by same name.

SUNNY BUNNY
Plush. Gaily dressed in red coat, yellow vest and green trousers.

BUNNY BULL
A clever Sateen toy. Rabbit on one side and bull dog on the other.

BROWNIE TINKLE BELL
"The Spirit of Christmas" doll. Has a tinkling bell for a heart.

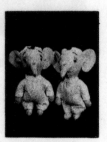

EDDIE ELEPHANT
Felt and gingham, from a character in a book by the same name.

PINKY PUP
Stuffed gingham from the book "Pinky Pup and Empty Elephant"

SPECIAL ASSORTMENT
42 Dolls (3 each of 14), shown on this page, $47.55 and with them you receive, free, this smart park bench and sign. The bench is 36 inches long— 19 inches high — done in bright yellow and green.

RESERVED FOR RAGGEDY DOLLS

EMPTY ELEPHANT
Gingham toy from the book "The Pinky Pup."

THE P. F. VOLLAND COMPANY
JOLIET, ILLINOIS

BOSTON : NEW YORK : CHICAGO

The Gruelle-inspired characters in the 1931 Volland character doll line included Raggedy Ann, Raggedy Andy, Beloved Belindy, Percy the Policeman, Uncle Clem, Pirate Chieftain, Eddie Elf, and new versions of the previously marketed Eddie Elephant, Little Brown Bear, and Sunny Bunny. Dolls based on characters by other Volland authors and illustrators included Bunny Bull, Brownie Tinkle Bell, Pinky Pup, and Empty Elephant, which had appeared in Volland books entitled The Jolly Kids *and* Pinkie Pup and Empty Elephant.

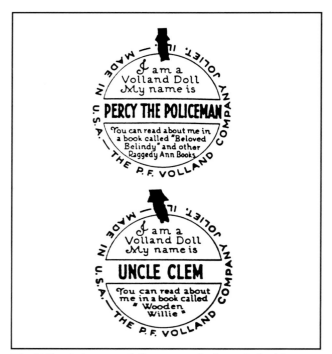

The Volland character dolls were made from cloth, felt, and plush, and averaged in height from eleven to sixteen inches. Though unmarked on their bodies or clothes, the dolls were sold with a distinctive hangtag, complete with name and the title of the book in which he or she had appeared.

A homemade Raggedy Ann doll, ca. 1930s. (Courtesy Barbara Barth; photograph by Audrey Frank)

Charles Miller and Johnny Gruelle, in 1932 he would move on to bigger things, becoming secretary of the Treasury under President Franklin D. Roosevelt.

In 1931, the Manning Company, publishers of *Woman's World* magazine, went to press with a compilation of Gruelle's "Rickity-Robin" stories, which he had written and illustrated for the magazine nearly ten years earlier. This magazine-size reprint appears to have been a Depression-era subscription promotion for *Woman's World.*

Though the toy, book, and magazine industries had suffered from the Depression's effects, the economic crash had not spelled collapse for what Gruelle had created. On the contrary, Gruelle's Raggedys seemed especially well suited to a hard-times marketplace. Gruelle's by-then familiar literary themes of loyalty, thriftiness, kindliness, and generosity (ones that had also appealed to readers in the teens and the postwar 1920s) were perfect for Amer-

icans, whose own finances and lives were straining, sometimes to the breaking point. Gruelle's mouth-watering descriptions of overflowing soda-water fountains, luscious ice-cream puddles, and magically replenishing doughnuts were visions of hope and abundance; of unanticipated treasures and better times ahead.

But as Johnny Gruelle worked during those first several years of the 1930s, producing his sunny, nostalgic stories and songs, he remained burdened by private worry. Having built a career around entertaining the public, he faced the sobering possibility that he might yet fare very badly indeed in the still-declining economy. And, he was not feeling well. Once again, he fantasized about new surroundings, dreaming of warmer, lighter places. And, like a migrating bird following the rays of the sun, Johnny Gruelle gathered his family around him, spread his wings, and traveled—this time, venturing south.

CHAPTER EIGHTEEN

Sailing into a Land of Light: Johnny Gruelle's Florida Years

Norwalk will not be the same without Johnny Gruelle, and it's up to someone to scheme to keep him here. Not because he is the outstanding writer of children's verse in the country, the most inimitable of cartoonists and the most prolific of lyricists. But because he is the original prince of good fellows, the best sport of them all.

E. HUMPHREY DOULENS, newspaper columnist
1932

From the time they first laid eyes on the sequestered house at 4455 Meridian Avenue in Miami Beach, Johnny and Myrtle knew it was for them. Sitting on the shores of the Nautilus Waterway, the two-story Mediterranean-style home was fronted by a courtyard and boasted a two-car garage, five bedrooms, a sprinkler system, a beamed ceiling, tile floors, and wrought-iron appointments. Upstairs, over the garage, was a room through whose windows streamed soft sunlight: the perfect space for a studio. It was, by Depression standards, a dream house.

Like many Americans, the Gruelles had initially been drawn to Florida during the 1920s, tempted by fat newspaper supplements filled with photographs of swaying palm trees, gleaming Mediterranean-style buildings, and prominent personalities dressed in white suits, all meant to lure chilled, weary Northerners and Midwesterners directly to the land of inexpensive properties and perpetual sunshine. By the time they made their usual winter trek south in 1932, the Gruelles had already wintered in Florida for several years, but because of Johnny's health, were now in search of a permanent home there.

Though they would keep their Shorefront Park home in Connecticut, the Gruelles were expecting this gracious home on the waterway to be their primary residence. Though Gruelle and his family had survived the first several years of the Depression, worry had cost Johnny in health and stamina. Among other things, he was contending with a medically diagnosed heart condition. But, once settled in his new home in the southland, Johnny knew he had found the change of surroundings he had been searching for. The breezes piqued his nostrils and the

In addition to entertaining at gracious gatherings in their own home, Myrtle and Johnny Gruelle attended many parties in Miami Beach.

sun warmed his skin. His eyes slowly became accustomed to the year-round tropical brightness, and Gruelle felt something inside him stir and awaken.

Rising before daylight, fortified with a cup of black coffee, Gruelle was energized, working all morning and into the early afternoon. Breaking only long enough to take breakfast with Myrtle, or to eat a light lunch, he would stay at his drawing board until two or three o'clock. Then putting aside his pens and brushes, closing his studio door, he would head out for some fishing on the waterway that lay just beyond his backyard.

The Gruelles filled their home on Meridian with Mediterranean-style furniture, which Johnny repainted and festooned with his fanciful flowers and critters. Downstairs in the bar, he hung the wall with

Johnny Gruelle and his son Richard pose in front of the family's resplendent Ford-8 convertible. (Courtesy Library of Congress)

rows of cartoons and inscribed photographs of prominent artists, business leaders, and politicians. Eventually there would be an inscribed portrait of Franklin D. Roosevelt, to whom Will Woodin had introduced Johnny. On their sun-dappled patio the Gruelles scattered leather upholstered settees, beach chairs, and a chaise lounge, all meant to invite repose. "An atmosphere of easy geniality pervades the whole place," a newspaper columnist would observe after visiting the Gruelles at home.

The Gruelles had been in south Florida for only a few months when Johnny received an invitation to become a member of the Committee of One Hundred of Miami Beach, an exclusive club of prominent American business and industry leaders who lived, permanently or seasonally, in south Florida. Nominated by committee member C. W. Hills, Johnny was voted in as a member of the Committee of One Hundred on February 6, 1933. In joining the committee, Gruelle would be in the company of men such as C. F. Kroger (founder of Kroger Stores), Frank B. Shutts (publisher of *The Miami Herald*), Benarr McFadden (publisher of *Physical Culture* and *Liberty* magazines), and his fellow Hoosier, humorist George Ade.

The Gruelles began entertaining committee members and others at sit-down dinners and afternoon fetes that spilled out into their backyard. Myrtle was completely at home as a gracious wife and hostess,

"The cartoon of the Ladies' Day has made a great hit with our people and has brought humor to a wide circle of people, who have not been laughing very much these days."

—Clayton S. Cooper
President, The Committee of
One Hundred of Miami Beach
1933

WORDS TO LIVE BY: THE RAGGEDY ANN PROVERBS

Beginning in May 1934, Johnny Gruelle began producing one-frame illustrated Raggedy Ann proverbs to be distributed by the George Matthew Adams Service newspaper syndicate. These daily messages were eventually carried in more than a dozen newspapers throughout the country, including Gruelle's hometown *Miami Herald* and East-Coast papers such as the *Boston Post*.

Gruelle had always fancied himself a poet, and his daily proverbs were intended to uplift and inspire readers who had already weathered five years of the Great Depression—also a time when Gruelle's books and dolls had become harder to come by.

Gruelle's succinctly crafted newspaper proverbs varied from day to day. Some were down-to-earth words of advice; others were lighthearted messages; still others possessed spiritual qualities, reading like haiku.

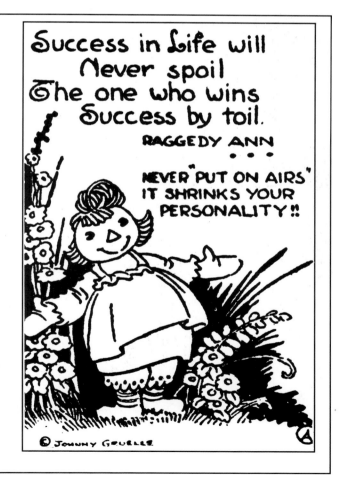

welcoming the likes of movie mogul Mark Honeywell, Maxwell House Coffee heir Will Cheek, auto-industry tycoon Edsel Ford, and banker Leonard Feathers. Gruelle's satirical cartoons had been his entrée to meeting these prominent personages. But it was his unfailing sense of humor and gentle presence that endeared him to the mavens and socialites. Ever a populist, accepting all men be they be paupers or princes, Gruelle was leary of the exclusivity of the Miami Beach club scene. But eventually he found his own special niche, where he could maintain his grass-roots philosophy, teasing the elite with humorous luncheon speeches that extolled down-home virtues, and further endearing himself to Miami Beach matrons and moguls by including their names in his bird's-eye-view cartoons done for *Life* and Miami's *Daily News* and *Herald*.

Despite Johnny's delicate health, the Gruelles embraced this Florida social life—a flurry of card parties, cocktail suppers, and spontaneous midnight cruises to Havana, Cuba, where they would hold forth with friends in the sidewalk cafés till dawn.

By spring of 1934, Gruelle had struck a deal to put a series of illustrated Raggedy Ann proverbs into national newspaper syndication (see illustrated sidebar). By October of that year, *Literary Digest* honored Gruelle in a prominent sidebar article entitled "Comics and Their Creators." All in all, life was good. However, troubles were brewing on another front.

During the first three years of the Depression, Volland had continued its practice of producing quality, higher-cost books and dolls, charging prices that (according to company vice-president Tracy Luccock) ". . . under conditions existing even up to 1932 did not prevent the Volland Company from doing a good business . . ." But, under deepening Depression conditions, buyers began resisting the high wholesale prices. Not being in a financial position to begin any new speculative ventures in the lower-priced markets, the Volland Company opted out of book publishing altogether.

By the spring of 1934, Gerlach-Barklow president Ted Gerlach was dead. While Gerlach-Barklow would continue to issue greeting cards under the Volland imprint, plans began for the dismantling of

Gruelle prepared this full-color cartoon for the Committee of One Hundred's First Annual Ladies' Day, depicting the committee's many members as small-town folk engaged in various comical shenanigans. (Courtesy Richard Gruelle Family)

what had, for twenty-six years, been Volland's book division.

To date, Volland had sold nearly 2,000,000 copies of Gruelle's Raggedy Ann books, not to mention more than 150,000 dolls depicting Gruelle's literary characters. But, ultimately, not even Gruelle's popular Raggedys were enough to keep Volland in the book publishing business.

The fate of Raggedy Ann and Andy seemed adrift. Not only would Gruelle's books and dolls no longer be produced, but Johnny was now also facing the grim prospect of discontinued royalty income. Gruelle knew he had to keep Raggedy Ann and Andy available not only as salable commodities, but also as figures alive in the public imagination. But there were several hitches, including Gruelle's contracts with Volland, which prohibited him from taking a Raggedy Ann book to any other publisher.

Gruelle began his salvage efforts by offering to buy back the plates and artwork for all of his Raggedy Ann books, but was quoted a $50,000 selling price. Though Gruelle would never directly procure the plates or his artwork, Volland would, by late 1934, assign back to him copyrights and trademarks for his Raggedy Ann and Andy books and dolls. Finally in control of all rights to his books, dolls, and the names "Raggedy Ann" and "Raggedy Andy," Johnny was free to find a publisher for his books.

Gruelle had also stayed in touch with trusted colleague Howard Cox. A longtime Volland salesman who had ascended through the company ranks, Cox had grown disillusioned with Volland's policies and by the early thirties had struck out on his own. As early as 1932, Cox (who had multiple connections in the printing and production arena) had urged Gruelle to shop his Raggedy material around to other publishers, offering his assistance with sales and marketing.

Cox envisioned a larger life for Gruelle's Raggedys and advised Johnny not to relinquish the control he

THE WHITMAN BOOKS

In 1935, with the equivalent of nearly two dozen different Raggedy Ann and Andy manuscripts ready to go, and no trade publishers knocking at his door, Johnny Gruelle turned to the Whitman Company, which dealt in less-expensive books merchandised chiefly through five-and-dime stores. In June 1935, Whitman went to press with two new works by Gruelle: a book of paper dolls and verses entitled *Raggedy Ann Cut-Out Paper Dolls* and *Raggedy Ann and the Left Handed Safety Pin*, an illustrated reworking of his "Peter and Prue" stories done for *Woman's World*. By year's end, Whitman had printed approximately 100,000 copies of both books.

By far, Johnny Gruelle's best work for Whitman was an oversized edition entitled *Raggedy Ann in the Golden Meadow*, published in December 1935. Based on his earliest newspaper serials, from 1922, the stories featured his favorite characters and motifs and were accompanied by some of Gruelle's finest illustrating work.

Johnny Gruelle would write and illustrate (and even create dummies for) two other small books for Whitman entitled *Raggedy Ann's Kindness* and *Raggedy Ann and the Queen*. Unfortunately, these were never published.

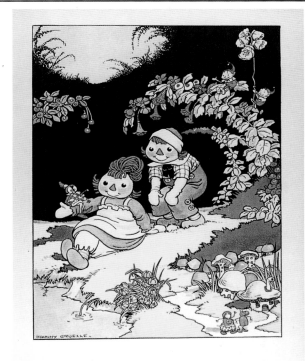

Gruelle's vivid illustrations for Raggedy Ann in the Golden Meadow *were inspired by the tropical colors of southern Florida. (Used by permission of Macmillan Publishing Company.)*

ROCHESTER TIMES-UNION

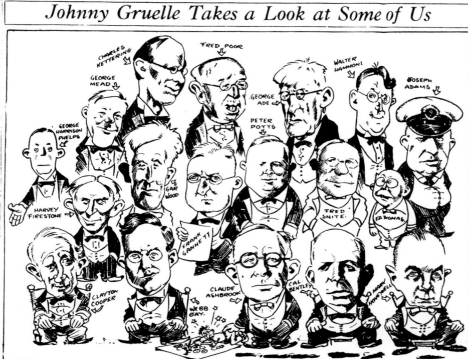

Gruelle traveled to other cities for banquets and special events, often lending his artistic talents to publications such as this one.

now had over rights to his dolls and books. To this end, Cox proposed that the Gruelles and he invest together, incorporating as a company in which Johnny would hold the controlling interest and would oversee all Raggedy publishing and merchandising. The Gruelles eventually agreed to the idea, and even arranged to borrow money to invest. But, the economics could not be worked out and Gruelle, Inc. was not to be, at least during Johnny's lifetime. Cox's concept for a family-owned business would, however, be a blueprint for a later partnership that would usher the Raggedys into the 1940s and beyond.

Gruelle was also ready to launch other characters that he hoped would become as popular as his Rag-

gedys. No doubt referring to his substantial stash of easily revisable newspaper serials, in the early thirties Gruelle wrote to D. L. Chambers: "I have at least ten books written [Raggedy Ann], and it would mean very little effort to change the name to another character. . . ."

Johnny would follow up by sending Bobbs-Merrill a manuscript entitled *Lovey Lou*, in which he had replaced Raggedy Ann and Andy with a new set of duet protagonists, Lovey Lou and Lovey Lewie. Gruelle observed: "I have given this much thought and believe that I have two little creatures who will grow much dearer to the hearts of mothers and children than Ann and Andy."

Regrettably, a stiff-necked librarian gave *Lovey*

Lou a scathing confidential review, advising Bobbs-Merrill not to publish it. Chambers would return *Lovey Lou* to Gruelle, along with a kindly worded rejection, blaming the turndown on "general market conditions." Though Gruelle would continue to count D. L. Chambers among his professional friends and confidants, he was deeply disappointed at this final rejection from the company that he, at one time, had dubbed "the good ole Hoosier outfit."

By 1935, Gruelle had connected with the Racine, Wisconsin-based Whitman Company to publish his new Raggedy books (see illustrated sidebar) and had, the year before, also authorized a Chicago-based publisher, M. A. Donohue & Company, to begin reprinting his Volland Raggedy Ann books and several of his Sunny Books. In a year's time, Donohue (which had purchased the plates from Volland) had published and distributed close to 30,000 copies of Gruelle's titles, and would continue reprinting.

Also in 1935, Gruelle received proposals for other Raggedy-related projects, including bids by the Blue Network of NBC and General Foods to put Raggedy Ann on the air, but both projects dissolved due to logistical snags. Gruelle had also begun negotiations for an animated color film about his dolls.

By this time, Worth Gruelle had moved from Connecticut to Miami Beach, relishing the chance to assist his father with illustrating. Worth later recalled fondly those days that sometimes began as early as 4:00 A.M. with a loud rap on his bedroom door—a father's not-so-subtle summons to his son that it was time to arise and work.

Drinking multiple cups of black coffee and chain-smoking dozens of cigarettes, Johnny would stay for hours at a time at his drawing board, turning out illustrations that had become luminous reflections of his Florida surroundings. Gruelle's work offered a respite from his mounting business worries. The maritime light that poured in his studio windows and reflected off every surface seemed to give Gruelle's color work—already clear and bright—more bril-

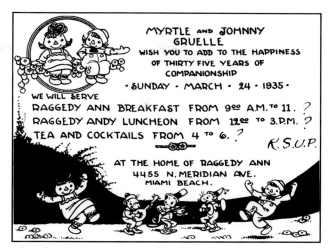

The whimsical invitation for the Gruelles' 1935 anniversary celebration. (Courtesy the Baldwin Library, University of Florida)

liance. It was as though everything his brush touched had been immersed in the clear, tropical light that surrounded him.

Gruelle's black-and-white line work had also assumed a new clarity, his Raggedy Ann and Andy figures boasting a sharp definition they had not possessed before. No longer depictions of three-dimensional dolls, these had evolved into stylized figures, with features and gestures especially suited to the printed page.

On March 24, 1935, Myrtle and Johnny Gruelle hosted a party to celebrate their thirty-fifth year of marriage. At least for a day, the Gruelles were able to forget their business and professional concerns and celebrate with family and friends. However, as it had throughout Gruelle's career, misfortune lurked nearby to deal him another low blow. Only one month after the anniversary party, Johnny Gruelle's attorneys contacted him with news that would eventually cost him thousands of dollars, disrupt his professional life, and make all of his other Depression-related problems seem small by comparison.

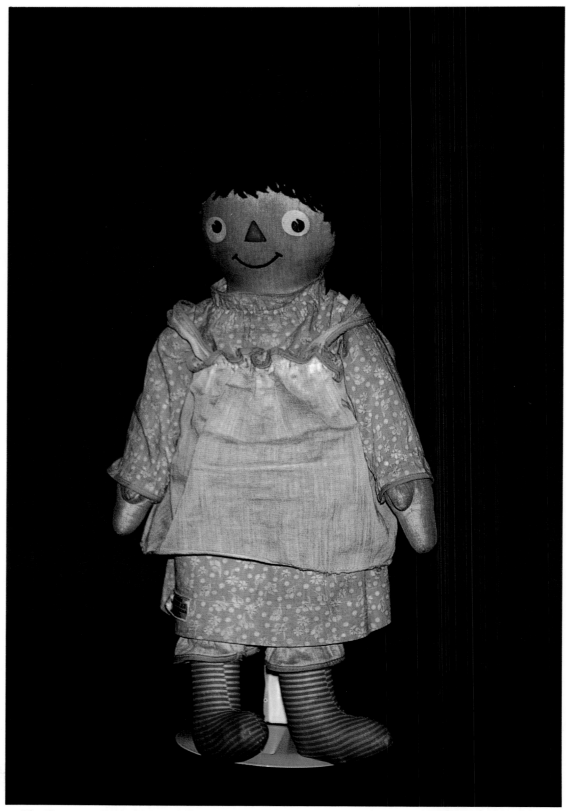

The Exposition Raggedy Ann dolls, patterned after a brand-new design prepared by Johnny Gruelle, wore see-through organdy aprons on which were sewn labels that read, "My name is RAGGEDY ANN," along with trademark and licensing information. With her bright-eyed expression and chunky topknot of yarn hair, the Exposition Raggedy Ann was a charming embodiment of the more stylized 1930s Raggedy Ann Gruelle had created for the printed page.
(Courtesy Candy Brainard)

CHAPTER NINETEEN

Raggedy Ann's Day in Court: Gruelle vs. Molly-'Es Doll Outfitters

No right to use the name "RAGGEDY ANN" on dolls is now held by anybody except by my present authorized distributors, Exposition Doll & Toy Mfg. Co.

The "RAGGEDYS" are peaceable folks stuffed with soft wadding but they "pack a big wallop" for those who threaten to hurt them or me.

JOHNNY GRUELLE
May 1935

Hatred brings a bitter taste
And sears the soul with spiritual waste

JOHNNY GRUELLE
1936

One morning, in early April 1935, sales agent Sam Drelich ventured to the New York Toy Fair, an annual event that not only served the New York-based toy trade, but also attracted vendors and buyers from other cities. Drelich had his own booth at the fair, but was also there to survey the current crop of new playthings. While making his rounds through the exhibitors' rooms in the Hotel McAlpin, he ventured into Room #879. There, his eye fixed on a, yarn-haired, triangle-nosed, pinafored rag doll accompa-

nied by a notice that claimed the exclusive rights and trademark for the doll's design and for her name: "Raggedy Ann."

"The acts of the defendant are seriously threatening to destroy the fruits of my labor and the goodwill associated therewith. . . ."

—John B. Gruelle
October 9, 1935

Spotting a trademarked Raggedy Ann doll at the New York Toy Fair may not have fazed the average toy buyer or sales agent. But it was enough to leave Sam Drelich weak in the knees, and with good reason. A company Drelich represented, the Exposition Doll & Toy Manufacturing Company, had just completed negotiations with Johnny Gruelle to manufacture and sell a brand-new, exclusively authorized Raggedy Ann doll; one that was meant to supplant the discontinued Volland doll. On behalf of the Exposition Company, Drelich had already begun taking orders from buyers, who were hungry for a new line of Raggedy Anns. Several thousand of the new dolls already had been produced, packaged, and were awaiting shipment to retailers.

Drelich immediately demanded a verbal explanation from the Philadelphia-based company displaying and laying claim to the impostor doll—a company called Molly-'Es Doll Outfitters. Drelich informed them of the recently authorized Exposition Raggedy Ann dolls. Then, wasting no time, he contacted Johnny Gruelle's New York attorney, John W. Thompson, who shot off a sternly worded registered letter to Molly-'Es, stating, "Your offering of these dolls under this trademark constitutes an infringement of Mr. Gruelle's trademark rights."

Once Johnny Gruelle had learned the details about the unauthorized Molly-'Es Raggedy Ann, he was chagrined to say the least. Myrtle was furious. Gruelle and his legal counsel began plotting how best to halt what appeared to be a blatant infringement on Gruelle's sole and rightful ownership of Raggedy Ann.

Gruelle and his advisors could not have chosen a more determined opponent if they had tried. Molly-'Es Doll Outfitters, Inc. was a well-established company, owned by Meyer and Mollye Goldman of Philadelphia. The thirty-six-year-old Mollye Goldman ("Miss Mollye," as she had come to be known

"The idea of a 'Raggedy Ann' doll came to [me] because [I] owned a 'Raggedy Ann' doll when [I] was a child, and the buyers wanted [me] to make a good rag doll."

—Mollye Goldman
November 9, 1935

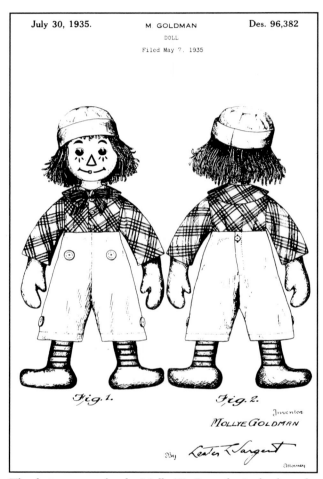

The design patent for the Molly-'Es Raggedy Andy showed a doll with yarn hair, striped legs, and triangular nose—an unmistakable "knockoff" of Gruelle's Raggedy Andy character. (U.S. Patent Office)

in the doll and toy industry) was a stylish, ambitious businesswoman. As a first-generation Russian immigrant growing up on West Philadelphia's Regent Street, Mollye had spent her childhood dreaming of dolls and finery, and became determined to make her mark in the doll business someday. Forthright and outspoken, she eventually built a company specializing in fashionable, hand-smocked and-embroidered

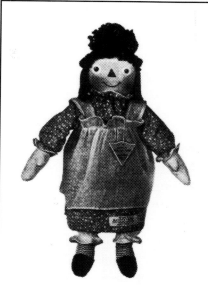

RAGGEDY ANN

REG. U. S. PAT. OFF.

RAGGEDY ANDY DOLLS

**NEW YORK OFFICE OF
JOHNNY GRUELLE**

*Fred A. Wish, Inc., Rep.,
12 E. 41st St.*

Dear Friends:

These "RAGGEDY" dolls and all the copyrights, trade marks, and good will connected with them are just as much mine as is my hand that has drawn their pictures appearing in the "RAGGEDY" books, cartoons and stories for nearly twenty years.

The TRADE MARK "RAGGEDY ANN" has been used by me and by my former authorized publisher, The P. F. Volland Company of Joliet, Ill., on the dolls and other articles since June, 1915, and has been registered for dolls in the U. S. Patent Office under the registration number 107,328, dated November 23, 1915.

Any representation contrary to these statements by me is false.

No right to use the name "RAGGEDY ANN" on dolls is now held by anybody except by my present authorized distributors, Exposition Doll & Toy Mfg. Co.

The "RAGGEDYS" are peaceable folks stuffed with soft wadding but they "pack a big wallop" for those who threaten to hurt them or me.

Sincerely,

JOHNNY GRUELLE.

───────────

EXPOSITION DOLL & TOY MFG. CO.

ROOM 319—200 FIFTH AVENUE, NEW YORK

Telephone: STuyvesant 9-0552

Authorized Distributor by Special Arrangement with Johnny Gruelle

SAM DRELICH AND HARRY WOLF

Sole Selling Agents

In May 1935, Johnny Gruelle responded to Molly-'Es' claim to his Raggedys with this sternly worded full-page ad in Playthings, *in which he staunchly defended his trademark and rights to the dolls he had created two decades before.*

doll clothes, intricate layettes, and showy Hollywood-inspired costumed dolls.

By her own account, Mollye Goldman had first become interested in manufacturing both a Raggedy Ann and Raggedy Andy after learning about Volland's demise, and after being told by department store representatives (from Macy's, Gimbel Brothers, and John Wanamaker, among others) that there were no longer any Raggedy Ann or Andy dolls currently available. Despite Depression conditions, Mollye had done well enough to finance an expanded plant and work force. In her continuing zeal to extend production beyond layettes, doll clothes, and carriages, it is no surprise Mollye seized on the idea to market her own Raggedys, knowing them to be proven, profitable commodities.

Shrewd and fully cognizant of the importance of protecting any claim she herself might make, Mollye Goldman had enlisted the services of patent attorney Lester L. Sargent, who ascertained that Gruelle's design patent for Raggedy Ann had, indeed, expired in 1929, and that Gruelle had not obtained a design patent or registered trademark for a doll *named* Raggedy Andy.

Armed with what she felt was valid information from her attorney, on March 26, 1935, Mollye Goldman had applied to the U.S. Patent Office for her own trademarks for "Raggedy Ann" and "Raggedy Andy"; trademarks that would later be granted to her on June 18, 1935. And, on May 7, 1935, Mollye Goldman would apply for her own design patent for a "Raggedy Andy."

In the meantime, Mollye Goldman had also taken another tack, inquiring through her counsel about purchasing a license from Gruelle to continue her manufacture of her Raggedy Ann and Andy dolls. However, Gruelle (who had spent too many months working out his own arrangements with Exposition) would not hear of it and advised his attorneys to turn down Goldman's request. These first few events would mark the beginning of a prolonged, ever-escalating battle between Johnny Gruelle and Mollye Goldman.

Molly-'Es took the offensive, sending threatening telegrams to the Exposition Company and circular letters to doll and toy buyers, asserting Goldman's purported ownership of the rights to Raggedy Ann and Andy. This had the desired effect of discouraging buyers from committing to the Gruelle-autho-

rized Exposition Raggedy Anns, for fear of reprisals from Molly-'Es. As a result, thousands of the newly manufactured Exposition dolls sat, unsold and uncommitted, with few retail prospects.

In April, Mollye Goldman also began asserting her ownership of Raggedy Ann and Andy through aggressive space advertising in *Playthings* magazine, flaunting as a trademark serial number (#363,008) what was actually only a trademark application number, since her trademark for Raggedy Ann had not yet been approved.

Gruelle shot back with a sternly worded space ad in the May 1935 issue of *Playthings*, intended to convey the message that Gruelle and his attorneys stood ready to do whatever was necessary to protect Johnny's ownership of his rag dolls. Though Gruelle had taken care to keep his own trademarks for Raggedy Ann current, nothing would disabuse Mollye Goldman of her belief that she had the legal right to manufacture Raggedy dolls.

Eventually Johnny Gruelle conceded that all reasonable efforts to set the record straight had failed. Knowing how costly and destructive it might be if he lost, Gruelle nonetheless decided that there was no other alternative but to take Mollye Goldman and her company to court.

On October 11, 1935, Gruelle's attorneys filed a Bill of Complaint in U.S. District Court for the Eastern District of Pennsylvania, citing Molly-'Es Doll Outfitters, Inc. for trademark infringement and unfair competition, and seeking to have Mollye Goldman's recently granted design patent for Raggedy Andy declared invalid. Further, the complaint sought to have Molly-'Es Doll Outfitters enjoined from further manufacture of Raggedy Ann and Andy dolls, and requested payment be made to Johnny Gruelle for damages, equal to his lost sales.

Thus began a long and strenuous legal battle, encompassing testimony and judgments that would

"The continued representation in advertising or otherwise by Molly-'es Doll Outfitters, Inc., that it has the exclusive or any right to use the names 'Raggedy Ann' and 'Raggedy Andy' obviously reduces the plaintiff's royalties for the use of these names as trademarks or goodwill marks."

—Fred Wish
Johnny Gruelle's agent
1935

raise important questions about unfair manufacturing competition, and about the differences between copyright law and trademark law during the 1930s. The case would be appealed several times, would extract a heavy financial and emotional cost from Gruelle and his family, and would not, ultimately, be settled until after Gruelle's death.

Gruelle's chief legal argument was based on his

THE MOLLY-'ES DOLLS

Though Sam Drelich had seen only a Molly-'Es Raggedy Ann at the 1935 New York Toy Fair, the company had, in fact, also begun manufacturing a doll they called Raggedy Andy, with intentions of marketing the two dolls as a duo. While lifting, outright, the primary distinguishing features of Gruelle's original Raggedy Ann and Andy (such as yarn hair, triangle nose, and striped legs) the unauthorized Molly-'Es dolls possessed several qualities setting them apart from either the Volland or Exposition Raggedys.

Their die-cut twenty-inch cloth bodies were longer than the Volland Raggedy dolls, and instead of red-and-white leggings and black fabric feet, the Molly-'Es dolls sported leggings of striped or plaid (sometimes sewn on the perpendicular) material and blue (rather than black) fabric feet. Instead of familiar shoe buttons, the Molly-'Es dolls possessed silk-screened eyes that appeared to look off to one side. And on its chest, each Molly-'Es doll bore a stamped-on message that read RAGGEDY ANN AND RAGGEDY ANDY DOLLS MANUFACTURED BY MOLLY-'ES DOLL OUTFITTERS, accompanied by a solid red heart— Mollye Goldman's brazen claim to ownership.

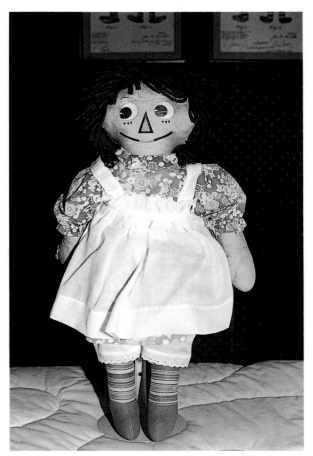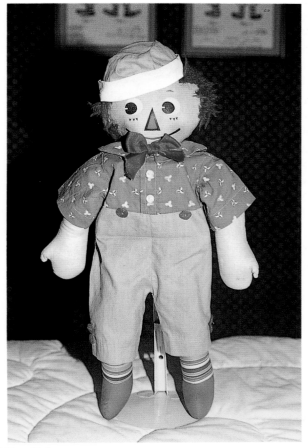

(Courtesy Barbara and Roy Dubay;
photographs by Craig McNab)

claim to all rights to his Raggedys, inclusive of copyrights and trademarks associated with all representations of "Raggedy Ann" and "Raggedy Andy." In their affidavits, Gruelle and his witnesses contended that there was an inextricable link between Gruelle's literary works and his rag dolls; that it was Gruelle's written and artistic portrayals that had popularized Raggedy Ann to the extent that consumers would also buy the dolls.

In his affidavit, Sam Drelich noted that it was ". . . apparent that anyone now entering upon the business of making and selling 'Raggedy Ann' and 'Raggedy Andy' dolls is doing so with the obvious intention of capitalizing upon the good repute and the wide public knowledge of the doll characters in Mr. Gruelle's books and other writings and drawings and of the 'Raggedy' dolls previously made and sold by P. F. Volland Company."

Rather than filing a response to Gruelle's Bill of Complaint, on October 25, 1935, the Goldmans' attorneys filed a Motion to Dismiss, contending that Gruelle's complaint was convoluted and confused. Mollye Goldman's attorney would argue further that Gruelle's trademark for the name "Raggedy Ann" (originally secured in November 1915) had become positively associated with his Raggedy Ann design patent (also secured in 1915, but which had expired in 1929). Because of this association, they argued, Gruelle's right to the trademark had, in fact, expired with the design patent, even though Gruelle had renewed his trademark.

Gruelle responded briefly to Mollye Goldman's affidavit, and by the end of November 1935, the case was submitted to the district court for final determination. Though several news articles announced a November 19 court date, Federal Judge William H. Kirkpatrick would make his ruling on the basis of already submitted affidavits and exhibits.

In the meantime, while Exposition grew more and more discouraged at trying to wholesale its authorized Raggedy Ann dolls, sales remaining slow, Molly-'Es, with its well-established networks of retail and wholesale customers, continued producing and selling thousands of unauthorized Raggedy dolls through an aggressive advertising campaign to the toy and doll trade.

Though a mysterious advertisement (appearing in the April 1936 issue of *Playthings*) suggested that Gruelle and Goldman were, somehow, cooperating on a licensed Raggedy Ann and Andy (see illustrated sidebar), the lawsuit continued. Judge Kirkpatrick issued his opinion on *Gruelle vs. Goldman* on July 23, and a final decree on October 5, 1936. While acknowledging that Raggedy Ann was known and loved by millions of children (having attained a place in the public esteem comparable to Mickey Mouse and other characters), on the evidence presented, Kirkpatrick dismissed the case.

It was Kirkpatrick's opinion that Gruelle was not, himself, in the business of making or selling dolls, and that Gruelle was, through his lawsuit, attempting to establish a prohibitive right to the trademark as a monopoly. "The right to a particular mark," asserted the judge, "grows out of its use, not its mere adoption."

Whereas a patentee may hold the rights to something without actively making and selling the item, the holder of a trademark cannot. As long as Volland was still manufacturing Raggedy Ann and Andy dolls, the Raggedy trademark had been protected by law. However, during the several-month-long hiatus between the time Volland had assigned all rights back to Gruelle and when negotiations were completed with the Exposition Company, the Raggedy Ann trademark was unused, and thereby left unprotected.

Gruelle and his attorneys were bitterly disappointed with the district court's decision. On October 5, 1936—the same day the final decree was issued—they filed an appeal petition, and a lengthy Assignment of Errors, to be taken up by the United States Circuit Court of Appeals for the Third Circuit.

The appeals proceedings began in March 1937, during which Gruelle's attorneys demonstrated how their client had been grievously wronged by the Molly-'Es company's infringement on his trademark and the ensuing unfair competition. In their December 23, 1937 opinion, the appellate court judges concurred with (and felt constrained to accept the ruling of) the district court: that although Johnny

"The appellant has no property right which is being destroyed, injured or interfered with."

—Harry Langsam and Peter P. Zion
Attorneys for Molly-'Es Doll Outfitters
March 2, 1937

Gruelle had validly received the trademarks by assignment from Volland, he had ". . . nonetheless abandoned them by reason of non-user in an existing business. . . ." According to the judges, Gruelle's eventual assignment of rights to the Exposition Company did not count as his being actively engaged in the doll manufacturing business.

However, the appeals court judges also ruled that, even though Gruelle had not gone directly into manufacturing his dolls after the Volland Company had transferred trademark rights back to him, the Molly-'Es company had, in fact, violated an active trademark. For, although Mollye had not begun full-blown promotion for her rag dolls until spring of 1935, Molly-'Es Doll Outfitters had been manufacturing and selling dolls called "Raggedy Ann" and "Raggedy Andy" as early as November 1934, predating by an entire month Volland's assignment of rights to Gruelle.

The appellate judges further held that the Goldmans and the Molly-'Es company had no property right in the trademarks "Raggedy Ann" and "Raggedy Andy," and ruled that Goldman's design patent (#96,382) for "Raggedy Andy" should be declared invalid. And, they held that Molly-'Es should be enjoined from any further intimidation of the Exposition Company.

The most signficant judgment on Gruelle's behalf concerned the use of the Raggedy Ann and Andy images and names. The judges held that in producing dolls that possessed "a deceptively similar appearance to the dolls of Gruelle's books, cartoons, and syndicated newspaper drawings" the Goldmans had appropriated the nationwide "valuable good will" that Johnny Gruelle had worked to build with Raggedy Ann and Andy. "Raggedy Ann," the appeal judges maintained, "is one in the public mind, whether she be personified by doll, cartoon, drawing, song, or book."

Henceforth, the appeals court ruled, Molly-'Es Doll Outfitters could not legally manufacture dolls that were named Raggedy Ann or Raggedy Andy. And, the judges ruled that Molly-'Es would have to provide restitution for the damages Gruelle had sustained.

"The 'Raggedy Ann' good will, built up over sixteen years, is of tougher fiber than to die of non-use in a few weeks; otherwise defendants would not be so intent on wresting it from its proper owner."

—John W. Thompson and Charles Howsen
Attorneys for Johnny Gruelle
March 1937

JOHNNY GRUELLE'S RAGGEDYS: WHY WOULD ANYONE INFRINGE?

With Raggedy Ann and Andy being such well known figures, and Gruelle publically identified with them as their creator, why would anyone have been tempted to infringe on his ownership?

Perhaps because Gruelle's inspiration for Raggedy Ann had come from a family-made doll; perhaps because even in their commercial forms, Raggedy Ann and Andy shared some characteristics of homemade rag dolls; or perhaps because Gruelle himself, as part of his marketing and image-making for his Raggedys, had cultivated in the public's mind homespun personae for his dolls—for all these reasons, many may have mistakenly considered Gruelle's patented, trademarked rag dolls to be "folk" entities. Something so universally comforting and familiar as Gruelle's dolls was innately at risk for being erroneously classified as public-domain material.

The popular and salable Raggedys were also tempting prey for companies wishing to take advantage of a sure thing, especially during the Depression. Few, if any, other commercial rag dolls patented and sold during the late 1920s and early 1930s had sold as well as Gruelle's distinctively designed Raggedy Ann and Andy. The Molly-'Es dolls—in both name and image—were a conscious attempt to copy Gruelle's dolls, appropriating Raggedy Ann's and Andy's already established reputation and public recognition. Propelled by her knowledge of P. F. Volland's reorganization, and by her assumption that Gruelle had "abandoned" his rights to the doll, Mollye Goldman saw great potential in making and selling these already-popular commodities.

After the long, exhausting months of legal battling, Johnny Gruelle was relieved and heartened by the appellate court's ruling. Though the damages to be covered by the Molly-'Es company would cover only a fraction of his costs and lost sales, receiving some restitution was better than none. Most importantly, Gruelle could be assured that, henceforth, no Molly-'Es dolls bearing the names Raggedy Ann and Andy would be competing with his own.

But by the time the appeals court judges had enjoined Molly-'Es from any further intimidation tactics, the Exposition Company had already ceased its production of a Raggedy Ann doll. Furthermore, Exposition would never proceed with a planned-for, authorized Raggedy Andy, fearing more reprisals and intimidation from Mollye Goldman. To make matters worse, Gruelle had been unable to interest any other company in producing an authorized Raggedy Ann and Andy, the manufacturers opting to wait until a legal settlement had been reached concerning the "true" ownership of Raggedy Ann and Andy. So, while Gruelle had technically "won" his case against Mollye Goldman's company, he had also lost valuable years of potential doll production and was now without a doll manufacturer. After nearly three years of legal battling, Gruelle was relieved, but physically and mentally drained.

During December of 1937, Johnny and Myrtle hosted a festive dinner party at home. A maid, costumed as Beloved Belindy, met guests at the door, and with storybook flourishes, served family and friends a sit-down dinner. As tired as he was, Johnny relaxed that night, joking and signing copies of his newest book, *Raggedy Ann's Joyful Songs*. With the lawsuit now behind him, he was beginning to look ahead to getting Raggedy Ann and Andy back before the public as authorized dolls.

" 'Raggedy Ann' is one in the public mind, whether she be personified by doll, cartoon, drawing, song, or book. The valuable good will which Gruelle has built up in this character of his creation is being appropriated by the defendants as a result of use of the tag 'Raggedy Ann' upon the dolls of the defendants' design and manufacture."

—Buffington, Davis, and Biggs, justices
United States Circuit Court of Appeals
December 23, 1937

GRUELLE AND GOLDMAN: FRIENDS OR FOES?

In April 1936, a full-page space ad appeared in *Playthings* magazine that surely must have baffled anyone who knew anything about the ongoing litigation between Johnny Gruelle and Mollye Goldman. An astonishing combination of written, artistic, and photographic copy (appearing to have been coproduced by Mollye Goldman and Johnny Gruelle) the ad touted the "association" of two great creative forces. The text incorporated one of Gruelle's original Raggedy Ann proverbs, and setting off photographs of both Gruelle and Goldman were gay, decorative motifs and calligraphy unmistakably rendered by Johnny Gruelle. The ad even carried a copyright notice (© 1936 John B. Gruelle), announcing that the Molly-'Es Raggedy Ann and Andy dolls were now being manufactured under an ". . . Exclusive License Agreement."

Why this ad would have appeared, at the height of the *Gruelle vs. Goldman* lawsuit, is anybody's guess. The federal judge had not yet made a determination in the case, and judging from the bitterness of the ongoing legal battling, any sort of exclusive license agreement between Johnny Gruelle and Mollye Goldman seemed unlikely indeed.

Gruelle had been firm in refusing Mollye Goldman when she had sought a license in 1935 to manufacture authorized Raggedy dolls. And as late as October 1935, Gruelle had claimed, under oath, that he had never granted Mollye Goldman any rights to use either the trademarks or designs for Raggedy Ann and Andy. Had Gruelle now, suddenly, had a change of heart, despite the ongoing legal battle? Were both parties attempting some kind of behind-the-scenes reconciliation? Or was the ad, quite simply, doctored artwork and text, submitted to *Playthings* as ad copy?

Mollye Goldman's own later recollections lend more mystery to this space ad. During the mid-1970s, by then in her late seventies, Mollye would reminisce often about her claim to Raggedy Ann, talking fondly and effusively of her supposed friendship with Johnny Gruelle. On other occasions Mollye would maintain (to doll collectors and reporters) that those who had through the years told and retold the story of the *Gruelle vs. Goldman* litigation had gotten the story "all wrong." And, until she died, Mollye proudly displayed on the wall of her Philadelphia apartment a framed copy of the artwork for the strange *Playthings* ad. "Johnny Gruelle liked my Raggedy Ann so much he

made up this picture for me," she would say about the framed piece.

There is tenuous evidence that Johnny Gruelle and Mollye Goldman may at one time, as early as 1934, have had preliminary conversations about the possibility of Molly-'Es producing several Gruelle-authorized dolls. Goldman would later claim this, proudly showing off a prototype of her own Molly-'Es Beloved Belindy doll. But it is hard to imagine any kind of a contractual licensing agreement occurring in mid-1936, at the height of Gruelle's lawsuit against Goldman.

The Gruelle family confirms that there was a point when Johnny Gruelle and Mollye Goldman may have been on cordial terms. So, it is possible, that Johnny, at one time, had prepared the Raggedy artwork for her, either likely before any litigation had begun or during the period directly preceding the judge's July 1936 opinion—evidence of some kind of strange, preliminary partnership, astonishing under the circumstances.

Unfortunately, there is little else to shed light on the genesis of the *Playthings* ad and any possible agreement between Gruelle and Goldman. What is true is that Mollye Goldman perpetually desired a positive (and profitable) connection with Raggedy Ann and Andy, in no way reflecting the reality of the ongoing litigation or the actual outcome of the at-times bitter *Gruelle vs. Goldman* lawsuit, which by spring of 1936 was hardly finished.

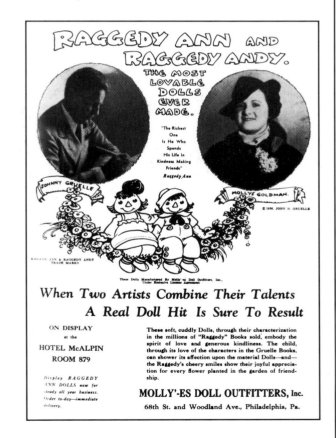

The Molly-'Es prototype Beloved Belindy doll. (Courtesy Patricia Smith)

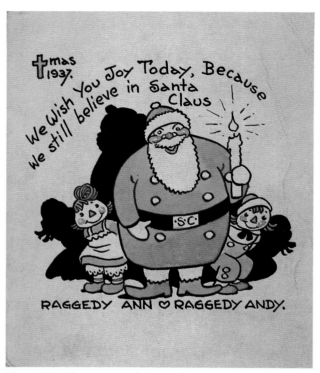

This 1937 Christmas card designed by Johnny Gruelle would be the last one the family would send before Johnny's untimely death. (Courtesy the Baldwin Library, University of Florida)

Doing his best to unwind during the Christmas holidays, Gruelle remained jittery and restless. Eating sporadically, he also found it difficult to sleep. After New Year's, Myrtle, Johnny, and their sons spent a few days relaxing and visiting together at Worth's home in Miami Springs.

On the evening of January 9, Myrtle Gruelle retired to her room to rest, leaving Johnny up talking to Dick. Suddenly, something roused her from her dozing. Sitting up quickly, she overheard a snippet of conversation from the living room. It was Johnny, speaking in a strange, low voice, offering to give Dick his favorite knife.

Galvanized by a bone-chilling premonition, Myrtle leaped from her bed. But before she could get from her room to where her son and husband had been talking, she heard Dick cry out. Then she heard a dull, heavy fall. Entering the room at the same time as Worth, Myrtle Gruelle found her beloved Johnny collapsed on the floor, dead of massive heart failure.

CHAPTER TWENTY

Goodbye, Uncle Johnny

Johnny had no regrets. There was an aroma of love all about him as he finally fell asleep. The mocking birds that he so loved, blessed the air outside. There was no darkness in that night. It was all light.

GEORGE MATTHEW ADAMS
January 1938

Though Johnny Gruelle had made a career out of making others laugh (or at least smile), among those who knew him best, there was unspoken consensus that Gruelle had died of a broken heart.

There was, of course, his very real, medically diagnosed heart condition. But, against the backdrop of his many successes, there were also the heartaches with which Gruelle had contended quietly. His daughter's untimely death; the retrenchments at the Volland Company; the more general, grinding pressures of the Great Depression—all lay as wounds on Gruelle's spirit. Ironically, Gruelle's Raggedys—those gentle, nostalgic souls created as an antidote for the stress of modern times—had been the very source of Gruelle's mounting, and ultimately fatal, stress as he fought valiantly to retain his rightful, legal ownership of them.

Gruelle's old friend from Silvermine, Clifton Meek, later remembered Johnny coming north for a visit during his last years. Though Gruelle talked an-

imatedly about the many fetes that filled his afternoons and evenings, Meek noted that Johnny (who had been trim and fairly energetic several years before) had appeared overweight and exhausted.

Meek dearly loved Gruelle and was especially struck by the irony of his friend's condition. Knowing that Gruelle had originally migrated to Florida in search of better health and professional rejuvenation, Meek had watched helplessly as Johnny innocently embraced the trappings and exhausting pace of the Florida social scene.

Many of Gruelle's friends wept openly when they learned of his death. But, recalling the many quiet promises she and Johnny had made to each other,

"The richest one is he who spends
His life in kindness making friends."

—Johnny Gruelle
1935

Everybody's Uncle Johnny. (Courtesy Jane Gruelle Comerford)

Myrtle would urge one of her husband's mourning colleagues, "Please do not sorrow for Johnny. His life was so fine and full. He has just gone on a fine journey, into a beautiful city, where he is greeted on all sides by those who loved him."

January 10, 1938 dawned sunny, but turned overcast by the time scores of Johnny Gruelle's friends and acquaintances arrived at the chapel of the W. L. Philbrick Funeral Home in Miami Beach to offer condolences to the Gruelle family. A service for Johnny Gruelle was conducted by Dr. Alisba A. King, pastor of the Miami Beach Community Church. Among the honorary pallbearers were Johnny's friends and fellow members of the Commit-

tee of One Hundred, J. A. Turrell, William Cheek, and Mark C. Honeywell.

Gruelle's death certificate would cite interment at St. Petersburg, Florida, but family members confirm that Johnny Gruelle's final resting place was in the little cemetery in Silvermine, Connecticut, where his daughter, Marcella, had been laid to rest nearly twenty-five years before. "Up North, across the road

"Johnny's passing was like his whole life; kindly, beautiful, always thoughtful of others, especially me. Our 38 years have been a beautiful lesson."

—Myrtle Gruelle
1938

A FRIEND DEPARTS

With the news of Gruelle's death came a flurry of heartfelt obituaries, appearing in national trade publications like *Publishers Weekly*, as well as in newspapers

Clifton Meek's newspaper farewell to Johnny Gruelle was accompanied by this original pen-and-ink rendering; one that Gruelle had given to Meek years before while both were still in Cleveland—a wistful portrait serving as Gruelle's own fitting farewell to himself. (Courtesy Jane Meek Diller)

all across the country. Each was an affectionate outpouring, commemorating a respected artist and author and a dearly loved man.

The Miami Herald's front-page obituary extolled Gruelle as a tireless worker, who always could find enough time to entertain his many friends, or present luncheon talks for the Committee of One Hundred. The *New York Herald Tribune* (which would continue to run Gruelle's "Brutus" strips until February 27, 1938, when they finally ran out of episodes) published an obituary highlighting Gruelle's long careers at both the *Herald* and *Herald Tribune*.

The Indianapolis Star honored its first staff illustrator on the January 10, 1938 edition's front page, noting Johnny's Hoosier origins, and his multiple contributions to the *Star*. Accompanying the piece were a pencil sketch by Gruelle of James Whitcomb Riley, the illustrated frontispiece of *Orphant Annie Story Book*, and a formal portrait of Johnny Gruelle, taken years before in an Indianapolis studio. In it Gruelle looked as many from Indianapolis likely remembered him: shy, pensive, and uncomfortable being before the camera.

By far the most moving and eloquent obituary memorializing Johnny Gruelle's life and career was written several weeks later by Gruelle's devoted lifetime friend and former protégé, Clifton Meek. Appearing in the *New Canaan Advertiser*, the piece was a reverent tribute, in which Meek extolled Gruelle as a friend and mentor. "He was," Meek wrote, "the soul of kindly helpfulness and constant encouragement."

To acknowledge the many condolences the family had received, Myrtle Gruelle and her sons sent out this simple, elegant card. (Courtesy the Lilly Library, Indiana University)

"Johnny shall carry on, and so shall I. . . ."

—Myrtle Gruelle
1938

from the country school we placed a small urn," Myrtle would write. "And, now the red maple I planted covers the whole plot with its bright red leaves. . . ."

With his sudden passing, Johnny Gruelle had left behind not only friends and family, but also an incredible legacy. His thousands of cartoons, which had probed and poked fun at a range of human foibles, had earned him devoted followings among the working class and elite alike. His comic pages and stories, rendered in a child's vernacular, had delighted countless little ones. His illustrations, ranging from the dreamy and romantic to the crisp and curvilinear, had graced dozens of books; inspired, captivating accompaniments to a whole host of tales.

But by far the most visible legacy was the one Gruelle had established years before, when he created his yarn-haired moppets—the Raggedys. Gruelle had always dreamed about launching new characters, ones he hoped might catch on and rival the popularity of his famed rag dolls. But during his final days Gruelle, in acknowledgment of his rag dolls' indisputable popularity, had devoted most of his time and creative energies to protecting and finding new venues for Raggedy Ann and Andy.

Myrtle, Worth, and Dick knew that, above all, it was the Raggedys that Johnny would have wanted to usher, with great fanfare, into the coming decades. Heavyhearted but clear-minded, the Gruelle family resolved to carry on.

But, as she looked ahead, Myrtle would have given a million dollars to have her life's companion—her sweetheart, Johnny—back at her side, if only for a moment, just to see him wink and hear him whisper in her ear again, "All for you, Kitten."

CHAPTER TWENTY-ONE

The Raggedys Carry On

With the wave of popularity for typical Americana, Raggedy Ann has come into her own in a big way. . . .

PLAYTHINGS
1941

When Johnny Gruelle died, Myrtle was devastated. ". . . My finest friend, lover, husband. I could not talk to him and I felt desperately alone," she would later confess. But, with the Molly-'Es lawsuit still fresh in her mind, Myrtle also did not intend to leave the business side of Raggedy Ann and Andy to chance. She quickly moved ahead with plans to protect and promote the legacy her husband had created.

On January 26—only two weeks after Johnny's death—Myrtle wrote to Bobbs-Merrill, requesting the return of plates and rights to *Johnny Mouse and the Wishing Stick* and *Orphant Annie Story Book.* "I will tell you why I want these . . . for Worth and Dick, our boys," she wrote. "Some time, maybe 20 or 30 years from now, they might want to publish their Dad's books."

Myrtle then turned her attention to her husband's Raggedy Ann and Andy dolls, and by year's end she had finalized an agreement to grant manufacturing rights to Georgene Novelties, a New York-based company specializing in character dolls. Named after its founding president, well-known doll designer Mme Georgene Averill, Georgene Novelties would begin producing its own whimsical version of Gruelle's Raggedys.

Meanwhile, Myrtle had been forced to contend with a problem she thought had been laid to rest. On March 4, 1938, Mollye and Meyer Goldman filed a petition for a writ of certiorari with the U.S. Supreme Court, apparently hoping for a reversal of the appeals court decision that would enable them to resume manufacture of dolls under the trademarks "Raggedy Ann" and "Raggedy Andy."

A very specific reason lay behind the Goldmans' request for an appeal. Less than one month before, Molly-'Es Doll Outfitters had been forced to file for bankruptcy. In short, the Goldmans were hoping that Raggedy Ann and Andy could help them raise the cash needed to pay off their many creditors.

But by April 1938, the Supreme Court had denied the Goldmans' petition; by June, Molly-'Es Doll

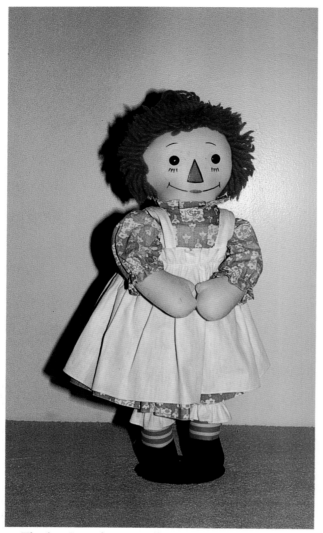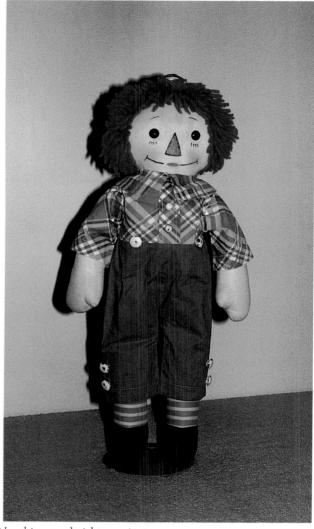

The first Raggedy Ann and Andy dolls produced by Georgene Novelties stood eighteen-nineteen inches tall, sporting ample reddish brown hair and a stenciled face with a red-orange triangle nose outlined distinctively in black. (Courtesy Pauline Baker)

Outfitters was also declared insolvent by the district court, its few assets to be sold privately. Among Molly-'Es' many unsecured creditors were the Gruelles, dating back to Johnny Gruelle's successful appeal and award of damages. Molly-'Es never paid the debt owed to the Gruelles (which, the record shows, amounted to at least $500, but could have been more). As long as she lived, Myrtle Gruelle could barely speak about the determined Philadelphia dollmaker who had blatantly and repeatedly tried to appropriate the Raggedys.

On October 2, 1939, Myrtle Gruelle, Richard Gruelle, and businessman Howard L. Cox filed a Certificate of Partnership with the state of New York,

to do business under the name "Johnny Gruelle Company." Cox (the former Volland salesman who had been a friend and advisor to the Gruelles during the 1930s) would participate as an investor and business partner.

Headquartered at 9 Rockefeller Plaza in New York City, the Johnny Gruelle Company's eventual aim was to oversee all trademarks and copyrights, as well as all publishing, motion picture, artwork, and licensing rights to Raggedy Ann and Andy and related characters. Additionally, the company would dip into the considerable store of Johnny Gruelle's serialized Raggedy stories—a stockpile that was far from being depleted.

Although the unauthorized Molly-'Es dolls were first to feature printed-on hearts, the Georgene Raggedys were the first authorized dolls to have hearts with the words "I Love You" printed in them—beginning an ongoing tradition for all subsequent authorized Raggedy dolls, regardless of manufacturer.

Beginning in 1939, and continuing during the next several years, the Johnny Gruelle Company issued five new Raggedy Ann books under its own imprint: *Raggedy Ann in the Magic Book* (1939); *Raggedy Ann and the Golden Butterfly* (1940); *Raggedy Ann and the Nice Fat Policeman* (1942); *Raggedy Ann and Betsy Bonnet String* (1943); and *Raggedy Ann in the Snow White Castle* (1946). All were edited compilations of Gruelle's serial stories, each featuring brand new illustrations by either Justin or Worth Gruelle. Eventually the Johnny Gruelle Company would acquire back from Donohue the plates for nine of Gruelle's Raggedy Ann books done for Volland, and would reprint those as well.

During the next several years, the Johnny Gruelle Company also began licensing dozens of consumer goods, ranging from building blocks to balloons to bed linens to baby toys—all bearing the Raggedys' likenesses. By late 1940, the Raggedys would be starring in their own animated cartoon, long one of Johnny Gruelle's dreams.

By spring of 1941, the Gruelle Company had enlisted William C. Erskine (formerly with Walt Disney) to manage its licensing. The Gruelle Company had mapped out a two-year advertising and publicity plan, based on the already brisk sales of authorized merchandise. Many retailers were planning coordinated Raggedy product promotions. Raggedy Ann

and Andy were proving themselves to be a commercial growth industry.

Then, in December 1941, the American fleet at Pearl Harbor was bombed, thrusting the United States into another war. Although the Raggedys were proven survivors, the question remained: could Gruelle's whimsical rag dolls weather another social and economic upheaval?

In fact, wartime did bring many changes to the playthings marketplace, and the Raggedy Ann and Andy licenses would be more important than ever as a financial underpinning for the Johnny Gruelle Company. Throughout the war, Georgene Novelties (producer of authorized Raggedy Ann and Andy dolls) and M. A. Donohue & Company (manufacturer of authorized reprints of select Raggedy Ann books) continued as cornerstone licensees. These earnings were augmented by several dozen other licensees, including Milton Bradley/McLoughlin Bros.; Saalfield Publishing Company; Dell Publishing Company; the Halsam Safety Block Company; Holgate Brothers; and even the P. F. Volland Company, which continued to produce Raggedy Ann and Andy greeting cards. Many licensees enlisted Johnny's son Worth and brother, Justin, to provide the whimsical, expert artwork that graced products ranging from books to board games; coloring books to puzzles.

By fall 1943, changes were afoot at the Johnny Gruelle Company. On October 1, the company partnership was officially dissolved, Richard Gruelle and Howard Cox assigning back to Myrtle Gruelle all rights previously shared as company copartners. Myrtle granted Cox the sole and exclusive right to use (and license others to use) the Raggedy Ann and Raggedy Andy characters, in any form except stuffed rag dolls (which Myrtle would continue to oversee and license directly). In this new arrangement, Myrtle retained ownership and control of the Raggedy rights and properties (receiving royalties on published works and licensed products) but, henceforth, Cox would manage the Johnny Gruelle Company as his business. Ultimately, it was up to the affable, outgoing Cox to see that the Raggedys remained available to their adoring public.

During the 1940s, Georgene Novelties added a twelve-inch double-faced "Awake-Asleep" Raggedy Ann and Andy to its line, eventually introducing its own versions of Gruelle's Beloved Belindy and Camel with the Wrinkled Knees character dolls. It

THE
GRUELLE IDEAL

It is the Gruelle ideal that books for children should contain nothing to cause fright, suggest fear, glorify mischief, excuse malice or condone cruelty. That is why they are called

"BOOKS GOOD FOR CHILDREN."

At the end of some of the earliest books produced by the Johnny Gruelle Company, on an otherwise unadorned last page, appeared this familiar watchword—a near-verbatim borrowing of what, years before, had been the P. F. Volland Ideal. (Used by permission of Macmillan Publishing Company)

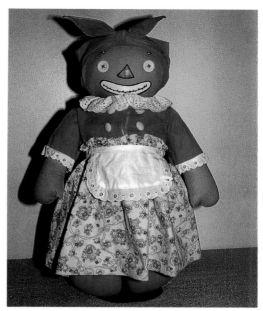

By 1941, Georgene Novelties was producing its own version of Gruelle's Beloved Belindy. (Courtesy Pauline Baker)

During the 1940s, Georgene Novelties was licensed by the Johnny Gruelle Company to manufacture a Gruelle character doll that had never before been commercially produced: the Camel with the Wrinkled Knees. (Courtesy Pauline Baker)

seemed that this generation of parents, themselves raised with the Raggedys, had created a new wave of popularity for Gruelle's characters.

In 1945, following the end of the war, Myrtle Gruelle remarried for a brief time, her married name (Myrtle Gruelle Silsby) appearing on some of the Georgene doll tags. By the late 1940s, the Johnny Gruelle Company was still overseeing several dozen licensees. By decade's end, cumulative sales of Johnny Gruelle's Raggedy Ann books stood at 7,000,000, nearly 2,000,000 of which had sold in the twelve years since Gruelle's death.

In comparison to the forties, the fifties would be a quiet decade for Gruelle's little rag dolls, consumer preference leaning to more realistic playthings. Though the Gruelle Company continued reprinting books in the Raggedy Ann series during the 1950s, it issued no new Gruelle material under its own imprint. And, the number of Johnny Gruelle Company licensees had slowly dwindled. In April 1956, the Gruelle Company sold television rights to the Raggedys to Robert Keeshan (otherwise known as Captain Kangaroo)—most likely an attempt to increase the dolls' visibility. But, by 1959, Howard Cox had moved the Johnny Gruelle Company from his office in the Time-Life Building in New York City to a re-

modeled garage on his farm in Princeton Junction, New Jersey.

Though in 1956 she had traveled back to Ashland, Oregon to visit old friends, by the decade's end, Myrtle Gruelle was not feeling as well as she once had. Well past her seventieth birthday, she began considering other business options for Raggedy Ann and Andy.

On June 20, 1960, three contracts were executed that would again alter the course of the Raggedys' business history. In effect, these three documents transferred to the Bobbs-Merrill Company of Indianapolis the entire right, title, and interest in the trademarks "Raggedy Ann" and "Raggedy Andy," giving the company the sole and exclusive right and license to use and sublicense others to use the Raggedy Ann and Andy characters.

Though Howard Cox would continue to receive an annual sum as long as existing publication licenses were in effect, the arrangement transferred direct control of the business of Raggedy Ann and Andy to Bobbs-Merrill, a large company well equipped to handle the dizzying task of marketing the Raggedys. It promised to be a brand new era for Raggedy Ann and Andy.

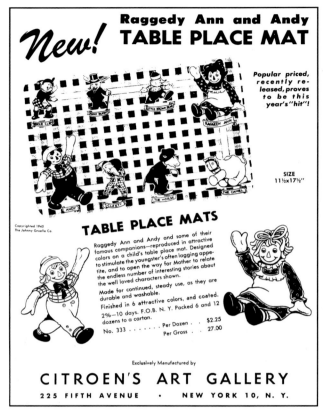

During the war, the Citroen Art Gallery in New York City was among the many licensees of the Johnny Gruelle Company authorized to produce products bearing the Raggedys' images. (Courtesy Arnold Citroen/Julie Duikjer)

This set of Crooksville china dishes was among the many Raggedy Ann and Andy products licensed during the 1940s by the Johnny Gruelle Company.

As well as making business sense, there was a certain bittersweet irony in the Gruelle family's new association with Bobbs-Merrill—the selfsame "good ole Hoosier out-fit" with which Johnny, for much of his career, had so wanted to establish an ongoing relationship.

Working directly with company president M. Hughes Miller, Myrtle, Worth, and Richard got down to business, and by fall of 1960, Bobbs-Merrill (then a division of the Howard Sams Company) had reprinted fourteen of the original Raggedy Ann and Andy titles, each issued in a dust jacket and retailing for two dollars.

Earlier that summer, Bobbs-Merrill had also set its editors to work on turning yet another sheaf of Gruelle serial stories into four new books: *Raggedy Ann and the Hobby Horse, Raggedy Ann and the Wonderful Witch, Raggedy Ann and the Golden Ring,* and *Raggedy Ann and the Happy Meadow.*

By June 1961, Bobbs-Merrill had contracted with Worth Gruelle to furnish forty color and black-and-white illustrations and a full-color jacket for each of the four new titles. To help him meet his tight deadline, Worth enlisted his eighteen-year-old daughter, Joni, to help with the coloring work. By fall, the presses were rolling, the four new books complete and on display in bookstores throughout the country in time for the mad rush of Christmas shoppers. These were the first *new* Gruelle-authored Raggedy Ann books to be published in fifteen years.

By 1962, more than 15,000,000 Raggedy Ann and Andy books had been sold; a sizable number of these were the new Bobbs-Merrill editions. Knowing that more than $50,000,000 of Raggedy Ann-related merchandise had sold since the 1920s, Bobbs-Merrill had also begun actively recruiting new licensees.

The expiration of Georgene Novelties' license in the early 1960s had given Myrtle Gruelle the opportunity to explore an expanded market for Raggedy dolls, whose rights she administered directly. When she and her sons first visited the Knickerbocker Toy Company's shiny new plant in Middlesex, New Jersey, and talked with the company's energetic and visionary president, Leo White, they knew they had found the right manufacturer.

Believing that the public would respond best to a new doll that looked like one they already knew and loved, Knickerbocker proceeded slowly with changing Raggedy Ann's and Andy's design, subtly modifying the dolls' faces with approval and input from the Gruelle family. Over the next few years, Knickerbocker would increase production of Raggedy Ann

and Andy dolls several hundred percent over what Georgene had been able to do.

The year 1965 marked the fiftieth anniversary of Raggedy Ann's original patent and trademark. Celebrations, which began during Thanksgiving week 1964, took the form of Raggedy Ann birthday parties in Easter Seals centers in forty-three states, organized by Myrtle Gruelle. At one, held at the Crossroads Rehabilitation Center in Indianapolis, Johnny Gruelle's cousins, Carl and Marion Gruelle, presided. About the celebrations Myrtle observed: "I thought it would be more in the spirit of Raggedy Ann to have parties for all those children than to throw some kind of lavish birthday party for us."

In honor of Raggedy Ann's fiftieth birthday, Knickerbocker gave her a special present: a pocket handkerchief, to be henceforth placed into the apron pocket of every doll. And, by this anniversary

year, more than 20,000,000 Raggedy Ann and Andy books had sold worldwide (5,000,000 copies being Bobbs-Merril reprint editions) and more than fifty different licensed products bearing the Raggedy image or logo were on the market.

The Raggedys had also ascended to international fame. In 1966, in honor of Monaco's Centennial, Princess Grace ordered hundreds of Raggedy dolls to decorate the Royal Palace; homespun reminders of the princess's own American roots. In 1967, Raggedy Ann and Andy were featured in the Montreal Expo '67's American Pavilion, billed as "the most popular dolls ever sold in the U.S." That same year, *Life* magazine deemed Raggedy Ann to be the classic American folk doll.

As the Raggedys' visibility in the marketplace increased, Myrtle Gruelle was contending with deteriorating health. Several years before, she had been

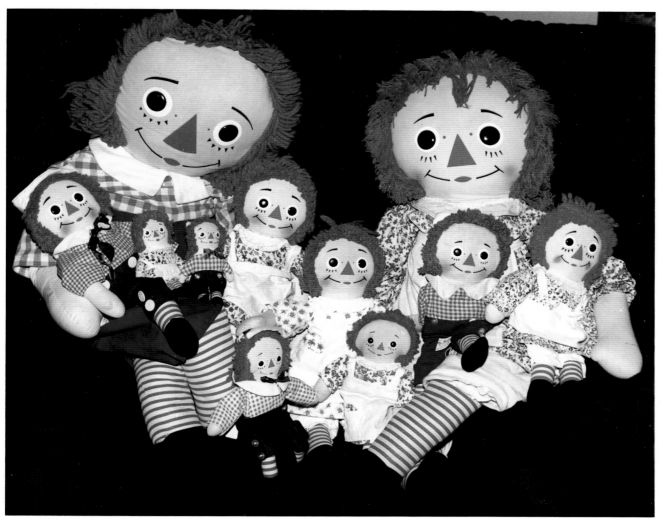

A gaggle of Knickerbocker Raggedys, manufactured in the 1960s and 1970s.

diagnosed as having Parkinson's disease, which was progressively debilitating. Though she did her best to keep up with her many civic activities, interviews, and the painting she had taken up several years earlier, she eventually succumbed to her illness. On April 25, 1968, at the age of eighty-three, Myrtle Gruelle died.

To the end, Myrtle Gruelle had been a shrewd and steadfast crusader for her husband's rag dolls. Despite her illness, she remained spirited and good-natured, never letting her growing physical disabilities stand in the way of her work. Both a gracious lady and a smart businesswoman, Myrtle had never lost her belief in positive thinking.

Myrtle's passing left the job of overseeing Raggedy Ann and Andy's substantial legacy to Worth and Richard. Bobbs-Merrill would continue reprinting Gruelle's books and granting licenses for Raggedy books and toys, and the Gruelle brothers would, as

In 1981, Kim Gruelle opened The Last Great Company in Cashiers, North Carolina—a memorable and magical shop offering not only works of art, but also good old-fashioned toys and handpicked traditional Raggedy Ann and Andy books and dolls.

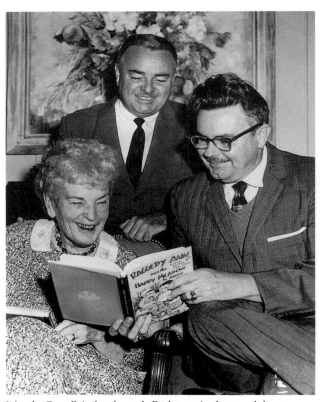

Myrtle Gruelle's battle with Parkinson's disease did not keep her from being a devoted and articulate spokesperson for the dolls her husband had created. Myrtle poses here in the early 1960s with sons Worth and Dick. (Courtesy The Miami Herald)

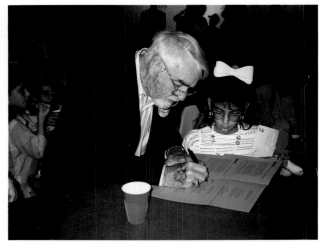

Continuing a tradition his father began, Worth Gruelle inscribes a program for a young fan at the 1989 reinstallation of the Original Raggedy Ann and Andy dolls at the Coral Gables Public Library, Coral Gables, Florida. (Photograph by Arnie Klein)

In 1941, Fleischer Studios enlisted Worth Gruelle as a cowriter for "Raggedy Ann and Raggedy Andy," a full-length Technicolor cartoon full of fanciful motifs that Johnny Gruelle himself would have approved of. (Courtesy Cleveland State University Library)

Myrtle had done, directly authorize the Raggedy Ann and Andy dolls. It was up to Johnny and Myrtle's two sons to sustain what they, themselves, would term the Raggedys' traditional, homespun essence, in the context of a very commercial, very competitive playthings marketplace. Though more expansive, it was the selfsame challenge that Johnny Gruelle had faced in his own lifetime.

During the 1970s, Bobbs-Merrill would be aquired by ITT, and Knickerbocker Toy Company, by Warner Communications. By the early 1980s, both companies would be gone. The Bobbs-Merrill trade division would be purchased by Macmillan, Inc., which would, henceforth, be the assignee of book copyright and trademark rights to Raggedy Ann and Raggedy Andy, and was also empowered to grant merchandise licenses. As always, the Gruelle family would continue to authorize production of the Raggedy Ann and Andy stuffed rag dolls, which, by the early 1980s, were being produced by Hasbro Industries,

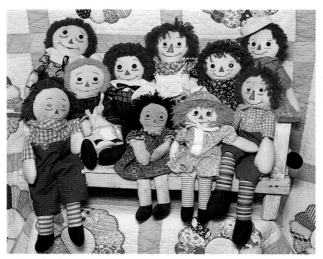

Through the years, home seamstresses have crafted their own versions of Gruelle's Raggedys, each possessing its own style and charm. (Courtesy Barbara Barth; photograph by Audrey Frank)

Inc. and Applause, Inc. (formerly Wallace Berrie).

With attendant surges and lulls (related to the economy and marketing) the Raggedys continue today, holding their own as popular contenders in the playthings marketplace; an important and historically relevant accomplishment in light of the fact that Johnny Gruelle originally created his dolls and books as salable commodities—characters possessing gentle, traditional attributes, but commodities nonetheless.

Without a doubt, Raggedy Ann and Raggedy Andy have survived multiple social and economic changes, enduring as popular, visible symbols of American childhood. Curators, collectors, and armchair psychologists have attributed the Raggedys' tenacity to a cyclical quest for things that are soft, safe, and nostalgic. Others agree that Gruelle's rag dolls have always been icons of stability, symbolic of love and nurturance.

Like many American folk heroes, the Raggedys' ongoing, international popularity has perhaps been best fostered by the many legendary tales in which they star as fearless and kindly ringleaders—fanciful accounts that sound just real enough to be true. For those wanting to go beyond the sales figures to discover the secrets behind the Raggedys' long life, the stories of magic and make-believe provide the vehicle. Being the yarnspinner from whose imagination the tales flowed, Uncle Johnny would not have wanted it any other way.

"There has been an upward trend since around 1968. I think it's related to the nostalgia business—Raggedy Ann is part of Americana."

—Leo Gobin
President, Bobbs-Merrill Company
March 1977

CHAPTER TWENTY-TWO

From Whence the Magic Came: Johnny Gruelle and His Muses

May all the songs of life be sunny songs.

JOHNNY GRUELLE

When young Johnny Gruelle took his first newspaper job, scratching out his work on crude chalk plates, the painstaking, stiff little drawings that resulted looked as if they might have been drawn by almost anyone. However, the limits of the medium belied Gruelle's artistic gift. When he finally had the chance to work in pen and ink, he blossomed, and his artistic improvement could be measured week against week. Within months, he was producing expert cartoons, and several years later was working in color. In 1910, when he bested 1,500 other entrants, clinching the coveted $2,000 prize and a position at *The New York Herald,* he had only been cartooning professionally for nine years.

Gruelle's rapid development into a skilled artist grew from a deep yearning and much practice. Though he may have begun with a "native" talent (some would claim, inherited from his artist father, R.B.) he had to work resolutely on improving himself.

Gruelle's choice of a cartooning career may have seemed worlds apart from the fine-art world of his father. However, it was from R.B. that Johnny learned the importance of technique, working diligently on perfecting his own style until, finally, in the words of longtime associate Howard Cox, "drawing came as naturally as breathing to him."

Cartooning gave expression to Gruelle's ironic view of the world. Had he wanted to, Johnny could have remained an editorial cartoonist for his entire career, and, no doubt, he would have been embraced as an esteemed member of that profession. But Johnny Gruelle had a bigger dream. Newspaper cartooning was but one step on a ladder leading to broader, more permanent entertainment venues.

Like other artists before him, Gruelle used newspaper cartooning as a training ground before seeking an entrée with magazines. Fortunately, it was at a time when magazine illustrators were gaining name

recognition, and magazine work could be lucrative indeed for the talented and prolific.

Magazine illustrating was, in turn, a good way for an artist to break into book illustrating. Gruelle knew this, and as he took this next step in 1914, he rode the crest of a period later referred to by art historians as "The Golden Age of American Illustration." By the late teens, Gruelle was not simply producing technically excellent drawings and watercolors; he was doing so prodigiously, and with remarkable facility. Gruelle's younger brother, Justin, at one time marvelled over the apparent ease with which Johnny worked, noting: "There seemed to be no impediment between thought, conception, and the final result. Most artists do a lot of agonizing over their work (I speak from experience). His years of experience at newspapers, no doubt, helped Johnny achieve this immediacy. It was remarkable."

Gruelle's son Worth recalls his father eventually being so sure of himself artistically that often he would not even lay out a piece in pencil first: "He'd visualize it—then draw it—his penwork was amazing." This facility served Gruelle well in terms of output, though, like any illustrator, his work varied. There would be a few sets of commissioned illustrations—most likely produced under tight deadlines—that clearly were not as inspired or technically good as Gruelle's others, suffering from careless linework and hasty coloring.

As experienced as he became, and as easily as artistic expression seemed to come to him, throughout his career Gruelle stayed in a learning mode, picking up techniques, styles, and popular formats. He was an astute observer, finding inspiration in magazines, at art shows, and in fairy-tale books illustrated by the likes of Arthur Rackham and others.

But Gruelle's various illustrating styles, as they developed, were very much his own. His pastoral fairy-story settings featuring hook-nosed magicians and velvet-skinned princesses; the bright, chaotic scenes of his loppy Raggedys cavorting in the Deep Deep Woods; or the multitudes of bustled-and-bearded folks that paraded across his bird's-eye-view cartoons—all were unmistakably Gruelle. Distinctive and original, his illustrations possessed, in the words of animation historian Donald Crafton, ". . . a clean, curvilinear style that looked ahead to the Disney graphics of the 1930s."

Many of Gruelle's illustrations contained not only elements of make-believe, but also familiar visual motifs borrowed from real life. Art historian and early childhood educator Carol Sullivan notes: "Gruelle's typical domestic scenes include casual family portraits on walls, unusual clocks, gaudily and gaily decorated Art Deco flowered rugs and draperies, large patterned pastel easy chairs (the American husband's throne), and the crazy quilts made of the marvelous new patterned materials introduced in the twenties."

As successful as he became as a book illustrator, Johnny Gruelle never completely gave up his first career as a cartoonist. Even in the late 1930s, when he was juggling other commissions, Gruelle was still drawing his "Brutus" cartoon for the *New York Herald Tribune,* and continued producing his "bird's-eye-view" cartoons—those nostalgic caricatures of one-horse-town crossroads populated by country bumpkins.

The evolution of his work, from awkward scratchings on chalk plates to the fluid pen-and-brush creations of his later books, entitled Gruelle to take his place in the inner circle of the century's best illustrators. Certainly it was as an artist and illustrator that he seemed to be the most inspired, producing his best and most memorable work. In his heart of hearts, Johnny Gruelle was, first and foremost, an artist.

However, for Gruelle, that was not enough. He also fancied himself an entertainer. In his quest to reach his public in as broad a fashion as possible, Gruelle had, early on, also begun developing himself as a writer. Curious about the potential (financial and otherwise) of writing, by the time he was settled in Cleveland, Johnny was already penning short illustrated stories for children.

Gruelle's decision to write *and* illustrate was partly market-driven, prompted by the discovery that he could earn more (in salary and reputation) by submitting illustrated tales than he could simply illustrating someone else's work. But, beyond the marketplace, it was Gruelle's own love for storytelling, and his innate grasp of what made a good tale, that attracted him to writing. Throughout his life, Johnny Gruelle never lost his childhood affection for the well-spun yarn.

He had grown up in Indiana during a time when the novels and poetry of the Hoosier state were, in the words of art historian Judith V. Newton, "rustic,

romantic, and often full of nostalgia." Many American writers and poets were celebrating their own sense of region, their provincial sketches appearing in large-circulation magazines intended for urban audiences, who were hungry for depictions of life in the country or the good old days. The Hoosier writers were participants in this, which would later be referred to as the "local color movement."

The Gruelle family's personal friendship with Indiana poet James Whitcomb Riley quite literally brought home for Johnny Gruelle the essence of regionalism, rural values, and love of times past. Besides celebrating the richness of Midwestern natural surroundings, Riley's verse portrayed good, common folk (hired hands, orphans, and the kindhearted souls who took them in) and, most importantly, extolled their ethics. Many of these attitudes, values, and literary images showed up later in Johnny Gruelle's own writings, in picturesque portrayals of down-to-earth characters (or critters) possessing the time-honored traits of honesty, caring, and kindliness.

Gruelle was also influenced by his father, who had authored the book *Notes: Critical and Biographical* as well as occasional art critiques for *Modern Art* magazine and *The Indianapolis News*. For a man with so little formal schooling, R.B. had developed a writing style that, while leaning to flowery description, was clear and intimate. From it, Johnny gleaned the importance of writing from the heart, and with flair.

Johnny Gruelle's work as a political cartoonist had trained him to extract storytelling inspiration from his surroundings. He became a master of capturing, combining, and processing the more elusive kinds of inspirations—snippets of events witnessed, phrases overheard, funny toys noticed in a shop window, even memories of his own childhood. His Raggedy Ann stands as but one example of how Gruelle could skillfully combine multiple inspirations into an integrated, original character.

Some of Gruelle's richest sources of literary inspiration were the traditional European folktales, which his wife, Myrtle, would often read aloud to him while he worked. Many of Gruelle's early stories (including those in his *My Very Own Fairy Stories* and *Friendly Fairies* volumes) were patterned after these traditional tales. In them, Gruelle incorporated multiple folktale motifs—those formulaic plot details and characterizations that appear repeatedly in folktales.

Among the motifs Gruelle liked best, and used often, were "Helpful Animals" (nonhuman characters who played the role of facilitator or assistance-giver); "Helpful Dwarves or Fairies" (fey critters who assisted the protagonists in their quest or mission); and "Magical Objects" (the various wishing pebbles, wishing sticks, magic burning sticks, left-handed safety pins, magic swords, lucky pennies, and golden rings, each of which could replicate themselves for deserving souls; could withhold their powers from the wicked; and if stolen or lost, could find their way back to their rightful owners).

By far, Gruelle's favorite folktale motif was the one called "Inexhaustible Food." To the delight of his little readers, Gruelle incorporated this motif in hundreds of his stories. His countless mouth-watering descriptions of bottomless soda-water fountains, rich ice-cream mud puddles, magic replenishing pancakes, and wild hot weenie trees were all distinctly American versions of the steaming porridge, fresh bread-and-cheese, and succulent game found in many of the European folktales.

Gruelle did not stop with the Americanization of his tale motifs; he did so with his settings as well. In *Raggedy Ann and Andy and the Camel with the Wrinkled Knees* (1924) Gruelle introduced a secret storybook setting—far from the probing eyes of mortals; perfect for the magical doings of his dolls and creatures. He called it the Deep Deep Woods. In the words of the late Martin Williams, "Gruelle's Deep Deep Woods is a very American enchanted place, by which I mean it is a singular combination of European elements and ones that he made up himself, using a very American imagination."

Gruelle infused his writings with zany words and names like *Dingbat* and *Boon Doggle*—ones he knew children would recognize, but which he humorously applied in his stories to people, places, or contraptions. Other words (like *Whangwhizzle* and *Whirligig-Boom*) were nonsensical creations, much like ones children or parents would have made up themselves.

Gruelle bestowed whimsical, alliterative names on his many characters: Maurice Mouse, Georgie Gray Squirrel, and Louey Lightning Bug were but a few. Other character names, like Snoopwiggy and Wiggysnoop, though nonsensical sounding, were inspired by real life—in this case, by Gruelle's twin terriers, Wiggy and Snoopy.

Gruelle's native innocence and connection with childhood colored not only his inspirations, but the ultimate style of his writing. "His conception of what would be interesting to a child is as near perfect as such things ever get to be," wrote a journalist in the 1930s. "He has the faculty of getting his characters into absurdly unreasonable situations, but he gets them there in what appears to be a logical manner, and gets them out without taxing the credulity of his young audience too much."

Though a somewhat ambivalent oral storyteller (his own shyness waging war with his urge to entertain), Gruelle loved the process of spinning tales with an ironic twist. Pervasive in all of his writings — from his very first magazine short stories to his later Raggedy Ann and Andy books — were the many humorous elements that welded together the sometimes intricate plots. Often these were subtle details or funny characterizations. Gruelle delighted in using these little twists and special effects to make a good tale better.

Driven by his own strong moral sense and feel for the marketplace, Gruelle made it his business to include in each story deeds of kindess and goodness, contrasted against semi-evil characters who, for all of their bad traits, were never quite beyond eventual reformation or redemption.

It is difficult, indeed, to find any sources describing Johnny Gruelle as anything but a kind, gentle, ethical man, very much in touch with the make-believe world of his primary audience. Martin Williams, author of an excellent critical piece on Gruelle, saw Gruelle's life as pervaded by a certain "moral innocence," and cites it as both the virtue and limitation of Gruelle's writings.

Whereas Gruelle's motifs, plots, and characters were geared to children, he was also writing for another audience; those people who would most likely be reading his stories aloud — adults. Gruelle couched much humor in double entendres that would make both children and adults laugh, for completely different reasons. He also frequently included plot elements to draw the adults into a gentle author-reader conspiracy about "keeping up the front" of magic, fairy doings, etc. Acknowledging both audiences, Gruelle wrote using the simultaneous voices of the age-old sage and wide-eyed child.

Gruelle knew that the ethics conveyed in his writings had to appeal to adults, fitting with whatever current childrearing practices were in the forefront. In his desire to write not only morally sound tales, but also salable ones, Gruelle carefully incorporated portrayals of the ideal child, filling his stories with clean, well-mannered, orderly boys and girls who respected their parents, learned from their elders, and reflected the highest virtues.

Like his artwork, Gruelle's literary style evolved over time. His first magazine stories were formal and wordy — understandable in light of the fact that at the time, Gruelle was just breaking away from the constraining ballooned dialogue of his comic pages. In only several years, Gruelle became adept at moving his protragonists smoothly through a variety of scenes and settings.

By the early 1920s, Gruelle was creating short, make-believe tales (like those in his Raggedy Ann books) and adventure stories (like his *Magical Land of Noom* and "Cruise of the Rickity-Robin" serial), which allowed for more robust presentations of morals, as well as inclusion of educational "gems" about science, nature, geography, and civics.

By the mid- to late 1920s, the quality of Gruelle's prose began to vary. Some say that this happened when Gruelle's two young sons, Worth and Dickie, became too old to serve as listening posts for his unpublished stories. Though Myrtle would continue to read Johnny's stories back to him, Gruelle no longer had his in-house juvenile critics on whom to "test" new material.

But something else had happened as well. In 1922, Gruelle had begun creating serialized Raggedy Ann stories for newspapers, sometimes at the rate of five or six chapters per week. By 1925, he was already compiling these into Raggedy Ann books, with very little editing. While his earlier books had boasted distinctive, fast-moving plots, these later books possessed a sameness in theme, setting, and characterizations. For better or worse, this literary recycling of his newspaper serials enabled Gruelle to produce his later Raggedy books quickly and on demand.

During the teens, twenties, and thirties, Johnny Gruelle's books were reviewed in newspapers and other popular venues. These descriptive articles seldom made critical judgments of Gruelle's writing. Instead, his books were treated as the P. F. Volland Company intended them to be: bright, cheerful gift items, with an uplifting moral. "An excellent book

Dr. Seuss

7301 Encelia Drive
La Jolla, California 92037

June 28, 1990

Dear Patricia Hall,

For some inexplicable reason I grew up
without knowing anything about Raggedy
Ann and Andy, or any other children's
stories by Johnny Gruelle.

I am, however, deeply indebted to him
for his satirical "bird's eye view"
cartoons in Judge and Life during the
teens and twenties. They really
excited me.

To this day, anytime I start to draw
a great big picture jam packed with dozens
of characters doing this-and-that, going
which-way and what-way, I nervously say
"Here, hopefully, comes a Gruelle."

When I'm finished, if I'm successful, I
bless his memory and thank him for his
help. But more often I say to myself I
shouldn't try this sort of thing. No
one can do it properly, but the master of
well-balanced uncluttered clutter,
Mr. Johnny Gruelle.

Best wishes,

Dr. Seuss

Theodor S. Geisel

Theodor Geisel, better known as Dr. Seuss, acknowledged how Johnny Gruelle's work had inspired him. (Courtesy
Audrey Geisel)

for the younger children . . ." or ". . . it is a book to delight any child . . ." were among the typical statements in these reviews.

Librarians and teachers during the twenties and thirties (and in subsequent decades as well) used Raggedy Ann and Andy books in their classrooms. Many corresponded with Volland, and with Gruelle, expressing delight with his books. But, during those and subsequent years, Gruelle's books seldom received any attention in library or children's literary review journals.

Mention of Johnny Gruelle's books or his life and career are still rare in the presently available textbooks devoted to the history of twentieth-century children's literature; his acknowledgment limited, at best, to a mention of his work as an illustrator.

When asked about the Raggedy Ann books, some present-day children's librarians react to the anachronistic qualities of Gruelle's prose, feeling that his works stand up best when viewed as gentle relics from a bygone era. One reviewer, commenting during the late 1970s, felt that Gruelle's emphasis on the gentler virtues—cornerstones of the Raggedy Ann tales—made the books "period pieces" to contemporary readers while also pointing out that Gruelle's artwork seemed more current, due to a revival of rag dolls.

Another reviewer (in England), in discussing a reprint of several Raggedy books, was not exactly smitten by Gruelle's prose, but pointed out the timeless quality in a rag doll who possessed magical attributes. "Children of any generation, even those sated with television marvels, might imagine for themselves just such a quaint, squashy figure as Raggedy Ann with her submissive consort Raggedy Andy, her candy heart and her magic pebble safely hidden in her stuffing and her awkward habit of splitting the stitches in her head when she thinks."

However, critical assessments of Gruelle's work often reflect the background and context of the critic. John Cech, professor of English and children's literature at the University of Florida, sees Raggedy Ann as a pervasive part of American cultural life, and observes several reasons for Johnny Gruelle's cool reception by librarians and children's literature scholars. Cech suspects that the age-old prejudice against (and jealousy of) commercial success (which is thought to somehow "taint" and otherwise dimin-

ish the quality of worthy products) might apply in Gruelle's case. "He may have been overlooked by the mainstream because his books were so commercial in so many ways, and the mainstream of children's literature studies tends to eschew the commercial."

Referring to the many venues Gruelle used to disseminate his images of Raggedy Ann and Andy, Cech observes: "I think Gruelle may have suffered from being associated with greeting cards and other commercial things."

In fact, Gruelle's primary affiliation with P. F. Volland—a purveyor of gift items (as opposed to being a trade publisher)—practically ensured that his Raggedy Ann books would be kept outside the mainstream of what would have been marketed to librarians and educators as "acceptable" and "reviewable" literature, published by a well-known trade house.

Martin Williams attributed Gruelle's lack of recognition to his prolific output and the attendant variations in the quality of his prose. Comparing Gruelle to Thornton Burgess and others who wrote newspaper and magazine stories featuring characters they had originated, Williams observed: "Take any popular artist. It's very rare that you get anybody writing on a generally high level most of the time the way Shakespeare did. . . . I think it's true of most prolific people. . . . It's true for Gruelle, as it's generally true of great numbers of our artists in the country, especially those who work in original American genres. . . . He [Gruelle] was making a living turning out stuff and he had a talent for turning out stuff. And, when you work in a public idiom, you do have to grind it out." An unabashed Gruelle fan, Williams further observed about Gruelle's stories: "I think the best ones are not only wonderful, but unique in children's literature."

Critical opinions notwithstanding, Johnny Gruelle is slowly finding his way into more and more literary and artist reference works. And, letters written to the Gruelle family by hundreds of children and adults, teachers and librarians, collectors and fans enchanted by Johnny Gruelle's prose and illustrations continue to come in annually, from around the world, standing as testimonials. The fact is, after seventy-five years, Johnny Gruelle and his loppy, lovable Raggedys are still able to "speak" to new generations as they head into a very modern twenty-first century.

APPENDIX A

Johnny Gruelle's Books: A Checklist

This appendix lists all published books written and/or illustrated by Johnny Gruelle that are known to the author. Information was gathered from multiple published and unpublished sources; among them, the author's Gruelle collection, other private book collectors, antiquarian booksellers, the Library of Congress, the National Union Catalogue, records of the U.S. Copyright Office, selected publishing company records, and numerous libraries, archives, and special collections.

The checklist documents book-length works, including hard-and soft-cover books, pamphlets, booklets, and song folios. The checklist is divided into six parts: books written and illustrated by Gruelle, books written by Gruelle but illustrated by others, books by other authors featuring illustrations by Gruelle, adaptations attributed to Gruelle, reprints (compendia) of Gruelle's works, and other Raggedy Ann and Andy books of interest (i.e., licensed works written and illustrated by individuals other than Gruelle). Entries include brief annotations that should prove useful to the scholar or collector.

In using this checklist the reader should note that only inaugural (not subsequent) copyright/publication/reprint dates are noted when known. Unless otherwise noted, Johnny Gruelle is the illustrator. Symbols/initials used refer to the following:

*—part of a larger compilation
\#—abridgment or chapter excerpt(s)
(VSB)—A Volland "Sunny Book"
(VHCB)—A Volland "Happy Children's Book"

Books Written and Illustrated by Johnny Gruelle

Mr. Twee Deedle (Cupples & Leon, 1913).
Reprints: McKay (n.d.).
Selected "Mr. Twee Deedle" comic pages, originally

published in *The New York Herald.*

Mr. Twee Deedle's Further Adventures (Cupples & Leon, 1914).
Reprints: McKay (n.d.).
Selected "Mr. Twee Deedle" comic pages, originally published in *The New York Herald.* Cited on several collectors' checklists, but not documented.

The Travels of Timmy Toodles (A John Martin "Jolly Book," John Martin's House, 1916).
A compendium of Gruelle's six "Timmy Toodles" stories, originally published in *John Martin's Book.*

My Very Own Fairy Stories (P. F. Volland Company, 1917) (VHCB).
Reprints: Donohue (1930s), Johnny Gruelle Company (1940s), Bobbs-Merrill (1960s).
Twelve illustrated fairy stories about children, magic, and a nursery full of dolls.

The Funny Little Book (Volland, 1918) (VSB).
Reprints: Donohue (1930s).
An illustrated tale about a whimsical little wooden family.

Raggedy Ann Stories (Volland, 1918) (VHCB).
Reprints: Donohue (1930s), Johnny Gruelle Company (1940s), Bobbs-Merrill (1961), Dell (1977), # * Wonder (1960), # Avenel (1967), # Franklin Watts (n.d.), # Derrydale (1988), * # Derrydale (1991).
Twelve illustrated tales in which Johnny Gruelle introduces his Raggedy Ann.

Friendly Fairies (Volland, 1919) (VHCB).
Reprints: Donohue (1930s), Johnny Gruelle Company (1940s), Bobbs-Merrill (1960).
Fifteen original illustrated fairy stories.

Little Sunny Stories (Volland, 1919) (VSB).
Reprints: Donohue (1930s), * Donohue (n.d.), * Laidlaw (1924), * Bobbs-Merrill (1972, 1974).
Three illustrated tales, plus several poems.

Raggedy Andy Stories (Volland, 1920) (VHCB).
Reprints: Donohue (1930s), Johnny Gruelle Company (1940s), Bobbs-Merrill (1960), * # Wonder (1960), Dell (1977), # Derrydale (1988), * # Derrydale (1991).

 Eleven illustrated stories marking the debut of Raggedy Andy, the little rag brother of Raggedy Ann.

The Little Brown Bear (Volland, 1920) (VSB).
Reprints: Donohue (1930s), * Donohue (n.d.), * Bobbs-Merrill (1974).

 An illustrated tale about a curious bear and his animal friends.

Eddie Elephant (Volland, 1921) (VSB).
Reprints: Donohue (1930s), * Donohue (n.d.), * Bobbs-Merrill (1974).

 The illustrated story of a little elephant and his adventures.

Orphant Annie Story Book (Bobbs-Merrill, 1921).
Reprints: Indiana Center for the Book/Guild Press of Indiana (1989).

 Ten illustrated tales—Gruelle's special tribute to his childhood idol and friend, James Whitcomb Riley.

The Magical Land of Noom (Volland, 1922).
Reprints: Donohue (1930s).

 Gruelle's lavishly illustrated adventure story for older children, incorporating twelve colorplates and numerous black-and-white illustrations.

Johnny Mouse and the Wishing Stick (Bobbs-Merrill, 1922).
Reprints: Bobbs-Merrill (1973).

 Thirteen illustrated episodes of Gruelle's "Johnny Mouse and the Woozgoozle" serial, originally published in *Woman's World.*

Raggedy Ann and Andy and the Camel with the Wrinkled Knees (Volland, 1924) (VHCB).
Reprints: Donohue (1930s), Johnny Gruelle Company (1940s), Bobbs-Merrill (1960), Dell (1978), * Lemon-Tree Press (1982), * # Derrydale (1984).

 An illustrated adventure story in eight chapters, telling of a lost doll, a funny camel, and a ship full of transformable pirates.

Raggedy Andy's Number Book (Volland, 1924).
Reprints: * Donohue (n.d.), * Bobbs-Merrill (1960, 1972).

 A linen "Volland Art Book" to teach toddlers their numbers through pictures and verse.

Raggedy Ann's Alphabet Book (Volland, 1925) (VSB).
Reprints: Donohue (1930s), * Donohue (n.d.), * Bobbs-Merrill (1972).

 Raggedy Ann's own illustrated, rhyming recitation of the ABCs.

Raggedy Ann's Wishing Pebble (Volland, 1925) (VHCB).
Reprints: Donohue (1930s), Johnny Gruelle Company (1940s), Bobbs-Merrill (1960), * Lemon-Tree Press (1982), * # Derrydale (1984).

 A fourteen-chapter illustrated tale in which the Raggedys go in search of a magical wishing pebble, and meet many new animal friends.

The Paper Dragon: A Raggedy Ann Adventure (Volland, 1926) (VHCB).
Reprints: Bobbs-Merrill (1972), * Lemon-Tree Press (1982).

 Eleven illustrated chapters that tell how the Raggedys help a little girl find her daddy.

Beloved Belindy (Volland, 1926) (VHCB).
Reprints: Donohue (1930s), Johnny Gruelle Company (1940s), Bobbs-Merrill (1960s).

 Eleven illustrated tales in which a wise and kindly mammy doll, Beloved Belindy, takes Raggedy Ann's place as the leader of the nursery.

Wooden Willie (Volland, 1927) (VHCB).
Reprints: Donohue (1930s), Bobbs-Merrill (1960s).

 Ten illustrated stories in which Uncle Clem (the Scottish doll) and Beloved Belindy meet up with a little man from Wooden Town.

Raggedy Ann's Magical Wishes (Volland, 1928).
Reprints: Donohue (1930s), Bobbs-Merrill (1960s), * Lemon-Tree Press (1982), * # Derrydale (1989).

 Eleven illustrated chapters chronicling the frolics of the Raggedys, witches and magicians, and their many animal friends in the Deep Deep Woods.

Marcella: A Raggedy Ann Story (Volland, 1929).
Reprints: Donohue (1930s), Bobbs-Merrill (1960s), * # Derrydale (1984), * # Derrydale (1989).

 Eleven illustrated stories, set mostly at the seashore; Gruelle's tribute volume to his late daughter, Marcella.

The Cheery Scarecrow (Volland, 1929) (VSB).
Reprints: Donohue (1930s), * Donohue (n.d.), * Bobbs-Merrill (1974).

 The illustrated tale of a happy-go-lucky straw man.

Raggedy Ann in the Deep Deep Woods (Volland, 1930).
Reprints: Donohue (1930s), Johnny Gruelle Company (1940s), Bobbs-Merrill (1960), * # Wonder (1960), Dell (1970s), * # Derrydale (1984).

 Twenty-one illustrated stories about the Raggedys' continued cavortings in the Deep Deep Woods.

Raggedy Ann's Sunny Songs (Lyrics and illustrations by Johnny Gruelle; music by Will Woodin) (Miller Music, 1930).
Reprints: * # Miller Music Corporation (1971).

 Sixteen illustrated songs about the Raggedys and their friends, with piano and ukulele arrangements.

Raggedy Ann in Cookie Land (Volland, 1931).

Reprints: Donohue (1930s), Johnny Gruelle Company (1940s), Bobbs-Merrill (1960), * # Wonder (1960), Dell (1978).

The continuing saga of the Raggedys and their magical, woodland friends, told in ten illustrated chapters.

The Cruise of the Rickity-Robin (Manning Publishing Company, 1931).

An oversized booklet comprising thirteen illustrated installments of Gruelle's "Rickity-Robin" adventure serial, originally published in *Woman's World.*

Raggedy Ann's Lucky Pennies (Volland, 1932).

Reprints: Donohue (1930s), Bobbs-Merrill (1960s).

Seven more chapters of continuing adventures of the Raggedys, the Bolivar, Noodles the Donkey, and other friends of the Deep Deep Woods.

Raggedy Ann and the Left Handed Safety Pin (Whitman, 1935).

Reprints: * Bobbs-Merrill (1974).

A little illustrated book about how the Raggedys' magical safety pin can turn selfishness into kindliness.

Raggedy Ann in the Golden Meadow (Whitman, 1935).

Reprints: * Bobbs-Merrill (1974).

An oversized edition of seven Raggedy stories and numerous proverbs, illustrated in black and white and color.

Raggedy Ann Cut-Out Paper Dolls (Whitman, 1935).

Two whimsical Raggedy paper dolls, colorful costumes, and original verses to cut out—all by Johnny Gruelle.

Raggedy Ann's Joyful Songs (Lyrics and illustrations by Johnny Gruelle; music by Charles Miller) (Miller Music, 1937).

Reprints: * # Miller Music Corporation (1971).

Twenty illustrated ditties in this, the Raggedys' second song folio.

Raggedy Ann and Maizie Moocow (Abbotts Dairies, 1937).

Reprints: * Bobbs-Merrill (1974).

An illustrated advertising booklet in which the Raggedys and their bovine friend, Maizie, extol the virtues of dairy products.

Books Written by Johnny Gruelle; Illustrated by Others

Raggedy Ann in the Magic Book (Illustrated by Worth Gruelle) (Johnny Gruelle Company, 1939).

Reprints: * # Wonder (1960), Bobbs-Merrill (1961), * Lemon-Tree Press (1982), * # Derrydale (1989).

Seven illustrated chapters in which the Raggedys become a part of their favorite fairytales and meet up with the Fuzzywump.

Raggedy Ann and the Golden Butterfly (Illustrated by Justin C. Gruelle) (Johnny Gruelle Company, 1940).

Reprints: * # Wonder (1960), Bobbs-Merrill (1961), * Lemon-Tree Press (1982).

A ten-chapter illustrated adventure in which the Raggedys enjoy magically replenishing goodies and discover the secret of a wondrous butterfly.

Raggedy Ann and Andy and the Nice Fat Policeman (Illustrated by Worth Gruelle) (Johnny Gruelle Company, 1942).

Reprints: Bobbs-Merrill (1960), * # Wonder (1960), Dell (1980).

Seven illustrated chapters in which a good-natured officer assists the kindly Raggedys in their adventures with the Hooligoolys and a Wild Gazook.

Raggedy Ann and Betsy Bonnet String (Illustrated by Justin C. Gruelle) (Johnny Gruelle Company, 1943).

Reprints: Bobbs-Merrill (1960).

Nine illustrated chapters of the Raggedys' adventures with a kindly lady with a magic apron.

Raggedy Ann in the Snow White Castle (Illustrated by Justin C. Gruelle) (Johnny Gruelle Company, 1946).

Reprints: Bobbs-Merrill (1960), * # Wonder (1960), * # Derrydale (1984).

The Raggedys' journey to a beautiful royal palace, told in nine illustrated chapters.

Raggedy Ann and the Happy Meadow (Illustrated by Worth Gruelle) (Bobbs-Merrill, 1961).

Reprints: Dell (1978), * # Derrydale (1984).

Fourteen illustrated chapters chronicling the Raggedys' continuing adventures with their animal friends—this time, in a magical meadow.

Raggedy Ann and the Hobby Horse (Illustrated by Worth Gruelle) (Bobbs-Merrill, 1961).

Reprints: Dell (1978), * # Derrydale (1984).

Eight illustrated chapters telling of a magical boat, two crabby witches, and a come-alive wooden horse.

Raggedy Ann and the Wonderful Witch (Illustrated by Worth Gruelle) (Bobbs-Merrill, 1961).

Reprints: Dell (1978).

An illustrated tale in eight chapters about Raggedy Ann's wishing pebble and the transformation of the once-mean Wanda and Winda Witch.

Raggedy Ann and the Golden Ring (Illustrated by Worth Gruelle) (Bobbs-Merrill, 1961).

Reprints: Dell (1978), * # Derrydale (1989).

Ten illustrated chapters that tell of golden rings hanging from trees, and how the Raggedys help a little boy find his parents.

Raggedy Ann and Andy and the Kindly Ragman (Illustrated by John E. Hopper) (Bobbs-Merrill, 1975).

Reprints: * # Derrydale (1989).

An edited and newly illustrated compilation of nine of Gruelle's "Jan and Janette" episodes originally published in *Woman's World*; this time, recast as Raggedy adventures.

Raggedy Ann and Andy and Witchie Kissabye (Illustrated by John E. Hopper) (Bobbs-Merrill, 1975).

Reprints: * # Derrydale (1989).

An edited and newly illustrated compilation of nine of Gruelle's "Grandpa's Stories," originally published in *Woman's World*.

Books by Other Authors Featuring Illustrations by Johnny Gruelle

Spotless Town—Thenewssaysso (Verses by Guernsey Van Riper) (*The Indianapolis Star*, 1905).

Black-and-white cartoons and verses satirizing Indianapolis city officials.

Indianapolitans "As We See 'Em" (Various contributors) (Cartoonists' Association of Indianapolis, n.d. —ca. 1905).

Black-and-white satirical cartoon portraits by Gruelle and others.

Grimm's Fairy Tales (Traditional; translated from the German by Margaret Hunt) (Cupples & Leon, 1914).

Twelve colorplates (including cover label) and several dozen pen-and-ink illustrations.

Nobody's Boy (Sans Famille) (by Hector Malot; translated by Florence Crewe-Jones) (Cupples & Leon, 1916).

Three colorplates and oval cover label.

Rhymes for Kindly Children: Modern Mother Goose Jingles (by Fairmont Snyder) (Volland, 1916).

Reprints: Volland (1928—author now listed as Ethel Fairmont), Wise-Parslow (1937).

Full-color illustrations.

Quacky Doodles' and Danny Daddles' Book (by Rose Strong Hubbell) (Volland, 1916).

Full-color illustrations.

All About Cinderella (Traditional; retold by Gruelle) (Cupples & Leon, 1916).

Reprints: * Cupples & Leon (1929, 1957), * Platt & Munk (1960).

Full-color and black-and-white illustrations.

All About Little Red Riding Hood (Traditional; retold by Gruelle) (Cupples & Leon, 1916).

Reprints: * Cupples & Leon (1929, 1957), * Platt & Munk (1960).

Full-color and black-and-white illustrations.

All About Mother Goose (Traditional) (Cupples & Leon, 1916).

Reprints: * Cupples & Leon (1929, 1957), * Platt & Munk (1960).

Full-color and black-and-white illustrations.

All About the Little Small Red Hen (Traditional) (Cupples & Leon, 1917).

Reprints: * Cupples & Leon (1929, 1957), * Platt & Munk (1960).

Full-color and black-and-white illustrations.

All About Hansel and Grethel (Traditional) (Cupples & Leon, 1917).

Reprints: * Cupples & Leon (1929, 1957), * Platt & Munk (1960).

Full-color and black-and-white illustrations.

All About Little Black Sambo (Though unattributed, based on story by Helen Bannerman) (Cupples & Leon, 1917).

Reprints: * Cupples & Leon (1929, 1957), * Platt & Munk (1960).

Full-color and black-and-white illustrations.

Sunny Bunny (by Nina Wilcox Putnam) (Volland, 1918) (VSB).

Reprints: Algonquin (1930s).

Full-color illustrations.

Children's Favorite Fairy Tales: The Stories that Never Grow Old (Traditional) (Cupples & Leon, 1918).

Full-color cover illustration.

The Bam Bam Clock (by J. P. McEvoy) (Volland, 1920) (VSB).

Reprints: Algonquin (1936).

Full-color illustrations.

Grimm's Fairy Stories (Traditional; black-and-white illustrations by R. Emmett Owen) (Cupples & Leon, 1922).

Three colorplates (including cover label), originally published in *Grimm's Fairy Tales* (1914).

Man in the Moon Stories Told Over the Radio-Phone: First Stories for Children Broadcasted by Radio (by Josephine Lawrence) (Cupples & Leon, 1922).

Reprints: # Whitman (1930).

Nine colorplates (including cover label) and numerous black-and-white illustrations.

Caricature (Judge-Leslie, 1922).

A selection of Judge cartoons by Gruelle and others.

Where Nature Lavished Her Bounties (Text by Bert Moses) (Jackson County [OR] Commissioners, n.d. —ca. 1925).

Two-color cover artwork.

Up One Pair of Stairs (Volume 3—My Book House) (Edited by Olive Beaupré Miller) (The Book House for Children, 1928).

Reprints: The Book House for Children (1947, 1958, 1960).

Colored illustrations accompanying "The Wee, Wee Mannie and the Big, Big Coo (A Scotch Folk Tale)."

Through Fairy Halls (Volume 6—My Book House) (Edited by Olive Beaupré Miller) (The Book House for Children, 1928).
Reprints: The Book House for Children (1947, 1958, 1960).

Colored illustrations accompanying "The Three Wishes (A Spanish Fairy Tale)" and "The Squire's Bride" (by Peter Christen Asbjornsen).

The Gingerbread Man (by Josephine Lawrence) (Whitman, 1930).

Gruelle's black-and-white illustrations, originally rendered for "The Adventures of the Gingerbread Man" story in *Man in the Moon Stories Told Over the Radio-Phone* (1922), have been reprinted here, colored by Robert Bezucha.

Adaptations Attributed to Johnny Gruelle (or Based on Gruelle's Stories)

MCLOUGHLIN BROTHERS

Raggedy Ann's Picture Book (Illustrated by Justin C. Gruelle) (#405) (1940).

McLoughlin "Little Color Classics" (All illustrated by Justin C. Gruelle)
Raggedy Ann Helps Grandpa Hoppergrass (#843) (1940).
Raggedy Ann and the Hoppy Toad (#844) (1940).
Raggedy Ann in the Garden (#845) (1940).
Raggedy Ann and the Laughing Brook (#846) (1940).
Raggedy Andy Goes Sailing (#883) (1941).
The Camel with the Wrinkled Knees (#884) (1941).
Reprints: * # Wonder (1960).

McLoughlin "Westfield Classics" (All illustrated by Justin C. Gruelle)
Raggedy Ann Helps Grandpa Hoppergrass (#60) (1943).
Raggedy Ann and the Hoppy Toad (#61) (1943).
Raggedy Ann in the Garden (#62) (1943).
Raggedy Ann and the Laughing Brook (#63) (1943).
Raggedy Andy Goes Sailing (#64) (1943).
The Camel with the Wrinkled Knees (#65) (1943).

SAALFIELD PUBLISHING COMPANY

Raggedy Ann and Andy With Animated Illustrations (Animations by Julian Wehr) (1944).

Raggedy Ann Picture-Story Book (Illustrated by Ethel Hayes) (#2929) (1947).

Saalfield "Treasure Books" (All illustrated by Ethel Hayes)
Raggedy Ann's Adventure (#463) (1947).
Raggedy Ann's Mystery (#463) (1947).
Raggedy Ann and the Slippery Slide (#463) (1947).

Raggedy Ann at the End of the Rainbow (#463) (1947).
Reprints: Saalfield (1961, 1962).

THE AMERICAN CRAYON COMPANY

"Old Faithful"—"Mary Perks" Books for Children (Drawings by Mary and Wallace Stover after Gruelle)
Raggedy Ann and the Laughing Brook (and Raggedy Ann Helps Grandpa Hoppergrass) (#1030) (1944).
Raggedy Ann and the Hoppy Toad (and Raggedy Ann in the Garden) (#1031) (1944).

PERK'S PUBLISHING COMPANY

"Mary Perks" Books (Illustrations by Mary and Wallace Stover after Gruelle)
Raggedy Ann Helps Grandpa Hoppergrass (#901) (1946).
Raggedy Ann and the Laughing Brook (#902) (1946).
Raggedy Ann and the Hoppy Toad (#903) (1946).
Raggedy Ann in the Garden (#904) (1946).

WONDER BOOKS

Raggedy Ann and Marcella's First Day of School (Illustrated by Tom Sinnickson) (#588) (1952).

Raggedy Ann's Merriest Christmas (Illustrated by Tom Sinnickson) (#594) (1952).

Raggedy Andy's Surprise (Illustrated by Tom Sinnickson) (#604) (1953).

Raggedy Ann's Tea Party (Illustrated by George and Irma Wilde) (#624) (1954).

A Puzzle for Raggedy Ann and Andy (Illustrated by Rachel Taft Dixon) (#683) (1957).

Raggedy Ann's Secret (Illustrated by Ruth Wood) (#727) (1959).

Raggedy Ann's Christmas Surprise (Illustrated by Tom Sinnickson) (#868) (A ca. 1960 reprint of *Raggedy Ann's Merriest Christmas*).

OTHER ADAPTATIONS (VARIOUS PUBLISHERS)

The Colorful World of Raggedy Ann & Andy. Designed for Reading, Painting, Coloring, and Decorating (by Johnny Gruelle) (Determined Productions, 1966).

The Raggedy Ann & Andy Storybook (Illustrated by June Goldsborough) (Grosset & Dunlap, 1980).

The Old Fashioned Raggedy Ann & Andy ABC Book (by Robert Kraus and Johnny Gruelle; Pam Kraus, editor) (Windmill Books, 1981).

Little Treasury of Raggedy Ann & Andy (Chatham River Press, 1984).

A boxed set of six small board books, all abridged adaptations by Corey Nash based on portions of: *Raggedy-*

Ann Stories (1918), *Raggedy Andy Stories* (1920), *Raggedy Andy's Number Book* (1924), and *Raggedy Andy Goes Sailing* (1941).

Raggedy Ann & Andy Giant Treasury (Adapted by Nancy Golden, illustrated by Johnny Gruelle, Justin C. Gruelle, and Worth Gruelle) (Derrydale, 1984).

Four adventures plus twelve short stories adapted from: *Raggedy Ann and Andy and the Camel with the Wrinkled Knees* (1924), *Raggedy Ann's Wishing Pebble* (1925), *Marcella* (1929), *Raggedy Ann in the Deep Deep Woods* (1930), *Raggedy Ann in the Snow White Castle* (1946), *Raggedy Ann and the Hobby Horse* (1961), and *Raggedy Ann and the Happy Meadow* (1961).

Raggedy Ann's Nighttime Rescue (by Eleanor Hudson, based on a story by Johnny Gruelle, illustrated by Judith Hunt) ("Happy House Books," Random House, 1987).

Raggedy Ann Gets Lost (by Daphne Skinner, based on a story by Johnny Gruelle, illustrated by Cathy Beylon) ("Great Big Board Books," Random House, 1987).

Raggedy Ann and Andy and the Magic Wishing Pebble (by Cathy East Dubowski, illustrated by Cathy Beylon) ("Random House Pictureback," Random House, 1987).

Raggedy Ann & Andy Second Giant Treasury (Adapted by Ellen Dreyer, illustrated by Johnny Gruelle, Justin C. Gruelle, Worth Gruelle, and John E. Hopper) (Derrydale, 1989).

Four adventures plus nine short stories adapted from: *Raggedy Ann's Magical Wishes* (1928), *Marcella* (1929); *Raggedy Ann in the Magic Book* (1939), *Raggedy Ann and the Golden Ring* (1961), *Raggedy Ann and Andy's Merry Adventures* (1974), *Raggedy Ann and Andy and the Kindly Ragman* (1975), *Raggedy Ann and Andy and Witchie Kissabye* (1975), and *More Raggedy Ann and Andy Stories* (1977).

Selected Reprints (Including Compendia) of Gruelle's Works

A Sunny Yearbook For Sunny Children (Various) (Volland, n.d.).

Excerpts (text and illustrations) from *The Funny Little Book* (1918), *Sunny Bunny* (1918), and *Little Sunny Stories* (1919) appear (along with other Volland "Sunny Book" excerpts) in this booklet.

Sunny-Book Readers—Number One (Laidlaw Brothers, 1924).

An elementary reading primer incorporating two stories from *Little Sunny Stories* (1919).

The All About Storybook (Traditional; various illustrators) (Cupples & Leon, 1929).

Reprints: Cupples & Leon (1957), Platt & Munk (1960).

Gruelle's full-color illustrations, and those of other artists, appear in this reprint of selected "All About" books.

Johnny Gruelle's Golden Book (Donohue, n.d.—ca. 1940s).

An oversized compilation incorporating *Little Sunny Stories* (1919), *The Little Brown Bear* (1920), *Eddie Elephant* (1921), *Raggedy Andy's Number Book* (1924), *Raggedy Ann's Alphabet Book* (1925), and *The Cheery Scarecrow* (1929).

My Own Set of Sunny Books (Donohue, n.d.—ca. 1940s).

A boxed set of reprints of four Volland "Sunny Books" including *The Little Brown Bear* (1920), *Eddie Elephant* (1921), *Raggedy Ann's Alphabet Book* (1925), and *The Cheery Scarecrow* (1929).

Raggedy Ann Stories to Read Aloud (Wonder, 1960).

A compendium of stories reprinted from twelve different Raggedy Ann books, with new illustrations by Rachel Taft Dixon.

Adventures of Raggedy Ann (Avenel, 1967; Franklin Watts, n.d.).

Reprint of five chapters, plus the preface and introduction, from *Raggedy Ann Stories* (1918).

A Raggedy Ann Song Book (Miller Music Corporation, 1971).

A selection of songs (with new piano arrangements by John Lane) reprinted from *Raggedy Ann's Sunny Songs* (1930) and *Raggedy Ann's Joyful Songs* (1937).

Raggedy Ann and Andy's Alphabet and Numbers (Bobbs-Merrill, 1972).

A compilation incorporating *Raggedy Andy's Number Book* (1924), *Raggedy Ann's Alphabet Book* (1925), and one chapter from *Little Sunny Stories* (1919).

Raggedy Ann and Andy's Animal Friends (Bobbs-Merrill, 1974).

A compilation incorporating *The Little Brown Bear* (1920), *Eddie Elephant* (1921), and one chapter from *Raggedy Ann in the Golden Meadow* (1935).

Raggedy Ann and Andy's Merry Adventures (Bobbs-Merrill, 1974).

Reprints: * # Derrydale (1989).

A compilation incorporating *The Cheery Scarecrow* (1929), *Raggedy Ann and Maizie Moocow* (1937), and selected chapters from *Raggedy Ann in the Golden Meadow* (1935).

Raggedy Ann and Andy's Sunny Stories (Bobbs-Merrill, 1974).

A compilation including reprints of *Raggedy Ann and the Left Handed Safety Pin* (1935), and selected chapters from *Little Sunny Stories* (1919) and *Raggedy Ann in the Golden Meadow* (1935).

More Raggedy Ann and Andy Stories (Illustrated by Johnny Gruelle, Justin C. Gruelle, Worth Gruelle, and others) (Bobbs-Merrill, 1977).

Reprints: * # Derrydale (1989).

An edited compilation of selected Saalfield "Westfield Classic" adaptations and selected stories that originally appeared in *Woman's World* magazine.

Raggedy Ann and Andy: The First Treasury (Lemon-Tree Press, 1982).

A compilation incorporating reprints of *Raggedy Ann and Andy and the Camel with the Wrinkled Knees* (1924), *Raggedy Ann's Wishing Pebble* (1925), and *(Raggedy Ann and) The Paper Dragon* (1926).

Raggedy Ann and Andy: The Second Treasury (Illustrated by Johnny Gruelle, Justin C. Gruelle, and Worth Gruelle) (Lemon-Tree Press, 1982).

A compilation incorporating reprints of *Raggedy Ann's Magical Wishes* (1928), *Raggedy Ann in the Magic Book* (1939), and *Raggedy Ann and the Golden Butterfly* (1940).

The Original Adventures of Raggedy Ann (Derrydale, 1988).

An oversized abridgment of *Raggedy Ann Stories* (1918).

The Original Adventures of Raggedy Andy (Derrydale, 1988).

An oversized abridgment of *Raggedy Andy Stories* (1920).

The Original Adventures of Raggedy Ann and Raggedy Andy (Derrydale, 1991).

An oversized compilation incorporating abridgments of *Raggedy Ann Stories* (1918) and *Raggedy Andy Stories* (1920).

Other Raggedy Ann and Andy Books of Interest

BOBBS-MERRILL

Raggedy Ann and Andy's Cookbook (by Nika Hazelton; illustrated by Johnny Gruelle, Justin C. Gruelle, and Worth Gruelle) (1975).

Raggedy Ann and Andy's Green Thumb Book (by Alix R. Nelson; illustrated by Johnny Gruelle, Justin C. Gruelle, and Worth Gruelle) (1975).

Raggedy Ann and Andy's Sewing Book (by Lydia Encinas; illustrated by Johnny Gruelle, Worth Gruelle, and John E. Hopper) (1977).

Raggedy Granny Stories (by Doris Thorner Salzberg; illustrated by Johnny Gruelle, Justin C. Gruelle, Worth Gruelle, and others) (1977).

Raggedy Ann & Andy. An Adaptation of the Animated Film "Raggedy Ann & Andy—A Musical Adventure" (by Kath-leen N. Daly, based on the screenplay by Patricia Thackray and Max Wilk) (1977).

Raggedy Ann and Andy and the Pirates of Outgo Inlet (by Catharine Bushnell, illustrated by Vernon McKissack) (Weekly Reader Book Club Edition) (1980).

Raggedy Ann and Andy in the Tunnel of Lost Toys (by Catharine Bushnell, illustrated by Vernon McKissack) (Weekly Reader Book Club Edition) (1980).

Raggedy Ann and Andy and How Raggedy Ann Was Born (by Stephanie Spinner, pictures by Carol Nicklaus) (1982).

Raggedy Ann and Andy and the Haunted Doll House (by Jane E. Gerver, pictures by Carol Nicklaus) (1982).

Raggedy Ann and Andy and the Absent-Minded Magician (by Jean Bethell, pictures by Carol Nicklaus) (1982).

GOLDEN PRESS

The Raggedy Ann Book (by Janet Fulton, pictures by Aurelius Battaglia) (A "Golden Shape Book") (#5951, #5902-1) (1971).

The Raggedy Ann and Andy Book (by Jan Sukus, illustrated by Ruth Ruhman and Gavy) (A "Golden Shape Book") (#5970, #5803) (1972).

Raggedy Ann's Favorite Things (Illustrated by Gavy) (A "Baby's First Golden Book") (#10748) (1972).

Raggedy Ann—A Thank You, Please, and I Love You Book (by Norah Smaridge, illustrated by June Goldsborough) (A "Golden Book") (#10487) (1972).

Raggedy Andy—The I Can Do It, You Can Do It Book (by Norah Smaridge, illustrated by June Goldsborough) (A "Golden Book") (#10494) (1973).

Raggedy Ann's Sweet and Dandy, Sugar Candy Scratch and Sniff Book (by Patricia Thackray, pictures by Carol Nicklaus) (A "Golden Scratch and Sniff Book") (#13542) (1976).

Raggedy Ann at the Carnival (by Patricia Thackray, pictures by Barbara Bottner) (A "Golden Look-Look Book") (#11830) (1977).

Raggedy Ann and Andy Go Flying (by Mary Fulton, illustrated by Judith Hunt) (A "Golden Storytime Book") (1980).

"Little Golden Books" (illustrated by June Goldsborough unless otherwise indicated)

Raggedy Ann and Fido (by Barbara Hazen, pictures by Rochelle Boonshaft) (1969) (#585).

Raggedy Ann and the Cookie Snatcher (by Barbara Shook Hazen) (#262, #111-57) (1972).

Raggedy Ann and Andy and the Rainy Day Circus (by Barbara Shook Hazen) (#401) (1973).

Raggedy Ann and Andy—The Little Gray Kitten (by Polly Curran) (#139, #107-21, #107-41) (1975).

Raggedy Ann and Andy Help Santa Claus (by Polly Curran) (#156, #457-1, #457-31) (1977).

Raggedy Ann and Andy—Five Birthday Parties in a Row (by Eileen Daly; illustrated by Mary S. McClain) (#107-4, #107-34) (1979).

WHITMAN

This Is Raggedy Ann (by June Goldsborough) (Whitman "Playpen Picture Books") (#2261, #2227) (1970).

Whitman "Tell-A-Tale" Books (illustrated by June Goldsborough unless otherwise indicated)

Raggedy Ann and the Tagalong Present (by Marjory Schwalje, illustrated by Becky Krehbiel) (#2542) (1971).

Raggedy Andy's Treasure Hunt (by Marjory Schwalje) (#2420) (1973).

Raggedy Ann's Cooking School (by Marjory Schwalje) (#2498) (1974).

Raggedy Ann and Andy on the Farm (by Eileen Daly) (#2596) (1975).

Raggedy Andy and the Jump-Up Contest (by Marjory Schwalje) (#2641) (1978).

HALLMARK

Raggedy Ann and the Daffy Taffy Pull (by Dean Walley, illustrated by Marianne Smith) (A "Hallmark Pop-Up Book") (1972).

Adventures and Surprises with Raggedy Ann and Andy (A "Hallmark Play-Time Book") (1974).

Hallmark "Story Cards"

Beloved Belindy (1974)
Henny (1974)
Marcella (1974)
Raggedy Andy (1974)
Raggedy Ann (1974)

Uncle Clem (1974)

Hallmark "Stand-up Story Cards" with 45 RPM Records

Raggedy Ann and Andy Go to Cookietown (1974).
Raggedy Ann and Andy Meet Dizzy Izzy and the Witch (1974).
Raggedy Ann and Andy in Dreamland (1974).
Raggedy Ann and Andy on a Journey Beneath the Enchanted Pond (1974).
Raggedy Ann and Andy on a Trip to the Stars (1974).
Raggedy Ann and Andy Visit the Kingdom of "Every Wish" (1974).

RANDOM HOUSE

Raggedy Ann at the Country Fair (by Michelle Davidson, illustrated by Laurie Struck) (1987).

Raggedy Ann's Seashore Adventure (by Michelle Davidson, illustrated by Jean Shackelford) (1987).

I Love You, Raggedy Ann! (Photographs by Anita and Steve Shevett) (1987).

Where Are You, Raggedy Andy? (Photographs by Anita and Steve Shevett) (1987).

Raggedy Ann, I See You! (Illustrated by Jean Shackelford) (A "Peek-a-Board Book") (1987).

Raggedy Ann's Picture-Perfect Christmas (by Gail Herman, illustrated by Deborah Colvin Borgo) ("A Read-to-Me Book") (1988).

Raggedy Ann's Book of Go-Togethers (Illustrated by Bobbi Barto) (1988).

OTHER PUBLISHERS

If I Met Raggedy Andy (Grosset and Dunlap, 1978).

Raggedy Ann and Andy's Grow and Learn Library (twenty volumes, author and illustrator not attributed) (Lynx Books, 1988).

APPENDIX B

Johnny Gruelle's Periodical Appearances: A Chronological Checklist

This section cites all magazine and newspaper appearances of Johnny Gruelle's work known to the author. Research for the checklist was based on issue-by-issue searches of periodical sources held in the Library of Congress, public and private libraries, and the collections of the author and others. While not documenting absolutely every periodical contribution Gruelle may have made, this checklist does cover the key ones.

The checklist is organized in three sections: Newspapers and Newspaper Syndicates, Magazines, and Comic Books. Each is arranged chronologically. Key information about types of cartoons, illustrations, and illustrated stories is included to further assist the scholar or collector.

Newspaper and Newspaper Syndicates

People (ca. 1901)
Indianapolis, IN
 Black-and-white chalk-plate cartoons and portraits (in Gruelle's own words) "of the police court type" (no extant examples).

The Indianapolis Sun (1902-3)
Indianapolis, IN
 Black-and-white (front-page) editorial cartoons and headline cartoons.

The Indianapolis (Morning) Star (1903-6)
Indianapolis, IN
 Black-and-white (front-page) editorial cartoons, stock-market cartoons, headline cartoons, sports cartoons, and satirical series cartoons for daily paper. Also black-and-white (some full-page) illustrations for *Indianapolis Sunday Star Magazine*. Also "Cousin Bud," a full-color half-or full-page comic in the *Star*'s Sunday comic section, presumably Gruelle's first color work, syndicated

through World Color Printing (see entry for World Color Printing below).

The Daily Sentinel (1904)
Indianapolis, IN
 Black-and-white front-page political cartoons, Sunday layouts, cartoon "portraits."

World Color Printing Company (1905-10)
St. Louis, MO
 Full-color (some full-page) comics, for preprinted sections provided to newspapers throughout the U.S., including, among others, *The Baltimore American*, *The Indianapolis Star*, and *The Los Angeles Herald*. Full-color (some full-page) comic strips including "Cousin Bud"; Handy Andy"; and "Bud Smith (the Boy Who Did Stunts)," a strip Gruelle inherited from cartoonist George Herriman.

The Cleveland Press (1906-10)
Cleveland, OH
 Black-and-white sports cartoons, children's puzzles, headline cartoons, "bird's-eye-view" cartoons, satirical series cartoons.

The Newspaper Enterprise Association (1909-10)
Cleveland, OH
 Black-and-white sports cartoons, headline cartoons, single-frame filler cartoons. Also "Playtime Stories" (illustrated short fairy stories) syndicated to multiple newspapers in the Scripps-McRae (Scripps-Howard) chain, including the *The Cleveland Press*.

The New York Herald (1911-18)
New York, NY
 Full-color and duotone comic strips, which appeared in the Paris and London editions of the Herald and were syndicated to other papers, including *The Washington (D.C.) Sunday Star*, *The Boston Globe*, and *The Mobile*

207

(AL) Item. Gruelle's work for The New York Herald included "Mr. Twee Deedle" (full-color, full-page from 1911 to 1915; half-page, duotone from 1915 to 1918); "Jack the Giant Killer" (half-page, duotone; only four episodes documented, August – September 1911); "Messengers of Santa Claus" (full-page, full-color Christmas greeting drawn by Gruelle with verses by Mary Watts, December 6, 1914).

United Features Syndicate (1922-24)
New York, NY
Serialized Raggedy Ann and Andy stories, accompanied by single-frame black-and-white illustration, appearing usually six days per week, syndicated to as many as forty newspapers throughout the U.S., including *The New York Sun, The New York Globe, The Cleveland Press,* and *The Oakland Tribune.* Serials entitled (depending on venue and date) "Bedtime Stories of Raggedy Ann and Raggedy Andy," "The Adventures of Raggedy Ann and Raggedy Andy," and "Raggedy Ann and Raggedy Andy."*

New York Herald Tribune (1929-38)
New York, NY
"Brutus" (from 1929 to 1932, a full-color, full-page strip; from 1932 to 1938, full-color, half-page strip).

The Miami Herald (1932-38)
Miami, FL
Occasional black-and-white bird's-eye-view cartoons.

The Rochester *Times-Union* (1934)
Rochester, NY
Special black-and-white cartoons honoring the Committee of One Hundred of Miami Beach's visit to Rochester (September 7, 1934).

The George Matthew Adams Service (1934-35)
New York, NY
Black-and-white single-frame illustrated Raggedy Ann verses, appearing in selected newspapers throughout the U.S., including *The Boston Post.*

The Miami Daily News (1935-38)
Miami, FL
Occasional black-and-white bird's-eye-view cartoons and illustrated advertisements.

Magazines

McCall's (1911-12)
Black-and-white cutouts accompanying stories and fairy plays written by Carolyn Sherwin Bailey. (September – December 1911; March 1912).

The Ladies' World (1911; 1913)
Illustrated children's stories including "Tommy Grasshopper's Pennies; or How Willie Ladybug Happens to Have Little Pennies on His Back" (December 1911);

"Johnny Cricket and the Beanstalk: A Story That Will Delight the Children" (January 1913); "The Children's Story: Tommy Grasshopper's Wings" (July 1913).

The Designer (1912)
A children's story entitled "Tommy Grasshopper's Adventure," written by Gruelle; illustrated by F. Strothmann (June 1912).**

Judge (1912-13; 1915-23)
Full-page, black-and-white (some duotone) cartoons and drawings; some smaller illustrations; multiple bird's-eye-view cartoons, including several covers and series that appeared sometimes weekly entitled "Yapp's Crossing" (1915-23).

John Martin's Book: A Magazine for Little Children (1913-14; 1916; 1918; 1921; 1922)
Black-and-white illustrations, illustrated verses and stories (some serialized) appearing sometimes monthly. Serials included "The Travels of Timmy Toodles" (1914); "The Land of Funny-O," by John Ruse Woodward, illustrated by Gruelle (1918).

Physical Culture (1916-21)
Black-and-white illustrations and cartoons accompanying adult fiction and nonfiction, appearing sometimes monthly.

Woman's World (1918-24; 1926; 1928-29; 1931)
Illustrated individual and serial stories for children. Series and serials included "Uncle Johnny Gruelle's Page (for Good Boys and Girls)" (1918-20; 1931); "Johnny Mouse and the Woozgoozle" (1920-21); "The Cruise of the Rickity-Robin" (1921-23); "The Left-Hand Safety Pin (Peter and Prue)" (1924); "Jan and Janette" (1928-29).

Leslie's Illustrated Weekly Newspaper (1919)
Duotone birds's-eye-view cartoon cover (August 30, 1919).

Good Housekeeping (1920-21)
Illustrated children's stories, appearing monthly, entitled "The Dwarfies."

Life (1927-28; 1933)
Full-page, black-and-white bird's-eye-view cartoons, appearing occasionally, entitled "Yahoo (Yayhoo) Center."

College Humor (ca. 1930s)
Black-and-white bird's-eye-view cartoons, appearing occasionally, entitled "Nile's Junction."

Cosmopolitan (1931)
Black-and-white, bird's-eye-view cartoon accompanying short story by George Ade entitled "Lullabye: The Fame and Fortune of Joe Rivits, Hitch-Hiker, told by the Father of Modern Slang" (January 1931).

Comic Books

Following Gruelle's death, the Johnny Gruelle Company authorized Dell (later Western Publishing) to issue illustrated adaptations of his tales in the form of comic stories and entire comic books incorporating Gruelle characters and themes. While some artwork was provided by Justin C. Gruelle, most was unattributed work. These comics included:

New Funnies—(Usually one Raggedy story per issue. Early issues also featured adapations of "Mr. Twee Deedle," by Justin Gruelle.) 1942-46 (#65-ca. #108).

Raggedy Ann—1942 (#5); 1943 (#23, #45); 1945 (#72).

Raggedy Ann + (and) Andy—1946-49 (#1-#39).

Raggedy Ann + (and) Andy—1950 (#262, #306); 1951 (#354, #380, #452); 1954 (#533).

Raggedy Ann and Andy (Giant Dell Comic)—February 1955 (#1).

Raggedy Ann and the Camel with the Wrinkled Knees (Dell Junior Treasury)—1957 (#8).

Raggedy Ann and Andy—1964 (#1); 1965 (#2, #3); 1966 (#4).

Raggedy Ann and Andy (Gold Key)—1971-73 (#1-#6).

*Johnny Gruelle claimed that United Features distributed his Raggedy Ann and Raggedy Andy serials between 1921 and 1926. However, only examples from 1922 to 1924 could be documented.

**Gruelle stated in print that he had done work for *The Delineator*, a home-pattern monthly that later merged with *The Designer* (a magazine in which Gruelle's work did, in fact, appear). However, an issue-by-issue search of *The Delineator*, beginning in 1908, revealed no Gruelle illustrations or text.

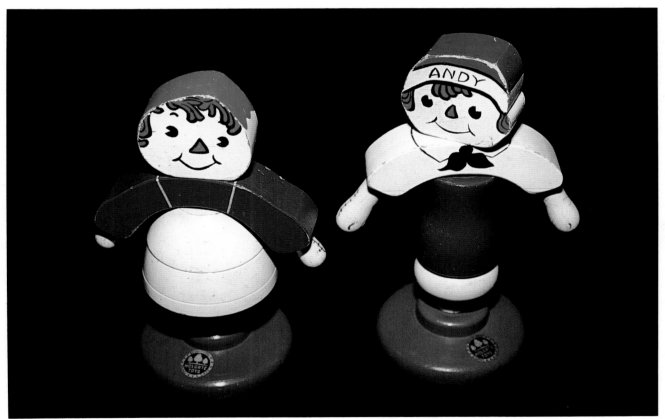

As a licensee of the Johnny Gruelle Company, Holgate Brothers manufactured this authorized wooden "Concentration Toy" during the early 1940s, designed as an educational stacking toy for toddlers.

MRS. HARTMAN.

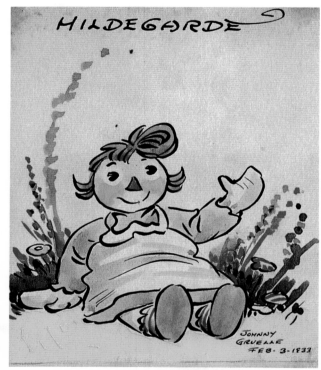

HILDEGARDE

Johnny Gruelle left his mark not only as a commercial author, illustrator, and toy designer, but also as a generous artist, who created hundreds of hand-rendered keepsakes, like these two party place cards. (Courtesy Jane Gruelle Comerford and Anne laDue Hartman Kerr)

Principal Sources

Articles and Chapters

Burdick, Loraine. "Johnny Gruelle and the Raggedys." In *The Antique Trader Weekly's Book of Collectible Dolls*, edited by Kyle D. Husfloen. Dubuque, Iowa: The Babka Publishing Company, 1976.

Clark, Thomas D. "David Laurance Chambers As I Knew Him." *Studies in the Bobbs-Merrill Papers (The Indiana Bookman 8)*, edited by Edwin H. Cady. March 1987.

Gardner, Martin. "John Martin's Book: An Almost Forgotten Children's Magazine." *Children's Literature* 18, edited by Francelia Butler, Margaret R. Higonnet, and Barbara Rosen. New Haven: Yale University Press, 1990.

(Gruelle, Johnny.) "Comics—and Their Creators: Johnny Gruelle." *Literary Digest* 118 (October 27, 1934).

Hall, Patricia. "A Child At Heart: The Fanciful World of Johnny Gruelle." *Traces of Indiana and Midwestern History* 2, no. 4 (Fall 1990).

Hall, Patricia. "The Raggedys Go West." *Table Rock Sentinel* 11, no. 6 (November/December 1991).

Johnson, Hope. "A Bright New World for Raggedy Ann." *New York World-Telegram and Sun Feature Magazine* (February 18, 1961).

Langer, Mark. "Working at the Fleischer Studio: An Annotated Interview with Myron Waldman." *The Velvet Light Trap*, no. 24 (Fall 1989).

MacCrae, Marjorie Knight (Justin Gruelle, artist). "Johnny Gruelle and His Raggedy Ann: Being a Christmas Fantasy Rounded Out by Facts." In *Landmarks of New Canaan*. New Canaan, Conn.: New Canaan Historical Society, 1951.

McCullough, Faith. "Out of the Pages." *Medford Tribune*, July 23, 1967.

O'Bar, Jack. "The Origins and History of the Bobbs-Merrill Company." *Occasional Papers, University of Illinois Graduate School of Library and Information Science*, no. 172 (December 1985).

Sher, Sandra. "Raggedy Ann: A Classy Doll." *The Museum of California* 12, no. 4 (January/February 1989).

Williams, Martin. "Some Remarks on Raggedy Ann and Johnny Gruelle." *Children's Literature* 3, edited by Francelia Butler. Philadelphia: Temple University Press, 1974.

Zimmerman, Ruth H. "Quacky Doodles and Her Family." *Doll Reader* 15 (October 1987).

Zipes, Jack, trans. (John B. Gruelle, artist). "A Note on the Illustrations." *The Complete Fairy Tales of the Brothers Grimm*. New York: Bantam Books, 1987.

Zipes, Jack. "Johnny Gruelle." In *Dictionary of Literary Biography, Volume 22: American Writers for Children, 1900-1960*. Edited by John Cech. Detroit: Gale Research, 1983.

Books, Booklets, Exhibition Catalogues, and Pamphlets

Braden, Donna R. *Leisure and Entertainment in America*. Dearborn, Mich.: Henry Ford Museum & Greenfield Village, 1988.

Buser, M. Elaine, and Dan Buser. M. *Elaine and Dan Buser's Guide to Schoenhut's Dolls, Toys and Circus, 1872-1976*. Paducah, Ky.: Collector Books, 1976.

Cabarga, Leslie. *Fleischer Story: In the Golden Age of Animation*. New York: Nostalgia Press, 1976.

Canemaker, John. *The Animated Raggedy Ann & Andy. An Intimate Look at the Art of Animation: Its History, Techniques, and Artists*. Indianapolis and New York: Bobbs-Merrill, 1977.

Canemaker, John. *Winsor McCay: His Life and Art*. New York: Abbeville Press, 1987.

Chase, Ernest Dudley. *The Romance of Greeting Cards*. De-

troit: Tower Books, 1927, 1971; New York: Cambridge University Press, 1926.

Crafton, Donald. *Before Mickey: The Animated Film 1898-1928.* Cambridge and London: MIT Press, 1982.

Dalby, Richard. *The Golden Age of Children's Book Illustration.* New York: Gallery Books, 1991.

Davies, A. Mervyn. *Solon H. Borglum, "A Man Who Stands Alone."* Chester, Conn.: Pequot Press, 1974.

Dickey, Marcus. *The Maturity of James Whitcomb Riley: Fortune's Way With the Poet in the Prime of Life and After.* Indianapolis: Bobbs-Merrill, 1922.

Garrison, Susan Ann. *The Raggedy Ann and Andy Family Album.* West Chester, Pa.: Schiffer Publishing, 1989.

Gruelle, Richard Buckner. *Notes: Critical and Biographical—Collection of W. T. Walters.* Indianapolis: J. M. Bowles, 1895.

Hearn, Michael Patrick. *The Annotated Wizard of Oz.* New York: Clarkson N. Potter, 1973.

Historic Preservation Area Plan—1: Lockerbie Square. Indianapolis: Department of Metropolitan Development; Indianapolis Historic Preservation Commission; Perry Associates, Architects and Planners, May 1978.

The Hoosier House. Indianapolis: Bobbs-Merrill, 1923.

Indianapolitans "As We See 'Em": Cartoons and Caricatures. Indianapolis: Newspaper Cartoonists Association of Indianapolis, n.d.

Kerr, Anne laDue Hartman. *Hearthstones of the Heart.* Grand Rapids, Mich.: Candle Press, 1991.

Magazineland, USA. Sparta, Ill.: World Color Press, 1977.

Manos, Susan. *Schoenhut Dolls and Toys: A Loving Legacy.* Paducah, Ky.: Collector Books, 1976.

Marschall, Richard. *America's Great Comic-Strip Artists.* New York: Abbeville Press, 1989.

Martha Chase Dolls. Rochester: Strong Museum, n.d.

McLaughlin, Dick. *From Humble Beginnings . . . The Cleveland Press, 1878-1953.* Cleveland: Cleveland Press, n.d.

Moses, Bert. *Where Nature Lavished Her Bounties: Jackson County, Oregon.* Ashland, Oreg.: Jackson County Commissioners, 1925.

Newlin, J. Ronald. *The Best Years: Indiana Paintings of the Hoosier Group, 1880-1915.* Indianapolis: Indiana State Museum, 1985.

Newton, Judith Vale. *The Hoosier Group: Five American Painters.* Indianapolis: Eckert Publications, 1985.

The Raggedy Rule Book: Information for Licensees. New York: Macmillan, 1986, 1988.

Revell, Peter. *James Whitcomb Riley.* New York: Twayne Publishers, 1970.

Schiller, Justin. *The Justin G. Schiller Collection of L. Frank Baum and Related Oziana.* New York: Swann Galleries, 1978.

Schoenhut Dolls. Rochester: Strong Museum, n.d.

Seitz, Don C. *The James Gordon Bennetts, Father and Son, Proprietors of the New York Herald.* Indianapolis: Bobbs-Merrill, 1928.

Solomon, Charles. *Enchanted Drawings: The History of Animation.* New York: Alfred A. Knopf, 1989.

General Reference Works

A.S.C.A.P. Biographical Dictionary of Composers, Authors, and Publishers. 3d ed. New York: American Society of Composers, Authors, and Publishers, 1960.

Anderton, Johana Gast. *The Collector's Encyclopedia of Cloth Dolls: From Rag Baby to Art Object.* Lombard, Ill.: Wallace-Homestead, 1984.

Arbuthnot, May Hill. *Children and Books.* 3d ed. Chicago: Scott, Foresman, 1964.

Banta, Richard Elwee, compiler. *Indiana Authors and Their Books, 1816-1916.* Crawfordsville, Ind.: Wabash College, 1949.

Butler, Francelia, ed. *Children's Literature 2.* Philadelphia: Temple University Press, 1973.

Coleman, Dorothy S., Elizabeth A. Coleman, and Evelyn J. Coleman. *The Collector's Encyclopedia of Dolls.* Vol. 1. New York: Crown, 1968.

Coleman, Dorothy S., Elizabeth A. Coleman, and Evelyn J. Coleman. *The Collector's Encyclopedia of Dolls.* Vol. 2. New York: Crown, 1986.

Commire, Anne. *Something About the Author. Facts and Pictures About Authors and Illustrators of Books for Young People.* Vol. 35. Detroit: Gale Research, 1984.

County of Douglas, Illinois: Historical and Biographical. Chicago: F. A. Battey, 1884.

Coyle, William. *Ohio Authors and Their Books.* Cleveland and New York: World Publishing Company, 1962.

Dzwonkoski, Peter, ed. *Dictionary of Literary Biography.* Vol. 46, *American Literary Publishing Houses, 1900-1980. Trade and Paperback.* Detroit: Gale Research, 1986.

Goulart, Ron, ed. *The Encyclopedia of American Comics from 1897-Present.* New York: Facts on File, 1990.

Hart, Luella. *Directory of United States Doll Trademarks, 1888-1968.* Self-published, 1968.

Horn, Maurice, and Richard Marschall, eds. *The World Encyclopedia of Cartoons.* Vol. 3. New York and London: Chelsea House, 1983.

Inge, M. Thomas, ed. 1978-81. *Handbook of American Popular Culture*. Vols. 1, 2, and 3. Westport, Conn. and London: Greenwood Press.

Kelly, R. Gordon, ed. *Children's Periodicals of the United States*. Westport, Conn. and London: Greenwood Press, 1984.

Lenburg, Jeff. *The Encyclopedia of Animated Cartoon Series*. Westport, Conn.: Arlington House, 1981.

Meigs, Cornelia Lynde. *A Critical History of Children's Literature*. New York: Macmillan, 1953.

Miller, John. *Indiana Newspaper Bibliography*. Indianapolis: Indiana Historical Society, 1982.

Mott, Frank Luther. 1957-68. *A History of American Magazines*. Vols. 3, 4, and 5. Cambridge: Belknap Press of Harvard University Press.

The National Union Catalogue—Pre-1956 Imprints. Mansell, 1972.

Official Gazette, U.S. Patent Office. Washington, D.C.: U.S. Government Printing Office, 1910-40.

Tebbel, John. 1975-81. *A History of Book Publishing in the United States*. Vols. 2, 3, and 4. New York and London: R. R. Bowker.

Magazines and Journals
(Multiple Issues Researched)

College Humor, Cosmopolitan, The Delineator, The Designer, Good Housekeeping, Growing Point, John Martin's Book, Journal of the Illinois Historical Society, Judge, The Ladies' World, Leslie's Illustrated Weekly, Life (the humor weekly), *Life* (Time-Life), *McCall's, The Moving Picture World, Parade, Physical Culture, Pictorial Review, Playthings, The Raggedy News, Rags, Publishers Weekly, Woman's World*.

Newspapers
(Multiple Issues Researched)

The Boston Globe, The Boston Post, The (Wilmington, DE) *Bulletin, The Chicago Tribune, The Cleveland Press, The* (Indianapolis) *Daily Sentinel, The* (Ashland, OR) *Daily Tidings, The* (Indianapolis) *Journal, The Indianapolis News, The Indianapolis Star, The Indianapolis Sun, The Joliet* (IL) *Herald-Times, The Los Angeles Herald, The Louisville Courier-Journal, The Miami Daily News, The Miami Herald, The New Canaan* (CT) *Advertiser, The New Canaan* (CT) *Messenger, The New York Herald, The New York Herald Tribune, The New York Times, The News of Delaware County* (PA), *The Norwalk Hour, The Oakland Tribune, The Paris Herald,* the (Indianapolis) *People,* the Rochester (NY) *Times-Union, The Tennessean, Wall Street Journal, The Washington Post, The Washington* (DC) *Star, The Wilton* (CT) *Bulletin*.

Company and Mail-Order Catalogues
(Multiple Issues Researched)

Bobbs-Merrill Company, Decca Records, Flambro Products, Hallmark Cards, Madmar Quality Company, Marshall Field Company, McCall's Patterns, Milton Bradley Company, RCA Victor Records, Sears-Roebuck Company, Service Merchandise.

Oral Interviews

Vital to the author's research were the in-person and telephone interviews, conducted with the following individuals between 1987 and 1992: Bill Blackbeard, Ralph Bloom, Candy Brainard, Jane Marcella Ferguson Braunstein, Sharon Brevort, Lynda Oeder Britt, John Cech, Jane Gruelle Comerford, Jessie Soltau Corbin, Monica Borglum Davies, Betty MacKeever Dow, Kathy Ellis, Kim Gruelle, Kit Gruelle, Ruth Gruelle, Worth and Suzanne Gruelle, Shirley Miller Holmes, Elizabeth Hoover, Joni Gruelle Keating, Anne laDue Hartman Kerr, Janet Smith Leach, Virginia Crandell MacDougall, Richard Marschall, Ruby Mason, Alice McGee, Graham Miller, Nancy Parkin, Peggy Y. Slone, Patricia Smith, Phyllis Smith, Jeanette Sterling, Andrew Tabbat, Gloria Timmell, Charlotte Miller Weller, Martin Williams.

Key Unpublished Materials

Rounding out the research database were many unpublished resources, which included:

Correspondence: Letters and memos generated by James Gordon Bennett, Lynda Oeder Britt, Jean Camm, David Laurence Chambers, Jessie Soltau Corbin, Howard Cox, Ethel Fairmont, Leo C. Gobin, Mollye Goldman, Johnny Gruelle, Justin Gruelle, Myrtle Gruelle, Suzanne Gruelle, Worth Gruelle, H. H. Howland, M. Hughes Miller, Jane E. Petersen, Ray Powell, Louise Henry Sturges, Martin Williams, Helen Younger, and Jack Zipes.

Genealogical Research and Cemetery Logs: Gaskill/Gruelle Families (1893), Grouvel/Gruelle/Grewell/Shelton Families (n.d.), Illinois D.A.R. (Cemetery log, 1974-75), Myrtle Gruelle (D.A.R. application, n.d.).

Memoirs, Diaries, and Family Histories: Justin C. Gruelle (family history, n.d.), Kim Gruelle ("The Gruelle Tradition: Four Generations of Artists," n.d.), Myrtle Gruelle (diary, 1923; "I Am But One," ca. 1946; lecture notes, 1951), Richard Buckner Gruelle (autobiographical letter, 1914).

Interview Notes and Transcriptions: John Randolph Bray (Mark Langer, interviewer, 1975), Virginia Crandell MacDougall (Marjorie O'Harra, interviewer, 1987), Clifton Meek (Martin Williams, interviewer, 1969).

Academic Papers: Carol Sullivan ("! Some Nice Kindly Thoughts About Johnny Gruelle !", 1982).

Bibliographic Checklists: Ray Powell (ca. 1968), Martin Williams (n.d.).

Other Sources

In addition to the aforementioned sources, the author researched U.S. Census Bureau records; city directories and phone books for vicinities where Johnny Gruelle lived and worked; selected public school and company histories; selected records of the P. F. Volland and Bobbs-Merrill companies; records of the U.S. Copyright Office; selected proceedings of U.S. circuit, district, and supreme courts; as well as deeds, plats, vital records, and other publically held documents pertaining to the Gruelle family.

Index

Adams, J. Ottis, 32
Ade, George, 163
"The Adventures of Raggedy Ann and Raggedy Andy" (newspaper serial), 131, 148
"All About" (book series), 84; *pictured, 85*
American (New York) Toy Fair, 124
Applause, Inc., 191-92
Archer, Harry E., 157
Arcola (Indiana) *Democrat* (newspaper), 27
Arcola (Indiana) *Record* (newspaper), 36
Ashland, Oregon, 140, 142, 143-44
Averill, Mme. Georgene, 183

Bailey, Carolyn Sherwin, 71, 72
Baum, L. Frank, 73, 106, 130, 135
"Bedtime Stories of Raggedy Ann" (newspaper serial), 131
Beers, Keeler, and Bowman, 121, 134
Beers, William, 109, 121
Beloved Belindy (book), 148
Beloved Belindy (character and doll), 185; *pictured, 150, 159, 177, 187*
Benday process (printing), 62
"Beneath Southern Skies" (ballad), 157
Bennett, James Gordon, Jr., 59, 62, 65

Bennett, James Gordon, Sr., 62
Benton, Rachel, 82
"Beyond the Moon" (ballad), 157
Bleecker, N. C., 74
Bobbs-Merrill Company, 129-37 passim, 153, 166-67, 183, 191; acquires rights to Raggedys, 187
Booth, Franklin, 73
Borgfeldt, 63
Borglum, Solon, 54, 59, 67
Bowen-Merrill Company, 130. *See also* Bobbs-Merrill Company
Bowen, Silas T., 130
Bray, John Randolph, 74, 97
Bray, J. R., Animation Studio, 97
Brehm, Worth, 70
Brownie Tinkle Bell (doll), *pictured, 159*
Brownies (dolls), 107
"Brutus" (comic strip), 158, 181; *pictured, 154*
"Bud Smith" (comic strip), 42; *pictured, 44*
Bunny Bull (doll), *pictured, 159*
Burgess, Thornton, 198
Burnett, Frances Hodgson, 112
Buster Brown (doll), 107

Camel with the Wrinkled Knees (doll), 185; *pictured, 187*

The Canal—Morning Effect, pictured, 32
Captain Kangaroo. *See* Keeshan, Robert
Carlson, George, 74
Cech, John, 198
Chalk plates, 37, 193
Chambers, David Laurance, 130, 145, 146, 153, 166
Character dolls. *See* "Raggedy" character dolls; names of individual dolls
Chase, Martha, 103
Cheek, Will, 164, 181
Cheery Scarecrow, The (book), 152-53
Children's Favorite Fairy Tales (book), pictured, 86
Citroen Art Gallery (New York City), 188
Clampitt, F. J., 115, 117
Cleety the Clown (character), 98
Cleveland Press, The (newspaper), 40, 42, 75
"Colonel Heeza Liar," (cartoon), 97
Committee of One Hundred of Miami Beach, The, 163, 164, 181
Coombs, Bertha M., 74
Cooper, Clayton S., 163
Coral Gables (Florida) Public Library, 108, 190
"Cousin Bud" (comic strip), 40
Cox, Howard, 112, 165-66, 184, 185, 187, 193
Cox, Palmer, 107
Crafton, Donald, 194
Crooksville Raggedy china, pictured, 188
"Cruise of the Rickity-Robin, The" (serial stories), 123, 125, 160
Cupples, Victor, 82
Cupples & Leon Company, 82-85 passim

Daily Sentinel, The (Indianapolis) (newspaper), 39, 40
Danny Daddles. *See* Quacky Doodles
Davies, A. Mervyn, 59
Davies, Monica Borglum, 59, 70, 89, 92
Deep Deep Woods, 145, 195
Dell Publishing Company, 185
Denslow, W. W., 74, 106, 137
Designer, The (periodical), 73
Dickie and Dolly ("Mr. Twee Deedle" characters), 62, 111; pictured, 91, 102, 110
Dolls, cloth, as commercial objects, 103
Dolls, rag, in history, 103
Dr. Seuss. *See* Geisel, Theodor
Donahue, M. A., & Company. *See* M. A. Donahue & Company

Drelich, Sam, 169, 170, 174
"Dwarfies, The" (serial stories), 127, 148

Eddie Elephant (book), 133
Eddie Elephant (doll), pictured, 159
Eddie Elf (doll), pictured, 159
Empty Elephant (doll), pictured, 159
Enright, Maginel Wright, 96
Erskine, William C., 185
Exposition Doll & Toy Manufacturing Company, 170-72, 176

Fairmont, Ethel ("Fairmont Snyder"), 99, 100
Feathers, Leonard, 164
Flagg, James Montgomery, 74
Folktale motifs, employed by Gruelle, 17, 19-20, 101, 125, 131, 195
Follett, F. M., 97
Ford, Edsel, 164
Forsyth, William, 32
Friendly Fairies (book), 195; pictured, 122
Funny Little Book, The, 115; pictured, 126

Gag, Wanda, 74
Gates, Josephine Scribner, 112
Gee, John, 96
Geisel, Theodor ("Dr. Seuss"), 197
George Matthew Adams Service (newspaper syndicate), 163
Georgene Novelties, 183, 184, 185, 187, 188
Gerlach-Barklow Company, 148, 164
Gerlach, Ted, 156, 164
Goldman, Mollye, 170-72; obtains trademark and patent for Raggedys, 172; dealings with Johnny Gruelle, 176-77. *See also Gruelle vs. Goldman*
Good Housekeeping (periodical), 125, 127
Gordon, Elizabeth, 96
Grey, Zane, 144
Grimm's Fairy Tales (book), 80-82
Gruelle, Alice Benton, 23, 26, 30, 48, 49, 107; pictured, 22, 688
Gruelle, Carl, 189; pictured, 28
Gruelle, Dickie. *See* Gruelle, Richard
Gruelle family: origin of name, 23; genealogy, 25; Midwestern roots of, 23, 27
Gruelle, John Beauchamp, 23
Gruelle, Johnny (John Barton): imaginative range of, 17; early influences on, 18-21 passim; first newspaper work of, 18, 37; contracts with *New*

York Herald, 18, 59-60; work habits of, 18, 78, 117, 125, 137, 142, 144, 148, 162, 167, 193-95; illustrates *Grimm's Fairy Tales*, 18, 82; conceives of Raggedy Ann doll, 18, 103-7; publishes *Raggedy Ann Stories*, 18, 108-15; creates Raggedy Andy, 107, 118-19; publishes *Raggedy Andy Stories*, 18, 107, 117-19; design sense of, 18; as artist and writer, 19, 20, 196; moral content of stories by, 20, 111, 127, 196; spiritual life of, 20, 127, 141; personality of, 20-21, 48, 106, 144, 156, 181; legal battles of, 21, 169-78; and popular entertainment industry, 17, 21, 71, 79, 86; birth of, 25-26; early life in Indianapolis, 27-31; influence of nostalgic regional lore on, 18, 30, 131, 195; J. Whitcomb Riley and, 18, 30, 131, 195; mechanical interest of, 31, 153; early schooling of, 28, 31-33; father's influence on early artwork of, 33; as cartoonist at the *Indianapolis Star*, 34, 37-40, 75; artistic sensibility of, as youth, 36, 48; on the *Daily Sentinel* (Indianapolis), 39-40; as *Star's* illustrator, 40, 41; as cartoonist on the *Cleveland Press*, 40, 42, 53, 75; as satirist, 42, 74-75, 164; first illustrated short stories and children's verses by, 42-43; courts Myrtle Swann, 47-49; marriage of, 49; daughter Marcella born to, 49; influence of Marcella Gruelle on, 49, 101, 102, 107, 112; home life of, in Irvington, Indianapolis, 50; home life of, in Cleveland, 53-54; influence of Winsor McCay and Robert Outcault on, 54; as watercolorist, 55; home life of, in Silvermine, Connecticut, 54, 67-70, 93; wins *New York Herald* contest, 57-59; creates "Mr. Twee Deedle" strip, 58-65; evolution of, from cartoonist to illustrator, 65, 67, 124, 125, 127, 194; at *McCall's*, 71-72; influence of European tales on, 73, 82, 194-95; work for *The Ladies' World*, 73; and *John Martin's Book*, 74; and *Judge*, 74-77; as practitioner of "bird's-eye view" cartooning, 74-75, 164, 195; and "Yapp's Crossing," 74-77; as magazine illustrator, 71-77, 124, 125, 127, 151, 194; role of meditation in work habits of, 77-78; as book illustrator, 79-86, 127, 194-95; business acumen of, 18, 79, 84, 96-100 passim; 106-8, 111-17, 124, 128-31, 152, 192; and *Grimm's Fairy Tales*, 80, 81, 82; influence of Arthur Rackham on, 82; relocates to New York City, 82; illustrates *Nobody's Boy*, 84; versatility of, 84; and "All About" books, 84-85; and death of Marcella Gruelle, 87-93; as illustrator with *Physical Culture* magazine, 89, 124-25; legendary origin of Raggedy Ann, 92, 107; illustrates *Quacky Doodles' and Danny Daddles' Book*, 93-101 passim; and P. F. Volland, 93-101, 115-21, 156-58, 164; as toy designer, 96; illustrates *Rhymes for Kindly Children*, 99; patents Raggedy Ann, 103-4; and Raggedy apocrypha, 107; makes first Raggedy Ann dolls, 108-9; markets Raggedy Ann stories to Volland Company, 111-15; grants right to manufacture Raggedy Ann dolls, 115, 170; influence of post-World War I cultural trends on, 124; as magazine writer, 124-27; writes/illustrates *Orphant Annie Story Book*, 130-32; scientific imagination of, 130-32; and newspaper serials, 131; influence of *Wonderful Wizard of Oz* on, 106, 133, 137; and interest in metaphysics and magic, 141; and Rosecrucian Order, 141; and family's sojourn in Oregon, 138-46; near-fatal illness of, in 1924, 146; reuse of newspaper serials in books by, 148-52; on promotional book tours, 156; as musician and songwriter, 157-58; returns to newspaper cartooning, 158; and lure of Florida, 161; resides in Miami, 161-67 passim; syndicates Raggedy Ann proverbs, 163; reacquires rights to Raggedys, 165; influenced by Florida locale, 165, 167; and Whitman Company, 165, 167; receives bids from radio networks, 167; and Exposition Doll & Toy Manufacturing Company, 168, 170-72, 176; and Bobbs-Merrill Company, 129-37, 145, 166-67; and lawsuit against Molly-'Es Doll Outfitters, 172-77; dies, 178; buried in Silvermine, Connecticut, 181; praised by obituary writers, 181; critics' views of, 193-98 passim; work by, as harbinger of Disney graphics, 194; innate sense of storytelling of, 194-96; observational powers of, 195; and adult readers, 75, 196; reception of work by, among librarians and teachers, 198; influence on Dr. Seuss of, 197; *pictured, 19, 26, 28, 29, 46, 52, 58, 69, 119, 138, 140, 149, 162, 180*

Gruelle, Joni, 188

Gruelle, Justin Carlyle, 18, 30, 33, 54, 57, 65, 67, 74, 92, 108; on influences of clowns on Raggedy Ann, 106; as artist continuing Johnny's work, 185; *pictured, 28, 29*

Gruelle, Kim, 42, 190

Index 217

Gruelle, Marcella Delight, 21, 49-50, 53-54, 59; and influence on "Mr. Twee Deedle" character, 91; untimely death of, 87-92; and Raggedy Ann, 92, 107, 112; *pictured, 49, 50, 60, 68, 70, 88, 90*

Gruelle, Marion, 189

Gruelle (Silsby), Myrtle Swann, 20, 45, 47, 48-50, 53, 67-70, 73, 87, 89, 91-92, 127, 141, 142-43, 170, 180-81; and origins of Raggedy Ann, 107-9; carries on Johnny's business after his death, 183-89 passim; remarries, 187; last illness and death of, 189-91; *pictured, 47, 52, 138, 162, 190*

Gruelle, Nathaniel ("Rice"), 27

Gruelle, Prudence (Johnny's paternal grandmother), 23, 29

Gruelle, Prudence ("Prudie") (Johnny's sister), 18, 29, 33, 107, 109, 156; *pictured, 29*

Gruelle, Richard Buckner ("R.B."), 18, 32, 48, 131; life of, 23-30; artwork of, 22, 24, 32; as landscape painter, 29, 49; influence on Johnny of, 19, 80, 81, 195; in Silvermine, Connecticut, 54, 66, 67; influenced by Arts-and-Crafts movement, 123; writes *Notes: Critical and Biographical*, 195; death of, 82; *pictured, 66, 68*

Gruelle, Richard ("Dickie"), 127, 139, 143, 147, 178; as partner in Johnny Gruelle Company, 184, 190; *pictured, 138, 162, 190*

Gruelle, Thomas, 27, 37

Gruelle vs. Goldman, 174-78, 183

Gruelle, Will, *pictured, 28*

Gruelle, Worth, 70, 92, 109, 111, 117, 139, 140, 144, 147, 167, 194; as artist continuing Johnny's work, 185, 189; *pictured, 138, 140, 190*

Halsam Safety Block Company, 185

Hamilton, Grant, 74

"Handy Andy" (comic strip), 42, 43

Harms, Inc., 157, 158

Hasbro Industries, Inc., 191-92

Heitman, William, 39

Herriman, George, 44

"Highlander" (doll), 111

Hildebrandt, Howard L., 54

Hills, C. W., 163

Hoffman, Caroline, 96

Holgate Brothers, 185

Honeywell, Mark, 164, 181

Hoosier Group, 18, 32

Hopkins, Sis, 75

"How Raggedy Andy Came" (story), 107

Howard, Roy W., 42

Howland, H. H., 129

Hubbard, Kin, 37

Hubbell, Henry Salem, 54

Hubbell, Rose Strong, 93, 96

Hughes, Jack, *pictured, 140*

Hunt, Margaret, 82

Indianapolis, Indiana: artistic "golden era" of, 27, 194-95; Lockerbie Street neighborhood of, 29-30; Eastside, 30-31; as portrayed in *The Canal—Morning Effect*, 32; newspapers of, 35-37

Indianapolis Star, The (newspaper), 18, 35, 37-39, 75, 181; founding of, 34; "Jim (Joe) Crow" weather bird cartoon by Gruelle, 39-40

"Jack the Giant Killer" (comic strip), 65

"Jan and Janette" (serial stories), 155

Jasmyn, Joan, 157

Jerome, M. K., 157

John Martin's Book (periodical), 73-74, 76, 96

Johnny Gruelle Company, 184-87

Johnny Mouse (doll), *pictured, 128*

Johnny Mouse and the Wishing Stick (book), 132, 134, 183

"Johnny Mouse and the Woozgoozle" (serial stories), 132, 134; *pictured, 128*

Judge (periodical), 74-77

Juvenile literature, evolution of, 79, 82

Keeshan, Robert ("Captain Kangaroo"), 187

Kewpies (dolls), 107

Kirkland, Elizabeth Brown, 96

Knickerbocker Toy Company, 188, 189, 191

"Knockers Club" (Silvermine, Connecticut), 67

Kroger, C. F., 163

Labor Signal (newspaper), 27

Ladies' World, The (periodical), 73

Last Great Company, The, 190

Lawrence, Josephine, 127

Leon, Arthur T., 82

Life (humor periodical), 151, 164

Life (Time-Life periodical), 189

Little Brown Bear (character and doll), 132; *pictured, 135, 159*

Little Gates to Nowhere (unpublished manuscript), 153

"Little Nemo in Slumberland" (comic strip), 54, 60, 65

"Little Orphant Annie" (poem), 107, 130

"Lonely for You (My Sweet One)" (ballad), 157

Long, Ray, 42

Loveland, Carl, 157

Lovey Lewie (character), 166

Lovey Lou (unpublished manuscript), 166-67

Luccock, Tracy, 164

"Lu-cille" (song), 157

Luther, Frank, 158

M. A. Donahue & Company, 167, 185

McCall's (periodical), 71, 72

McCay, Winsor, 54, 60, 65

McCulloch, George F., 35, 40

MacFadden, Benarr, 124, 163

McGinty, Officer, 31, 54

McKee, Homer, 40

McLoughlin Bros., 185

McMahon, John E. ("Jack"), 157

Macmillan, Inc., 191

Madmar Company, 158

Magazine of Fun, The (periodical), 75

Magical Land of Noom, The (book), 133, 136

Malot, Hector, 84

Man in the Moon Stories Told Over the Radio-Phone (book), 127

Manning, Walter W., 125

Marcella: A Raggedy Ann Story (book), 153

Martin, Earle E., 39, 40

Martin, John (Morgan von Roorbach Shephard), 73-74

Mathews, Horace and Cora ("Chum"), 47, 142

Matzke, Albert, 54

Meek, Clifton, 20, 42, 77, 179, 181

Mercer, Johnny, 157

Merrill, Col. Samuel, 130

Miami Herald (newspaper), 163, 164, 181

Miami News (newspaper), 164

Millar, Addison T., 54

Miller, Charles, 158, 160

Miller, M. Hughes, 188

Miller Music, Inc., 158, 160

Miller, Olive Beaupré, 96

Milton Bradley, 185

Modern Art (periodical), 195

"Mr. Twee Deedle" (comic strip): *New York Herald* publishes, 18, 59-60; origins of, 59; design elements in, 60-61; evolution of, 60-65; as morality tale, 61-62; and new printing technology, 62; creation of doll based on, 63; as harbinger of Raggedy Ann, 63, 102, 110-12; demise of, 65; influence of, on Gruelle as author and illustrator, 65, 82; examples of, 56, 60, 61, 64, 91, 102

Mr. Twee Deedle (book), 82; *pictured, 78*

Molly-'Es Doll Outfitters, 170-75, 183

Molly-'Es dolls: compared to Gruelle's Raggedys, 170, 173; commercial success of, 174; legal fate of, 175

Moore, Prudence Elizabeth, 23

Moses, Bert, 144

Muskegon Toy and Garment Works, 119

My Very Own Fairy Stories (book), 101, 111, 195; *pictured, 112*

Neighborly Poems (book), 130

New York Herald, The (newspaper), 18, 57-60, 62, 63, 64, 83. *See also* Bennett, James Gordon, Sr. and Jr.; *New York Herald Tribune*

New York Herald Tribune (newspaper), 158, 181

New York (American) Toy Fair, 169

Newspaper Enterprise Association (N.E.A.), 43, 54

Newspaper serials, Raggedy Ann and Andy, 131; as sources of Gruelle books, 148, 196. *See also* "The Adventures of Raggedy Ann and Raggedy Andy"; "Bedtime Stories of Raggedy Ann"

Newspapers. *See* specific names

Nobody's Boy (book), 84, 85

Non-Breakable Toy Company, 115

Notes: Critical and Biographical (book), 195

Oeder, Andrew Henry, 67

Oeder, Emma, 67, 140-46 passim

Oeder, Lynda, 67, 109, 140; *pictured, 138*

O'Neill, Rose, 107

Orphant Annie (doll), 132

Orphant Annie Story Book, 130-32, 181, 183; *pictured, 132*

Outcault, Robert, 54, 107

P. F. Volland Company, 18, 93, 101, 103-9, 111-21 passim; ideals of, 96; markets dolls based on Gruelle characters, 132, 135, 156-57, 159,

160; Gruelle's dissatisfaction with, 128, 135, 147; marketing strategies of, 99, 156-58; ceases publishing Gruelle's books, 164-65, 175

Paper Dragon, The: A Raggedy Ann Adventure (book), 150

"The Passing of Summer" (drawing), 181

Peninsular Engraving Company, 37

People (Indianapolis) (newspaper), 37

Percy the Policeman (doll), *pictured, 159*

Physical Culture (periodical), 89, 124, 125

Pinky Pup (doll), *pictured, 159*

Pirate Chieftain (doll), *pictured, 159*

Playthings marketplace, 124, 185

Playthings (periodical), 172, 174, 176, 183

Potter, Miriam Clark, 96

Proetz, John, 157

Putnam, Nina Wilcox, 115

Quacky Doodles' and Danny Daddles' Book, 93-102 passim; *pictured, 98*

Quacky Doodles (characters and toys), 94-95, 99, 100, 101

Racketty-Packetty House (book), 112

Rackham, Arthur, 82, 194

Rae, John, 96

Raggedy Andy doll: conceived of by Gruelle, 18, 107-17; distinctive elements of, 18, 19; patent for, 118; commercial success of, 121, 155-56, 187, 188-89; subject of lawsuit, 172-73; manufactured by
—Gruelle family, 108-9; *pictured, 108*
—Volland, 119-20; *pictured, 119, 120, 159*
—Molly-'Es, 170, 172-76, 183; *pictured, 173*
—Exposition, 176
—Georgene, 183, 185, 188; *pictured, 184, 185*
—Knickerbocker, 188-89, 191; *pictured, 189*
—Hasbro, 191
—Applause, 193
—homemade; *pictured, 192*

Raggedy Andy Stories (book), 107, 117, 119, 121

Raggedy Andy's Number Book, 148

Raggedy Ann doll: conceived of by Gruelle, 18; distinctive elements of, 18-19, 103-7; origins of, 103-13 passim; patent of, 103-4; trademark for, 105, 108; and "Uncle Clem," 111; and legendary candy heart, 111; commercial success of, 112-28 passim, 155-56, 165, 187, 188-89; nostalgic appeal of, 124; subject of lawsuit, 172-

73; consumer products related to, 184-85, 188; fiftieth anniversary of, 189; traditional essence of, in competitive marketplace, 191-92; manufactured by
—Gruelle family, 107-9; *pictured, 108*
—Volland, 109, 115, 117, 123, 128; *pictured, 113, 114, 116, 120, 159*
—Molly-'Es, 170-76, 183; *pictured, 173*
—Exposition, 170, 174, 176; *pictured, 168, 171*
—Georgene, 183, 185, 188; *pictured, 184, 185*
—Knickerbocker, 188-89, 191; *pictured, 189*
—Hasbro, 191
—Applause, 193
—homemade, *pictured, 160, 192*

Raggedy Ann and Andy and the Camel with the Wrinkled Knees (book), 144-45, 195

Raggedy Ann and Andy and the Nice Fat Policeman (book), 31, 185

Raggedy Ann and Betsy Bonnet String (book), 185

Raggedy Ann and the Golden Butterfly (book), 185

Raggedy Ann and the Golden Ring (book), 188

Raggedy Ann and the Happy Meadow (book), 188

Raggedy Ann and the Hobby Horse (book), 188

Raggedy Ann and the Left Handed Safety Pin (book), 165

Raggedy Ann and the Queen (unpublished book), 165

"Raggedy Ann and Raggedy Andy" (animated film), 191

Raggedy Ann and the Wonderful Witch (book), 188

Raggedy Ann Cut-Out Paper Dolls (book), 165

Raggedy Ann in Cookie Land (book), 156

Raggedy Ann in the Deep Deep Woods (book), 156

Raggedy Ann in the Golden Meadow (book), 165

Raggedy Ann in the Magic Book (book), 185

Raggedy Ann in the Snow White Castle (book), 185

Raggedy Ann proverbs (syndicated series), 163

Raggedy Ann Stories (book), 103, 112, 115, 117, 121, 123, 152; *pictured, 19, 113*

Raggedy Ann's Alphabet Book, 148

Raggedy Ann's Joyful Songs (book), 157, 176

Raggedy Ann's Kindness (unpublished book), 165

Raggedy Ann's Lucky Pennies (book), 156

Raggedy Ann's Magical Wishes (book), 150

"Raggedy Ann's New Sisters" (story), 111

Raggedy Ann's Sunny Songs (book), 157, 158

Raggedy Ann's Wishing Pebble (book), 148

"Raggedy" (Volland) character dolls, 132, 135, 156-57, 159, 160. *See also* individual names of dolls

"Raggedy Man, The" (poem), 107, 130

"Rags" (doll), 110

Rhymes for Kindly Children: Modern Mother Goose Jingles (book), 99, 100-101

"Rickity-Robin" stories. *See* "Cruise of the Rickity-Robin, The"

Riley, James Whitcomb: 29, 141, 181; influence on Gruelle of, 18, 30, 107, 129-30, 195

Roosevelt, Franklin D., 163; as Gruelle collaborator, 156

Rosecrucian Order, 20, 141

Ross, M. T., 96

Saalfield Publishing Company, 185

Sans Famille. See Nobody's Boy (book)

Sargent, Lester L., 172

Schoenhut, A., Company, 97-100 passim

Shephard, Morgan von Roorbach. *See* Martin, John

Shutts, Frank B., 163

Silvermine, Connecticut: as artist colony, 54, 67; ambiance of, 67, 77-78

Silvermine Guild of Artists, 67

Smith, Sidney, 42

Snyder, Fairmont. *See* Fairmont, Ethel

Soltau, Edward, 30, 50, 75, 142; *pictured (with wife Grace)*, 52

Soltau, John, 30

Stark, Otto, 32

Steele, T. C., 32

Steinhardt, A., and Bro., 63

Stepping Stones (musical), 157

Stevens, Gay, 157

Stewart, J. N., 74

Story of Live Dolls, The (book), 112

Sun, The (Indianapolis), 36, 37

"Sunny Books" (Volland series), 115, 133, 148

Sunny Bunny (book), 115

Sunny Bunny (doll), 132, 135; *pictured, 159*

Swann, William Fenton and Harriet Foster, 48, 50, 70

"Tearful Tale of the Moonman, The" ("Mr. Twee Deedle" episodes), 62

Thompson, John W., 170, 175

"Thrilling Adventures of Andy and Ann on the Cruise of the Rickity-Robin, The" (serial stories), 125. *See also* "Cruise of the Rickity-Robin, The"

"Tommy Grasshopper" stories, 73

Toy manufacturing, after World War I, 124

Travels of Timmy Toodles, The (book), 77

"Travels of Timmy Toodles, The" (story), 76

Trepagnier, Vera, 115

Turrell, J. A., 181

Twee Deedle (character). *See* "Mr. Twee Deedle"

Twee Deedle (doll), 63

Uncle Clem (character), 150; (doll), *pictured, 159*

"Uncle Clem" (story), 111

"Uncle Johnny Gruelle's Page for Good Boys and Girls" (serial stories), 125

United Features Syndicate (distributor of "The Adventures of Raggedy Ann and Raggedy Andy"), 131

Victor Records, 158

Vining, Irving, 144

Volland, P. F., Company. *See* P. F. Volland Company

Volland, Paul Frederick, 96, 98, 101, 111; murder of, 115

Waldo, Helen, 74

Wales, James, 74

Walker, Izannah, 103

Washington (D.C.) Society of Fine Arts, 56

"We'll Wallop the Kaiser" (sheet music), 157

White, Leo, 188

Whitman Company, 165, 167

Williams, Martin, 195, 198

Wish, Fred, 172

Woman's World (periodical), 125, 133, 137, 145, 160

Wonderful Wizard of Oz, The (book), 106, 130, 135

Wooden Willie (book), 150

Woodin, Will, 156, 158, 160, 163

World Color Printing, 40, 42, 43, 44

"Yapp's Crossing" (bird's-eye view cartoon), 74-75, 77, 140

Yates, Jack, 74

"Yayhoo (Yahoo) Center" (bird's-eye view cartoon), 151

The author gratefully acknowledges the assistance of James Summerville in compiling this index.

Designed by Dana Bilbray, Tracey Clements and Jean Huang
Composed in Goudy Old Style by Northwestern Printcrafters
Four-color separations by Dai Nippon Printing Co.
 (Hong Kong) Ltd.
Printed on 113 gsm matte art paper by sheet offset press and
 bound in Saifu Cloth. Smyth sewn by Dai Nippon Printing
 Co. (Hong Kong) Ltd.